ACCLAIM FOR JULIEN LEVY'S "MEMOIR

"Lively and thoroughly engrossing ... spice about some of the best-known figures in twentieth-century art, and many of these accounts add information which may even alter our conception of history." — AFTERIMAGE

"Entertaining, distinguished, informative. Could not be more charming. And satisfactory too, because the author loves his subject." — VIRGIL THOMSON

"Levy's memoirs are neither art criticism nor art history. They are the tales of a generation of men and women who taught us how to look at the whole world with new eyes." — LOS ANGELES TIMES

"His memoirs give important background material for the social history and the love-hate ambience of that era's art. The book is certainly difficult to put down once started." — LIBRARY JOURNAL

"Fascinating ... This story of an unusual art gallery and its enterprising proprietor is a delightful introduction to an important twentieth-century art movement." — AMERICAN ARTIST

"Conveys the frenetic, experimental quality of the art world in those years, when a multitude of conventions were available for the shattering, and the artists were happy to pitch in, creating a style that rendered the stuff of dreams part of daily, waking life." — HARPER'S BOOKLETTER

"Provides a close-up of who and what constituted the aesthetic avant-garde in the United States in the last period when American art was under the domination of Paris." — HAROLD ROSENBERG, NEW YORKER

"A colorful picture of an era and of its colorful denizens." — SAN FRANCISCO CHRONICLE

"Reading Levy's elegant, rancor-free prose, we are always persuaded that art is both noble and ennobling — an idea too little expressed in the marketplace today." — ALAN G. ARTNER, CHICAGO TRIBUNE

artWorks

For as long as there has been art, there has been discussion about art. Over the past two centuries, as ideas and movements have succeeded each other with dizzying speed and the debate between various aesthetics has turned increasingly vivid, art criticism and theory have taken on an unprecedented relevance to the development of art itself.

ARTWORKS restores to print the most significant writings about art— whether letters and essays by the artists themselves, memoirs and polemics by those who lived with them in the thick of creation, or illuminating studies by some of our most prominent scholars and critics. Many of these works have long been unavailable in English, but they merit republication because the truths they convey remain valid and important. The list is eclectic because art is eclectic; taken as a whole, these titles reflect the history of art in all its color and variation, but they are bound together by a concern for their importance as primary documents.

These are writings that address art as being of both the eye and the mind, that recognize and celebrate the constant flux in which creation has occurred. And as such, they are crucial to any understanding or criticism of art today.

Apollinaire on Art: Essays and Reviews, 1902–1918
edited and introduced by LeRoy C. Breunig
with a new foreword by Roger Shattuck

Futurist Manifestos
edited by Umbro Apollonio
with a new afterword by Richard Humphreys

Surrealism and Painting
André Breton
with a new introduction by Mark Polizzotti

Selected Letters, 1813–1863
Eugène Delacroix
edited and translated by Jean Stewart
with an introduction by John Russell

Letters to His Wife and Friends
Paul Gauguin
edited by Maurice Malingue

My Galleries and Painters
D.-H. Kahnweiler, with Francis Crémieux
with an introduction by John Russell and new material

Stieglitz: A Memoir / Biography
Sue Davidson Lowe
with a new foreword by the author
and a new preface by Anne E. Havinga

Letters to His Son Lucien
Camille Pissarro
edited and with an introduction by John Rewald
with a new afterword by Barbara Stern Shapiro

The Innocent Eye: On Modern Literature and the Arts
Roger Shattuck

Memoir of an Art Gallery

Julien Levy

Introduction by Ingrid Schaffner

artWorks

MFA PUBLICATIONS
a division of the Museum of Fine Arts, Boston

To and for Jean

MFA Publications
a division of the Museum of Fine Arts, Boston
465 Huntington Avenue
Boston, Massachusetts 02115
www.mfa-publications.org

For a complete listing of MFA Publications, please contact the publisher at the above address, or call 617 369 3438.

Originally published in 1977 by G. P. Putnam's Sons, New York. This edition is reprinted by arrangement with The Estate of Julien Levy and Jean Farley Levy.

PHOTOGRAPH CREDITS: All photographs provided by kind courtesy of The Estate of Julien Levy, except: pages i and xvi: Courtesy of Jonathan Bayer; pages iv (top) and xxi (bottom): © The Estate of George Platt Lynes; page iv (bottom): © Lee Miller Archives, Chiddingly, England; page vii (bottom left and right): Courtesy of Jay Leyda; page ix: © 2003 Man Ray Trust / Artists Rights Society (ARS), New York / ADAGP, Paris; pages xiii (bottom) and xviii: Courtesy of James Thrall Soby; page xxii (top): Photo by Peter Pulham.

Every effort has been made to contact copyright holders of the images not listed. Any oversight in this regard is purely unintentional.

ISBN 0-87846-653-3
Library of Congress Catalogue Card Number: 76-24793

Available through:
D.A.P. / Distributed Art Publishers
155 Sixth Avenue
New York, New York 10013
Tel.: 212 627 1999 · Fax: 212 627 9484

FIRST ARTWORKS EDITION, 2003
Printed and bound in the United States of America

CONTENTS

Illustrations follow page 160.

Portrait of an Art Dealer

From 1931 to 1949, Julien Levy's New York gallery played an essential role in the shift of the avant-garde from Paris to America. It championed experimental film and photography and served as a venue for artists fleeing Europe and Hitler. It presented the first New York exhibitions of artists such as Henri Cartier-Bresson, Joseph Cornell, Frida Kahlo, Salvador Dalí, Arshile Gorky, Lee Miller, René Magritte, and Dorothea Tanning, all the while promoting a vision of art at its broadest. There were "idea shows" suggested by such critical thinkers as André Breton and Marcel Duchamp, as well as shows about fashion, design, dance, popular culture (Walt Disney and Gracie Allen both showed here), and even music (including a performance by Paul Bowles). In bridging the gap between Gilbert Seldes's early modern model of the "seven lively arts" and today's more academic "visual studies," the activities of the Julien Levy Gallery spark electric. It is also a place to watch as the identity of the art gallery as a commercial institution takes shape, from a near-curiosity shop (books, prints, and lampshades were among the first wares) to a contemporary art gallery: naked, white, and modern. All this history argues for the need to read Levy's memoirs afresh. But there remains a simpler reason for picking up *Memoir of an Art Gallery*: Julien Levy tells it as he lived it, with wit and appetite. This is a book that deals in sensual adventure, which is exactly what you hear in Levy's voice, whether written or spoken.

The first time I heard Levy speak was in a WABC radio recording, aired on June 11, 1938, and now in the collection of the Museum of

Broadcasting. People who knew Julien Levy often speak of his voice, which I listened for and heard twice in the course of researching the exhibition "Julien Levy: Portrait of an Art Gallery."[1] Named after the memoirs now being introduced, "Portrait of an Art Gallery" aimed to conjure the dynamism of a transitional period in American art history through the doings of this maverick art dealer. In the WABC broadcast, Levy was defining the art movement with which his name was synonymous: "Sur-RAIL-ism." Or so he pronounced it, in a voice inflected as much by his upper-middle class New York upbringing, as by his years doing business in Paris, as well as by cigarettes, cocktails, and a sophisticated sense of culture. In short, it was deep, smoky, and a little affected. The next time I heard his voice, it had aged a few decades, and now when Levy said the word, it was as if a train was rumbling right through the middle of it: surrrrrrrRRRAILLLLLLism. He was narrating a short film called *Surrealism Is...,* in which he also starred. The film was made as a project with students at SUNY Purchase, where, late in his life, Levy had plans—which never came to pass—to establish a Center for Surrealist Studies. The class appears to have been psychedelic in form: hippyish-looking students conducting experiments in creative automatism outdoors in the open fields around Levy's house, or playing indoors with his collection of Surrealist art and other curiosities.

Levy presides over the film, a grand wizard imparting his life's work to a new generation. For that is what his commitment amounted to—much more than just the art of his day, something he sold as part of his job, Surrealism was an avocation to which he was dedicated. You hear it in his recital of the movement's definitions, poems, and erotic prayers.

1. Co-curated by Ingrid Schaffner and Lisa Jacobs, "Julien Levy: Portrait of an Art Gallery" was presented by the Equitable Gallery (now AXA) in New York from August 14 to October 31, 1998. The exhibition was accompanied by a book of the same title, published by The MIT Press.

"A little more than green and less than blond," he intones after Paul Eluard and Benjamin Péret's 1925 proverbs. "What is Day?", an indoctrinated student recites from a 1928 dialogue. "A woman bathing nude at nightfall." You see it in Levy's surroundings; besides being chock full of art treasures—there are Max Ernst's collages and frottages, Alberto Giacometti's sculpture *On ne joue plus*, and Dalí's painting *Accommodations of Desire*—the shelves are loaded with the kinds of optical devices, found objects, and natural artifacts through which the uncanny expressed itself every day to properly attuned Surrealists. The movement's love of games is evinced by a chess board, evocative of the ones made by artists for the gallery's 1944 exhibition "The Imagery of Chess." Indeed, Levy liked to imply that where he failed as a businessman, he succeeded as a collector. But this seems too modest an account of the active devotion with which Levy practiced Surrealism during his entire life. "Pop art is a neo-Surrealism," he concludes toward the end of the film.

A rakishly elegant man in his youth, Levy in the film appears (and sounds) aged into a regal wreck of the figure described by the dealer James B. Meyers: "Julien Levy reminds me of Antonin Artaud, probably because I had seen a photograph of Julien with a shaved head, which Berenice Abbott had taken years before in Paris. He is intelligent and handsome with a profile rivaling that of the great actor John Barrymore."[2] (Note Barrymore's bad behavior in the memoir to come: he pees on a painting by Max Ernst.) The shaved head also deserves further comment. Levy claimed that he was following a folk wisdom to rejuvenate his scalp by rubbing bear grease into it. He also liked to say that Marcel Duchamp had put him up to it, by saying that shaved heads were quite the thing among the radical chic in Paris in 1928.

2. John Bernard Myers, *Tracking the Marvelous* (New York: Random House, 1981), 43.

Levy's devotion to Surrealism was seconded only by what he called his "hero-worshipping" of Duchamp and Alfred Stieglitz, whom he claimed as his godfathers in art. Both men were high priests of early Modernism. Prone to sermonizing and wearing capes, Stieglitz instructed Levy (along with the countless other acolytes who would sit at his feet) to be reverent, especially of photography—then a new medium of dubious aesthetic standing. More profanely, Duchamp inducted the young man into the living pleasures of bohemia when he invited him to tag along on a trip to Paris. On board ship, the two men speculated on the makings of a self-lubricating mechanical woman and discussed plans to shoot a film using Man Ray's equipment. As told in the memoir, the film was never made, but the trip altered the course of Levy's life. Both Stieglitz and Duchamp were also artists, dealers, publishers, curators, writers, and lovers of printed matter—all inclinations they passed along to Levy. Besides running a gallery for almost nineteen years, Levy wrote extensively (including a beautiful proto-history of Surrealism in 1936 and monographs on Eugène Berman and Arshile Gorky)[3] and helped create exhibitions throughout his life (such as "The Disquieting Muse" at the Contemporary Art Museum in Houston in 1958). All of his own shows were accompanied by brochures that announced not only the exhibition but a high sense of style as well. As an artist, Levy was purely an amateur, but he did make a few short Surrealist-style films in the 1930s, including a romp with Max Ernst set at Caresse Crosby's mill retreat outside Paris, and exquisite portraits, full of motion, of Mina Loy shopping at the *marché aux puces* and of Lee Miller.

Memoir of an Art Gallery proves Julien Levy to be an excellent

3. Originally printed on multi-color papers and in different colors of ink, and published by Caresse Crosby's Black Sun Press, Levy's 1936 *Surrealism* (conceived as a kind of user's guide to the movement) was reprinted as a serviceable paperback by Da Capo Press in 1995.

raconteur as well. He knows the value of exaggeration and elision when it comes to crafting the better story. And this is precisely how the book is constructed—tales of luminaries like James Joyce and Giorgio de Chirico, and incendiary episodes such as "Duchamp's Kiss" and "Walpurgisnacht Chez Tzara." Each chapter becomes its own piece in a lapidary account that leaves, as all remembrances do, gaps and fissures. To fill in some of these gaps, let's add a little more family background. Julien Sampson Levy was born in New York on January 22, 1906, the oldest of three, with a brother Edgar (Ned) and sister Elizabeth. His mother, Isabelle Estelle Isaacs, had been orphaned as a child and was raised by an uncle, who would co-found the first English-language newspaper for Jews in America. For generations, the Isaacs had been a prominent Jewish family; Rabbi Samuel M. Isaacs read over Abraham Lincoln's funeral cortege when it passed through New York. Levy's father, Edgar, who was also raised in the city, had first studied art before becoming a successful lawyer and real estate entrepreneur. He and his partners, including Isabelle's cousin Stanley Isaacs (later a borough president of Queens), were among the first to develop luxury apartment buildings along Park Avenue. Later in life, Edgar's real estate empire would obviously aid his son's desire to set up shop in Manhattan. Both parents, in fact, seem to have had much to do with Levy's becoming an art dealer. And though Julien depicts his father as a philistine, the elder Levy collected art and dabbled in painting, and also seems to have had a genuine sympathy for his son's interest in art. Furthermore, as much as Julien sides against his conventional parent and acts like a bohemian, he never truly rejected Edgar's bourgeois tastes or values. He was, as most Surrealists were, an armchair radical.

Julien's mother doted on her oldest son. When as a boy he contracted rheumatic fever, the family moved to Scarsdale, where Levy attended the progressive Roger Ascham School before enrolling at

Harvard University. Harvard, unlike the rest of the Ivy League, admitted Jews; Levy's mother had attended Harvard's sister college Radcliffe, where her ties later proved useful in helping her son find his way out of an English major and into the study of art. During the summer of Levy's freshman year, his mother was run over and killed. According to the local newspaper's obituaries, "Mrs. Levy, accompanied by a Mr. Jacobson, was walking toward Mamaroneck road when an automobile...bore down upon them, crashing into both. The automobile knocked Mrs. Levy down passing over her." "As she lingered over her fatal injury, her one concern was the welfare of her husband and children," another one wrote, "and her sole regret was that they would be deprived of such service and comfort as might have been able to render to them, had she been spared a few years more." Still a third noted that "Mrs. Levy was a member of the Women's Club and frequently seen in productions by the Wayside Players and the Fireside Players."

Buried in these shards are a woman's creative aspirations. But what is most glaring is the fact that, however violently it rent through his life, Julien's mother's death reads largely as an absence from his memoirs. It's the absence filled, or at least marked, by the intense attachment Levy formed for his mother-in-law, the poet and painter Mina Loy, whose own glamour and sense of personal drama were part of the mythology of the Paris scene during the 1920s.[4] The fact that she was the widow of one of Duchamp's heroes, the Dada poet and boxer Arthur Cravan, who disappeared at sea, only heightened her mystique. More than a muse (and less than a mother), Loy is certainly a complicated figure in Levy's early life as an art dealer and as a husband to her daughter Joella. During their marriage, Joella efficiently ran the day-

4. Cf. Carolyn Burke, *Becoming Modern: The Life of Mina Loy* (New York: Farrar, Straus and Giroux, 1996).

to-day operations of the gallery in New York, while Loy (flightily) acted as Levy's agent in Paris. Nurtured by both, Levy was indulged as a son, lover, boss, partner, and proud father of three sons—until Joella left him in 1937 due to his drinking and philandering. At the time of his death, Levy was reported to have been at work editing the voluminous correspondence he kept up with his mother-in-law throughout the rest of her life.[5]

But the story is getting ahead of us. Back at Harvard, after his mother's death, Levy continued on the path she had set for him, which notably included Paul Sachs's king-making course for museum professionals, "Museum Work and Museum Problems." There he met Alfred Barr, Jr., Philip Johnson, and Lincoln Kirstein, all to be affiliated with the Museum of Modern Art, and A. Everett (Chick) Austin, Jr., the future director of the Wadsworth Atheneum in Hartford, among others. Of this institution-bound group, Levy distinguished himself by quitting a semester before graduation in order to try to get a job in the movies (he was besotted with Gloria Swanson). When running errands as a prop boy for Columbia Studios in New York failed to match his aspirations, however, he returned to his initial interest in art. Knocking around the galleries with his father, Levy met Duchamp, who was then acting as Brancusi's agent. The two formed a friendship, and in February 1927 Levy embarked with Duchamp for Paris on that fateful trip. Returning six months later, he arrived home with his new bride Joella and, among other things, their wedding gift from Brancusi, *The Newborn*, a bronze head now in the collection of the Museum of Modern Art. Levy's Paris plunge instilled an ambition to open his own gallery in New York—an ambition that his father agreed to support, provided his son serve a proper apprenticeship. And so from 1928 to

5. Grace Glueck, "Obituary," *New York Times* (February 11, 1981).

1931, Levy worked as an assistant at the Weyhe Gallery, which specialized in rare books and prints, and where he had his first experience as a dealer, presenting photographs by Eugène Atget.

On November 2, 1931, Julien Levy opened his own art gallery with tribute to Alfred Stieglitz and American photography. Following that, he went on to present a basically European avant-garde aesthetic and culture, thereby establishing himself as the middleman between artists and collectors, a pioneering purveyor of wares to the Modernist institutions being developed by his former classmates. Throughout the 1930s and 40s, all of the major museums interested in acquiring cutting-edge contemporary art bought from Levy. It is interesting, then, to take note of the prejudices that attach themselves to Levy's mercantile enterprise. Writing for *Vogue*, one journalist described him in nearly Fagin-esque terms: "His keen and almost glittering eye, focused on the Parisian scene, may discover this decade's Cézanne at any moment—a possibility that keeps him and his clients slightly feverish at all times."[6] Written in 1938, this statement serves to remind us that the Germans were certainly not alone in their anti-Semitism. Levy, for his part, resented the secondary status accorded dealers within the echelons of the art world, which clearly benefited from their vision and risks.

Then again, he himself did not always give credit where it was due. One of his gallery's claims to fame is that in January 1932 it hosted "Surréalisme," the first exhibition devoted to the movement in New York. This much is true, but it short-shrifts the importance of Chick Austin's earlier "Newer Super-Realism," held at the Wadsworth Atheneum, albeit to less public fanfare than Levy's show, which won a huge New York audience and national press. The two shows ended up being collaborative in that they shared many (though not all) of the same works. But the fact remains that Austin's show was its own ini-

6. Sallie Faxon Saunders, "Middle Men of Art," *Vogue* (March 15, 1938), 102.

tiative, and by opening on November 15, 1931, it could rightfully claim to be the first exhibition of Surrealism in America.[7]

There are several other claims worth tempering. The first is small and involves Levy's "discovery" of Joseph Cornell. It's an excellent story about Cornell—and he probably was a most gray young man—stopping by the gallery to look at photographs, only to become, at the behest of the dealer, the first home-grown American Surrealist. What's missing, however, is any indication of how deliberate and thorough Cornell was in his haunting of New York's art world. Perhaps Levy, like most of Cornell's contacts, had no idea how well-connected this most discrete of artists was. If anything, Cornell may have seen in the dealer a potential advocate for his own interests in photography and collage. Indeed, over time, Cornell worked hard to distance himself from his original identification with Surrealism, which he came to see as a form of black magic. (And he seems to have never forgiven Levy for scheduling all of his gallery exhibitions around Christmas time, the better to flog Cornell's collage objects as toys for adults.)

Then there's Levy's purported rescue of Eugène Atget's great photographic archive of Paris. Levy slightly glorifies his early investment in and enthusiasm for the work, at the expense of Berenice Abbott's essential role. An American photographer based in Paris, Abbott physically prevented this vast collection of plate-glass negatives and prints from being pitched in 1928 into the dustbin of history. Long after Levy's interest had waned, she continued to make it part of her life's work to care for and promote the archive, finally landing it a place in the Museum of Modern Art, where it exists as the Abbott-Levy Collection, in 1968. Still, to be fair, Abbott was no less proprietary against Levy's

7. For a thorough discussion of the two shows, see the excellent article by Deborah Zlotsky, "Pleasant Madness in Hartford: The First Surrealist Exhibition in America," *Arts Magazine* (February 1986), 55-61.

claims, and Cornell's championship by Levy was absolutely critical to launching his career, so these revisions to Levy's memoirs have more to do with tone than with fact.

And who knows if, as a fledgling gallerist, Julien Levy actually invented the gallery press release and the cocktail party opening? No such patents exist. But the dealer's claims to priority seem worth defending. Levy's gallery certainly made art openings, which had hitherto been insular affairs for collectors, into public events that anyone could attend simply out of interest in seeing something new. This is one of the greatest pleasures of *Memoir of an Art Gallery*: its snapshot depictions of a cultural scene in which, it seemed, anything could happen. Between the wars, not only was the art world much smaller, but with the economy in Depression there was considerably less at stake. There were opportunities for experimentation, and openness in general about what culture could be. Pay attention to all that Levy embarks on, either in hopes of making money or achieving fame. Among his freshest schemes were: Swiss Cheese cloth (his plan to print photographs onto utilitarian objects and materials);[8] the curved gallery wall (his second gallery location featured an undulating wall upon which works of art seemed to unfurl as viewers moved by them); the gallery caravan (in 1941, Levy took his stock on the road to San Francisco, then Los Angeles, in hopes of drumming up West Coast collectors); Salvador Dalí's "Dream of Venus" (a Surrealist funhouse for the 1939 World's Fair); and "The Carnival of Venice" (the gallery's 1933 exhibition of photographs by Max Ewing of celebrities, socialites, and friends aping in front of a painted Venetian backdrop—Warholian photobooth-ography thirty years before Pop!).

8. Here Levy deals another slight to Berenice Abbott, when he credits her only as a helpful young woman who took pictures for him; her studio stamp is clearly visible on all of the prototypes for Levy's photo-objects. These are now in the photography collection of the Philadelphia Museum of Art.

On a much darker note, throughout the gallery's history there are the undercurrents of accident, alcohol, guilt, and depression that appear twisted into this memoir's silences. Most tragically, in recounting Arshile Gorky's suicide, Levy isn't altogether clear that it occurred only a month after he had injured them both in a car crash in which Gorky's neck and painting arm were both broken. Levy recounts the episode like a cineaste's dream, starting with chickens and brakes squawking, and ending with the closing of the Julien Levy Gallery in 1949, a year after Gorky's death. Here, as in some other places, Levy's account seems too pat, too remote, to convey the true shades of personal memory. It also downplays the downspin of his business, which had been growing steadily out of touch with the latest advancements in art. Uninterested in Abstract Expressionism, Levy stood by Surrealism, to be eclipsed by dealers who maintained more current visions: Pierre Matisse, Sidney Janis, and Betty Parsons among them. But such is the case with good story telling and storytellers—they invite further unraveling.

First published in 1977, *Memoir of an Art Gallery* closes with Gorky's last words, echoed here by Levy in tribute to the history of his gallery: "Good-bye my 'loveds'." However, the story hardly ends here. Levy's 1944 marriage to his second wife, the sculptor Muriel Streeter, ended in divorce. On January 20, 1957, in Bridgewater, Levy married Jean Farley McLaughlin, to whom he dedicated this book, and who remains devoted to preserving her husband's memory. Until he died in 1981, at the age of seventy-five, Levy remained an engaged emissary of Surrealism. In his later years, he cultivated a Stieglitz-like habit of wearing capes. No doubt he cut a daunting silhouette on his regular visits to New York, where he kept up with contemporary art (he saw Surrealism in the work of artists as diverse as Joseph Beuys and Tom Wesselman) and collaborated with his fellow dealers (including Richard Feigen and Leo Castelli) to show and sell work from his collection. In the late

1970s, Levy was introduced to curator David Travis of the Art Institute of Chicago. Apparently, when the gallery closed Levy had a lot of left-over photography inventory, notably hundreds of works by Jacques-André Boiffard, Lee Miller, Robert Parry, Man Ray, Maurice Tabard, and others. Forty years later, these prints emerged from storage to constitute a virtual missing history—occluded from both photography and Modernism—of Surrealist photography. During Levy's lifetime, a large number of works were acquired by the AIC to form the Julien Levy Collection. More recently, in 2001, the Philadelphia Museum of Art acquired through gifts by Levy's widow and Lynne and Harold Honickman all of the remaining photographs from Levy's estate to establish the Julien Levy Collection of Photographs.

What became of other effects of the gallery's history? Key elements found their way to private and public collections: Cornell's *L'Egypte de Mlle Cléo de Mérode cours élémentaire d'histoire naturelle* to the Robert Lehrman Collection, Washington, D.C.; Max Ernst's *Vox Angelica* to the Daniel Filpacchi Collection, Paris; Dalí's *Persistence of Memory* to The Museum of Modern Art, New York; Giacometti's *On ne joue plus* to the Nasher Sculpture Center, Dallas; Gorky's *New Hope Road* to the Museum of Fine Arts, Boston; Frida Kahlo's *Self-Portrait Dedicated to Trotsky* to the National Museum of Women in the Arts, Washington, D.C.; Pavel Tchelitchew's *Phenomenon* to the Tretyakov Gallery, Moscow; Dorothea Tanning's *Guardian Angels* to the New Orleans Museum of Art, and so forth out into the world.[9]

And what of the papers? In compiling his memoirs, Levy gathered his archives around him, including brochures, reviews, and other related ephemera, to work in a small writing studio on his Connecticut property. It's unclear how the fire began, but much of the material was

9. Many works in Levy's personal collection were sold at auction by Sotheby's in November 1981.

destroyed either by flames or water. Whatever could be swept up was saved in a storage area attached to the house, and considered basically inaccessible due to its poor condition. This is not to say that all was lost, and indeed, recent efforts to process what does remain have turned up some astounding stuff. By way of example, let me end with my own story. Last year, I was working on a book about Salvador Dalí's "Dream of Venus" pavilion, a story in which Levy naturally plays a leading role. I had all but completed my research when the treasures started emerging from the nooks and crannies of Jean and Julien's house. They included such things as a gramophone record called *Dream of Venus* (labeled as a recitation by actress Ruth Ford and an accompanying chorus for the World's Fair), a typed manuscript for the same ("Behold! I am Venus! I am the most beautiful woman in the world!"), a list of rejected names for the concession ("Dalí Trance Forms" and "Dalí's Wet Dreams" among the lamest), and, most astonishingly, photographs of a strange studio session that involved dressing live models in dead seafood for an unrealized photo-mural. And it didn't all offer itself at once, but as if summoned piece-by-piece, just in time to fuel the narrative I was in the process of constructing.

You might call this surreal and leave it at that: Julien himself evidently cherished such coincidences. The real point is that much remains to be known and written about Julien Levy, about his life, his work, his influence as an important American art dealer, and his far-reaching, often arcane interests. His memoirs only begin to tell the tales.

INGRID SCHAFFNER
New York, May 2003

Ingrid Schaffner is Senior Curator at the Institute of Contemporary Art, University of Pennsylvania. Her most recent book is *Salvador Dalí's Dream of Venus: The Surrealist Funhouse from the 1939 World's Fair* (Princeton Architectural Press).

Memoir of an Art Gallery

When I was fourteen years old, I was conducted through the Uffizi Galleries in Florence by a plump, pretty woman named Hazel Guggenheim. For a length of time I would not pass beyond Botticelli's "Birth of Venus," before which I stood stubbornly spellbound.

"Come," said Hazel, taking my hand impatiently, "would you not rather have a real woman like me, for example, than that painted thing?"

"No," I answered tactlessly and emphatically. "I would rather have that painted thing."

The Julien Levy Gallery was begot of a couple of haphazard indeterminates. Sometimes I think that this *contre*-chat with Hazel was one. Later there was my achievement of a near flunking grade, D, in freshman English in 1924 at Harvard. That seriously depressed my prospects of becoming a famous author, a notion of my fond mother and the proud Annie Windsor Allen at her small progressive school in Scarsale, Roger Ascham. I graduated from Ascham after composing some very blank adolescent verse and an inept graduation playlet, also in blank verse, sufficient indication to these good ladies that I should be sent to Harvard for a little finishing polish from George Kittredge, Charles Copeland, George Santayana *et al.*

My path seemed clear and bright until, tangled in the faulty spelling and catastrophic grammatical lapses of my first term paper, I was led into conference with my faculty adviser, who happened to be Paul J. Sachs, a man of weight in the Department of Fine Arts. The time had come to decide the direction of my major studies at Harvard.

"Sign up with us for Fine Arts," urged Sachs. He was very proud of his department. Impulsively, I followed his advice.

I had no way of knowing the state of art education in other universities around the country, except that it was generally understood that such education was purely academic—that is to say very conservative. At Harvard, the young, or more precisely, rejuvenated Fine Arts Department had more vitality than the renowned English department from which Santayana had already resigned and Kittredge and Copeland were about to resign without outstanding successors.

In Fine Arts, the Brahmin docent Edward Waldo Forbes, of shy charm and incongruous bangs, guided us, whether we had talent or not, into practicing each of the historic techniques in succession, including colored Egyptian bas-reliefs, Grecian urns, medieval gesso panels, and *fresco vero*. Though a poor way to teach originality of style, this was a most important training for the mind's eye and the hand's muscle in understanding the basics of an artist's work and materials. I remember the gracious Professor Kingsley Porter, who mysteriously disappeared off the coast of Ireland during my sophomore summer, and meticulous Arthur Pope, who taught the rules for establishing a palette with the "color solid" device, a color chart in three dimensions which appealed to my love of gadgetry and, although he would have been distressed by it, my interest in abstraction. Also on campus were several brilliant young tutors and postgraduates: Chick Austin, Henry-Russell Hitchcock, and Alfred Barr.

The centrifugal force, I felt, was Paul J. Sachs, a very important, rotund, seemingly pompous little man. I say pompous only because that was my first fearful impression before I experienced his gentleness, scholarship, and dedication. He was a kingmaker without kingly pretension. In fact he was not then properly a professor, and would continually correct us when we addressed him as "Professor Sachs" or "Dr. Sachs." "Mr. Sachs," he would patiently admonish us. A modest retired banker, he was recreating Harvard's Fogg Museum, mainly by generous donations in successive years from his wonderful collection of drawings. He also conducted an important course in the techniques of museum direction; for, in addition to art appreciation, he was able to

10

cover the down-to-earth side of how to manage an institution, its finances and its budget, how to handle trustees, and how to interest the rich in donating funds—the last an essential function for which any museum director should have an exaggerated talent. Later I was to discover that he was marvelously successful in placing museum directors throughout the country.

Perhaps I was a candidate to become one. Sachs invited me several times to his home, Shady Hill, where his more promising students had the privilege of studying his great collection of drawings and prints, or sitting around the fireplace smoking, engaged in serious but informal discussions. All this might have been a step, for me, toward a more scholarly career.

Another teacher in the department, however, was sending me piping in a different direction. This was Chandler Post, who from time to time took his students to the movies as an extracurricular diversion. He would lead us in whistling at Gloria Swanson when, her black curls stowed under a cap, ill-disguised in pants, she chose to volunteer for the Foreign Legion. And he would outdo us in laughing at the slapstick of Buster Keaton. It was most unusual for an art professor at that time to be interested in and guiding students to films. The concept of the seven lively arts had not yet been invented by Gilbert Seldes. But owing to Chandler Post's divergence from the norm, I became seriously interested in the cinema as an art form and combined with my art history courses some work in the physics of optics and the psychology of vision. Psychology Professor Troland gave me access to a research laboratory which included a darkroom. There I spent considerable time experimenting with photography during my last year at Harvard. Thus, in 1931, when I opened my gallery of contemporary art, one of my initial interests was to promote the recognition of photography as a form of modern art.

ThE GallERY

The Julien Levy Gallery was to continue through 1948, during those crucial years between Dadaism and the apotheosis of Moma-ism (Museum-of-Modern-Art-ism). It was to be the gallery that represented the most enduring artists of the period: the Surrealists.

One afternoon in late 1930, the instruments for planning an art gallery were arranged before me and, in a shock of recognition, I saw them as one of the metaphysical ambiguities painted by Giorgio de Chirico before 1914, which became prototypes for all subsequent Surrealist painting. The remembered picture consisted of disparate objects assembled in trompe l'oeil on a wall. Yves Tanguy spoke often of the time he saw his first de Chirico from the window of a bus. As a young sailor in the merchant marine on shore leave in Paris, he rode past a gallery which had a metaphysical canvas by de Chirico hanging in the window. He jumped off the bus and spent the rest of the afternoon staring at the painting, finally saying to himself, "This is opening paths for me. I want to become a painter and to enter such a world as this." On my wall were my T square and dividers; on the table four biscuits, three cookie wrappers, leftover lunch, and the thumbtacked blueprint of my ideas for alterations of the premises on the fourth floor of the little brownstone at 602 Madison Avenue.

The discovery of such a ready-made paraphrase would auger well for my commitment. In such enigmatic still lifes the seed was germinated for the beginnings of the art of our day, if not the beginning of the end of the art of our day. Discrete discontinuity: Chirico in Italy, Paul Klee in Germany, Picasso in Spain, and Marcel Duchamp in France had since the year 1910 and thereafter, been preparing the future; each was about to undo his genius to find out how it ticked.

My dream was that America, so common-sensical, my country of pragmatism, would see more of that undoing (or should I say unraveling?) in my gallery if my efforts might persist over the next several decades. Such avant-garde experiments in remaking the whole face of modern art had been exhilarating in Europe in the early 1920s, but I had been too young and too far away to participate. Now they might be given continuity closer to home, and the thirties promised to be just as fabulous, and the forties, too, if rather more distantly fearsome.

So that early afternoon I sat looking at some rubble that remained from the previous tenant (a beauty parlor) and frowning at an awkward corner formed as the wall angled past a supporting column. "How are we to get around that?" I wondered, and decided that the shortest way would be a curve. My gallery was to be the first to have a curved wall! In this first location on Madison Avenue, the curved wall was purely decorative. Later I was to further expand the idea so that the pictures hung, not parallel on a rectangular wall, but each turned slightly away from the other along the curve, so that as the viewer passed he saw only one at a time. I looked again at the—by then, a little aided—accidental de Chirico still life. Disparate, incongruous, and prophetic collection: T *square*, French *curve, cookie* dividers for the future. And ominous on a spike, the cost estimates. Like a Dada Babel. All disheveled naïveté and hope.

Hope . . .

Joella, who had been my wife since 1927, came out of the washroom where a hotplate had been plugged in for making coffee. Perspiration prettily beaded her eyelids and upper lip. "Let's get busy," she said.

Noisily, my secretary, John McAndrew, pounded in from the fire escape. "Elevator's out of order again," he huffed.

"Perhaps it's just taking a breather in the basement," I suggested.

John thought we should landscape the firestairs so that our visitors might enjoy the emergencies. A friend at Harvard and a brilliant student of architecture, he came to assist me in the gallery while marking time between a dreary job in an architect's office and a hoped-for career teaching architectural history. Later he did teach history of architecture at Vassar, became curator of architecture and industrial art at the Mu-

seum of Modern Art, and later director of the Wellesley Art Museum. Now retired, he has been president of Save Venice, Inc., living half the year abroad in Venice. I made my suggestion of the curved walls. Down came the celluloid French curve from the Chirico miscellany. We drafted the line on the blueprint. Then, looking at his watch, John said, "Stieglitz. You have an appointment."

For my opening, an exhibition of American photography, I hoped for the cooperation of Alfred Stieglitz, the grand old man of photography and one of the first photographers to move from pictorial photography to clear, realistic images. He had a gallery at 291 Fifth Avenue in which he showed sharp focus photos, both his own and those of contemporaries who subscribed to his credo. Stieglitz published a magazine called *Camera Work* and in his "291" gallery from time to time had also shown drawings by some modern European painters. I particularly remember seeing the exciting new work of his good friend Francis Picabia. Stieglitz had recently moved uptown to a gallery high in an office building, was devoting himself entirely to American painters and photographers, and was calling the gallery An American Place.

Bareheaded, I set out on the short walk down Madison Avenue to Steiglitz'. Half a block later, as I reached the corner of 57th Street, it started to rain.

My path usually twisted up Madison to 58th, then to Fifth Avenue, ending at the Central Hanover Bank, where I went almost daily after lunch to make small deposits and withdrawals. For a large institution this branch was pleasantly intimate. Instead of the tall cashier grilles of the time there were massive marble counters, a little over waist high, thus allowing an illusion of chatty communication between yourself and money. As in the Berlin Zoo trenches, the counters offered a measure of safety without giving the inmates the feeling of being caged or the public that of being behind bars. I enjoyed leaning my elbows on the counters for a few minutes and talking with the tellers, who often had anecdotes to exchange between deposits and withdrawals, especially after I had become somewhat notorious because of two or three "artistic" interludes.

14

The first incident of note that occurred at the Central Hanover was when I paid little Serge Lifar, the star male dancer of the Ballets Russes, for my sale of his collection of costume designs and sketches for stage sets gathered during his days as a favorite of Diaghilev. I exhibited this collection because of the many drawings by certain artists I was particularly interested in—major painters in the Surrealist movement who were then almost unknown in America: Max Ernst, Miró, de Chirico. The entire collection was sold to Chick Austin for the Wadsworth Athenaeum in Hartford, and when Lifar got his check he asked me to introduce him at the bank. He wanted to cash it and "feel all the dollars" in his hand immediately.

We entered the bank. Lifar took an appraising look at the bank counters. With a joyous shout he executed a double entrechat and a leap—the famous leap in which he seemed suspended in air, magically evoking the great Nijinsky. Then he was over the counter, landing on an overturned drawer of hard coins, to the consternation of tellers and the two armed guards, who somehow saw fit not to shoot. "The most famous leap of Lifar," he said as he calmly cashed his check. "If only Nijinsky had seen."

The next fablemaking occasion at the Central Hanover was when Salvador Dali wished to transform his first U.S. profits into traveler's checks. He insisted on changing $5,000 into checks of small denomination. I explained that this would be a bulky business, but that was just what he wished. He said his bundle must have bulk to be really convincing.

Dali began signing very slowly, carefully, and elaborately. In fact he occasionally improvised little landscapes and battle scenes in combination with his signature.

"You will have to reproduce each of those signatures," a bank official tried to explain.

"I can do that too—Dali surely can reproduce Dali." And he continued stubbornly with the elaborate, and one would suppose, unreproducible signing.

Of course he never would reproduce them. I heard later that when he

came to cash the first checks in Paris he met with no objection, even if he initialed them with a simple "S. D." His drawing on an American Express check was even then worth more than the modest face value.

Another time that fine artist Frida Kahlo, wife of Rivera, the most noted muralist in Mexico, caused a sensation. Arriving inside the bank with her, I found we were surrounded by a flock of children who had followed us, despite all protests of the doorman. "Where is the circus?" they were calling. "Fiesta" would have been more accurate. Frida was dressed in full Mexican costume. She was beautiful and picturesque but sadly she did not wear bouffant-skirted native costume for effect. "I must have full skirts and long, now that my sick leg is so ugly." She suffered from a disfiguring and crippling malady of the bone.

The bank was the farthest outpost of my daily promenade. On the way back I would usually stop in at the café of the Hotel Madison for an aperitif if not for their delicious luncheon. This café was very baroque in red and gold, with marble-topped tables. I was particularly fond of it because Joella and I had celebrated the end of prohibition there before repeal had legally gone into effect. The café had been newly decorated, its original old bar reinstalled and restocked, and most humanly, its managers, impatient for the proper moment, had allowed our small party a day-early preview.

On the corner of Madison Avenue was a stationery store run by the brothers Gottfried. Here I would pick up a copy of *Art News*, or *Dial*, or *Creative Arts* and sooner or later most of the better foreign art publications. The brothers had not only discovered that 57th Street had a clientele with rather unusual demands, but they became interested in further services they might offer and soon built up a considerable knowledge of books and revues of special interest for us.

Riding up in the elevator, I would often stop at the floor below my gallery to browse in Edgar Wells' bookshop, a clublike establishment offering old and rare books in the English tradition. Another pleasure was that of occasionally waving from the gallery window at the enchanting young sisters from Boston who had a pied-à-terre in the penthouse across the street. Shy, modest and charming, two of the sisters, Betsey and Minnie Cushing, sometimes drifted into the gallery for a

chat. Betsey later married James Roosevelt, and is now Mrs. John Hay Whitney. Minnie was to marry Vincent Astor, and later became the wife of the painter James Fosburgh. The sister whom they called "Babe," now Mrs. William Paley, I did not know.

This particular rainy day on the corner of 57th and Madison, during the short walk to Stieglitz' An American Place, I found myself thinking with poignant immediacy not only of Alfred Stieglitz but even more of Marcel Duchamp, the two men who have had the greatest formative influence on my present temper. I thought how I would like to have both as spiritual fathers. I decided to adopt them as godfathers, and in my mind I did.

DuchAMp

I had first met Marcel in 1927 at Joseph Brummer's gallery in a private house in the East 60's when he was arranging an exhibition for his friend Constantin Brancusi, the great Rumanian sculptor then unknown in America. What an awe-full experience for me, the resplendent array of primordial shapes being set on pedestals and arranged and rearranged to catch the optimum light. Duchamp, a Frenchman, had lived in New York much of the time since his debut as the hero-villain of the 1913 New York Armory show, the first important showing to Americans of the newest movements in modern European and American art which had caused a cultural shock and scandal. His painting "Nude Descending a Staircase" was described by critics of the time either as a landmark or an "earthquake in a shingle factory."

This day I watched him acting as volatile and impish impresario, and when he discovered that I had vehemently persuaded my father to pay $1,000 for Brancusi's extraordinary marble "Bird in Space" we began the friendship which was to last his lifetime. That sculpture had been in the Quinn collection, the first truly great collection in America of modern art.

My father, Edgar A. Levy, was in the real estate business, mainly building apartments on Park Avenue on land he owned or leased, some of which he held and managed. Both my father's and mother's families were around New York long before Park Avenue existed. My mother was an Isaacs, from a prolific family of four or five generations of rabbis and lawyers in New York. My father's family, also early New Yorkers, originally from England, had great style—especially my father's uncle Clarence, who died in Paris in the arms of his mistress at eighty-two. My prosaic father had studied to be an artist, but became a lawyer and

businessman to pay off the debts his adventurous father had left and to support his widowed mother. Perhaps that is why he was so ambivalent about my venture in the art world.

At this time my father showed signs of affluence, or at least a willingness to spend money on himself. After a short spurt of buying art to furnish an apartment he had taken and was redecorating to occupy his mind after my mother's death, his purchases ended. By the time I had my own gallery neither he nor any member of my family ever bought anything at all, though they often came to my openings for the fun.

A few years after he acquired it, my father sold "Bird in Space" for twice what he had paid. I said, "But, Dad, it is priceless, you must not part with that lovely piece!"

"You are not a good businessman, my son," said my father. "There's no such thing as priceless. Doubling one's initial investment in a short period of time—that is good business."

In the beginning, whenever I could make my influence felt, I would attempt to direct my father's acquisitions in directions that agreed with my taste. His usual advisers were his friend and business associate, Al Bing, and Al's adviser, Walter Pach. Al had been collecting for some years with the advice of Pach. I particularly remember his fine paintings by Redon, that fantastic colorist who together with Turner and Monet would later be called prototypes of abstract expressionist art. I recall he had one of the great bronzes by Marcel's brother, Duchamp-Villon. Whenever my taste and that of Pach and Bing coincided, and in the case of the Brancusi "Bird" it did, I might persuade my father to buy. Under these circumstances, I was a welcome and frequent visitor at the Brummer Galleries and was granted the opportunity to meet with Duchamp under more than casual conditions. Before six weeks were run, I found myself bound for Europe in the company of Marcel, who had undertaken to introduce me to Man Ray and secure for us an opportunity to use Man Ray's studio and camera to make a short experimental film for which I had been writing the scenario.

Duchamp had simply said, "If you have three hundred dollars to buy the raw film, and enough besides to purchase tourist passage, why then—come along with me."

19

DucHAMPiANA

On that first voyage with Duchamp, we would sit together in the lounge of the paquebot *France*, smoking, drinking moderately, beer or Cinzano *à l'eau*, until the time Marcel would find himself a chess game. We talked—I intently, Marcel tolerantly. Marcel giggled; it made him seem younger despite all his tired irony. He seemed to remain a boy, and his seeming humility may have been pride. He was to become one of my closest friends. I felt him to be more of an elder brother than a figure of imposing authority.

Marcel toyed with two flexible pieces of wire, bending and twirling them, occasionally tracing their outline on a piece of paper. He was, he told me, devising a mechanical female apparatus. His painting of the bride could be the diagram of a soft anatomical machine. He said, jokingly, he thought of making a life-size articulated dummy, a mechanical woman whose vagina, contrived of meshed springs and ball bearings, would be contractile, possibly self-lubricating, and activated from a remote control, perhaps located in the head and connected by the leverage of the two wires he was shaping. The apparatus might be used as a sort of *"machine-onaniste"* without hands. I fell in with this fantasy and suggested that she could be equipped with a mechanism by which the lower portion of her body was activated by one's tongue thrust into the mouth in a kiss. It was then that Marcel unbent, giggled for the first time, and admitted me to his inner circle of intimate friends.

"The lines of the wires," he went on, "when they are shaped to give just the leverage needed and then removed from their function as messengers between the head and vagina, they become *abstractions*. You understand? And to no apparent purpose." Such abstractions were of long-standing interest to Marcel. They were, in fact, a continuation of

work already more or less accomplished in his studies for the large painting on glass, "La Mariée mise à nu par ces celibataires, même." In 1913 he wrote this note for the Glass:

> In the hanged female—establish the expansion
> Barometer
> The filament material is able to elongate or retract
> according to the atmospheric pressure organized by
> the "Wasp"
> (Filament material extremely sensitive to the differences
> of artificial pressure ordered by the Wasp)

The filament in this case was an equivalent for the wires.

At the time I met Duchamp he was known as "that painter who refuses to paint," and a thoughtless person might conclude that his fame derived from what he did *not* say and what he did *not* do. He usually wore a tan suit darker than his face, freckles and sandy hair, and when he smiled, his teeth showed slightly yellowed. He was quite invisible! Certainly he was silent. His only gestures were ambiguously negative. I once invited him for cocktails in Paris. At the appointed hour he rang the doorbell where I was staying with Joella's mother, Mina Loy, at 9 rue Saint-Romain and said, "I have come to say that I cannot come," and then left. A new idea would appear in the painting world and someone would always say, "Duchamp first suggested that," although where or when they could never remember. Marcel was essentially a cryptic figure, and if his cryptic attitudes were but a pose, that pose had become second nature, and his enigmatic aspects were what intrigued people and formed a basis for his fame. The *secret* he never explained. He smiled and you could take this smile as mysterious or as merely vacant. If he would not explain, then books and articles would be written by others to describe what may never have been meant.

He was a high priest, and his words were puns. Some he showed me:
"My niece is cold because my knees are cold."
"Daily lady *cherche demêlés avec* Daily Mail."
"*Paroi parée de paresse de paroisse.*"
"*Lits et ratures!*"

21

He abandoned painting in 1923, immersed himself in the study of numbers, became a chess master and theorist, and wrote a book, *Opposition and Sister Squares Are Reconciled,* which only a few chess experts can understand. He'd gone through the apprenticeship of the modern artists and developed his own style, culminating in "The Bride" and "Nude Descending a Staircase." His reason for ceasing to paint is expressed in one of his cryptic beliefs: one should try never to repeat oneself. Perhaps the best explanation was suggested by H. P. Roche when he quoted, "Don't repeat, in spite of the encores."

Duchamp once organized an investment trust to play roulette at Monte Carlo using a system he had devised. This venture neither won nor lost. It covered his expenses, but there was nothing for the stockholders. He was beginning to arrive at his system of dynamic equilibrium by which he proudly neither profited nor lost. All his subsequent activities were on this basis, until very late in his life, after marrying Teeny. The books he published, of great quality and workmanship, sold for a very low price. "When I sell the entire edition," he would say, "I will break even."

In the late twenties he had two addresses in Paris, one in an attic studio, seven flights up without an elevator, on the rue Larrey, and one with a very likable American girl, Mary Reynolds, on the rue Hallé. I could always find him in either place, as if he were in both at once. If I did not wish to climb to his rue Larrey studio I would shout up and he would meet me at the restaurant of a nearby Turkish mosque for coffee. Or, if I would visit Mary, Duchamp would also be there.

His adoption of a second name, Rrose Sélavy, by which he was to sign many of his later works, notably several "Ready-mades," had come about one evening (I wish I had been there) at the Boeuf Sur le Toit. To announce his departure for the urinal, Marcel had written with soap on a mirror, "*Arrosé, c'est la vie.*" (Loose translation: to make water, that's the life.) Jean Cocteau misread the scrawl and for the rest of the evening insisted on calling Marcel "Rose." Retaining the double *r* of *arrosé,* thus was born Rrose Sélavy. Occasionally I play with the possible combinations Marcel may have had in mind: "*Sel de ma vie, c'est Arrosé du Champs,*" or, "Eros du Champs." Many years later

Marcel told me he always thought that he had meant *"Eros c'est la vie*—love is life." (With the two *r*'s of Rrose pronounced separately: er-rose).

His apparent juggling with time and space added significance even to Duchamp's slighter gestures. Around 1937, the artist-architect Frederick Kiesler, who owned the "Réseaux des Stoppages," a large but at first glance unprepossessing canvas, gave it to me to see if I could sell it. I hung it on a wall in my gallery. I could not easily call it a painting, although signed—three times in fact. If it had been on a small piece of paper, I would have said that it was some accidental scrap, a rumpled sketch used once to clean the palette. The large area of cracked monotonous canvas grew familiar with time, and as it did, it become preposterously congenial. It had an unobtrusive but insistent personality and I was tempted to speculate a little about this quality, as I knew that Duchamp himself would not give any answers.

The body of the canvas is printed with greens and ocher, the colors of the famous "Nude Descending a Staircase." Part of the painting is half erased, but one can distinguish what seems to be multiple female figures grouped like the composition of Cézanne's "Les Baigneuses." If these are what they seem, then the picture should be hung vertically with the nudes upright, but it remained impossible to determine the top and the bottom of the picture—although when I saw it hung vertically, I found Duchamp's signature in the lower righthand corner, with the date 1911. But there is another signature one sees in pencil with a date, 1913, when the picture is hung upside down. Should not this signature apply to the design drawn over the whole canvas in pencil, which can be recognized as a rough sketch for "La Mariée," executed in glass (1915-1923)? The Glass is Duchamp's major work. There is a third signature when the canvas is hung horizontally. This would apply to the strange series of lines, circles, and numbers, the lines traveling toward a large bull's-eye of circles which would be the "Réseaux des Stoppages." This portion is of a later date—would it be the year Marcel stopped painting? I argue that the canvas was probably made up of the souvenirs of the first painting Duchamp ever attempted, of the project for the culminative work, and the postscript when he would last set brush to canvas. The whole

had been launched upon the public without explanation, to make what effect it could by means of its own mysterious worth, wound up to run by its own inner springs for as far as it might carry.

Such a gesture would not be foreign to Duchamp. His great "Mariée," subtitled "A Delay in Glass," was obviously an experiment in the dynamics of space. The composition was devised so that it might retain a constructive relation with whatever heterogeneous things passed in back of the transparency. The "Mariée" seemed to absorb them all, partially, into her own cosmogony, while at the same time she lent some of her own form indefatigably to them. There can be no doubt that this big toy was a sincere experiment with space, and a successful one. It projected, too, slightly into time, for the glass broke one day. Duchamp was called to America to reconstruct it. To everyone's surprise he was gleeful. "Do you think I should have made it on glass," he said, "if I had not expected it to break?" He showed them a sketch he had drawn, prophesying the shape of the fragments, and the composition of the reconstructed glass could truly be said to have improved with the addition of the ineradicable cracks. The railroad-track marks of the "Réseaux des Stoppages" are the form of those cracks of the big glass. This picture is another experiment with time, which I call *delay in time*. The problem is really not what such a painting means—but what it may come to mean!*

Many years later I thought I had found an answer of sorts to the question so many were to so fruitlessly ask: "Why, Marcel, did you give up painting?" To which Marcel imperturbably replied in the form of counterquestions such as "Why indeed?" or, "Why not?" In 1957 I reviewed for *Art News* a reprint and translation of some of his notes for the *Green Box* which I once had tried to translate one summer while vacationing on Cape Cod. It had proved a difficult task which depended entirely on the cooperation of Marcel—in which case I felt he might as well translate them himself, for not only was the handwriting extremely

*Some of this essay quotes from my article published in *View* Magazine, 1944.

24

difficult to read, but the notes were compact with sous-entendus and double meanings so cryptic, so difficult even for Marcel to redecipher, that it might best be left to posterity with "more time and more people." Here is my review:

ESPRIT DUCHAMP

During the years 1911 to 1915 Marcel Duchamp accumulated at the bottom of his bureau drawer innumerable documents, notes, drawings of mechanical elements, and scraps of ideas more or less related to the concept of, or at least collected during the creation of, his important painting on glass, "La Mariée mise à nu par ces celibataires, même." In 1934 he reproduced some ninety of these notes, *cervellites* as he called them, in careful facsimile (even reproducing the varieties of papers and the actual shapes of the torn edges of each scrap) assembled in a limited edition of twenty green boxes. George Heard Hamilton of the Art Department of Yale University has since made a selection of twenty-five fragments accessible by translation and somewhat clarified by a perceptive preface and readable print (Duchamp's handwriting in the originals was often almost illegible).

Do these jottings provide any clues to the mystery of Duchamp, any thread through the labyrinth of the "Mariée"? At first reading they seem elusive as the *esprit francaise* of which Duchamp is such an elegant representative,—the meaning of the word *esprit* ranging as it does from spirit, to mind, to wit. And how may we distinguish the serious from the humorous, equate (or equivocate) *Duchamp the realist, the nihilist Duchamp*?

The Green Box is opened, but the notions it contains still appear hermetic. Only one thing is clear, that the Glass is *studied,* that it involves a background of speculative research, more so perhaps than the work of any living artist.

Under his bed, 11 rue Larrey, Duchamp kept a plate glass (wires cemented on in lines later incorporated in the Chocolate Grinder segment of the "Mariée"). This, after collecting dust, was photographed by Man Ray as an aerial view, "Elevage de Poussière." The first note we read from the "Box":

25

 To raise dust
 for 4 months. 6 months which you
 close up afterwards
 hermetically.—Transparency
 —Difference. To be worked out

Was it by more than coincidence that Duchamp posed a moustache on the "Mona Lisa"? One reads the following in Da Vinci's *Notebooks:*

 Concerning the local movements of flexible dry things
 such as dust and the like
 I say that when a table is struck
 in different places the dust
 that is upon it is reduced to various shapes
 of mounds and tiny hillocks. . . .

And again, lines from Da Vinci's *Notebooks* that might well have fallen out of Duchamp's *Notebox*:

 Make tomorrow out of various shapes
 of cardboard figures, falling from our jetty;
 and then draw the figures and the movements
 made by the descent of each,
 in various parts of its descent.

Haven't we here a suggestion of the problem worked on by Duchamp in his painting, "Nude Descending a Staircase"?

For the sixteenth century Leonardo, the analysis of motion was zealously pursued: the flight of a bird, the circulation of the blood, the trajectory of a missile in space and time (and in psychology, irony, and gamesmanship). On further reading in the *Green Box* one notices how many of the jottings involve problems of the space-time continuum. Space has always been a concern of the painter, but space-time (perhaps why the "Mariée" was subtitled "A Delay in Glass") is modern.

When the large Glass, the "Mariée," with its skeletal images, is installed in the middle of a room or gallery, the figures of casual people moving before and behind are merged in the picture, so that the frame and the painting act as a sort of static composer of fluid accidents in the

26

surrounding space. A concept of "delay," a strainer of events, a time-filter. Here is the proposition as written by Duchamp:

> Use "delay" instead of "picture" or
> "painting"; "picture on glass" becomes
> "delay in glass" does not mean "picture
> on glass"—
>
> —to make a "delay" of it in
> the most general way possible,
> not so much in the different meanings
> in which "delay" can be taken, but
> rather in their imprecise reunion.

Sampling the *esprit* of Marcel Duchamp is intoxicating. His significance is in hiding for the seeking. To any reader interested in intellectual exercise, *From the Green Box* is a fascinating curio. To anyone interested in the art of our century, so inevitably curious about Duchamp, this book, until more material may be published, is indispensable; very distilled, very heady, very essential.*

When submitted to him for approval, my comparison of Duchamp's surrender of painting in favor of other-dimensional speculation (and chess) with the abandonment of painting for engineering by Leonardo da Vinci, was awarded with what I can only describe as his Gioconda smile.

*This entire "Esprit Duchamp" essay appeared in *Art News* in 1957 as my review of *From the Green Box* by George Heard Hamilton.

Duchamp's Kiss

On my wall today, reminding me of Marcel's devious inventions, is a zinc cut called "The Kiss," the plate the printer used for the cover of my catalogue for the Man Ray exhibition in 1945. It was designed by Duchamp. Man was the expatriate American who had become the most noted painter-photographer in Paris. He was the only American member of the original Surrealist group and had long been a close friend of Marcel's. Marcel told me he had blown up a photograph, reproduced it, reduced it, and reenlarged it several times. I can't say that all this processing shows; it is only a fact that adds to the depth of the history of the final result.

The original photograph was a 36 mm frame from a movie, the famous old kinogram which was the first kiss in the annals of cinema. A black couple kissing, this close-up frame was just of noses and lips, about to meet (or just parting), so enlarged, bendayed, processed, polkapatterned, that the original image was all but impossible to identify. To most, it looks at first sight like a splash of water in a sieve or a splash of snow on a window screen.

This playing with reductions and enlargements was something many of us interested in photography had been doing for some time. Man Ray had suggested using coarse-grain emulsion and coarse-grain developer, just when all the commercial research was toward reducing the grain to make smoother photos. Man asked, "Why necessarily smooth?" Texture had already been achieved by using rough papers, but here was an opportunity for using it in the image itself. I had been making texture-images to find new outlets for applied photography. I tried, for example, to interest fabric companies in making photographic textiles by sensitizing their cloth and then printing the cloth with a photo. I suggested a

28

rock, the photo of a real and uncomfortable-looking rock covered with lichens, photographed by someone like Paul Strand or Ansel Adams. As a Surrealist I intended to use some of this rocky textile for my daybed cushions. Pleasant to rest one's head on the surprise of a soft stone.

In 1939 I lived for a time on Grove Street in Greenwich Village. Matta Echaurren, the Chilean painter and newcomer to the surrealist group in my gallery, was a neighbor. He and I had been photographing sidewalk chalk drawings left by children, what the French called *graphite*, later recognized in some of the paintings of Dubuffet (and, more recently, made a subject of study as street art, in *Graffiti*, a book with text by Norman Mailer). First was a series of hopscotch drawings, chosen because these half-obliterated variants on traditional schema reminded me of some of the compositions of Massimo Campigli, one of my more gifted painters, who died recently. His work was so well appreciated in Italy it was almost entirely purchased by Italian collectors, so that very little has reached America to be exhibited since I presented him in the thirties.

The sidewalk sketches we found were most interesting in series, a theme with variations, and easy to assemble, as they were newly drawn each day after school and abandoned each evening. They ran the gamut from hopscotch to obscenity, and startling four-letter words appeared and disappeared almost as frequently as the more polite games. There were also hearts and mottos and attempts at representation, and cartoons such as "Matta loves Paquarito."

We once found all of them combined in one "ready-made." A brick wall showed a chalk-drawn head like a Miró balloon, a four-letter caption, with a third dimension made by a truncated plumbing pipe protruding from the wall at proper genital height, and two tile pipes accidentally leaning against the wall forming trouser legs. There were all the props, for a moment, for us to record. Not all there (except the plumbing pipe) next morning.

I showed some of these photos to Marcel. He suggested a collection of verse and drawings from lavatory walls. Graffiti? *Graphites?* These would be pornites. Select the best. Photograph them. Montage them. Rephotograph them. Enlarge them. Project the enlargement on a lavato-

ry wall. Rephotograph that. Reduce a collection of these composite walls to a single microfilm. An anthology of thousands. The devil's prayer on the head of a pin. Provide negatives of the microfilm for enlargement in part or whole, to any degree of magnification, for the home lavatory.

On that first voyage with Duchamp, sailing for France in 1927, many hours were passed discussing a scenario for the film we planned to make. We had just enough money for material and one reel of finished film, without actors, unless we exploited friends, or derelicts and models from the Quartier. Man Ray had promised the use of his camera, studio, and lights. We argued scripts. Collaboration was agreeable. Marcel liked company and competition; I would have felt insecure alone, but with Marcel my inexperience was compensated. Destiny seemed happily to have set my course, but when destiny takes the helm, it is seldom long before she changes tack.

The very next morning we sighted a westbound ship and a message was flashed across. Man Ray had been called to New York, would be away for several weeks. Our project was at least postponed, if not permanently shelved. But our relentless propeller drove on, and as one expectation vanished behind us, another appeared ahead.

JOELLA

"Do you know Joella Loy?" It was Bob McAlmon, a debonair and gregarious Yankee who asked the question while we sat in the bar. Since there was no more scenario to be talked about, Marcel had filled his pipe and returned to silence. Bob was a writer, loved to drink, and as a publisher (Contact Publishing Company) had brought out some of the earliest work of his close friend William Carlos Williams. Along with Bill Bird, whose publishing house (Three Mountains Press) joined his in 1925, he had presented Mina Loy, Ezra Pound, Marsden Hartley, Ernest Hemingway, Ford Madox Ford, and others. His was an aware and sensitive taste and he gave generously of his time, talent, and money to help writers he believed in, as did Ford Madox Ford.

"The most marvelous *jeune fille* in all the world," said Bob. "Her mother is Mina Loy."

Marcel had spoken before of Mina Loy, as they were good friends. I had read some of her poems:

> Lepers of the moon
> all magically diseased
> we come among you
> innocent
> of our luminous sores
>
> unknowing
> how perturbing lights
> our spirit
> on the passions of Man
> until you turn on us your smooth fool's faces
> like buttocks bared in aboriginal mockeries. . . .

Yes, I had heard of Mina Loy. We talked about her work, about avant-garde writers, the American expatriates in Paris, about publishers and the public, the *Dial* and the *Little Review,* Gertrude Stein, Pound, Hemingway, Billy Williams, Scofield Thayer, Nancy Cunard, Jane Heap, and Margaret Anderson. Then about Paris versus New York, speakeasies and bistros, women and doxies, men and supermen. Marcel temporarily handed me over, bag and baggage, to Bob.

"Listen! You should live in the Quartier, the Istria, unnerstan',— Hotel Istria. Marcel will tell you the same. He lived there once." Bob signaled the waiter. "Another *fine.* Courvoisier, y' unnerstan'? Two more Courvoisiers. *Encore deux Courvoisiers.* None of your damned Biscuit. I know the difference, and my friend does too. I've lived in France even if I don't grow those long hairs on my lip." And, turning to me, "Hotel Istria! Man Ray's studio right next door. A nice little place. Get the room Brett and Mike used to have. You read *Sun Also Rises*? Hemingway?"

I nodded. Bob continued, "Duff Twisden, Lady Duff Twisden, and Pat Guthrie—Brett and Mike in the book—used to be around the Quartier all the time, and that Harold Loeb fellow."

"I don't know how Hemingway gets away with it," Bob would say morosely. "Stole all his stuff from me." This was not quite true. Both Hemingway and McAlmon learned their studied simplemindedness from Gertrude Stein, and to a certain extent from William Carlos Williams. When Eliot wrote "The Waste Land," putting American rhythms into his beautifully turned style, making a classic, a transformation of the ordinary, there was little sense in further developing that vein—since he also successfully conveyed that everything was futile anyway. Much like Picasso, he fractured the future for many of his contemporaries.

Bob ordered more drinks and went on talking. Hemingway was always a favorite subject with him. "The way that guy hauls off and pretends he's going to hit you. It's because he's scared. Way down deep Hem has always been scared."

Through the fog of Bob's stories I began to see some stars, dim constellations, a whole universe of people and talk I had scarcely suspected

in reading their books. The lepers of the moon? That night I dreamed, and in my dream was Joella Loy, "the most marvelous *jeune fille* in all the world." She was fair, and had braids, long braids, twisted in coils over her ears. Or they hung down and were tied with little ribbons. They swung through the air behind her when she turned her head, when she smiled.

Bob became my guide the first ten days in Paris. Doing the town with Bob McAlmon was like riding a sightseeing bus, except that people and what they did were pointed out, rather than the monuments and what had been. In fact, the people were not only pointed out but they were often invaded. Bob seemed to know almost everyone of importance in the arts and would barge in and introduce himself to those few he didn't. Such was his sincerity and charm that I never, in those days, saw him rejected. Perhaps a family of tourists from the Middle West would have objected, or an elderly French couple on their way to or from church, but these were not types Bob would consider of interest. He was rich, generous, adventurous, and from the first thing in the morning on, usually full of liquor. It would not be for several more years, when he was sated, sometimes sodden and just as filled with liquor, that enchantment faded for him and for those he intruded upon, even some he had thought were his best friends. Sick with tuberculosis and alcoholism, he retreated to a sinecure as postmaster, in a little town in the Southwest, in Arizona or New Mexico, where he died after the war.

In his heyday, Bob had a plenitude of talent. His vitality, intellectual honesty, and charm overflowed almost wastefully. I must always be grateful to him and to Marcel. Marcel introduced me to Bob and Bob introduced me to Joella, who became my pride and the light of my heart.

Bob had not always had money to burn. He was separated from a wife whose father provided him with a liberal stipend. She was the poetess, Bryher, heiress to the ample fortune of an English peer, Sir William Elliman. Their marriage was said to have been a "peculiar" one, and a tragedy for him, for it was never consummated. She was then staying with Hilda Doolittle, daughter of the distinguished astronomer, Professor Eric Doolittle, and she was an early love of Ezra Pound's. I was never to meet Bryher, nor know anything of her at first hand. His envi-

ous friends were accustomed to referring to Bob McAlmon as "Bob McAlimony."

The day we arrived in Paris, I had scarcely unpacked, scarcely overcome the roll of the sea in my legs and the fatigue of the train, when Bob asked me to go to a party with him. He came up to the door of the Istria at six o'clock and we went to the studio of Peggy Guggenheim, at that time Mrs. Lawrence Vail. The place was crowded. Hemingway, Pound, Cocteau, Gide, Kay Boyle, Jimmy the barman, Janet Flanner, Natalie Barney, Bob Chanler, Pascin, I don't know who all was there. I remember talking to Isadora Duncan. She lay on a couch and her bulk hung over all four sides, streaming with plum-colored silks. Beneath the hennaed hair and behind the swollen face there seemed to be another face, a little girl's face slightly out of focus.

Bob Chanler's voice filled almost the entire room, but just behind me I could hear someone say, "Try some of this gin, my dear. It's prohibition gin imported from the States. It gets you drunk *rapidly*." And someone answering, "*Il faut de l'eau fort, pas trop d'effort.*"

That was Marcel. and Mina Loy was saying, "Speak-easy? Why if I ever tried to speak easily some policeman would come up and give me a really hard sentence."

In a voice purposed to be overheard by James Joyce, shouting roughly and irritably, was Pascin, the erotic Polish painter who shortly was to commit suicide—in retreat, it would seem, from satiety. "He doesn't write anymore, but he has a quantity of photographs taken of himself,—with one eye closed, two eyes closed, three. . . . Once I saw a photo with all five eyes closed. That man Joyce is, *quand même,* a genius!"

Then Joella was in the room, like light breaking through clouds. It was Joella, I knew, although her hair was cut short in an efficient bob. Other people welcomed the sight of her, too. There were cries of "Joella!"

"Little Joella, here she is!" "So Mina lets you go now to the big, bad parties?" "*Ecco* Gioella" "Come here and talk to us, you adorable child." Joella, not at all a child, was a mature and competent young woman, it seemed to me. She was nineteen.

I don't know if it was that same afternoon I told her about my dream

and she answered that she used to wear her plaits in *Schnecken;* they had just been cut off.

At gatherings such as this the most fertile contacts between the best talents of Paris and New York could be made. At Gertrude Stein's I was to meet Pavel Tchelitchew and many others. My lifetime love for French literature began when I met Adrienne Monnier, and through her, Paul Valéry, and Max Jacob. Adrienne was a friend of Sylvia Beach and her bookstore was across the street from that of Sylvia's Shakespeare and Co., where the English-speaking writers gathered, notably Joyce and Hemingway. This was a heady brew such as one could not hope to find assembled and accessible in New York in those days.

Mina at first would not consent to our marriage. Joella and I had known each other for a couple of months—or forever.

"They tell me you are an adventurer? An odd kind of adventurer indeed, to be excavating in the dust of women who haven't a penny to call their own. You must really be as innocent as my most sympathetic daughter—and she is unbelievable, as her mama should know. I have told her about life each evening since she was five years old, and each morning she forgets. Be off, now. I have a desperate little business here, and Joella is my chief workwoman. If you disrupt our precarious affairs, we must all eat nothing but stardust. *That* I am sure you have never tasted for a consistent diet?"

Mina moved crossly and imperiously about the studio, the "factory" she called it. Always dreaming of sugar angels; producing lampshades of her own design, of spun glass and frosted cellophane, *mappemondes* and arum lilies, cherubs, flowers, and *passe-partouts* caught in modern manacles of electric light. All Paris lighting was then atrocious. These miracles cost $5. The business was financed by Mina's friend, the art patron and later avant-garde art dealer, Peggy Guggenheim. Peggy also gave a stipend to the writer Djuna Barnes. Mina's enterprises vacillated between the reaches of her imagination and the depths of copyright, debt, merchandising detail, and her feeling that she was being "commercialized." She floated among the three workgirls, looking exceptionally young, almost blond, because her gray bobbed hair held so

much vivacity as to be ageless. A handsome woman, she had once had, I was surprised to learn, jet black hair in a pompadour. And a handsome woman she was at that moment, quite able to compete with her past. Her hips were capable, a paint-stained smock gathered about them, and she came toward me brandishing the gun of a compressed-air brush—a Diana, bold and aggressively intelligent, and in great disarry—as brave and perhaps as silly as the old Diana armed with ineffectual bow and arrows. What remarkable adventure was hers with Hippolytus?

In snatches of conversation I learned of Mina's life. Born like a rose in an English garden, she had been stormy and uncontrollable in the days when languor and refined submission were required of ladies. She sketched too well for the county sketching class and wrote too well for glib belles-lettres. She married a little man of old family and small estate, Stephen Haweis. She had a minuscule inherited income. They went to live in Florence, which was the Bohemia of the century's turn, and their first child died in infancy:

> While listening up I hear my husband
> Mumbling Mumbling
> Mumbling at the window
> Malediction
> Incantation
>
> Under an hour
> Her hand to her side pressing
> Suffering
> Being bewitched
> Cesira fading
> Daily daily feeble softer

And after they took the girl to the doctor, and to the "wise woman" too:

> Knowing she has to die
> We drive home
> To wait
> She certainly does in time

36

It is unnatural in a Father
Bewitching a daughter
Whose hair down covers her thighs.

What but divorce could transpire for a woman and the husband whom she considered "unnatural"? Before the final divorce Joella and Giles were born, and Haweis went to the Bahamas where he has lived ever after. When I last heard, he was in his nineties and enjoying life on one of the smaller islands.

About 1915 Mina came to America. She left her children in the charge of their old Italian nurse on the Costa. "The mentality of a child and of a peasant are close together. If you are not yourself a peasant mother, it is imperative that you delegate the first childhood years to Nurse. The little being is properly human and deserves a jury of its peers." This is how Mina explained her apparent desertion. And the radiant young Joella was the *quod est demonstrandum.*

Mina lived first in a studio room in the Carnegie Hall building on 57th Street, later in Greenwich Village. It was the time when Alfred Stieglitz had opened his first gallery, "291"; when Scofield Thayer was publishing the magazine *Dial*; Eugene O'Neill was writing for the Province-town Playhouse, where Mina once had the lead in a playlet with William Carlos Williams and Zorach the sculptor as coactors. Mina was beautiful and unattainable. She had many admirers. Their fate, and that of Stephen Haweis, must have been the fate of Actaeon, who once incautiously looked upon Artemis. Not until Cravan Lloyd walked into the Village—"into the half-baked underworld"—was Mina won.

Cravan Lloyd? I am indefinite about his name, as I am about everything that concerns him. As, in fact, everyone seems to be. In the year 1940 a very young poet named Brion Gysin spoke to me of Cravan. He did not know that I had been Cravan's related-in-law, but was speaking in general of ghosts. "Above all," he said, "I am haunted by a man known as Cravan. I feel sure he is not dead, or if he is, he is among my present stars." I promptly offered to introduce him to Cravan's daughter, my beautiful sister-*out*-law, Fabienne. He was incredulous. "But there it is again, the magic, don't you see? Cravan is unbelievable!"

37

Cravan was a nephew of Oscar Wilde. I *think* his correct name was Fabian Avenarius Lloyd. He wrote in France under the pen name of Arthur Cravan. His and Mina's daughter, Fabi, refers to him as Cravan Lloyd. He was a poet and a prizefighter. Breton said, "Cravan was Surrealist in the *challenge*." And that was the way he lived. He has always seemed most vivid to me and I apostrophize him in the night. . . .

Arthur! Arthur!

Bravado, Cravan, how you are transformed! Into a praying mantis that flew into my room years ago and nibbled into my ear that you were Arthur Cravan, friend of our best friends, father of my first wife's half-sister. Are you praying now, or preying, out in the wild?

If I have not been misinformed, you were the nephew of Constance, beloved wife of Oscar Wilde; you were involved in the beginnings of the Fabian Society, and named your unborn daughter Fabienne. You were large, handsome, and an impractical joker. Why did you disappear?

The first time I had documentation of you was in Stieglitz' gallery, "291," when he showed me a photograph of you with a lapful of Siamese cats; your socks embroidered with Napoleonic bees. And there was the time there appeared on my wall a mantis, clawing a painting by Yves Tanguy—if it was you. Then that summer night in Yves' own room when we spoke of you and mantis again, you flew in the window. We preserved you in a jelly jar. Jean Cocteau thought you very genial, a Knight of his Round Table. Marcel Duchamp thought you were a Marcel Duchamp. He told me this once, and, unbelievably, another mantis flew by. When I was living in Greenwich Village, a girl who said her name was Margie (she later explained it was a marginal name) rang the doorbell, boldly put her foot in the door, and asked, "Did you call my call house?" A mantis was tangled in her hair and she was your joking daughter Fabienne, quite disguised. I have a short film of your fight with the world champion prizefighter Jack Johnson. It was mislaid for a period, and the day it turned up, I swear a mantis entered my house again.

You disappeared mysteriously in Mexico, was it into the sea? Some rumors, no doubt apocryphal, had it that you bought and rebuilt a seago-

ing craft in which you sailed away forever, leaving Mina pregnant on the shore. Remember that outworn taxi joke of yours: "Are you free? *Vive la* Liberté!''

I have seen few photographs of Cravan. The one of him with the Siamese cats, stitting on a couch like an oversized archangel, shows the hands that Mina said could only be described as steamshovels. I have others, in motion and still, of the fight between Cravan and Johnson in Barcelona. I have read secondhand quotations from him. Very few of his words have been published. Breton mentions him in a list of writers who preceded the Surrealists. There was a manuscipt in Mina's possession attributed to Cravan: "Oscar Wilde is Alive!"

> I had slipped into my stomach, and must have begun to fall into a fairy-like state; for my digestive tube was suggestive; my mad cells danced; and my shoes seemed to me miraculous . . . I pulled open the door; an immense man stood before me.
> —Monsieur Lloyd?
> —That is me, said I; will you please come in.
> And the stranger trod over my doorstep with the magic airs of a queen or a pigeon. . . . Then, after some moments, he whom I thought a stranger said:
> —I am Sebastian Melmoth.
> Never shall I be able to render what passed within me: in a sudden and total self-suppression, I wanted to fall on him and clasp his neck, to embrace him like a mistress, give him to eat and to drink, put him to bed, dress him, become his procurer, in short, to draw all my money from the bank and fill his pockets. The only words I could succeed in articulating to sum up my innumerable sentiments were: "Oscar Wilde! Oscar Wilde!'' The latter understood my trouble and my love, and murmured: "Dear Fabian.''
> . . . The moment after, a mad curiosity spurred me to wish I might distinguish him in the darkness . . . I went therefore into a neighboring room to find the lamp, but at its weight, I knew it to be empty; and it was with a candle that I returned to my uncle.
> I immediately looked on Wilde; an old man with white beard and hair, that was he! . . .

40

—You are alive, when all the world thinks you dead; M. Davray for example affirmed to me that he had touched you and that you were dead?

—Why of course, I was dead—my visitor answered with a manner so atrociously natural that I feared for his reason. . . . ''

Cravan would march about New York with an admiring string of urchins trailing behind; he, the *voyou*. He made enormous jokes when wit went the whole hog, so to speak, an easy trick which permitted him to preserve amid the most evident trivialities all his nobility. He could have his way with women by the crook of a not too small finger, with men by the pressure of his shoulders and his fist, with intellectuals by the persuasion of a silver tongue.

He yielded to no one, but his meeting with Mina enkindled a sort of superlunary flame—the meeting of the immovable and the irresistible. They sat, not only at night, but days and nights, imperturbable, on a bench in Central Park, reading the Bible together. Neither had a penny. Cravan was a conscientious objector and left England when war began. When America entered the war Cravan moved again, this time after marriage with Mina, to Mexico where they lived, she told me, upon peons' purses offered for the winner of village boxing bouts, while Mina took in laundry. Mina one day found herself pregnant. Seven months later, Cravan placed her on board a passing Japanese hospital ship at Vera Cruz. Fabi was born on the ship and brought to Paris where Cravan hoped to follow them, but he was never seen again. Once Mina was requested to identify a pacifist whose name was Cravan, imprisoned in New Mexico, but he was not her husband. Another time she received from one of his girlfriends, with no explanation save that it was found on a beach, an empty, bloodied moneybelt which she recognized as that which Cravan used to wear, the girdle of Hippolytus.

Mina wrote to me once about him:

You know, he was so extraordinary. Especially as he was so simple in his extraordinariness one would, to explain him, write an analytical treatise. His life was unreal, or surreal, in that he never *was* the things he became. He never got nearer to a thing than in so far as a poet requires—to take contact with it. For instance, he became *champion de Boxe amateur*

41

de la France without boxing, because all the challengers sat in a row and he was presented and they all resigned. Nobody would box him so he was champion. He got a job at Brentano's and threw all the books in his first client's face because she said, *"allons, allons!"* when he fumbled with tying up the string. He considered it outrageous that a mere little French actress should say *allons, allons* to *Him,* and he walked out. He once went to the Closerie des Lilas bar-restaurant in Paris with a friend and remarking what stupid faces everybody had, expressed his emotion by challenging, then beating up the whole place. When the police arrested him, the people he had beaten up insisted that the police set him at liberty, because, they said, *"C'est Cravan et il est si sympathique."* I don't think it's much good saying he was a wood chopper in Australia or a boxing master in Mexico, everybody has done *those* sorts of things He once got a job as a chauffeur at a sugar factory in Berlin, and upset his boss in a ditch, and then, pointing to the overturned car, walked off saying, *"You* can pick it up." He used to walk about Berlin with four prostitutes on his shoulders. The police ordered him to leave, and he asked if they could give any reason for turning him out. They replied that there was no particular reason, merely, *"Sie sind zu auffallend"*—you are too "noticeable."

Fabi was about ten years old when I met her half-sister, Joella, in Paris. Even then Fabi seemed to me like some small mythological beast, only half human, a very young female centaur or Minotaur, somber and unpredictable beneath black bangs, glowering at me, lit with her own spark, and when she so wished, with fitful brilliance. She is a stately woman today, wildly handsome, resembling a drawing by George du Maurier, and I trust she has not lost a fraction of her initial savagery.

Shortly after I married Joella, I was asked in one of Mina's letters:

Will you—this is serious, and you will make a face—take on the nominal responsibility of my Horror in the blissful event of my ascension into heaven? You know, it's all very well, but I must make a will or she might go to my relations. All you have to do is take my allowance to the keeper of the Zoo and ask him to board Fabi on it—she'd stay put, all right! And my ghost would not haunt itself with her possible complexes.

These women—Joella and Mina, the small Fabi and several of their friends—were different from the girls and ladies I had known heretofore. I was ripe to be deeply impressed.

I had scarcely known my own mother, an elusive, beautiful woman, always traveling with my father or immersed in her own "projects." She had been killed by an automobile when she was forty-three. I was but seventeen and just out of a period when females, especially mothers, were to be disregarded by any boy with self-respect.

I remember my mother chiefly by a sternness that would cross her lips when she scolded me, an expression that would flicker at the corners of her mouth into irrepressible mirth, so that I knew only too well that her vindictive attitude was not at all serious. I wished to exhibit proudly to her any accomplishment at which I might arrive. That perhaps is the basis for my ingrained exhibitionism, for I am an exhibitionist, if only of other people's work. But before I had anything to show her—my wife or my gallery or my children—she was gone.

I was not even present when she died. It was during the summer after my first year at college. The news was sent to me by telegram, and I thought there was nothing to do but put my inarticulate filial feelings into a neat little package and hide it in a back drawer with all memories that would have no further continuity in life. I don't believe I was very sad at that time. I was deep in dreams, ignorant of reality. When I came home I even resented being driven to the cemetery. I could not connect ashes in a cemetery with the idea of Mother.

My loss did not deprive me of all feminine influence. I was too accustomed to, and too fond of, the comforting indulgence by which woman can enchant a boy or a man. But the young women I met before Joella seemed sentimental, avid, and unreal. For some time, while a seventeen-year-old freshman at college, I received telephone calls from a mysterious girl named Lillian. She would call and say, "This is Lillian. You don't know me, but I've been in love with you ever since you came to Cambridge." Finally I overcame my diffidence and agreed to meet her. I hoped, I suppose, for a most romantic adventure, but I was conventionally introduced to her parents as "the fellow who I am going

with.'' She was pretty enough but scarcely the great beauty of my dreams, and I would have departed without further formality if I had not been curious to know how she had chosen me for her special advances. After perseverance, I learned that her mother took in laundry for the college, and by reading her mother's discarded laundry bills she had become interested in the extent of my wardrobe, the cleanliness of my person, and my general desirability, according to her lights, as a prospective husband.

At Harvard, dating college girls, some the daughters of family friends, meeting others my autocratic father judged suitable at New York parties, I learned how to protect my freedom and eligibility. In Paris, adventurously alone, faced with the Loys, my infantile defenses proved not only inadequate, but undesirable.

When a couple are in love, the young woman in full use of her gifts is able to nurse and nourish the imagination of a man in a way peculiarly feminine and creative. She seems to extend into her man's ideas the silent and intuitive attributes of the womb. A mother does this when nightly she weaves dreams about the future of her infant. She makes a fragile and opalescent nest of faith and pride and loyalty which is home for a hero, the baby man. The essence of this spiritual housekeeping was its quiet inevitability. I had found little of this authority in those girls I had met heretofore. Most were competitive, flirtatious, and openly aggressive. Even more than myself they were questioning the meaning of their existence.

From the first moment of my meeting with Joella, she was most willing to give me charming glimpses and promises of the serene and sunlit vistas she cultivated for those she might love. And in return it was not long before I was emptying the pockets of my boyish disorder, so that my motley collection of souvenirs could be touched and illuminated by the rosy fingers of her approval.

According to Mina, when Joella was five years old she had been a pink, blue, and gold bunch of happy plumpness. At fourteen, in boarding school in Potsdam, she was remarkable for her indefatigable and serene aura of happiness, her eyes open like saucers in an expression of perpetually surprised delight. And, at nineteen, in Paris, helping her

44

mother support them by working nights in the little lampshade factory, charming the *haut monde* clientele in the tiny shop by day, Joella was busy, cheerful, and radiant. Except for the future, the present seemed the most wonderful gift anyone could wish from life. When the future came increasingly into question, she manifested that rich, feminine projective imagination of good things to come. Sweet shock, and shock. Contact with gentle summer lightning and foretaste of great power and greater ambition.

How shall I tell of our excursions in Paris? It was the loveliest time of the year in the world's loveliest city. Throughout the city we walked, nightlong, our arms entwined, from the gay streets into the dark, through the heart of Paris where gaslight transformed the garden of the Tuileries, across the mysterious and miniature Isle St. Louis, down the steps of the embankment, and along the Seine, back into the sequin luster of some café or brasserie, from echoing Gregorian chants heard in the convent chapel on the rue Monsieur to the great concerts thronged with jeweled noblefolk at the Salle Pleyel, watching from the shadows of some gateway a family in hired coaches, splendid for the night, drive off to a ball, or, our own dancing in quick tight circles to the music of an accordion on the Montagne St. Geneviève, then sitting in parks and talking while the lights in suggestive yellow windows go off one by one. Always there were other lovers, walking in close embrace, sitting on benches, meeting boldly or parting in dark doorways, kissing and crying and fighting and parting, to embrace again, never to part—while all Paris smiled upon lovers and permitted them anything.

> *Paris, reine du monde,*
> *Paris, c'est une blonde,*
> *. . . ça c'est Paris.*

The difference between love and other abstract subjects is that in love there is so much to tell, and so little point in telling it. Eventually we were married. Mina finally gave her consent. We were married in the *Mairie* of the 14th *arrondissement* by a stout, red-cheeked, black-bearded functionary with a tricolor stretched across his front expanse.

45

James Joyce and Constantin Brancusi were invited to be our witnesses, and Brancusi arrived late and out of breath with a wedding present, a brass oval sculpture called, precociously, "Le Nouveau-Né." Joyce did not appear.

My father visited Paris that summer in time for the wedding, met and was reconciled to Joella, relinquishing his hope that I would choose a bride from his milieu. I agreed to accept my new responsibility, abandon my European life and dreams, my unmaterialized prospects in the cinema. I was to enter an apprenticeship in my father's New York real estate business as assistant supervisor of building construction. Destiny indeed had changed tack, I marveled, as I took Joella back to America with me to begin my new job, to start our family of *nouveaux-nés.*

By the time three years had passed, we had two children, Javan and Jerrold. Jonathan was to follow. I am brought to that rainy reminiscence on the corner of Madison Avenue and 57th Street, the day I privately adopted Marcel Duchamp and Alfred Stieglitz as godfathers. Since the wedding in Paris, my time had been spent in arduous, artless business apprenticeship, first in my father's business, where I was really general errand boy on the job while an apartment house at 315 Central Park West grew from its foundation to full-capacity rental; and then as an assistant in Erhard Weyhe's art bookstore and gallery, absorbing wise and generous procedural tutelage from Mr. Weyhe in the bookstore and Carl Zigrosser in the gallery. Finally the day came when I felt the need to work for myself. I did not function happily under authority. Once I made my dreams and plans fully coherent, I had a long talk with Joella, who would have to share my risks.

"I will soon be of age to receive the principal of the small trust fund willed to me by my mother," I told her. "This could be saved for a rainy day or be tossed into a venture all my own."

"What would your mother wish?" Jo-Jo wanted to know.

"When she died, Dad was rich and strong-willed, as you well know. I think Mother wanted to help insure my independence. . . ."

The direction of my independence, I had decided, must find a course among my primary passions; art, cinema, and photography. Mother's legacy would not go far in financing my own movie, especially now that

new and costly sound-on-film had raised the ante for even the most modest of shoestring experiments.

"I'm all in favor of the Julien Levy Gallery of Modern Art," Joella declared.

So as not to lose sight of the dual objective of promoting camera work as well as every form of art, my opening exhibit was announced as a Retrospective of American Photography.

PHOTOGRAPHY

Not having the humility to be a true believer in anyone, including myself, I was never truly a disciple of Stieglitz, unconvinced, certainly, of his mystique as an art dealer, which, at any rate, I did not entirely understand. His professed mission was to dismay the rich into uncalculated sacrifices at the altar of Art, and to defend the sacred artist with selfless devotion. I was more inclined to think that capital and art were irreconcilable. Also, I still believe that the "poor artist" was too often merely a poor artist. Furthermore, I looked with some distaste at the rather childish and incongruous dependence of Stieglitz on a circle of flattering devotees. All this combined to tempt me into the ranks of those who were often bored by the endless monologue that could be Stieglitz. None of these reservations, however, could do more than slightly dilute my intense admiration for what he had begun in his gallery by way of widening America's vision and opportunity to see. And here is evident the parallel with Duchamp, who had contributed so forcefully to that vision in the Armory Show in 1913.

Van Wyck Brooks, a leading intellectual, critic, and a future dean of early American letters, once said of Stieglitz, "There was an element of the mystagogue in him, and it irritated people when he pretended that his pictures could not be bought but only acquired under certain circumstances."

Like the Ancient Mariner, with his glittering eye and skinny hand, and the wild tufts of hair that grew out of his ears, Stieglitz had his will with everyone, for who could choose but to listen when he talked, like a spellbound three-year-old? I wanted to see Stieglitz alone. There was

47

that other aspect of Stieglitz: the photographer who was beyond criticism. I wanted to enlist his interest and cooperation in the opening show of my gallery. I had already encountered difficulties when asking Paul Strand if he would lend a group of his prints. And as he was one of Stieglitz' first and foremost disciples, I had some hope that Stieglitz might be able to mollify him.

The personality of Paul Strand, or personalities, was always a continuing surprise to me. Unless I was an irritant, whom he saw as persistently putting up enthusiasms and preconceptions which he saw as opposition, he could only be thought of as self-contradictory. In little ways. He lived in a dull basement in the middle West Side, I think just off Central Park West, furnished as if it belonged to his mother. Perhaps it did, but Paul was no longer a boy and, in fact, at that time his wife Becky was with him. I suppose I had expected the white antiseptic walls such as Stieglitz threw about his velvet-black photos. Like Stieglitz, Paul was one of those photographers who seemed to have been born with a black cloth over his head like a caul. He was saturnine, looked wiry and quick, was tired and slow. His eyes were bright with what could have been eagerness but immediately proved to be bitterness of a most arrogant and defeated sort. Indirectly, as in an off-angle mirror, I was reminded that Stieglitz with all his benignity was also a bitter man. He, too, often talked of his bitterness, though gently. Unlike most painters I met, the photographers, as I think of it, were a misanthropic lot. Could they be frustrated painters? They seemed underworld men accidently out of their darkrooms. Excepting Cartier-Bresson, who was unquenchably eager, shockingly optimistic, wide-eyed with wonder and naïveté. But then Henri was a radical in the darkroom, violating all the sacred rules. Perhaps that is why I liked him and decided to defend his "snap-shotty" miracles to the point of attacking the photo gods, my gods too, the purists, the three great S's—Stieglitz, Strand, Sheeler— and their school. Hiding behind a pseudonym, Peter Lloyd, I wrote in the catalogue for my show introducing Henri in America in 1932:

* * *

48

ANTI-GRAPHIC PHOTOGRAPHY

To Julien Levy:

You ask me to send recent photographs by Henri Cartier-Bresson for exhibition, and here they are, but I wonder how our public in New York may be affected by such an exhibition as you propose? I myself am *emballé* by the vigour and importance of Cartier-Bresson's idea , but an essential part of that idea is such a rude and crude, such an unattractive presence, that I am afraid it must invariably condemn itself to the superficial observer—as if a Della Robbia should be cast in gold before it might be appreciated. If Cartier-Bresson were more the propagandist and could efficiently promote some theory or another to excuse his work—but you know how he is, sincere and modest . . . Chaplin has always retained his original cameraman, crude motion and crude chiaroscuro, "bad" photography in a protest against the banal excellencies of the latest Hollywood films; and indeed the funny man would dissolve in that suave lighting which brings a Garbo to life. . . . You have two exhibition rooms in your gallery. Why don't you show the photographs of Cartier-Bresson in one, and the innumerable, incredible, discreditable, profane photographs that form a qualifying program for his idea in the other room? Septic photographs as opposed to the mounting popularity of the antiseptic photograph? Call the exhibition amoral photography, equivocal, ambivalent, anti-plastic, accidental photography. Call it anti-graphic photography. That will demand the greater courage, because you have championed since the beginnings of your gallery, the cause of photography as a legitimate graphic art. And because you may bring down upon your head the wrath of the great "S's" of American photography whom you so admire. Yes! Call it ANTI-GRAPHIC PHOTOGRAPHY and work up some virulent enthusiasm for the show. There is no reason why your gallery should not fight for both sides of a worthy cause.

<div style="text-align:center">

My very best regards, etc., etc., etc.

Always entirely yours,

</div>

Paris, June 3rd, 1932. Peter Lloyd

". . . and of course I never manipulate my prints," Strand repeated with emphasis. "Except that I recoat my paper with a second platinum solution. That the commercial papers now are too thin, that they skimp

on any ingredient that is an expense in quantity at the expense of quality, goes without saying. My richer darks must be reinforced, but that isn't manipulation in any tricky sense, you know, like painting splashy emulsion in some sections and skimpy in others to imitate brushwork. . . ." Strand was showing me a series of immaculate small jewels, contact prints from his summer in New Mexico. My favorite was a landscape of successive horizontal horizons retreating for miles, every detail distinct, a regiment of incredibly sharp definitions. "I will buy that," I said. When I learned the price, a stiff one and a shock to me, I was already on the horns of a dilemma. There were three more I would also covet and finally own.

Strand demanded that I buy. The alternative was that he would not lend or contribute to the show at all. "Testify to your sincerity," said he. "I never have any success selling in an exhibition, just get my prints back frayed and dirty." A rather lame excuse for what amounted to little short of extortion. It's possible he suffered from a misapprehension, one I now suspect colored and made more difficult my financially precarious gallery years: that I had ample funds or lavish backing from my family. That people had such an idea never occurred to me, anymore than it would have crossed my mind to complain of my shocking lack of funds, or offer that stark reality as interesting, or as a wedge to force down a price. I wanted better appreciation and prices for those whose work seemed to me worthwhile. I had dedicated myself, my fragile funds, and my enterprise to bringing this about. Perhaps I should have faced Strand down. That courage might have saved me years of similar indecision and anguish whenever money and art got mixed up in my mind. I was too appalled by the force of his bitterness. What if Stieglitz, (for Strand said Stieglitz would bear him out) and all the others had Strand's point of view? My slight capital would be wiped out before I even started.

Paul, of course, hoped he was setting a precedent. I, of course, hoped he was not. I decided to temporize, to wait and see. In any event I wanted to own a Strand. In all innocence I had expected him to lend, perhaps even present me, with one. I thought he would congratulate me, embrace me, for the temerity I was about to show in championing photog-

raphy as an art. Now, instead of arguing I looked bleakly at myself, realizing how presumptuous my amateur hopes must appear to his cynical professional experience. I became abject, apologetic. I offered to buy one, even two. Strand, perhaps a little ashamed, perhaps not, offered to give me one photograph for every one I would buy.

There still remained the question of price. One hundred dollars a print. This was modest against the thousand Stieglitz usually asked for his. I have always found bargaining unbearable. It was I who was determined to insist that fine photography had a high value, in order that such value be established. By that same token I couldn't protest his price. It was at this juncture I telephoned to Stieglitz for a conference. I would submit to the ethics and judgment of that grand old man of photography and idealistic art dealing.

If I had expected to find a consoling ally, I was disappointed. Flanked by his two selfless and eternal minions, "Zola" and Cary Ross, supported by the penetrating eyes, muscular torso, and febrile hands of Georgia O'Keefe reflected in platinum photos that lined the wall behind his cot, and served intermittently by the approval of Dorothy Norman as she passed to and fro on numerous errands, Stieglitz took command.

"Salesmanship begins at home," he sternly suggested, "and your father is just as wealthy as his friend, old Al Bing, or as Al Gallatin, or as any of the other Als." True, my father had ample money until the recession a year or two later, but his affluence had little to do with me. Dorothy Norman was promptly dispatched to collect a thousand-dollar subscription to An American Place from my father, in return for which he would be given an original Stieglitz print, one Stieglitz thought Dad might loan to my exhibition. Stieglitz got the subscription but I never received the print from Dad. For representation of his work Stieglitz did not lend, but sold me, a copy of *Camera Work* containing reproductions of his most important photographs which, with his permission, I might tear out, frame, and hang. He explained that he had directed their production personally, and he had considered them as authentic as any series of darkroom prints. And so do I.

I retreated, not happier but wiser, still preserving an awed devotion to that dedicated man.

Stieglitz

Stieglitz would wander around his gallery like a Western prophet or an Eastern guru.* "All art is rooted in love—in heartache."

His favorite painter, Georgia O'Keefe, when I first met him, was acting as his model, posing generally in the nude. He took close-ups of all parts of her body; her hands, her breasts, and hung them on one wall in a series. On the other wall would be cloudscapes. These exhibitions he called "equivalents." "Beauty is the Universal Seen."

In later years he took to living almost entirely in the gallery, wrapped in his black cloak, cared for by his faithful attendant "Zola" and his bright disciples, Dorothy Norman and Cary Ross. "I decided to devote my life to finding out what people really mean when they speak; what they mean when they say one thing and mean another, say one thing and do another. The fact that all true things are equal to one another is the only democracy I recognize."

His black eyes would sparkle. Stieglitz talked in parables of his own and would give excerpts from his unwritten memoirs in short bursts of speech:

"The struggle for true liberation of self, and so of others, was to become conscious within me. . . ."

"I had always felt as a child that I had been promised a free America, a world that, in reality, I never found to exist. As a result of which, I have spent the better part of my life attempting to create the kind of

*The Stieglitz quotes are reconstructed from memory, stimulated by rereading Dorothy Norman's "Notes from Conversations with Stieglitz," which appeared in *Today and Tomorrow*, numbers 1 and 2.

world I felt I had been promised, in which the principles I had been taught might be practiced.''

"I cannot look upon anything as mine unless it is available for all. . . .''

He would point to photographs on the wall, and the hair in his ears would bristle. ''The subsconscious pushing through the conscious, driven by an urge coming from beyond its own knowing, its own control, trying to live in the light, like a seed pushing up through the earth, will alone have roots, can alone be fertile. All *idealism* that does not have such roots must be sterile, must defeat itself.''

"When I am asked why I do not sign my photographs, I reply: 'Is the sky signed?' ''

"I have always believed that what people give in return for a work of art should be equivalent to what they feel they can sacrifice, in order to free the artist to live, to create further, in freedom. . . . That, to me, is the proper price for art.''

Just as Duchamp considered that one should live neither for profit nor for loss, Stieglitz had his own peculiar monetary system. For his pictures he would maddeningly quote different prices to different clients, oblivious of the fact that they might compare notes. There seemed little consistency in his methods. He would begin by saying that if you love art enough you should pay more. At other times he would say that if you really loved it you deserved it at a discount, and he would forever alter this mix. For example, to the charming and important collector Duncan Phillips the price one day would be much too high because Duncan Phillips could both afford it and appreciate it. At another time it would be very low because Phillips loved it. The same variation would occur when Cary Ross, who had almost no money but wished to purchase a Stieglitz,would offer all the money he had. One time Stieglitz would accept this offer, another time he would drastically reduce the price, or say to Cary, "Because you love it, you can have it.''

He would further elaborate in defense of the artist: "If a work of art has not been acquired and protected by the public during the lifetime of the artist, it should not be utilized after his death to deflect people from

supporting and championing the living. It is absurd to maintain that if the work of those who die is destroyed, art itself will die. I have sufficient faith to believe that art will always rise again, in every age, inevitably.''

"There is erosion, always more erosion, and for this reason the colors are changing all the time," Georgia O'Keefe was telling me, in her low, gentle voice, about the country that was "her country" where she thought she would like to live, perhaps the rest of her life, the Indian country near Santa Fe, near the little, not the grand, canyons of New Mexico. "That's why the colors are never the same. Browns, oranges, red, and then violet and deep into a purple. It seems endless, you know, and most unreal while all the time it is very real."

"I am trying to catch Stieglitz," I said, "like the canyons." She knew what I meant, or gave the assurance of knowing, before I explained. "To fix him in my mind, as if to write about him some day perhaps."

"He is not easy."

"Very hard," I agreed. Yet he was definite enough; all his statements, if at times longwinded, were equally clear, almost childlike, and consistent, predictable to the point of becoming his own cliché. He was as easy to find as his routine was repetitious, his black cape and hat never changed (indoors or out if I remember rightly). When all he asked was faith, what made him so unbelievable? While immutable, so hard to fix? "Like the canyons, ageless, changeless, yet different all the time." It's the erosion, but this I said only to myself.

When one of the many rich and irritable collectors found both his moralisms and his prices inexorably high and muttered "old windbag" and "faker," I, too, would sometimes agree like the child at the magic show who cries "It's just a trick" and "I know how it's done," even while the prestidigitator has carefully explained the trick and shown how it is done. Behold! It is done, and, with a gasp of surprise, we find it wonderful.

As if the child had cried at the Emperor's new clothes, "But he hasn't any clothes at all!" And so it was true. Behold, the nude Emperor was

54

as beautiful as an angel, and the dressed and furbelowed burghers were but dressed and furbelowed burghers.

I had no difficulty in assembling the other photos. Ralph Steiner lent graciously, for he and his wife, Mary, were already occasional friends of Joella and myself. I visited other important "S" photographers: Charles Sheeler and Edward Steichen, and they were generous with loans of their best work.

I turned to Stella Simon for some prints by Clarence White. Stella had been my earliest introduction to the world of photographers. Her son, Louis, had been a great friend in college and the summer after my sophomore year I had gone to Mexico with him, along with his mother and members of the Clarence White School of Photography, all women, who were taking a summer field trip with White as instructor. The ladies' expedition had broken up with White's sudden death two days after arrival in Mexico City. Louis and I were somewhat aware of a distressing "disagreeableness" with Mrs. White by long-distance telephone and telegraph over the disposal of poor Mr. White's body. There was gossip of a mistress among the ladies, something of that sort. In any case, probably not unfairly, I was given an embarrassing impression of Mrs. White and felt reluctant about asking her to lend. So I went to Stella, who indeed had a collection of White's prints and of several others of the important early American masters, including Gertrude Käsebier. She put me in touch with Annie Brigman and the West Coast group. I now had assembled more than enough to overflow my gallery. In deference to Strand's principles, I happily bought several of each, all at prices I could afford and that the owners and photographers considered equitable.

The prints had to be exhibited under glass, so framing presented a problem. I devised some economical methods that were to serve me for years. One was a frame into which I could slip two sheets of glass with the prints pressed between them. Creating a sort of transparent border, the print seemed to be suspended in air, and photographs looked particularly well shown this way. The rear glass could be replaced by a mat or colored cardboard so that these convertible frames were really quite versatile.

55

I worked out a double horizontal row of decorative molding strips all around the gallery walls, spaced two feet apart, the center between them near eye level, about five feet above the floor. Most galleries at that time were skying their pictures so they had to be looked up to. Painted the color of the walls, my moldings were grooved so that photos or drawings could be slipped into the groove under the sheets of glass and held in place without framing. The top moldings could also support "S" picture hooks in the same fashion as the usual ceiling molding, without unsightly nail holes or the equally distasteful monks' cloth wallcovering. I much preferred smooth plaster as a background for pictures.

Along the base of one gallery wall was a waist-high counter, beneath which were racks holding some fifty portfolios of prints. The walls of this room were white, dead white, with an effort made to avoid any yellowing from sunlight, a special formula of paints suggested to me by Hobe Erwin, or it might have been George Sakier. Both were interested friends and always ready with helpful suggestions. Each possessed the most charming and fertile of imaginations asking only to be exercised, Hobe as an inspired decorator and George as a fine artist and master industrial designer. Though Hobe died long ago, his unique wallpaper designs are still produced and are classics. George retired to Paris some years ago and devotes his time to painting.

For the portfolio racks and all other wood trim I chose a photographic gray. I was unable to arrive at the photo feeling I wanted with any of the flat or enamel finishes on the market. I hit at last on a flat gray covered with thick coats of transparent lacquer. Curiously, I felt able to spend freely in devising decorative settings for my artists' work, while parsimonious when it came to the outright purchase of pictures for myself, an attitude I was to regret. But it did seem to me that my function should be that of an exhibitor rather than a collector. To present art well was my first objective. As often as my heart was torn by the departure of one of my favorite paintings, just so often, or almost as often, did I congratulate myself on the fluidity, the changeableness of my surroundings. Given my very limited funds, I could not choose to be both showman and collector. The entire "backing" of my gallery consisted of the modest sum left to me by my mother when she died. It had also to support my growing family.

56

Part Two
602 Madison Avenue

Having assembled my American photos for the opening exhibition (planned for the fall of 1931), I sailed with Joella for a summer in Europe shopping for the gallery. Man Ray would help collect photography by Europeans. We had no notion of where to buy paintings. An advertisement in a magazine led me to the gallery of Jeanne Bucher. I was most fortunate: photographs never did sell, whereas the first year sales of the paintings I bought from her paid the rent.

I had an inclination, suspended on board ship between France and America, to toy with the portable movie camera my family had lent for the trip, a 16 mm Bell & Howell. It was still a novelty, and film was not too expensive for short, shoestring experiments. I had no serious project, nothing whatsoever in mind. But I arrived at the idea, during lifeboat drill the first morning out, to sink the ship. On such a bright cloudless day it would seem at best a minor *tour de force* to extract even the ghost of a disaster with that little mass-produced mechano-chemistry box; yet with even no stronger creative calling than mine, who knows what events might not be impelled, set in motion, what prophesies or discernments discovered?

There I was, then, lying on a deck chair, rolling ludicrously from side to side, camera pointed at the boat-deck hatchway from which passengers sauntered without panic and only an occasional serious face, each carrying or wearing life vests.

"Having some sort of fit, Julien?"

I stopped my gyrations but forgot to take my finger off the button, so there stood, for one rocking, rolling sequence, a perfectly upright, perfectly cherubic George Platt Lynes, the gifted photographer and friend I had met through John McAndrew. With uncommendable opportunism I

recruited him on the spot. "Do something, Georgie! Cause a diversion!" The foghorn roared. On that top deck the horn was so close it was irritatingly loud. George's serenity changed abruptly to the expression of an angry Pluto. Others frowned too, and I got my sequence of panicky faces. That, with cigarette smoke blown across the lens, did it.

We went to the game deck, George had his working camera, a 5″ x 7″ plate holder with a black hood. He was well on his way to becoming a successful professional. We spied Mr. Four by Four, as we called him, and his wife playing shuffleboard. Innocent occupations before the catastrophe, I thought, and started to shoot. Shuffling too energetically, the man slipped and sprawled, providing us with amusing material for film and stills, and some mild social blackmail. We had wanted to meet the man anyway, Mehemed Agha, the new art director of *Vanity Fair* magazine.

"What sort of a man," I asked Agha over a vermouth cassis, "is Crowninshield? . . . Condé? . . . Who is the great power, the arbiter of taste, aside from you, of course? . . . What writing style do I affect, what length press release? . . . Is a press agent necessary? I would much prefer to find my own path to the public."

"You seem to be quite capable," said Agha.

Natatcha and Dr. Agha joined us for dinner that second night out, together with a splendidly dressed couple who, earlier, had insisted on buying us all several cocktails in the lounge and now I had begun to dream might be perceptive and enthusiastic collectors, and, perhaps, devoted clients of mine. How soon the fancy was to vanish, as it did with many successive others. People with means and no taste for art: a reality and disappointment to which I could never quite become inured.

At this dinner we discussed all forms of cuisine, Continental and American, provincial and cosmopolitan. There were other Americans at our table. One was Bob Pitney who could out-*trompe-le-goût* of any Frenchman. A convivial eccentric, he had an unlimited income and enjoyed sharing his love of good food with his friends, often giving extraordinary dinner parties on which he and his cook lavished great pains to create surprise. A typical menu might begin with oysters on the half-shell, baked and served on heated shards of glass, looking so well

chilled that any unwary tongue would be burned. For dessert perhaps there would be coffee and vanilla ice cream pressed in moulds, shaped like roast squab and crusted with brown sugar for a roasted effect, served with a sauce of maple syrup. Between the oysters and dessert there might be such a delicacy as foie gras sculptured into cutlets, with tiny mushroom-shaped truffles and mashed potatoes served in toast ice-cream cones. He remained the rich gourmet until his untimely death—from richness and obesity.

"I hope you never show that bit of film you took of my pratfall," said Dr. Agha.

"Only upside down and backwards," I promised. That was how it was cut into my film.

I believe it was on this voyage that we had a storm at sea which almost sank the *France*. It swept aside all messages from shore, all news from any continent, and all passengers below except myself. Then I made a portentous discovery. It was drink that saved me from sickness, when half the crew as well as all the other passengers were incapacitated for one whole day and a night. I discovered that drinking kept me on my feet, that reeling with drink allowed me to roll with the sea, warmed me against the wind, and wet me against the spray. If I was unable to keep down the first drink, I drank the second double, and so on until my tired stomach eventually yielded to a pleasant intoxication. I dined that evening with the captain and what there was of his functioning crew at the single long table. He told me we wouldn't have been so badly battered except that we had been called off course by an SOS from a sinking freighter. The need to slow down, turn, circle, and stand by until rescue operations were feasible had put extra strain on our old ship. It had sprung several leaks and shipped considerable water. Fortunately another boat, a German freighter, had come along and relieved our big liner, so we were now proceeding full speed ahead and riding the storm satisfactorily. The disjointed bulkheads were receiving emergency repairs and would soon be patched. Limping but safe, we were to arrive in port not more than a few hours late.

Joella was up for breakfast the next morning. More and more passengers appeared on deck. I didn't sober up as quickly as they regained

their sea legs. One night I awoke in my cabin to see, or imagine, before my eyes a ghostly illuminated carafe of water. It remained suspended, shimmering a second, swaying, then disappeared. Shortly it appeared again, hung before me, and vanished as I reached toward it. Again and again it appeared and disappeared, an apt, accusing mirage. I sat stiffly upright in my bunk, with a cold sweat on my forehead, an eerie sense of deafness, a cottony feeling as though I were in a cold, silent void, all senses numb except my staring eyes that attended and inexorably saw the apparition again and again. With a wrench I broke the spell of growing terror.

"Joella!" I cried hoarsely, and woke her up. "Do you see it? Say you do or say you don't."

"See what?" she asked.

"Carafe of water."

"But of course I see it," she said calmly.

"Now it's gone."

"It is and it isn't," said Joella, with irritating matter-of-factness. "It's the *phare*."

It was the lighthouse. I could now see its intermittent beam passing through the porthole, revolving around the cabin, and refracting through the carafe of water that hung above my washbasin, shining through it, now on, now off.

I was to tell the story of the vanishing carafe to Massimo Campigli. In exchange, he told me several tales of a kind I call generically "Massimos." It isn't easy to define the structure of these Massimos. Perhaps I can convey their slant best by retelling one or two.

Finding himself exhausted and almost penniless late one night (and Campigli slyly avoids asserting or denying that he was drunk, but some bewilderment or fuddled alienation is always implicit in a Massimo), in the poorer quarters of a large and strange city, he rolled into a flophouse to sleep himself back to sanity. The atmosphere was uncomfortable, if not actually hostile, and he found sleep fitful and uneasy. Lying half asleep, he was startled by a noise, a shuffling and squeaking. A candlelit head began moving a foot or two above the floor in the thick darkness. It appeared to be bodiless, and moved along, not rolling but steadily ap-

proaching until it came up to him, floating below bed level. It was a sweating, unshaven face, nostrils flaring, eyes staring. Campigli dared not move until it had passed him and vanished somewhere further along the row of fetid cots. It did not reappear. Eventually sleep descended. And so until the next morning when a fascinated Campigli watched a legless beggar hoist himself down from his cot, strap his stumps to a badly oiled dolly, pad himself out past the other lodgers, and vanish into the corridor, the *homme tronc*, with his tin cup and pencils to sell.

Another Massimo takes place one morning in jail (was he jailed or visiting a friend of his, the jailer?) when he was much puzzled and alarmed by the strange behavior of a prisoner glimpsed through the bars of a cell door. After periods of almost motionless impassivity, this man would suddenly start making wild gesticulations, stop to peer transfixed out the window, then sit down and relapse into profound, detached inaction. These periods alternated, the action always of brief duration, the quiet periods sometimes very protracted but always marked by great solemnity. Campigli demonstrated; standing, gesticulating, peering, then sitting, blankly wondering, or frowning, occasionally smiling as if at some inner joke, or sullen and worried, but eventually a jack-in-the-box, up again, with arms waving. All the appearance of some strange, frightening, sad schizophrenia.

"What may be his affliction?" Campigli finally asked with some awe.

"Affliction? Oh, him"—the jailor smiled—"he is playing chess. He plays almost every day."

"Chess?"

"Yes, with the prisoner across the courtyard, out that window there. They play it in their heads, of course; they have no board. Very clever. There, he is signaling his next move now."

My trail leading to Campigli was first picked up in a most casual happenstance, as trails often are. One of his paintings was reproduced in the back pages of a magazine, Jeanne Bucher's ad in *Cahiers d'Art* magazine I think, which I chanced to find lying in the ship's lounge on our voyage to France. In Paris, Jeanne Bucher showed me more work by Campigli, that was, as I had suspected, enchanting.

What a dear, bright, unselfish little lady was Jeanne. She ran her gallery on a supposedly commercial basis, but her true fuel was enthusiasm for art and for people and getting them together. She also furnished us with an introduction to Max Ernst, whose work I had loved ever since seeing his book *Histoire Naturelle* while in college. Jeanne gave us the address on the Villa Seurat where the Campiglis lived. We hastened to visit them.

"Your wife is so *bellissima,*" said Campigli, "May I ask her for a kiss?"

Joella kissed him.

"*Vous aussi,*" I said, not to be outdone, turning to Mme. Campigli, "*Voulez-vous me baiser?*" Her face flamed.

"*Embrasse ce monsieur,*" said Campigli with a comprehending chuckle, affirming the innocence of my intentions. He never failed thereafter to suggest that I ask this or that woman the question. "They like it when you are a wicked-looking American," he would say, watching expectantly as I floundered between adventures and misadventures. I kept the joke going for his amusement long after I was made to realize that popular French slang had added the double meaning to *baiser:* make love.

An apotheosis for Joella, and an insight for me into the interplay of artist and subject, was offered when Joella sat for her Campigli portrait. His concept molded her future bearing, the carriage of her head, and embellished the directness of her gaze; while the impact of her Praxitelean features invaded his archaisms so that for a time the women in his canvases wore a resemblance to Joella, and Joella made her entrances a living Campigli.

The three portraits of Joella were most striking and led to enough commissions the following year to induce the Campiglis to visit America. In New York he worked simultaneously on portraits of Becky Reis, whose husband, Bernard, was my accountant, and another young woman. The latter was a charmingly pretty, very unformed young woman (she had no navel, as she announced while we were swimming one day at their Maryland estate, obliquely across the bay from the Annapolis Naval Academy). She and her husband would have been enriched, one

would have thought, by owning the truly lovely portrait that Campigli achieved. This was not to be, and I learned my first lesson in the difficulties of portrait commissions. Although commissioned most happily in advance, it was not loved when completed. "It doesn't do her justice," said their friends. I was deeply disappointed in their judgment, for the portrait was extraordinary, and I could only suppose that they said this not because the portrait was either bad or unflattering, but because friends preferred to compliment the lady rather than the likeness.

In Paris, shipment of Campigli's canvases to New York was arranged. I took a short flight to Berlin, my first plane ride, to learn what might be new in German photography, leaving Joella with her mother and little sister Fabi in Mina's apartment on the rue Saint-Romain. The flight was a small taste of the rather amazing moral and political chaos I was to encounter around the Kurfurstendam. The lurching plane threw financiers, rascals, movie stars, and *ungemütliche-Herren* indiscriminately into one another's laps. One such casual jolt led to an invitation to a large reception that same evening at the home of the German movie star Brigette Helm where, happily for my more serious intentions, I met an experimental filmmaker, a free-lance director-producer named Albert Victor Blum, and I was on my way with him the next day to visit the photographer Laszlo Moholy-Nagy.

I found Blum's dauntless idealism engaging. His shock of gray hair and straightforward blue-eyed glance contradicted the fear he professed to feel every minute of those days. He was a Socialist, possibly a Communist. My very innocence made his stories of the endless annoyances he suffered from the growing numbers of Brownshirt hoodlums more amusing than believable to my naïve ears; rather like some detective story spun in a smoker, or science fiction. Though that very day, on the way to Moholy's, I saw the streets suddenly cleared at the cry of *"Schupo"—Schutzpolizei*, the riot squad—and a careening truckload of Brownshirts drive down the Friedrichstrasse, a patrol car with helmeted armed men on a running board. In the suddenly emptied street, Victor seized my arm and urged me into a doorway.

Moholy wanted to show me the walls near his apartment in the district of the new, modern-design workers' housing units. They were

marked with bullet holes. Some weeks before, a demonstration against workers living there had turned into a riot, suppressed with bloodshed.

"Well, if it isn't student duels I guess it must be political escapades," I said. "You Germans are very pugnacious." Moholy was Hungarian and Blum was Viennese, but that was not why they looked at me askance.

We went through albums of Moholy's photographs and "photograms," his abstract designs of light and shade made by placing objects on photosensitized paper and exposing them to light: shadow pictures made without a camera. I made a selection for an exhibition to which Moholy had agreed with enthusiasm. I bought a number of his prints and several original photograms, for which he asked what seemed a high price. However, I decided that while in Germany I would purchase everything I wanted with no demur as I did not expect to return regularly. After schnapps and coffee, Moholy asked us if we would like to go with him and his wife, Lucia, some weekend to a nudist camp where they often vacationed. It was decided for the next weekend and I asked if I could bring my camera. "I'll try to get permission," Moholy promised.

"Why did you let him overcharge you for those photos?" Victor asked me later.

"He doesn't know anything about me. How else could I assure him I would give an exhibition and send him his share of any sales?"

"He gave away more than you bought to another American he met for the first time just the other day," Victor informed me. "He is devious."

"I found him very charming," I said, "and certainly his book the Bauhaus published, *Malerei, Fotographie, Film,* is a significant contribution."

"Oh yes, if you like the Bauhaus approach," Victor conceded, "at least the photograms are unique. You have an irreplaceable value there."

I wondered whether Man Ray or Moholy had first developed the idea of photogram. Man called his "Rayograms," but the process was almost identical. Victor didn't know. Moholy-Nagy was at any rate the

first to write a description of that innovation and other new uses of the camera.

We went that evening to a small movie house showing a film of Victor's, *Wasser*. This was a montage of water in every form, from its source in a little spring, flowing on to a river, down to the sea, with interludes of water taps, face washing, water drinking at a *Bad*, or spa, swimming, spitting, urinals, mosquito-breeding ponds, baths, showers and rain, waves and storms, and whatever else wet Victor found to photograph. It was edited with rhythm and poetic tension, made, as were almost all of the avant-garde films of those days (in opposition to the high cost of Hollywooding) on a pittance from the artist's own pocket, and spliced with ingenuity, sweat, and the hopes of immortality. The very limitations gave incentive for innovations that would permit grandeur to grow from simplicity. *Wasser* was very exciting, as was his current work in progress, *Hände (Hands)*. Blum used no technicians, no lighting except nature's, no actors except incidental people, which kept his work candid and real. The following weekend, he would be filming his new movie at the nudist colony, which would help justify my own camera. Well, thought I, he will find hands at the nudist colony, too.

While I was with Blum, I conceived the idea of gathering together 16 mm reprints of his and other experimental films—all I could assemble, so that I could present them in America. The first Film Society was to come of this idea. Blum gave me prints of *Hände* and a sports montage to bring to New York. Poor Blum, I never heard from him again. He disappeared, probably violently, in the early days of Hitler.

Late that night I wandered alone through the Friedrichsgasse and encountered Philip Johnson, then a promising architect, in a *Lokal*. He led me to other spots and showed me that there existed a Berlin night life such as few could have imagined. The grotesque decadence I was to discover over and over again in Berlin those short weeks could only be compared, one might suppose, to Paris during the last days of Louis XVI.

My nudist camp weekend extended to a week, during which I acquired a splendid sunburn, most uncomfortable the first few days, as I did not have an unburned place to sit on. It was a quasi-comic holiday,

67

contributing nothing to my gallery except the friendship of a young *Fräulein* who led me to meet the artist Herbert Bayer. She was a secretary in the Dorland advertising agency, for which Bayer worked as an art director. He was one of the most promising designers at the agency, a good-looking young man, freshly out of the Bauhaus, who was well aware of the other movements in modern painting. Although he had never seen himself as a Surrealist or associated with the Surrealist group in Paris, many of his collages and gouaches were so full of the Surrealist spirit that I bought a few.

Like all the other girls, the *Fräulein* was not very exciting at the colony, but suddenly, in the train on the way back to town, fully clothed, I found her *ausserordentlich*.

Bayer's collages came to be included in my first Surrealist show. I also bought photographs by a friend of Bayer's at Dorland named Umbo, of whom I have not heard since. Bayer, just before Hitler came to power, decided to leave Germany and I was to see him again in New York. He later got a job with Container Corporation of America and not only continued to paint and design in his free time, but together with Joella, whom he married after our divorce, was influential in encouraging the arts in the ski resort of Aspen. It was his idea to encourage Walter Paepcke and his Container Corporation in their generous advertising sponsorship of modern art. Acting in recent years as a design consultant, he continues to produce and exhibit his own work.

Back in Paris and assembling work by French photographers, I remember most vividly the charm of André Kertész and the impish vivacity of Brassaï. The work of Paul Nadar was being carried on by his son, who furnished me with reprints from the original negatives to supplement my small collection of perhaps a dozen original prints, already becoming rare and difficult to find. I was in danger of catching collector's fever.

I was to fail in my attempt to bring photographs into the market as fine art in a price range adequate to justify limited editions. True, museums later slowly admitted photographs into their collections of prints and the graphic arts, and some modern art historians were persuaded to include a chapter of photographic reference as part of the story of art,

but my three early years of effort seemed a total loss and did not meet with sufficient support to continue to nourish the photography hope for my gallery. Almost no one bought, in spite of the fact that during the period 1931-1933 I showed not only the photographers already mentioned, but also Berenice Abbott, Eugène Atget, Margaret Bourke-White, Matthew Brady, Brassaï, Manuel Alvarez Bravo, Alvin Langdon Coburn, Imogene Cunningham, Walker Evans, David Octavious Mill, Daguerre, André Kertész, George Platt Lynes, Man Ray, Paul Nadar, Paul Outerbridge, and others. It was fortunate that mine was also an art gallery; thus I was not without another string to my bow with oil-on-canvas paintings, even if most of these were neither conventional nor easily sold.

Once set on course, the tasks and pleasures of the gallery routine became automatic, hectic, and continuous. No sooner was the opening, with its excited combination of high hopes, rewards, and disappointments, one day in the past, ashtrays emptied and crumpled catalogues put in the trash, than work on the coming exhibition had to be started, press releases written, new catalogues designed and printed, envelopes addressed and mailed, and unframed pictures set in frames borrowed or hastily improvised. A certain rhythm soon became habitual. Daily there was the influx of visitors, Saturdays were marked by special crowds and confusion, a mingling of artists and patrons, a lively divergence from the austerity of other galleries of the era. I was inventing gallery showmanship as I went along. Every third week during the season saw the figurative death of one show and the birth of another. I soon found it to be a gratifying way of life, rich with human contacts of a less banal caliber than the usual business. It gave one a fine sense of creative accomplishment, and offered high-intensity ego rewards and disappointments along with the constant cliffhanging or balancing act of keeping solvent.

My vanity would like to say I discovered the artists I chose, who of course were physically first discovered, one supposes, by their mothers, by midwives, or obstetricians, then gradually by themselves. I can say I was both early and helpful in their recognition. A few accidents leading to my first meetings with some of them might bear telling.

It was 1931. The name Salvador Dali caught my attention abruptly, overheard in casual conversation at Pierre Colle's Paris gallery one afternoon. Someone had been to an exhibition of his work in Barcelona and it was—what was the whispered word?—"questionable"?

Now there occurs to me a sudden insurgence of hallucinatory images, of innumerable little men riding bicycles and balancing on their heads long loaves of bread and, yes, each in underpants abominably soiled with excrement. Where had I seen these little men? Could it be in numerous recurrent dreams of my own in which I walk away from a Paris *vespasienne* and become tangled in their traffic as troops of them converge on me from all sides? Finally they emerge from memory and are immobilized with the name Dali printed beneath a reproduction seen in a Barcelona newspaper while I wait to have my haircut by the ship's barber on the paquebot *France* some year in the past. That doesn't explain the *vespasienne,* except of course there came the time when I saw the painting itself, "Illumined Pleasures," a very small panel in a large black Dutch frame in the window of the Goemans gallery on the Paris Left Bank. Surely I had gone in and looked at the exhibition, perhaps even priced some of the paintings. But weren't they already sold? Anyhow as I had recently married, I am sure I was not thinking of acquiring any other object for my affections . . . at my age of twenty-one I was not interested in the *merde* of the grasshopper's child. (Dali in his nightmares often identified his father as an enormous grasshopper and titled one of his painting "Myself at the Age of Ten as a Grasshopper's Child.")

Now, however, in 1931, I had encountered Pierre Colle, a younger man than I, dark, magnetic, and burning with enthusiasm in his new gallery in Paris on the Rue Cambacérès, where he had been showing such painters as Derain and Matisse, soon was to exhibit Bébé Bérard. He was a man of great perception and honesty, and was to become a close associate of mine, quite like a Paris partner, as I was to be his unofficial partner in New York. I found Colle preparing to have recent Dali paintings shipped from Spain for exhibition in his gallery. Dali was coming to Paris, too, and I should meet him. Pierre and Dali were interested in arranging an exhibition in New York.

"But the Customs," I murmured. As for the old ladies, their probable pother and dither would cost me no blushes, but Customs would surely prove less modest and more insurmountable. I feared the worst.

"No fear," said Pierre. "Monsieur Dali has promised to make himself unobjectionable. He will modify. Just a little unobjectionable, but enough. He is so versatile." Pierre had three of the new paintings, they were *sans ordure,* and certainly masterly and startling enough. If not the old Roquefort, at least, as Dali was to say, the real Camembert. Two were already sold to American collectors, one to Philip Goodwin, another to Mrs. Murry Crane, both of whom were to be most generously involved with the Museum of Modern Art in years to come. That Mrs. Crane bought a Dali indicated that even the old ladies might approve. The third, unsold, was about $250 *prix de marchand*—price to the trade.

So I bought "The Persistence of Memory."

With some trepidation I brought it to Mina's apartment to show Joella and my father, who was passing through Paris on his way to Le Touquet and golf. To my surprise Dad was enthusiastic. He commented on the meticulous technique; he took the image to represent the "flow of time." This interpretation would not have occurred to me among all the other aesthetic and philosophical implications of that picture. "Time flies, isn't there a fly on the watch?" he joked. He was pleased that his enthusiasm encouraged me. In those days $250 was a high price, more than I had ever spent for a painting, and this by a relative unknown at that. My father was also pleased when I told him that if he liked it "so would America." He urged in vain that I change the title, "Persistence de la Mémoire" to "The Limp Watches." My father, I believe, was the first, but not the last, to indulge in that banality.

I was almost disappointed by his easy acceptance of this soft cheese. I hoped that its deceptive mildness might prove a wedge for an understanding of the violent contribution to the menu of modern art Dali offered with his imaginative snapshots of intercranial space, post-Euclidean composition, animalization of machinery, displacement of the orgasm, mobilization of the dream, intercourse of the eyes, the smashing of the mental molecule. All my phrases, but we may also add

71

those of Dali: "paranoiac delirium, cannibalism of spring, conquest of the irrational."

If I had slight misgivings about the versatility that produced the paintings Dali sent that year to Pierre Colle, I set about in the course of time to acquire more powerful manifestations. Soon I had occasion to buy from Paul Eluard the earlier "Illumined Pleasures" and from André Breton the "Accommodations of Desire," both originally chosen by them for reproduction in the magazine *Révolution Surréaliste*. These two panels, great paintings and loves of mine, subsequently went into the collections of Sidney Janis and Wright Ludington. Wright later, in the sixties, most generously gave me the opportunity of again owning my favorite Dali, and "Accommodations of Desire" is now mine. Sidney has given his "Illumined Pleasures" to the Museum of Modern Art.

Dali himself, in Paris, in a black shirt and crimson tie, a tightwaisted black pinstripe suit, and orange shoes, I think; his mustache not at all bizarre but neatly clipped; Dali, when I first met him, offered no confirmation of my preconceived notion that he might be slick or pandering. He was disquieting to me. He has never ceased to be so, not because of ambiguity but rather by his singleminded intensity and frankness. He fixed his piercing black eyes on me, he crowded against me, his restless hands alternately picking at my sleeve or suit lapel or fluttering emphatically as he described his very newest, his most revolutionary of all Dalinian theories, his most recent work as yet unseen, perhaps as yet unaccomplished and now being enacted in his mind's eye. He bombarded me with staccato mispronunciations of the French language that would seem untranslatable and incomprehensible, except that their intensity propelled them directly from his conception to my reception—as if the words were not conveyors but merely an accompaniment of background noise. *"Les comédons authendiques, les brais comédons scubdur supériorre, d'andérriorr, brotté combisiffmong."* Every possible consonant became a percussive *b* and all *r*'s violently rolled. Thus the *bbbarrrage*. In French, it translates to *"Comédons authentiques, vrais sculpture supérieur d'intérieure, frotté convulsivement."* To me, in English, it roughly meant "authentic meteorites, true meteorites, superior sculpture of the interior, rubbed convulsively."

Comédons I had never heard of, and they impressed me, as Dali ex-pelled the words and squeezed large spheres of the air with his hands. They seemed to me akin to meteorites of real flesh and real blood. They were, actually, I was to learn, in Dali's tortured vocabulary, small bits of snot. (Much later, I found the correct translation of *Comédons* was blackheads.) Highly magnified, Dali explained, after having been pen-sively picked from his nose and absent-mindedly rolled between his thumb and forefinger into satisfying shapes. The only difference, it would seem, between Dali and another nosepicker was that Dali would treasure his unconsciously shaped globules, magnify them, draw them, paint and thus exhalt them.

In all this conversation there seemed no relevance to the exhibition to be planned for New York—no dickering, no questioning, no specula-tion, no dissent but neither any assent. I still could not discover if I would be permitted to display any of these new pictures and sculptures (if the *comédons* were, as it would seem, to become sculpture). It re-mained for Gala (at that time Gala Eluard, Paul Eluard's wife, who had become Dali's mistress) to indicate that Dali would perhaps look with favor on an exhibition in my gallery, and that practical matters *peut s'arranger,* can take care of themselves.

In practical matters theirs was a very smooth-working team. It was Gala-Dali and Dali-Gala, as others were frequently to tell me. I soon came to intensely dislike dealing with such artist-manager *combines,* particularly if the manager was an inartistic spouse. I thought of myself as dealing from enthusiasm and not from cupidity, whereas the wife, like a tiger defending a cub, took for granted I, or any dealer, was a pred-ator.

So, freezing in terror before Gala, I still had enough self-respect and purity of motive to cope with her from the start, and Gala was notori-ously formidable.

What was far sorrier than the sordidness of the business dealings was the possible corruption of the artist and his work by other artist-manag-ers, and this I could not in any way avert.

Quite a few people who should know have claimed that de Chirico's wife disturbed the integrity, if not the profound clarity, of that extraor-

dinarily gifted man. As to this I could not say. Is integrity corruptible? Perhaps sometimes in our corrosive world it simply gets very, very tired, the clinker of a once glowing coal.

As for Gala and Dali, that self-confessed pseudo-paranoiac was so explosive he was fortunate to be matrixed by a Gala before he went to pieces. It seemed to me that Gala was doing more to guide than to diffuse this maniac missile, and I believed her when she said she wanted no more than the "chance" for Dali.

Meanwhile, Dali, pursuing his own thoughts, would roll his eyes like frantic juggling balls, widen his gaze so that his pupils hung in their whites like little marbles, then narrow his eyes to a stare of bright shiny black beads, furtively glaring from side to side while his white teeth would gnaw his lower lip, gnaw it sore. A handsome young man, he looked, that instant, like a rat. All this, Dali would say, suddenly aware of his grimaces, was not *"comme je pense, mais* quand *je pense"*—not "as I think, but *when* I think."

Now, Dali said, *"Tiens, il faut étudier mes rêveries pour comprendre."* One must study my reveries to understand. And he fetched a sheaf of notes from his overcoat pocket. *"Et à bientôt, lise-le, si Dali te dise,"* said Gala with unexpected and poetic intimacy. *"Au revoir, Julien,"* she murmured and in a voice fully of complicity, which I soon learned was a tone she used often and quite impersonally.

These vignettes failed to illuminate for me the exact nature of Dali's psychosexual attitudes. They were, however, an exercise of the violence, concentration, and clarity of his visual intensity; how his sharp black eye-lenses could focus on minute detail at great distance—insisting, provoking, hallucinating.

Whatever negotiations were to be concluded with the Dalis were not accomplished just then. They soon departed Paris. Pierre Colle was empowered to contract for a show for Dali, and Pierre was amenable to whatever would be suitable to me. He was quite unmercenary; we understood and liked each other from the baginning. At that moment his heart was not in his art business. He had become a happy stallion for a beautiful music hall vedette named Damia. Soon he would be swept off his feet—meeting his lovely and permanent bride, Carmen. But then,

Pierre's gallery was a hobby for an affectionate horse. Lucky Pierre.

He shipped me my first Dali show with no guarantee of sales from me, no cash down, and framing and shipping expenses prepaid. For my part I managed, fortunately, to sell out the show.

To gossip for a moment, let me recount the story a friend of mine, a very beautiful girl, told me. It seems Dali once proposed to her an experiment with Eros. He and she, situated at opposite ends of her bedroom with an imaginary line between them, should attempt to seduce each other visually in every imaginable way *jusq'au orgasme mutuel* without ever touching across the invisible barrier. This was of course the same motif that formed a large part of the plot of his and Luis Buñuel's film *l'Age d'or.* The scenes in that movie describe the attempt of the hero and heroine to reach each other in spite of the most bizarre interruptions. (At the time I first saw it I thought how preoccupied Dali was with sexual frustration.)

I am quite sure he was frustrated in this raffish, voyeur's proposition of his. She, a lively American girl, recalls feeling "as if turned to wood." Understandable. Her name was Daphne.

Almost immediately the gallery assumed a certain prestige, already seemed more assured and established than it really was. A small but steady stream of the general public was supplementing the friends, artists, and gallery habitués who constantly came in and out. We were selling. The Campiglis at least had sold out, except for "Biographie" (later sold), "Le Café" (still mine), and the three portraits of Joella, which I kept and recently gave to our children.

I refused to notice that the margin of profit didn't quite make ends meet, although my rent was low. The salary of my secretary, John McAndrew, was tiny, as was that of the handyman who came to clean and make deliveries. The margin of profit never managed to meet our business and family needs. The latter increased as fast as the sales. This little Surrealist gap we dared not question was always open except for a short time in 1936 when it all but disappeared. It seemed almost immodest to look closely at the immaculate line between profit and loss. It was as though if we were to really cross from the red to the black we might find ourselves in heaven; we would perhaps, in poetic fact, be dead.

J.C. of Utopia Parkway

It was a dull afternoon in November, 1931, and a gray young man came into the gallery. I say gray because he was huddled in a decrepit overcoat of that shade and his complexion was rather cold and gray. This young man wordlessly and seemingly aimlessly was haunting my gallery, haunting to me because I was scarcely aware when he came and went. The Julien Levy Gallery was spanking new and I no more welcomed his constant presence than dust. Here was my debut: a flawless exhibition of American photography in the front room, showing such clean precisionists as Stieglitz, Strand, Sheeler, Steichen, Steiner. In the back room, an array of old photos attracted Joseph, for the gray young man was, of course, Joseph Cornell, who on previous visits had shown some knowledge of the history of photography and even inquired the price of a Nadar portrait of George Sand while furtively studying a golden brown image of Cleo de Merode. "I can't buy, but I might swap." I think I heard him say. He brought me, some days later, the tightly curled roll of an original forbidden Brady print. I still have it. A magnificent, shocking photograph of the dead, the mutilated, the atrocified of the Civil War, never reproduced in any of the official histories, suppressed and perhaps forever lost but for that savior-scavenger, J.C.

The climate of my gallery that fall day was particularly propitious for Joseph. It was late and I was anticipating closing time and working with several crates of paintings for the Surrealist exhibition I'd planned for more than a year. I had just decided to lend it first to the Wadsworth Athenaeum in Hartford before showing it in my gallery. This group of Surrealist objects, literature, sculpture, and paintings was dear to my

76

heart. Contemporary art historians will never convince me that the first American Surrealist show was not mine.

Joseph inched closer and closer, peering over my shoulder. "Closing time . . ." I suggested. But he had already fumbled out of his overcoat pocket two or three cardboards on which were pasted cutouts of steel engravings. *Collages!* I glanced hastily at a bundle of collages by Max Ernst only just unpacked and stacked on the bookshelf. But these were not any of those. "Where did you find these?" Was it not a blessing I hadn't thrown the man out, thought I.

"I make them, " Joseph said. And showed them to me. There was the image of a fashionable fin-de-siècle young woman being sewn together on a sewing machine table. That one I remember well. ". . . the chance meeting of a sewing machine and an umbrella on a dissecting table"—Lautréamont. What a wonderful, irrational discovery, that two entities unutterably dissimilar should in their conjunction make another that is in itself a third and independent creature. Not a grotesque combination of the parents, not a cumbrous Siamese twin, not a dead stuck-up combine, but a persuasive, convincing new species, living all on its own. It is not the stone monster with the head of a woman and body of a lion that was the riddle of the Sphinx. The wonder of the Sphinx was its riddle. That it could conceive and speak, or the equal wonder that it could so enkindle the imagination that a man might believe in its prescience and its speech, even to imagine killing it! This is the potential magic of collage.

"You wouldn't mistake, now, one of mine for one by Max Ernst, would you?" he was saying.

That question removed from me the need for tact. That he too wished for his own style and so sensitively recognized the pitfall of imitation, saved me the embarrassment, the difficulty that I always had in presuming to make suggestions to an artist. One would not encroach on a touchy and important ego.

"Yes," I said, "I would almost think they were by Max if only because of the precision and your delicate understanding of what can and cannot be matched. Try to find your own images, entirely yours, full of

your own private joys or agonies. What does this elegant woman mean to you, be she sewn or undone? Who or what do you really love? And why don't you . . ." I continued, seeing an opportunity to impress a cherished notion of mine on a possibly compliant novice (I wouldn't have dared suggest anything to Ernst), "try working in the round? Maybe add some motion, some mobility? Look. Here's a photograph of a man with a gun." I pointed to one of the sepia prints on the wall behind me. "And here's a partridge. One could paste them at two ends of a shadow box. Build a little sloping alley and let a bullet, or a ball bearing roll between them." I glanced at him, but you would never know from his expression whether he was considering or resenting another's idea. Or had he already mentally accepted and accomplished the matter?

Then Joseph said, "I am a Christian Scientist. You wouldn't know that, of course."

"That's quite all right," I said, startled. "So is my wife, so is my mother-in-law."

"Ernst disturbs me."

"He intends to disturb. Surrealism intends to be disturbing. It probes the subconscious, you know, all those repressed ideas. Opens a new world that might, so to speak, be Pandora's box, "I answered.

". . . as if there were some deviltry," pursued Joseph. "But then, of course, they wouldn't exist at all, his collages I mean, because evil doesn't exist—you would know if you understood Mrs. Eddy."

I repeated that my wife believed in her, said I had read a bit and hoped I had some understanding. "I had a healing once, they think. But to have no shadows, no discords in art, as if all were sweetness and light, that abstraction is too final," I argued testily, "like Malevich's 'White on White.' "

"White is just what I mean," asserted Joseph. "Not monstrously, but in wonderful variations. All I want to perform," he continued stubbornly, "is white magic."

In spite of those elements of sad nostalgia and innuendo that could not always be considered either angelic or naïve, white magic was essentially what Joseph Cornell eventually performed—tenderly, ecstati-

cally, profoundly. I always feel enchanted and basically innocent before an object by Cornell.

Before leaving that evening he gave me his address. Joseph Cornell, 3708 Utopia Parkway, Flushing.

Parting now from Max Ernst, Joseph crystallized his own ideas. First he added to the engravings such glitter as mirror and tinsel. He closely examined some of the collection of old French puzzle boxes and watch springs in old containers with transparent covers (backed by views of the Arc de Triomphe) I brought out to show him. I had found these years before, sleuthing with Mina for finds in the Marché aux Puces in Paris. Within a week he returned with several objects in three dimensions, a few with moving parts. I immediately decided to include them all in my surrealist show. I recall two: "Book and the Ball," which Alfred Barr was later to buy, and the "Soap Bubble Set," which Chick Austin soon bought from me for the Wadsworth Athenaeum. Several constructions in the round were under tiny glass bells, and in several small boxes the mobile principle consisted of rolling steel balls. These were delivered well thought out and so promptly one wondered how they could have been made so quickly following our talk. One could imagine his feverish activity, as though they were ready in his mind just waiting for my spoken word or approval. And the spirit of execution was entirely that of Cornell, quite unlike Max's or Man Ray's or any other Surrealists then working in Paris. The results were a new thing for this old world, perhaps the first series of Surrealist objects made in the U.S.A.

My Surrealist exhibition in January, 1932, was, overnight, to turn my gallery into the unforgettable moment in art history it can still claim. I could not have been more delighted with the phenomenal excitement it achieved, in New York and elsewhere, especially because from lack of money and lack of space I had worried it might seem a bit sketchy. Even Europe was suddenly conscious of the Julien Levy Gallery, it seemed. Mail and press clippings poured in.

The show's somnambulistic improvisation was original, spontaneous, and lively, essentially Surrealist in spirit. If Breton had been here at that time there would no doubt have been a more orthodox representa-

79

tion. Manifesto-heavy, it might have collapsed of its own rigidity. I wished to present a paraphrase which would offer Surrealism in the language of the new world rather than a translation in the rhetoric of the old.

It had been to strengthen its impact, to lend it museum authority, but above all to do a favor for one of my best and most stimulating friends, Chick Austin, who begged to have it, that I lent him the whole group of paintings and drawings so painstakingly collected. Chick had only recently been made director of the Wadsworth Anthenaeum, and we both understood that the show would lend him prestige.

The museum's exhibition, just before Christmas, 1931, was extensive and solemn. Mine had the advantage of intimacy and enthusiasm, partly due to the limited size of my just two rooms in a building no wider than a New York brownstone. It was packed with the force of the unconscious, of our secret desires, of that iceberg of which only the smallest fraction shows, the bulk remaining submerged and powerful. Perhaps forced compression increased the impact. There hung "The Persistence of Memory," 10 by 14 inches of Dali dynamite. Although this particular painting was to attain inordinate fame (cartoons of it were in the more lurid tabloids, journalists from coast to coast wrote stories about "Limp Watches"), its duality showed the beginning of a temporary adulteration of Dali's style, introducing a new period of his that was to last for about two years. During this period he readjusted to commercial necessity, to success in the Paris market, to an indolence resulting, no doubt, from the security of his contact with Pierre Colle. Also, his spontaneous violence, appreciated by the Surrealists, was compromised by his efforts to address himself to some of the sophistries of the Surrealists he now met in person. Or perhaps it was already the influence of Gala, whom he had now tempted permanently away from Eluard. In any event, there was, as I say, dilution. Dali was not to regain his pure, agonizing, Spanishly cruel brand of Surrealism until he was again, for a while, independent of the art markets of Paris and America, with a generous subsidy from the English patron Edward James. This was to last for several years, a period of really high achievement, 1933 to 1937 or thereabouts.

In a period of American solemnity about art, though I realized my Surrealist show was perhaps imperfect, I hoped it was sufficiently provocative to awaken everyone's curiosity and suggest the spirit if not the complete alphabet of this new tendency in poetry and art. After all, improvisation rather than calculation is much nearer the essence of Surrealism, the "school of the unconscious." What is more, I believe that, like a sense of humor, it should be practiced in the most contagious way, daily, and by *everyone*. Although there may always be expert professional comedians, their special act is not the only sort of funny. What variety, if each of us released his personal wit! As for thorough, unleavened pedantry, about art *or* wit, I find it wearing. A complete exhibition of, for example, humor gravely studied by critical anthropologists . . . well, I can't find a single chuckle for the jokes recounted in Freud's *Jokes and Their Relation to the Unconscious.*

So I confess with no shame that the first Surrealist exhibition in New York was unpretentiously assembled with a light heart, accidents, unorthodox ideas, and plenty of pleasure; the only way I know how to do things.

The Christmas tree Joseph Cornell helped us decorate that year, and the Magic and Prestidigitation show Chick Austin staged on New Year's day for our children and our friends' children shared the same spirit. The tree looked heavenly even when daylight was on, and the rabbits from Chick's hat were quite real and hid in the apartment, not to be coaxed out until a later day.

The exhibition also included photographs by George Platt Lynes that were improvised by several of us in my apartment with George manipulating the lighting and snapping shutters on a potpourri of objects such as my molded antique bottles and our Brancusi "Nouveau-Né," all with double exposures and other controlled accidents in the Surrealist manner.

Among the unorthodox ideas were some Cocteau drawings I had decided to show. They were, I was later informed, anathema to the orthodox founding fathers of Surrealism. I was forced to apologize to each in turn as later I came upon them, thrice to Breton, twice to Ernst, once to Eluard, and silently to the unspoken reproach of Duchamp. But . . . I

had a package of these drawings entrusted to me to sell by the destitute and dying Pierre de Massot, who had TB. The inclusion of Charles Howard was a sanguine mistake, as he was only passingly Surrealistic. One might say the same for Picasso, who had already renounced his short affiliation with the Surrealists. The exclusion of Joan Miró and Yves Tanguy was also no doubt unpardonable, but I had nothing by either artist and decided not to try to borrow any, finally, when time and space were short. The Ernsts on the other hand were legitimate Surrealism and magnificent. "Loplop, le Supérieure des Oiseaux," a flurry of mauve feathers, was bought from the show by my good friend from Harvard days, the analyst Allan Roos. Max's "Soleil en 1900" I showed but refused to sell. It is still in my collection. My only Dali, "Persistence," was supplemented by his "Bord de la Mer," borrowed from A. Conger Goodyear, a canvas he had purchased when I bought mine from Colle that summer, and "Solitude," which was consigned to me for sale, I think by Mrs. Murry Crane.

A real *coup*, along with my discovery of Joseph Cornell, was the inclusion of a seventeenth-century curiosity in the manner of Giuseppe Arcimboldo, a head viewed vertically with a landscape seen horizontally, which was to influence Dali in some of his later double-image paintings, in particular the *Head* (was it Dali's idea of Sade?) *viewed as an African Village.* This seventeenth-century ambiguous "Landscape" was lent by Alfred Barr.

I included my own frieze of negative photostats, a series of shocking cover-page seriocomic collages from the New York *Evening Graphic,* the yellowest of vulgar journalism and incredible Americana featuring the story of "Peaches" and her "Daddy" Browning. Premonitions of Pop Art?

I borrowed a Pierre Roy from Brummer because, although Roy considered himself independent of the Surrealist movement, Chick and I thought that the spirit of his work was entirely within the definition Breton had established. This was not the first or last time an artist who did not want to be a Surrealist was included, willy-nilly. Chick was successful in pursuading the trustees of his museum to buy "The Electrification of the Countryside" by Roy, one of their earliest ventures into modern art.

I also showed Marcel Duchamp's "Why not Sneeze?" which consisted of a small wire birdcage filled with marble lumps of sugar, a thermometer stuck in the top (to take the temperature of the cool marble?). "Why not sneeze Rrose Sélavy?" was painted in black, in reverse, on the underside. To see this, one lifted the cage and read it in the mirror on which the cage rested. The marble, far heavier than the sugar it appeared to be, tended to make people who picked up the cage lurch a bit from the unexpected weight—a *trompe-l'oeil* in a muscular dimension.

I know very little about the painter Viollier, whose "Psyche" was also included, mainly to establish for myself an advantageous rapport with a dealer. I purchased this painting from Léonce Rosenberg, with inconclusive plans for a one man show for Viollier in the future. Léonce was the younger and more experimental of the two Rosenberg brothers, both of whom were influential in the Parisian art market. I was still too small a fry for Paul to take any interest in, but Léonce, being younger, was less august, and quite amiable. Viollier himself was shortly to fade from sight, one more painter who did not fulfill his original promise.

To make the show rich in texture and supplement my limited resources in painting and wall space, I included an exhibit of my large collection of Surrealist books and periodicals, bought at the Librairie Corti, official bookshop for the movement in Paris; and miscellaneous objects such as Man Ray's "Boule de Neige," a paperweight bought from him in Paris that he had had a European novelty company make from his design. It consisted of a glass ball filled with water in which floated a photograph of a girl's eye (Lee Miller's), larger than life, enveloped in a snowstorm of floating white flakes when the globe was agitated. Cornell made a montage that was used for the catalogue and later adapted for the jacket of my book *Surrealism,* published in 1936.

Finally there were three montages, all in gouache with photography, by Herbert Bayer: "Vogel mit Ei," "Atelierstrand," and "Liebesknöcheln." As I have said, Bayer was an advertising man, working in Berlin with an international agency, which only goes to show that Surrealism was creeping into commercial art in Europe before Madison Avenue ran it into the ground.

Before reverberations from the Surrealist show died down, words of Surrealism echoed back from the most unlikely places. I received a

thick package containing a manuscript and a letter asking me to "read these pages and advise if they might be considered Surrealist and if they might under such circumstances find a publisher."

I started to read. It was about a young girl, told in the first person. In a rather naïve, almost illiterate style, the story unfolded of the usual love requited only too well before marriage and of the subsequent betrayal, that is to say, desertion, by the hero, or villain, whose name was, unbelievably, Nigel. Nigel having left this young lady in the lurch, she found herself living in a fantasy world, presumably Surrealist, peopled mostly by white-jacketed men who kept her under restraint. Several times she managed to escape through a window only to be returned to her monastic cell. Surreptitiously she wrote these memoirs, and flirted outrageously with one of the white-coated men in order to have her manuscript smuggled out and sent to an art gallery as a first step toward publication.

It ended with a paragraph stating that she had long lost track of, and almost given up hope of finding, Nigel. That is, until she could escape again through the window and come to New York. Once there, she would look through the art galleries until she found someone reading the manuscript, and that someone without doubt would be Nigel himself. She would walk up behind his chair while he was intently perusing her work, raise her knife, and plunge it— At this moment I hastily shoved the manuscript into a desk drawer. I called Allen Porter and asked him to get it out of the drawer, out of the gallery, return it to the address on the envelope as rapidly as possible.

In the next morning's mail a letter from the author's doctor arrived, explaining he had forwarded the manuscript and asked if I as therapy for his patient, would write a kind and understanding letter in response when it was returned. Such notoriety brought in very little new business.

My best clients were those who, by whatever accident, had already stumbled on one or another of the artists I was planning to unveil, or who already owned a painting or two of the recondite moderns that I would show and, considering them their own special pets, found my activity most sympathetic, a confirmation of their own independent judg-

ment. One usually came to know these people through the artists, who gave me letters of introduction or at least a list of those scattered and various people in the United States who already owned some of his pictures. It seemed both good policy and due deference to their adventurous taste to ask to borrow one of their paintings for that artist's exhibition. From this they sometimes went on to buy from me with the agreeable feeling of being on the inside track. Thus for my first painting exhibition, the work of Campigli, I had assembled a list of patrons and lenders from him and his obliging dealer in Paris, Jeanne Bucher. I borrowed from Maude and Chester Dale, T. Catesby Jones, and Bernard Reis. The last two were not spectacularly wealthy but interested in modestly participating in the cultural adventures of their time and owning some experimental pictures they liked to live with. Bernard and Becky Reis' collection was to grow as they became more and more personal and helpful friends of painters and sculptors, and as their taste and discrimination grew. She had at one time been in an art gallery in Paris, he was a public accountant with interests in law, economics, and sociology. He began offering his services as financial adviser to artists and to me in exchange for pictures instead of fees. Making out income tax reports, he found himself privy to and advising the artists on domestic and other problems. He and Becky were quickly versed in the many odd personal and impractical embroilments that only artists can wish upon themselves, and could tell amusing stories. Becky, tiny and cheerful, a marvelous cook, gave little dinners at their house, which developed into a congenial meeting place for artists.

While Bernard was my accountant, it was exhilarating to hear him speculate on how he would one day transfer my bookkeeping system from just an inventory to that of capital gains, a state of prosperity I could scarcely imagine, and that my gallery was never to achieve.

I eventually met a few of the notable collectors, each of whom broadened his collection by becoming interested in one or two of the other painters under my aegis. Maude and Chester Dale came to lend a Campigli and remained to buy a Dali; Edgar Kaufman wanted to patronize Frida Kahlo Rivera and commissioned a Peter Blume; the formidable Dr. Barnes arrived for a de Chirico . . . but that comes later.

85

Most of my secretaries, each in turn, became involved in the life of the gallery. They were underpaid, but for the most part devoted and loyal. Having intimate relations with the customary heartbreaking state of my accounts, each did his or her best to interest some friends of their own in buying. John McAndrew was responsible for introducing Munroe Wheeler to the gallery, which brought in Glenway Wescott, the novelist central to another large and influential group, all greatly helpful. Munnie disappeared from the scene when he became a dominant figure in the Museum of Modern Art and had to be discreet and impartial.

Many of those who worked for me went on to bigger things. Allen Porter, the secretary who was with me longest, through the early, more adventurous years, moved to a good position at the Museum of Modern Art. He introduced many friends to us, one of whom, Jimmie Pendleton, a fashion decorator, became fascinated by modern art and as a client enthusiastically brought in *his* clients and friends. Another secretary, Jacob Beane, later became Curator of Prints and Drawings at the Metropolitan Museum.

Eleanor Perenyi, I remember, always wanted to continue in the footsteps of her writer-mother, whom she succeeded in making a collector of Leonid and Eugene Berman while she was my secretary. Eleanor later wrote a story, published in *Town and Country* magazine, about a young art dealer. Perennially in debt, even far behind in paying the writer's secretarial salary, he did not seem to care. *She* worried. The rent was due, the phone bill overdue, the electricity about to be cut off, and he refused to care. One day, after he sauntered out for one of his long lunches, a man came in to whom she sold a painting, an important one. The gallery owner returned and she told him with pride of the sale. "You have enough money for months. You can pay my salary. All our worries are over." He looked at the check and demanded, "Which painting?" When she told him, he went pale and said, "How could you possibly sell that beautiful painting to that disgusting man? I have never allowed him in my gallery. You did this while my back was turned. You're fired."

Years later, my third wife, Jean, found the magazine in my barn, the

pages marked to my attention. She rushed into my study, laughing and excited. "Don't tell me you're that man! I remember this story from years ago and—this is ridiculous—I told my mother at the time, 'That's a rare man, *The one I'm going to look for!*' I loved that dealer; he was indifferent to failure, in love with beauty; a romantic, a fool like me, not caring about money! So, Julien, I found him. It's you!''

Nellie Howland was not my secretary long, for she became engaged to James Thrall Soby, heir to a pay telephone fortune and soon, along with Jim, an art patroness in Hartford. Lotte Barrit was a secretary for several years until she left to work for Chick in 1941, married Bob Drew-Bear, then retired to raise a family, coming back to gallery work in about 1964 in Baltimore. She was until recently an important executive in the Chicago and New York galleries of my friend Richard Feigen—the man who did much for the Surrealists, giving them shows and stimulating the interest of Chicago collectors in the late fifties.

Lotte brought in Baron Kufner, a mixed blessing. He was to finance my quixotic 1941 expedition, the mobile caravan "gallery" I developed that traveled from New York to the West Coast, showing all the Surrealists and others. It was a critical success, attracting large crowds, especially in Los Angeles, but disastrous financially, the baron withdrawing his money as precipitately as he had offered it.

Another secretary was Ruth Francken, a pint-sized girl, who departed to live in Paris and became a formidable sculptress of gigantic objects. And my favorite: poor Maggie Dunham; witty, marvelous, competent, who died of polio on her vacation one summer. Elena Mumm Thornton, later to marry Edmund Wilson, was the most beautiful and least secretarial of them all.

Allen Porter was the most invaluable. He was with me longest and during the exciting, crucial, pioneering years. Of all things, he was color-blind. A strange attribute for a gallery man, but I found it of great value for the simple reason that, like a blind man who becomes more sensitive to sound, one color-blind can become incredibly sensitive to shape. In hanging shows his sense of form and balance was impeccable. If I told him the dominant color of a picture, his tenacious memory would keep this in mind and he could avoid color clash. When asked

87

how he might convince a client about a painting if all he saw were tones of gray, he said, "Oh, all I need is to listen to Julien describe the colors: 'See that delicate shade of violet,' or 'What a shocking yellow,' and then repeat his phrases. Since it works, at least I know that Julien isn't color-blind, too." Allen, who loved to tease and joke, must have kept the staff well amused at the Museum of Modern Art during his tenure there.

Because of the same acute sense of form and balance, he was most helpful in the typography work in which I found myself involved every three weeks, devising novel announcements that from the first departed from the cliché of engraved invitations sent by everyone else at that time. He also contributed to the layout design I made for my book *Surrealism* for which the publisher Caresse Crosby gave carte blanche to design whatever my fancy might dictate. Allen and I played not just with various type choices but also with the colored inks and paper that gave maximum effect at little cost to the book.

On the whole, it was gratifying that the team spirit was such that during the life of the gallery even the elevator man and the janitor tried to bring in friends for Christmas shopping.

I had none of the continuity of selling experience such as less experimental galleries might later boast, nothing like the hordes of speculative buyers of art-as-a-commodity one saw in the fifties and sixties, of sheep-following-a-trend. The gallery was not large, impersonal, or profitable. I would not have had it otherwise, had I the chance to do it again.

I wish I could make precise the feeling I had of what I can only call self-significance that opening day of the 1931 Campigli show, my first art exhibition, as I looked around the gallery and the two score visitors who were being served sherry near closing time. I was not the impresario of a smashing success, but neither was I the undertaker for a failure. The press promised to be reasonably kind, there was a chance of enough sales to give bread and butter to the artist for what amounted to a year of his work, and encouragement enough for another show another year later, when he might be ready with new material. All the indications were toward expanded sales, there being no place to go but up.

The gallery was an infant, not a prodigy, but breathing and in good health. I envisioned that it might grow to maturity and, barring disaster, contribute its bit to history, then either die a natural death of old age or pass on into the hands of a son of mine and so change, but continue anew. It all seemed good, I had done it, and all my plans were working out. This self-satisfaction, this "I did it," spread to the color of the walls, the choice of the artist and the pieces shown, the exact placing of each hanging, the lighting, the design of the announcement, the carefully conceived releases for the critics, slyly written in the style of each. This feeling even somehow spread to the pictures themselves until I could almost believe I had participated in them too. This proprietory pleasure was never to leave me, nor the troublesome conflicts that sometimes arose from such solipsist fantasies. Still, some compensation was needed or there would have been no drive to continue, considering my lack of avarice, my downright foolish but basic disinterest in or distrust of business drive or making money. There it was, then, this "I did it" artist-identifying pride that must have been the real incentive.

If there was ever a slighting remark made about one of the paintings I would say, with some hypocrisy, "How badly the artist would feel if he knew you said that." But it was I who felt hurt or insulted beyond all recourse, and incapable of an impersonal and businesslike attitude where the gallery was concerned.

"Isn't it a marvelous exhibition?" I said, and fortunately, my little claque, Joella and John McAndrew, and perhaps others, agreed with me.

After the Campigli opening, Bernard and Becky Reis asked us to come home with them for a simple, impromptu supper. They went on ahead while Joella and I stayed to turn off the lights and close up. I found myself coming back up alone in the elevator, turning the lights on again, for just one more look.

Eugene Atget

That Eugène Atget, the eccentric old photographer, lived just up the street on rue Campagne-Première, at 17 bis, within easy visiting distance, I was happy to learn. It was 1927 and I was living in the Hotel Istria recommended by Bob McAlmon—dreaming in the room once loved in by Hemingway's Brett and Mike, wherein, according to legend, they one day ordured the bidet, with disastrous effect when they turned up the spray. One of Atget's photographs appearing in Breton's magazine, *Surrealist Revolution*, had caught my eye. "Pass by and knock on his door any afternoon at all," Man Ray urged. "If he is in you will be welcomed."

One sunny day I wandered up the street, passing the town studio of the American sculptress Mariette Mills and her broker husband. Mariette was half American Indian, had studied with Brancusi, knew "everyone" in Paris.

I found the ancient Atget at home. He was not in the best of health and told me he was beginning to feel his years. He must have been about seventy, though he looked older and was to die before the year was out. He welcomed me with formal hospitality into his small, poor, crowded lodgings on the first floor of one of those buildings that correspond in Paris to our New York brownstones. Across the hall lived the concierge-janitress. The bathroom was his darkroom and I could just catch a glimpse past the half-closed curtain of a second small room with the bed unmade. In his much-lived-in parlor workroom we sat while Atget brewed coffee on a small burner, then added a quick splash of rum. Around us from floor to ceiling were neat shelves piled with photography plates, proofs, books, and heavy paper albums of prints. Each had a brown strip backing carefully labeled with classifications by subject:

90

Cirques, Arbres, Enseignes, Chiffoniers, Petits Mètiers. All these documentations of circuses, trees, signs, rag-pickers, small tradesmen: subjects by the hundreds, prints by the thousands, crowded the shelves and a single long wooden work table pushed against one wall. This barely left space for the two wicker chairs on which we sat for coffee and our first conversation.

He had as a young man been a sailor, he told me. I tried to fathom what undercurrents brought sailors into the ways of modern art—Tanguy, Per Krohg, Tal-Coat. . . .

Atget protested he was not an artist, only *"un amateur photographe,"* but when he was younger, yes he had once wished to be a painter. He left the sea to become a bit-part actor touring the Provinces. It was then he acquired his *amie,* a constant companion of the theater years. Ten years his senior, she became his mistress and wished him to live with her in a more or less *serieux* way.

The camera, in a form that could use negative glass plates and reproduce quantities of prints, was then quite new and an apparatus that fascinated him at first as a toy rather than a livelihood. He had saved to buy one as another sailor might buy a monkey in some port as a pet. Just when he discovered that taking pictures could become a *métier,* he was not sure. It was some time after he had come to Paris, over thirty years previously, to the same little apartment where we sat. It had been a good life, doing what he enjoyed most. And there, filed in albums, was the Paris he discovered for himself. His girl had lived with him until her death not long before. It was since then, he said, that he had begun to feel his age. He couldn't carry his heavy, ancient camera around as easily anymore. But he would have none of the modern portables. They could never become part of him, he said. "Too old to learn new tricks," he implied.

So full of care and love, he would not really call his way with a camera a trick except by way of humility. Man Ray had tried to lend and teach him to use a little Rolleiflex that Man could readily spare from his battery of cameras and every other sort of gadget. But Atget complained that *le snapshot* went faster than he could think. Despite Man's explanations—how to regulate exposure to be as slow as he wished—"*Trop*

vite, enfin.'' Too fast. He used his clumsy camera's slow exposure, with a pinpoint lens opening that gave pinpoint detail to his prints. He made elaborate preparations. The subject would be studied sometimes for weeks before the camera was set up, to determine the moment of perfect light and perfect mood, the right angle and composition. For, as Stieglitz articulately, so Atget inarticulately, objected to cropping or any later manipulation. Such ideas probably never occured to him. The picture was to be captured intact on the viewfinder. Developing and printing were pure mechanics.

He would crouch with the black cloth over his head, connecting his eye and camera like a patient hunter in his blind until the prey posed itself to meet the shot.

His was never a well-paying business; his mistress must have contributed to their living. His venture began with a few assignments, but generally he preferred to give himself the project and peddle his picture-story later. This occupation very soon developed quite spontaneously into a passion. He collected an archive of classified documents, at first to no particular end, he explained. Until the collection, over years, amounting to more than 4,000 careful photographs, became a record of aspects of a Paris that were to slowly vanish. Before he died he tried to interest museums in Paris and London in purchasing this historical collection. He succeeded in alerting the Academie des Beaux Arts to his work, and they retained, at his death, a set of his series of historical monuments of Paris. Some 400 prints recently turned up in the cellar of London's Victoria and Albert Museum, mostly of architecture and iron-work, and rather faded, I hear. Often, he told me, he sold prints of his photographs as models to be used by painters too lazy to go on location themselves. More likely, some of them cannily recognized the caliber of Atget's perception, selection, and composition, if not also the quality of his special chiaroscuro—and his special soul. One such painter was Maurice Utrillo. In his later potboiling days he purchased and copied with oil colors hundreds of Atget views. Others who owned Atgets were Degas, Picasso, Braque, and Foujita. Another painter who would have embraced Atget was de Chirico. As far as I know, the two knew nothing of each other, although they often expressed the same strange spirit. I

noted in particular a print of two rearing white papier-mâché horses, a façade for a tent in one of the Street Circus series, one of the many I bought from Atget. He sold prints to me at ten francs, at that time about forty cents each, and would sell but a limited number at one visit, to give him time to reprint them, and refile them without confusion. In the period before my return to America I haunted his rooms, bought an enormous number of his prints, which meant dozens of rewarding visits with that extraordinary man.

Berenice Abbott came with me on one of these visits. Recently Man Ray told me that it was *he* who introduced Berenice, while she was his student, to Atget, his old and valued friend. Except for Man, very few of Atget's visitors who appreciated his work seemed to buy very much. Man Ray made quite a collection, which he has given to the George Eastman House in Rochester. I bought as many as possible, several hundred, because I would so soon be leaving Paris and had a sense that I might not ever find this or that monochrome for my own again. Within six months of my return an urgent telegram came from Berenice: ATGET DEAD. MUST SAVE COLLECTION FROM GARBAGE. CONCIERGE WILL SELL FOR ONE THOUSAND DOLLARS. PLEASE SEND. I had already shown some of my prints to friends in New York, to Stieglitz who, with no sign of jealousy, agreed that Atget was one of the greats. My own convictions confirmed, I sent the $1,000 to Berenice. I also persuaded Erhard Weyhe, in whose Lexington Avenue bookstore I was working, to send Berenice the money to put together a book in Paris: *Atget Photographe de Paris*; and arranged an exhibition for the book, a few Atget originals and Berenice's reprints in November and December, 1930, in Weyhe's gallery, which Carl Zigrosser then ran. Unfortunately, it was a very badly made book and very few sold. I later invested another $1,000 Berenice said she needed to preserve the plates. Many people were not aware I was the joint owner of these photographs, which did not seem important to me. What did matter was that between us, we saved the collection, and, in 1968, we sold it to the Museum of Modern Art.

Atget's scenes were almost always empty of people, because his camera was too slow to stop motion. So, in the early morning hours, he would photograph the empty streets in which no passerby could blur the

93

image. But in this immense loneliness there seemed nevertheless to be a population, ghosts that animated the empty street or empty room—or a concentrate of that spirit that was Atget's own, like the love he had spent living with his model until the second when his shutter sprang to grasp her one last time.

In one of my earliest gallery shows, on December 12, 1931, a selection of Atget originals were hung in the front room and portfolios of the reprints made from the original plates by Berenice were for sale. In the other room were portraits, both originals and reprints, by Paul Nadar. As Atget was the master of the Paris scene in the early days of photography, so Nadar was the first great French portrait photographer. Nadar had died and his son ran a large portrait photography establishment in Paris somewhat on the order of Bachrach's in New York. I was relieved to learn from him that most of his father's negatives still existed and were, in fact, in his possession. We made arrangements to sell reprints of these through my gallery. The negatives were not for sale, Nadar *fils* being a prosperous photographer in his own right and a respectful son. But the reprints, although lacking the subtle depth of print tone that had been in the original gold emulsion paper, were nevertheless arresting, psychologically astute, and intensely fascinating historically, including as they did so many of the great men and women of that last half of the nineteenth century. Many are photographs now well known to photography buffs: Delacroix, Baudelaire, Corot, George Sand, Dumas *père et fils,* and countless others of special interest from all the worlds—art, literature, music, the nobility, and politics.

My gallery sold both Atget and Nadar reprints at $10 each. I asked $50 to $100 for the Nadar originals and, sadly, sold very few, perhaps only one. One of my friends from college, Kirk Askew, bought a lovely warm-toned original of George Sand. I remember this because I was to see it hanging in his study year after year, a woman not beautiful but handsome. This portrait reminded me somewhat of a cross between Gertrude Stein and my cousin Edith Rich Isaacs, who was editor of *Theater Arts* magazine. George Sand wore a voluminous striped taffeta gown which Joella copied to wear to a "Come as Your Favorite" charity ball that winter at the Waldorf.

Atget originals were not for sale excepting an occasional duplicate. Berenice and I were in total agreement: all the originals must go as a complete collection to a museum. Paul Vanderbilt tried to interest the Smithsonian Institution. I tried to interest either the Museum of Modern Art or the Eastman people in Rochester. Maude Dale considered buying them to give to the French Institute, which was a pet project of hers at that time. She hoped to establish it firmly as a house of Franco-American cultural relations. But in all cases the figure we were asking proved an insurmountable stumbling block. It was very little, really: $10,000. We were just too far ahead of the trend. The negatives were to be included, provided a sum would be provided to properly preserve them, since they could rapidly deteriorate from improper storage and age. The total, divided by the thousands of priceless negatives and prints, brought ridiculously low the cost of each photograph, a mere few dollars. "But for photos? After all!" was the response. There were simply no takers. When they were finally all sold to the Museum of Modern Art much much later for much much more, we all considered the arrangement just and fair.

Much has been written about what Atget thought he was doing, and I am of the opinion that words have been put in his mouth about ideas that were not his. He told me he was simply preserving carefully the vanishing world that he loved, and keeping an archive of important classified documents. He was a remarkably simple man, extremely modest. In truth, he was unaware of his achievement. He left 10,000 photographs in hundreds of series, but each individual picture was an essential pearl in the string that was his Paris. And he was making a new statement with every picture, transcending the document and creating poetry that outlived his Paris and will outlive us all.

After Christmas, 1931, came Cinema, with which we opened the season for 1932. It only remained for us to find and rent a mechanical piano. I had a 16mm print of the "Ballet Mécanique" obtained from Léger the previous summer. As part of my program to promote camera work as an art I hoped to be able to sell short films in limited editions to collectors. George Antheil would lend us the player piano roll for his

music. George had married one of the Perlmutter girls whom Joella had known in Paris. I had known, casually, her sister, the wife of René Clair. It was she who posed as Eve to Duchamp's Adam in the charming Man Ray photo after Cranach. I treasure a print of this document and always withheld it from exhibition out of deference to the husband, although he well could have taken pleased pride in that little belly, of a shapeliness both Botticelli and Cranach would admire and that few girls, even when just a little pregnant, possess. It is now a well known photo-document, often shown as a Duchamp memento as well as a Man Ray photo.

As for Man Ray, we decided to round off the program with his film, *L'Etoile de Mer*. John McAndrew found a piano. He would pump Antheil for Léger and hand play Debussy for Man Ray. So we issued invitations for an evening of avant-garde film at the gallery. Guessing at protocol, we sent separate invitations to William Randolph Hearst and to Marion Davies. Hearst came with a party that included Mrs. Hearst. But my sense of drama, or glamour, was to be let down as Miss Davies failed to put in an appearance.

The evening was an exciting and happy one for me. It was a momentary triumph. In another of my ambitions, I had arrived. Dali's *Un chien andalou* was shown in the gallery the following year to launch our new project, the Film Society, along with a memorable performance of the Weill-Pabst *Dreigroschenoper* (Threepenny Opera), and later, the controversial *l'Age d'Or* by Dali-Buñuel (which hastened that society's demise). These showings were outwardly successful, each seemed bigger and better, but there was the hint of an unpleasant dénouement, of defeat, that now and then accompanied my pioneering ventures. This was at times brought about, I surmise, not only through certain envious ill-will that came my way but also by some tendency of my own toward self-destruction. (Was this perhaps the hidden portion of naïveté and hopeful idealism?) Inevitably I was to discover that the ultimate plum was not only out of my reach but firmly grasped by others. The Film Society was a nucleus for what eventually became the film library of the Museum of Modern Art. "First's the worst, second's the same, last's the best of all the game," as the children sing.

However, we are ahead of my story. That first movie showing I watched Man's protégé Kiki's bosom, filmed by Man in her great days before she became fat and drug-rotted, and then Dudley Murphy's beautiful wife was swinging in Léger contratempo to the plunging of an engine piston. I was reminded of early attempts to enter filmland, and of my youthful interview with Dudley Murphy and the short period working as his assistant. What we were supposed to accomplish I never quite knew, such was the mystery of shooting an isolated sequence for a Hollywood producer. Murphy's undertaking was a small dream-sequence to *Sunya*, then being filmed by Cosmopolitan Studios in New York. I was really just an errand boy without errands, or did I in the entire course of those months really run an errand or two? Most of the time I spent watching Gloria Swanson as she made this first of her many comeback films and submitted to elaborate makeup ministrations. She too waited, all made up. Mysteriously nothing would happen. Again the following day, the same: the making up, then no action, only to make up again and wait the day after that. Waiting and watching, and I invented a little plot for my *Kafka's Castle,* the first of many, that it was she who was watching *me.* After that fruitless but amusing adventure there was another with Kiki and the film I never realized in Paris, a visualization of T. S. Eliot's *The Waste Land.*

What was Kiki to be? The trickle in the dry sand? The project came to a halt after I declined to make love to her. She then declined to model or act for me, saying, *"Tu n'est pas un homme, mais un hommelette."* (Did she mean omelette?). But by that time I had met Joella and could no longer be touched or moved by Kiki's charms or taunts nor could I do less than postpone my pursuit of a career as a movie director in favor of finding a way to support a wife.

Joella held my hand that first cinema night in my gallery as I relived my early aspirations. Comte Raoul de Roussy de Sales introduced himself. He was a French intellectual, author, and journalist—the New York correspondent for *Paris Soir.* Man Ray had asked him to look me up. I immediately liked his melancholy and ironic profile and what I could sense of his grace and depth of mind. He was to become one of my dearest friends.

97

That same night George Antheil asked me to discuss with him the possibility of collaboration on a technicolor *Faust,* with my scenario and his score, the script for which he hoped to sell to Hollywood. "Be sure," I told George when we were together a few evenings later, "that they exaggerate the black and white. No color movie is valid all in color."

"That's mighty potent Dada, and I agree," said George. He was a handsome cherub with blond bangs, somewhat like an angelic Truman Capote. George was virile, well-intentioned, and incapable of being malicious. "A color film all in monochrome. That will be splendid!"

"But with one tiny thread of scarlet," I admonished, having a vision of Goethe's *Faust: Part II,* the *Walpurgisnacht* with the mouse and scarlet thread. Unlike Dali, who claims to "dream in technicolor," both color and sound enter my dreams as accents rather than in continuity. I believe this holds for many people, so that it seemed to me the subconscious could be most readily approached if color and sound were intermittent. So at that time I urged less sound, particularly less dialogue, in the talkies and, it would follow, less color in the chromies. Antheil apart, the only other cinema buff I then knew who seemed able to understand this may have been Eliot Elisofon, who was many years later to do the superb color photography for the film about Toulouse-Lautrec, *Moulin Rouge.* That all the elements of a film should enter only in proportion to the artistic effect desired, and not as brash exploitation of the miracle of all sound, all color, all stereo, was then a fresh idea. "As a matter of fact, why not make our movie all *still?*" I inquired. We laughed, and our collaboration was stillborn, our All-Still, All-Monochrome Technicolor Movie. But I tucked the idea away for possible elaboration. It did suggest the feasibility of someday enlivening a movie documentary of some painter's painting.

I now owned white tie and tails, Joella saw to that. Inquiring about for a smart but not too expensive tailor, she found Tony Williams, who was just starting a partnership with an Italian cutter. They made a business suit for me, and the full-dress suit I wore for the first time to a banquet celebrating the opening of a new building for the Whitney Museum.

I was seated between Edith Halpert and Edward Alden Jewel, that "Jewel of the Times," as Peggy Guggenheim was to call him. In a distinguished company of the professionals of the art world this was distinguished seating indeed, near the Whitney's directress, Juliana Force. Jewel was dean of New York art critics and Mrs. Halpert was fast becoming a most influential modern art dealer in New York; and that meant in America at that time. Her swift rise was no surprise to the art world because of her acumen, her ambition, and her close friendship with Mrs. Whitney and Mrs. Havemeyer, to say nothing of her growing intimacy with Mrs. Rockefeller. There even was to be gossip that she was as instrumental as Paul Sachs in the nomination of Alfred Barr as director of the Museum of Modern Art.

When speeches were made over coffee, I was introduced as the youngest newcomer to this circle and I proposed a toast "to the *hope* for American art." Now this was fresh of a junior and I knew it. I put strong emphasis on the word "hope." This implied that American art had not as yet arrived. That was just how I felt. In the group of artists present, with the exception of John Marin, I did not think there was one that represented a truly native art, independent of European fashion, and at the same time of first rank. In literature one might speak of Melville, Poe, Whitman, and Henry James as capable of influencing, more than being influenced by, the Europeans. I attempted after dinner to clarify my meaning to Juliana, to apologize for my innuendo, but she either hadn't paid me much mind or didn't care, and wished me a hearty "Good luck."

Edith had noticed and remarked on my courage. I was always to feel friendship and goodwill from Edith although she was another dealer. From most of them I slowly learned to expect more or less dangerous rivalry. Jewel was gently admiring, influenced perhaps less by my accomplishments than by my acceptance by those who were crucial powers in his world. Jewel's consequent respect quickly was communicated to or was shared by all the other critics except proud and independent Emily Genauer, whose taste and mine were almost always very much out of accord. Even when we liked the same thing it was for different reasons.

99

The immediate prestige of my gallery opened a vivid social life for us. Whether I enjoyed the dressy and too often stuffy affairs or not, I was easily persuaded that such constant gaiety was an excellent step toward better business. Joella for her part felt she was in her element. Handsome, Junoesque, charming, with her European accent and her candid interest in other people and their small talk, she proved an attractive guest and hostess that season. Our first big ball was at the Lewisohns'. Margaret and Sam put us on their list for the huge annual New Year's Eve party in the great ballroom of their Fifth Avenue house. The old man, Adolph, was still living and thoughtfully led me through the art gallery, which was filled with one of the best private collections of which New York could then boast. Of particular interest to me, of course, were the modern paintings. The next generation, Sam and Margaret, were really responsible for these. Although liberal and advanced in their taste compared to the old man, they were never to have sufficient courage or interest to be of help to me. If Whistler was modern enough for Adolph, who really prefered San Martini, then wasn't Van Gogh modern enough for Sam? One might even guess he really preferred Corot.

The Lewisohn home, once the elaborate and overwhelming dimension of the New Year's reception was out of the way, formed in more intimate moments the nucleus of a salon of the arts, except that it seemed to me a bit hampered by the awesome weight of riches and the dominance of Sam's artist friend and adviser, Maurice Sterne, a charming painter but a man whose taste and expertise were, I felt, lacking in vision or greatness. More stimulating salons were few and existed chiefly in the semi-bohemia of comparatively poor relations of the rich families, mavericks such as Peggy of the Guggenheims, Maude of the Cabots, or Caresse of the Peabodys. What a desperate need there was in America for such oases where our fledgeling culture could crossbreed and find nourishment and where that rarer avis, the genius, could now and then find his peer. But how sadly few such catalysts for cathexis were, and how faithless often. Nor could one find in this country even the convenience that a Paris café can provide. Many times one painter or another would suggest a form-it-yourself group of congenial lonely

souls. Alexander Calder briefly organized café dancing Sunday evenings in a restaurant on upper Third Avenue. Matta and I hunted through the Village for a co-operative saloonkeeper to set up a gathering place. These projects were abortive, started artificially, more from boredom than from zest, and died from lack of spontaneity or response.

In time my gallery became just such a place of meeting, so I have been told, since the old guard and the new talent, the monied and the threadbare, all gathered there. They assembled not only to look at paintings, but much more often to exchange ideas, and sometimes just to get in out of the rain. A sampling of the "beautiful people" or at least the interesting people drifting about in those days might be reviewed at an exhibition I gave of "The Carnival of Venice," photographs by Max Ewing. Ewing was a young dilettante who later that same year committed suicide. The catalogue for the exhibition, with a preface by Gilbert Seldes, is reproduced on the following pages.

THE
CARNIVAL
OF VENICE

PHOTOGRAPHS *By* MAX EWING

LONG after I had learned about Max Ewing's talents and had become familiar with, but not at all tired of his talents, I discovered something totally unexpected and very disarming about him: he always tells the truth. The more highly-colored, the more removed from the ordinary his accounts of things may be, the more certain they are to be literally true, to the smallest detail. He chooses that smallest detail rather well.

In his novel, *Going Somewhere*, he follows another method, which is probably the contemporary version of the baroque. Against such a rich background as this, you say, surely nothing quite so unfancy as the conversations of these New Yorkers could take place. I advise you to take up the argument with yourself before you take it up with the author.

The photographs in his Carnival of Venice also appear before a high background. They were all taken in his New York studio-apartment. Into this apartment entered, as you will see from the catalog, some representatives of the Faubourg Saint-Germain, of Piccadilly, of Wall Street, of Broadway, of Park Avenue, of Harlem, of Hollywood, and of Coney Island. The photographer was not serious about his business. The subjects came because he invited them and told them they could be whatever they liked in Venice. I doubt whether Mr. Ewing was trying to penetrate to the subconscious desires of his subjects. I think that he wanted to make a series of entertaining and admirable photographs. In that endeavor, as in all his others, he has succeeded.

GILBERT SELDES

1. Berenice Abbott
2. Duke de Arcos
3. Joseph Brewer
4. Madeleine Boyd
5. Frank Bishop
6. Claire Bishop-Huchet
7. Hugh Brooke
8. Ruth Baldwin
9. John Becker (as Proust)
10. Herbert Buch and Joe Gould
11. Dorothy Crawford
12. Miguel Covarrubias
13. E. E. Cummings
14. Princess Nina Chavchavadze
15. Richard Clemmer
16. Marion Carstairs
17. Eve Casanova
18. Lucia Davidova
19. Irma Duncan
20. Muriel Draper
21. Alice De La Mar
22. Mrs. George Dangerfield
23. Agnes de Mille
24. Georg Emanuel
25. Paul Flato and Spivy
26. Lewis Galantiere
27. Taylor Gordon
28. Barrington Hall
29. Janet Harbeck (as Dietrich)
30. Louise Hellstrom
31. Samuel Hoffenstein
32. Edith Hoffenstein
33. Mabs Jenkins
34. Lincoln Kirstein
35. Kate Drain Lawson
36. R. Ellsworth Larsson
37. Peggy Le Boutillier
38. Julien Levy
39. Joella Levy
40. George Platt Lynes
41. Robert Locher
42. Aline MacMahon
43. Marion Morehouse
44. Paul Meeres
45. Tom Mabry (Death in Venice)
46. John McAndrew (as Tarzan)
47. Lois Moran
48. Marguerite Namara
49. Isamu Noguchi
50. Mae Noble
51. Paul Osborn
52. Florence Osborn
53. Jack Pollock
54. Joe Paulin
55. Allen Porter
56. Rita Romilly
57. Alice Robinson
58. Paul Robeson (as Othello)
59. Fred Ritter
60. William Ritter
61. Boonie Goossens Reagan
62. Gilbert Seldes
63. Amanda Seldes (as Madame Butterfly)
64. Dorothy Sheldon
65. Tonio Selwart
66. Marion Tiffany Saportas
67. Spivy
68. Esther Strachey
69. Mrs. Frederic Stettenheim
70. Lou Tellegen
71. Comtesse de Villeneuve
72. James Whitall
73. Edward Wassermann and En Cas
74. Lloyd Wescott
75. Mamie White
76. Sister Martha Winslow

For years Joella and I saw much of the Barrs, Alfred and Marga, or Daisy as she was often called, a nickname bestowed, I believe, by Russell Hitchcock. The annual New Year's morning eggnog party had not yet become the almost regal function it was to be in later years. It was still small and seemed to me a pleasant and, I hoped, continuing family party—which meant the Askews, Allen Porter, Russell Hitchcock, Chick and Helen Austin, John McAndrew, Agnes Rindge, Jere Abbott, Iris Barry, Dorothy Miller, Elody Corter, and Ernestine Fantl. No trustees; we had some dancing to a Victrola and talked shop. When later these became rather large and imposing affairs they lost all interest for me.

I first met Alfred at Harvard during my senior year. He had come as a postgraduate from Princeton to study museum management under Paul Sachs. I had consistently failed in my attempts to interest the unbudgeable art department of Harvard in modern art, yet to some extent Barr succeeded. Proof, among other reasons, to me, of his qualifications as director of the Museum of Modern Art. Sachs, I recall, gave Alfred permission to arrange a small exhibition in the Fogg Museum of whatever he could borrow "locally." He was, I believe, even restricted to what he could find among the student body, a neat problem in local exhibitioning, fund raising, picture borrowing, and cataloguing. Alfred performed well. I don't know how he ferreted out *my* name, but he discovered that I had two or three pictures on my dormitory walls—a Chagall etching, a Campendonk woodcut, a Klee color lithograph, a drawing by Egon Schiele, all little treasures I had managed to afford while on a hiking trip in Germany the previous summer. He borrowed them for the show.

The best and most culturally fertile salon I was to know in the thirties grew from little Sunday gatherings at Kirk and Constance Askew's, where many of my Harvard and New York friends gathered. They were, sadly, discontinued, Kirk saying, "The war. Too expensive, too much drinking, and we are growing old." Kirk's system of invisible manipulation that kept the evening both sparkling and under control is worth noting. It combined the hidden rigidity of as carefully combed a guest list as any straight and proper social arbiter might arrange, with the

frothy addition of the uninhibited of Upper Bohemia, plus, one at a time to avoid jealousy and sulks, a single real lion. Two were asked together only if they expressed a desire to meet or already knew and liked each other *and* admired each other's work. There developed and was maintained a colorful variety of conversations, many fruitful contacts, some light flirting, some sex, and a little matchmaking, with an occasional feud for spice. A small group of regulars came every week and provided the dependably witty core of the parties, so that on rainy or otherwise off nights there still would be no risk of boredom. By the time we arrived each Sunday, perhaps Henry-Russell Hitchcock, an impressive authority on architecture and my old Harvard tutor, would be in town for the weekend, and ensconced behind a demitasse and a snifter of brandy, sipping from each and talking in measured, uninterrupted, and interminable tones to Agnes Rindge, who, down from Vassar where she taught art history, would be a patient listener until Allen Porter arrived. She would leave Russell abruptly to chatter with Allen. By that time Russell might not even notice, for there were enough new arrivals to form a shifting audience for him the rest of the evening. In another corner of the drawing room would be Esther Murphy, another indefatigable monologuist, knowledgeably opinionating on current politics. If Virgil Thomson was there, and he was more often than not, he would need the third corner as he too liked to preempt an audience. The fourth corner belonged to Constance Askew. There she, at least early in the evening, could receive. Since there were but four corners, the rest of us would circulate. Near Constance would be guests who had come earlier to dinner, always one or two couples besides the out-of-towners: Russell, Agnes, or occasionally Chick Austin, who would be staying the weekend. The dinner guests were alternately young New England couples of old family, museum curators, or critics. Not the newspaper critics; these were considered rather too lowbrow for the Askew Sundays, Henry McBride of the *Sun* excepted. Such authors of books of criticism as Richard Offner, Erwin Panofsky, or Étienne Gilson (who were really more aestheticians than critics, or as Kirk would most properly call them, "art historians"), would be in attendance. The Barrs came often in those early days. Liela Wittler of Knoedler's would turn up, so would

105

Nellie and Adam Paff, Kirk's partner in the American branch of Durlacher Brothers. There were also Fania and Carl Van Vechten, the elegant author; Max Ewing; lively and convivial Tom Howard; Phillip Johnson and his sister Theodate; and Amanda and Gilbert Seldes (the writer). Muriel Draper, mother of the dancer Paul, might appear with Lincoln Kirstein in tow. Muriel had her own salon, too. Lorna Linsly (who in the world was she?) was always there. Composer Paul Bowles and his wife Janie with one or another of the ''serious ladies'' about whom she was to write her rather strange and interesting book *Two Serious Ladies*. The Stettheimer sisters sometimes appeared: Carrie, Ettie and Florine, the painter who was Duchamp's special friend. These and many others came in and out with a dependable regularity that gave one a sense of belonging to an entertaining inside group.

The single lion? Many of the above were lion enough and, although at that time in a cub state, definitely on their way. Shall we say that the lion for the evening was Paul Sachs, the kingmaker of the art world? If so, the drinks would be served very sparingly until he had made his farewells, probably before midnight. Then, Allen would say, ''Everyone let down their hair.''

But the most interesting, if not the most sober part of the event, would occur toward four o'clock in the morning. In the little anterooom of the Askew's a lurid post-mortem would dissect the lion and all amusing incidents of the evening.

I was first made aware of the Neo-romantic painter Eugene Berman when Russell Hitchcock unrolled some Berman drawings one evening at the Askews'. What virtuoso, or virtuosi, virtually everything! The pen line sparkled with shadows. Not the fine outline of Ingres or Picasso, but the Impressionist spatter of Tiepolo. Chiaroscuro in the grand manner. They were spread out on the floor. Russell said he would sell them. He had met Berman in Paris that summer. They now carried on a constant correspondence, Russell promising to drum up sales if possible. Agnes Rindge and Kirk and I each bought one.

How and when could I see a Berman painting? Well, Joseph Brewer, another of the Askew coterie, bought one in Paris and expected it would be shipped soon, he said. From his father he had inherited a lot of

money, a doting mother, and the nervous system of a white rabbit. He owned a piece of a publishing firm, Brewer and Warren, a pegboard for the study of semantics, and a Scotch terrier as temperamental as himself. Allen said, "Do you know that every day Joseph telephones his home, sometimes twice a day? It keeps the dog from being lonesome. That dog just waits for the phone to ring. His master's bell! And the call costs nothing of course, nobody picks up the receiver. Joseph listens to the ringing signal awhile, then hangs up. I say, did you know Carl Van Vechten flatters himself he can bark just like a dog?"

Oh, but indeed I did know. I was in Harlem one night, at Small's Paradise, dancing. A dog barked under the table. "Think nothing of it," I had said to Joella and the others with me. "That's only Carl Van Vechten practicing." Carl crawled out from under our table, furious.

"How did you guess?" he asked. He was mortified. It wasn't long after that Carlo learned about Joe's idiosyncrasy with the Scottie, or the Scottie's idiosyncrasy with Joe. Somehow Van Vechten or someone managed to purloin a key to Joe's apartment and there Carlo was one afternoon when the phone rang. He picked up the phone. And barked. Joe was halfway home in a taxi before he realized that dogs don't answer telephones.

Joe Brewer's Berman was a painting of a large, somber interior, dark olive with maple-yellow striped wallpaper behind a figure lounging half-seated on a cot, a small window high up on the wall to one side opening to a night sky. There was a weighty feeling for the pâte of paint and for the fate of man. Seeing one such painting was enough to give body to the drawings and convey to me a feeling of Berman's promise.

Here might be one of the immediate answers to my unvoiced questions: In what new direction might my gallery go? Which of the new ideas could I wholeheartedly accept? Wouldn't it be human rather than abstract? Fleshly rather than mechanical? Illogical as we are, I did not believe propositions in mathematics were the answer. Why not restore man and woman, with his and her provoking irrationalities, to the center of the universe from which Copernicus and Descartes, like the angel guardians of Eden, dispossessed them? Put each of us, put you or me right in the middle, for our consciousness is all we really know, and

next to us our mates and families, and then our friends and on, very far out. . . .

Man is not a calculating machine which would conquer the world, but engagingly human. I cannot feel that progress is the only aim of man, or that art and religion are barbarous, as Descartes decided. His theory set man against himself and his irrational being. The idea of the supremacy of reason, applied to history as well as to knowledge, was useful in its time. It countered the old assumption that civilization had degenerated from that of ancient Greece and Rome, opened the way for the theory of progress and the subservience of knowledge to human needs, and was aided by the secular spirit that began with the Renaissance. But two ideas accompanying this begin to look dubious. One, that moral and material improvement depend on the intellect, on science and the politics of man as God; the other, a deliberate ignoring of the fact that the natural world can change, that science cannot be based on certainties. We are beginning to realize that we have no guarantee that science can progress indefinitely, except to our possible detriment. For these reasons, and because above all the Surrealists valued intuition and the irrational, Breton and Dali proclaimed the fall of Cartesian thought.

We all took enormous glee in the destructive wit of Dada, but that revolution was won long ago. The academic was consummately deposed. The Surrealists seemed human enough, psychologically speaking, at least the anthropomorphic painters: Ernst, Tanguy, Dali. Miro perhaps verged on abstract, but not really, for he had laughter.

The Surrealists remontaged man. The Neo-romantic Berman reestablished man and his artifacts—vulnerable, cultured man rather than Cubist man. Neo-romantic was perhaps a misnomer. Berman and his group, his brother Leonid, Tchelitchew, Bérard, and Tonny were *Neo-renaissance* more precisely; romantic only in the trappings of melancholy and ruin, poverty and nostalgia, that was an integral part of their life at this time, and not untrue of the human situation in general. Behind the crazy glitter of false values, dark forces were lighting the way to another war. Berman lived away from the posters and barkers, not behind the footlights but backstage where the dramatist-playwright and actors really worked.

108

Berman's method was expert; he knew how to draw, an ability often concealed if not entirely lost or missing in the work of many moderns. Picasso is one of the great exceptions. His draftsmanship showed handsomely in the Blue Period before Cubism and in the Rose Period following, from which Berman quite naturally proceeds.

I made a mental reservation: always look at an artist's representational notebooks before accepting his distortions. Soon after, when I reached Paris in the summer of 1931, I sent Berman a note by pneumatic, a *petit bleu*, via the carrier mechanism that zips through tubes under Paris. Our department stores once had them clicking and whirring overhead carrying change. This one was asking Berman for an appointment. He answered promptly.

> *5 Rue des Lions St. Paul*
> *Paris (IVe) le 20 Juillet 31.*

Monsieur:
Je vous attendrai Mercredi entre 2½ et 4 heurs d'après-midi—si ce jour ou cette heure ne vous conviendraient pas, veuillez me fixer vous-même un des jours suivants immédiats vers le même heure si possible. Pour Mercredi réponse inutile.

> *Veuillez agréer, Monsieur, mes salutations respectueuses*
> *E. Berman*

The St. Paul quarter was a run-down district in the heart of old Paris, a slum of ancient glory that had become dilapidated, with a frayed grandeur and poverty after Berman's own manner. Once noble, at one time the Paris ghetto, it was now too shabby and inconspicuous to attract even the bohemians. Rents were probably even cheaper than those of Montmartre, and the elegance inconspicuous but genuine. Here was a romantic and unsuspected facet of Paris. Joella came along with me. Berman had his studio on the second floor of a palace converted into small apartments, without *ascenseur* but with a broad curving marble staircase to climb. Berman's room was vast, the ceilings high, and there was a balcony on which he slept. The light was fine, cold, and painterly. What there might be of heating and plumbing I was not to know. Berman was polite, nervous, and apologetic. He had almost no paintings to

show. That year's work belonged to his dealer, Jacques Bonjean. But there were countless drawings. So many and so marvelous it was hard to make a selection. I bought a quantity, and one painting: "Intérieure Rouge," haunting and powerful. I keep it to enjoy and as a souvenir of our first meeting.

A mousy little man, Genia gave a timid, furtive impression, but this was because he was shy at first and blushed easily, a blush that suffused the top of his round balding head like one of his own sunsets.

After I bought the drawings there was little time for further amenities. His cousins were expected. They were his burden, he confided, as though we were already the intimate friends we were to become. These cousins were more or less dependent on him. A husband and wife, they had, in affluent days, been his patrons at the time of his most severe poverty, and now, and probably forever after, he was to be their provider. The husband had been a successful banker in Russia, and was now indigent. Genia seemed to be somewhat in love with the wife.

These facts about Berman, and many more, resembled a gloomy minor Russian novelette of the last century. There was nothing about Genia that seemed impressive; there was nothing about his painting that was not.

My first Berman show was assembled from these drawings together with paintings borrowed from Hitchcock, Brewer, and James Thrall Soby. One, very fine and unique, a large figure piece, I borrowed from the Boston Museum of Fine Arts, which had acquired it almost by accident. It was an experimental purchase made by a young curator, and other officials of the museum seemed rather unsure of it and were surprised and pleased when I asked to borrow it and the exhibition proved a notable success. Mine was not the first Neo-romantic show in New York. I remember there had been one prior to mine, almost unnoticed and soon forgotten. This was in a place called the Balzac Gallery, a basement off Park Avenue at 57th Street, and I had seen it. But it was presented in conjunction with a remarkable showing of early de Chiricos, melodramatic paintings that preceded his better-known metaphysical series. So breathtaking seemed the de Chiricos that I paid scant attention to the Tchelitchews, Bérards, and Bermans in another room.

110

That was also the occasion of my first meeting with that sinister and bewildering adventurer in the arts, Maurice Sachs, distracting enough in himself to hold the part of my attention that was not devoted to de Chirico. Sachs was a man so treacherous to his friends and enemies that it is generally believed he was exterminated by his own cellmates in a German concentration camp for his betrayals.

Although the drawings of Berman sold well during my show, the real clamor was for the paintings, which were not for sale. I wrote several times to Genia expressing the hope for more paintings for an exhibition the next year. I learned that his dealer, Bonjean, was on the verge of going out of business, and the opportunity was offered to me to take over Berman's contract. The arrangement common between French dealers and their artists was an advance of a certain sum annually in return for total output for that year. I proposed, and thought it more fair, to give a guarantee of a minimum sum in return for an option on first choice of a certain number of paintings at a price fixed in advance. The scale of prices was always based, curiously enough, on size, irrespective of quality. This was the custom in France. The size of French canvases was designated by number and shape. For example, *30 figure* measures 92 cm high by 73 cm wide; *40 figure*, 100 cm high by 81 cm wide; *40 paysage*, 100 cm wide by 73 cm high; *10 marine*, 55 cm wide by 33 cm high. *Figure* and *paysage* have nothing to do with subject matter, but with stock proportions of the canvas: *figure* tall and narrow, *paysage* wider compared to height, and *marine* the widest. The proposed contract with Berman was modest, the amounts seem small to me today when compared to all the subsequent rises in the art market, but for that time the total was most fair, and sufficient for a living in France.

It was very satisfactory at the time to Berman, who could retain some of his work as well. For me, with almost no capital for speculation, it was astronomical. I hardly dared! This quandary, my first opportunity to be a real dealer rather than just a showman, was relieved by my friends in the Askew coterie, with the additional support of Jim Soby, whom I got to know in the course of the Berman exhibition and through the good offices of Chick Austin. Together we formed a group that would underwrite a contract with Berman for at least one year, each agreeing

111

to buy one painting sight unseen. There was unlimited confidence, it would seem, in Berman's integrity, and also a wild scramble for fear some outsider might buy before we did. Agnes Rindge, Kirk Askew, Chick Austin, and Soby were the mainstays, each not only buying one but promising to sell another to a friend. Jim even offered to advance all the money, but this was not needed, as I could now foresee delivery of the paintings in short order. I bought two on my own speculation to offer Genia the guarantee of a minimum of eight sales for the coming year.

Subsequently, when the others dropped out, Jim Soby helped me to continue the annual arrangement, building for himself a really definitive Berman collection, over several years, until a firm market was established for Genia's work in this country and he came to New York to live in 1936. Soby continued rounding out his impressive collection through my gallery until he became a trustee of the Museum of Modern Art.

Jim was the least plausible looking millionaire I had ever met. In spite of Chick's prospectus, that Jim was young, enthusiastic, earnest, and seemingly helpful in Chick's increasing friction with his trustees, or perhaps because of Chick's hint that Soby was ambitious for power in the art world, I was surprised to encounter such an open-faced and ingratiating young man.

Eddie Warburg was one of the rare good friends who were also patrons of the gallery. He bought one of the early Berman paintings, a dark, compelling courtyard scene which he soon thought of returning. He tried every means of lighting, but it was such a dark picture, and so highly varnished that any illumination was reflected and distracting, rendering the image almost invisible. He was not the first who had found dark Bermans difficult to light. I discovered optimum lighting to be almost no light at all, which sounds absurd. But in my dining room one evening, lit only by the dining table candles, a Berman on the wall suddenly assumed its full beauty. I realized that under stronger light the pupils of one's eyes contracted, so the picture remained dark and obscure. With less light, pupils opened and the picture became mysteriously visible. It was, after all, a night scene.

Eddie was delightful, full of candor and enthusiasm. Early in his ven-

tures as an art patron he had first been encouraged and then severely disappointed by Lincoln Kirstein. He was neither the first nor the last to experience one or another form of this disillusionment. Eddie, together with Chick Austin, whom nothing could daunt, were involved early in the financing of the Balanchine Ballet project that was promoted and finally carried to success by Lincoln. Both Eddie and Chick became disillusioned along the way.

One could scarcely imagine Kirstein as a non-hero. How impetuous, shy, eager, knowledgeable, and yet seemingly humble, above all how handsome and overflowing with vitality, Lincoln was. Joella called him a "Jewish Lindbergh." Was there an envious core to be suspected in this apparent heir to all good fortune? Was his problem power? Or were these facets only exposed to me? Because all our meetings were somehow beset by misunderstanding. Perhaps it was the accidental friction of our particular characters, temperaments, but for me it presented a most painful puzzle.

The first misadventure occurred many years ago, when Lincoln was still an undergraduate and editing his admirable magazine, *Hound and Horn*, which managed to be far better than any other undergraduate review of its period. Coeditor with Lincoln was an old schoolmate of mine, Bernie Bandler, and it was to Bernie that I one day submitted an article, my first literary effort, for publication. It was not in expectation of friendship's favors that I chose Bernie—I did not think he could be influenced by friendship—but because I could hope for a courteous and helpful refusal if the piece had to be rejected. However, Bernie received my contribution with excessive enthusiasm, indeed with a letter almost embarrassing in its sumptuous array of compliments. My style was "terse and vigorous, comparable to that of Alexander Hamilton," he wrote. He said I might expect to see the piece in print in the spring number of *Hound and Horn*. I was overjoyed.

But not for long. Bernie had not only overplayed his enthusiasm but overrun his authority. Shortly afterward the manuscript was returned with a curt rejection from Kirstein and an abject, confused apology from Bernie which explained nothing. My disappointment can be imagined. Lincoln, however, was entitled to his opinion. My real resentment was

on Bernie's behalf. It seemed to me he had been ruthlessly put in a painful position that could well jeopardize our friendship. In fact, try as I might, I was never able to dissipate an awkward cloud of guilt on Bernie's part. Lincoln, I felt, could have had more tact. For myself, I reasoned that perhaps my manuscript deserved no better, and felt only the temporary disappointment of a rejected author.

I continued to admire Lincoln's brilliant career as he went from one adventure in the arts to another, always cutting a striking figure. In the early years of my gallery he loomed too, as someone of importance in the Museum of Modern Art, not directly, but because of his friendship with influential people at the museum and with Eddie Warburg and Nelson Rockefeller, the two younger trustees.

One day Lincoln came to me with an exciting project. He wanted to organize a competition for photomurals. The winning photographer would receive a large cash prize of several thousand dollars, to install a mural in Rockefeller Center. What was of real interest to me was that all projects would be exhibited by the Museum of Modern Art. This meant that photography would be given museum recognition on a large scale, and I enthusiastically recruited a group of photographers whose work I found interesting. I even advanced expenses to those who could not afford to do the work on their own gamble. Berenice Abbott was one of those. She and I did a joint maquette of a montage based on an idea of mine which she photographed. The expenses were about $300, then a goodly sum, for the enlarging paper, which was new and costly, and the mounting. Others had similar costs. Among those I had in mind to ask to contribute a mural was Steichen. I rushed over to his studio to present the project. To my chagrin, he pointed to a large photomural, a picture of the George Washington Bridge, that he had completed. He said Kirstein had asked him to do the work some time ago. Furthermore, he had been assured of the prize! I was too stunned to comprehend. To dispel any of my doubts he showed me the dimensions of the final location for the mural that had already been given to him. I felt deceived and was shocked, not to mention how the photographers involved felt. I still wonder how it could have happened.

As had Bernie years before, it was now my turn to apologize to the

various artists I had invited to compete, and hand them the rejection. The exhibition at the museum, however, did proceed as planned by Lincoln, and for consolation, not only did my photographers have good exposure, but the show was to give a considerable boost to the cause of photography as an art.

Eddie Warburg was seriously worried that "nobody cares about me, except for my money."

"Isn't it lucky, Eddie, that you have such a lot then, to be loved for?" I said, to joke him out of despondency, perhaps with the wrong remark. Eventually a famed New York psychoanalyst analyzed him out of his interest in patronizing the arts. Some psychoanalysts, like some modern architects, prefer you to live in a glass house, and perhaps paintings detract from the view.

I am very fond of a story Eddie told me. When quite young, he had returned from a trip to Europe one autumn, possibly his first excursion away from home alone. None of his family came to the boat to meet him, only the chauffeur in a big limousine. Crushed with disappointment, he was driven to the Warburg mansion on Fifth Avenue and stood, while the chauffeur unloaded his luggage on the sidewalk, looking mournfully at that formidable pile of gray granite. "Never mind, Master Eddie," said the chauffeur. "Remember, be it ever so humble. . . .

At the end of my first season Alexander Calder appeared. The *gros bon* Sandy with Medusa (as I heard him call the lovely Louisa), and their dog Feathers, were now living in New York. I remember "Feathers," the wire portrait of his dog. He had mechanized sculptures to show, and a few that were fixed and motionless. I had seen some in Paris when Sandy had his studio in the Villa Seurat near Campigli's. So had Marcel Duchamp, who called them "mobiles." These ideas were developed along with toys he had been making and selling to department stores. Sandy's art had become a new, machine-driven form of abstract sculpture. The pieces moved either by clockwork or a small electric motor. The toys had been simpler and more ingenious, based on the eccentric motion of oval wheels or a bent axle moving when propelled or drawn across the floor by a child—waddling ducks, head-and-tail-

wagging dogs. I told Sandy I felt strongly that similar simplicity controlling the movement would be more pure and interesting art than the elaborate patterns made by motors. Although complicated, the machinery repeated patterns mechanically and eventually became, it seemed to me, predictable and monotonous. The question remained, what other propellant? I suggested letting them drift and turn without motors. Eventually Sandy developed his unique use of delicate balance, motions of infinite variety, moved by a breeze or fingertip touch.

I had first met Sandy when I was serving an apprenticeship in the Weyhe Bookstore and Gallery in 1929. He came to discuss with Carl Zigrosser, my boss, an exhibition of his wire portraits, free-standing small works of bent wire at which he was very adept, having taught himself to do complicated outlines using one unbroken flowing line. He later reminded me of a story I told at our meeting. It seems a carpenter had been doing some repair work in the bookstore and had accidentally cut off a segment of his thumb. The doctor told him that the piece could be grafted back on while the cut was still fresh, but the piece of thumb could not be found. Some weeks later, however, the day Sandy was there, I thought I had found it, while looking for a book for Abby Rockefeller. To avoid upsetting an important client when the morsel fell out of a bookshelf, I had hidden it hastily behind another book, and it was never seen again. Sandy says he did not quite believe the story, but found it memorable.

Now, at my new gallery, Sandy wanted a show. I was not enthusiastic. As I have said, the repetitive, mechanical quality of these first mobiles dismayed me. I was about to leave for Europe. It was spring and time to assemble my exhibitions for the following season. So it is to Joella that credit may be given for my staging Sandy's first New York show of mobiles. She adored Sandy and everything he did, and made all arrangements while I was away. The exhibition received an enthusiastic review by Henry McBride, who urged his readers to see this "first New York showing of Calder mobiles at the Julien Levy Gallery in New York." Shortly before I sailed there had been a party in my gallery for Sandy's "Circus." Edla Frankau, a longtime friend of mine, and her mother, Aline Berstein, came. Aline brought Thomas Wolfe and shortly

116

thereafter the "Circus" was shown again, in her own home. Wolfe immortalized the circus in a segment of his novel *The Web and the Rock:* the chapter on "Piggy Nolan's Circus."

I lost Sandy as a potential member of the gallery group in spite of Joella's warm efforts. To my disgust, his electric motors blew fuses in the gallery, and worse, holes had to be dug in the pristine walls for new outlets. I was furious, and no doubt, unduly sarcastic, and when the time came for another show, to present the new and beautifully balanced mobiles for which he became famous, he turned to another dealer, Pierre Matisse.

Pierre opened his gallery in the Fuller Building two years after mine. I had known him through his wife, Alexina Sattler. "Teeny," who came from Cincinnati, Ohio, had been a girlhood friend of Joella's, whom she met when she went to France. She stayed with us in our little New York apartment on East 51st Street for several weekends when we were first married. She was madly in love with Pierre, and Joella and I were tolerant chaperones. I remember her excitement over a date she had with him, to go to a fancy-dress party in Brooklyn. Joella and I amused ourselves improvising her costume, Joella sewing patches on her dress of curly metallic dishpan cleaners and I devising a wig with some copper springs from the corner hardware store. The inch-wide copper springs made a heavy wig with snappy curls, and I speculated what the proper Brooklyn accent would be: coils or curls? She came home intoxicated and engaged.

Pierre's gallery and mine carried on a friendly rivalry. Our lines never really crossed. He came on the scene with a good stock of his father's paintings and was able to deal in the more established figures of the period, men like Picasso and Miro. This I could only envy from a distance. I lost surprisingly few younger men to Pierre after Calder. One was Yves Tanguy, whose escape from Paris during the war Pierre aided. Later a few moved from me and went to Pierre when I found myself becoming too crowded to do them justice. Rufino Tamayo for example, and Alberto Giacometti.

I both loved and fought shy of Sandy because of his elephantine quality. There are two distinct breeds of artists—the *costaud* and the high-

strung. Sandy was the former, in such good company as Picasso, Leger, Derain, de Chirico—all with full, rugged peasant faces, large strong hands, indefatigable force. If I were an artist I would class myself with the high-strung I suppose; the wiry, thin, and often intellectually arrogant such as Duchamp, Dali, Balthus, Delvaux, Cocteau, Tchelitchew. Such a divisive typing is a dangerous generality, meaning no more than fat and thin, extrovert and introvert. (Yes, I consider Dali an introvert.) But to generalize even more dangerously I have noticed how often the former are inclined to be expansive and communal and the latter aloof and princely in their secret social attitudes.

Sandy had no overt politics or prejudices that I know of, if not those of Jeffersonian democracy. He always reminded me of a big, dancing Teutonic bear with his rib-crushing hug and steamroller dancing. It was a miracle to watch this great fellow with his large hands gracefully and delicately manipulate the tiny little wire figurines of his circus.

It was the end of our first season when I left Joella installing the Calder show and sailed for Europe to arrange for future exhibitions. Going to Paris was becoming for me the wrestling match between Hercules and Antaeus, I being Antaeus and Paris the ground on which I was thrown to rise again, replenished tenfold. In addition to tending to business, I filled my spiritual and intellectual luggage with all manner of things to bring back to America, with certain frivolities and sensualities, too, spices that my puritan American family had omitted and that my sophisticated European wife made clear she understood.

I was to stay with Mina Loy, my delightful mother-in-law, in her Paris apartment, across the court from her friend, the writer Djuna Barnes, near enough and yet far enough from the artists' quarter of Montparnasse and the Saint-Germain district. Mina's household, always in a state of delicate equilibrium between threadbare poetic freedom and aristocratic elegance, would be a perfect location for my own balancing act between America and Europe, the new world and the old.

I remember the first time I met her. She was systematically disorganizing her lampshade factory workroom, while across Paris, Joella was

trying to maintain serenity in their lampshade and bric-à-brac shop just off the Champs-Elysées, where an important client was about to place an all-important order. This madcap and ridiculous enterprise was, as I have said, something Peggy Guggenheim had set up and financed for Mina. She harbored the generous but ill-judged notion that from such a business Mina could derive nourishment and be free to write her poetry. True, Mina designed the lampshades and other objects with taste and delicious originality, and Joella made a winsome salesgirl by day, acting as forewoman in the factory during off-hours. But the practical administration was fast avalanching into a nightmare. Leaving the shop where the rich customer had placed a large order, rushing across Paris to the workroom which reverberated with the sound of discord and where the three noisy workgirls were threatening to walk out, Joella found Mina distracted, placating the vociferous production line and changing, at the same time, a pattern for the shades. Joella rested for a moment against the doorway, a finger pressed to her temple—a little perspiration beading her bow-shaped upper lip, a tear squeezed back in her blue eyes, breathing a short prayer for succor. It was from scenes like this that I had taken Joella's hand and led her into marriage with me.

With Joella gone, the business all but collapsed, and hearing of her distress, my father helped Mina to independence by repaying to Peggy the investment she had made. Mina was a vitally creative person but she was neither endowed for, nor productive in, repetition and routine. Peggy, I am sure, would have recognized this if Mina had complained, and would freely have released her from any obligation. Mina, however, was proud and had become a slave to a business which Peggy would happily have forgotten long ago, but continued to support from loyalty. With my father's gift, which Mina could accept since "Edgar (my father) was in the family," Mina finally found herself comfortable and unworried. And she was able not only to find time for writing but for her painting too, she let me know.

Mina's book, though only partially finished, was already some five hundred pages long and one of the most remarkable manuscripts I have had the opportunity to read. Before it was ready for the world, while

119

still unborn so to speak, I begged without success to be allowed to send the uncompleted first draft to a publisher. Her paintings also proved to be a delight, and these she agreed to let me show in my gallery.

Her apartment was by Loy out of the Marché aux Puces, the famous flea market where one could then buy fabulous odds and ends with only a few sous. Designed with many *pensées* but very few pence, expressing Mina's imagination, the flat became for me a fairyland dream. Rooms were divided by wirework or wickerwork cages in which birds flew or hopped about. Doors were always glass, the panes covered with translucent material so that there was privacy but also light. Indoor plants were living everywhere. Whatever patching of crumbling walls, or decorative coloring there might be was mostly done with scraps of metallic paper—wrappings from countless bonbons pasted together in floral collages. And colored cellophane everywhere. To one brought up in a land still redolent of Grand Rapids, leavened with heirlooms, this abundance of subtle, casual visual experience was a banquet for which I had been starved. More than this, it was an encounter with beauty that had no practical, moral, or prestige implications whatsoever.

Before arriving at Mina's apartment I had another adventure. In the Gare Saint-Lazare the night my boat-train drew into Paris, I was reminded by posters of the Cirque d'Hiver. Thinking it must be near the last, if not the last, performance of the season, I checked my luggage, and wasting no time, taxied straight to the theater. It was already late, perhaps ten o'clock. I would not have been surprised to find the box office closed, but was disconcerted to hear that the show was on but admission was private. Dejected, I explained to all who would listen that I had come straight from America just to see the Cirque d'Hiver; just for this one night, allow me, *s'il vous plaît,* just to peek for a minute. Suddenly there appeared a man in authority. "But come in. *Entrez Monsieur l'Américain, entrez Monsieur le Dévot. Suivez-moi. . . .*" And I was led to a seat in a loge. I was served champagne. Everyone was drinking champagne. I was presented to beautiful women, beautifully gowned, their escorts in full dress, and soon I was to watch a breathtaking aerial act. After some pretty clowning, the Fratellinis gave away a bride! Across the highwire danced the bride and groom toward a preach-

er at the far platform. It was a real wedding, I was told, of the Fratellini daughter to another member of the troupe, the aerialist. When the rings were exchanged all the lights went low except for blue spots that played on revolving balls lowered from the roof and studded with tiny mirrors. Reflected, luminous spots danced on the arena and audience alike, a snowstorm of magical flakes.

It was Fernand Léger who had told me not to miss the circus. A fan of all seven lively arts, he was for me the French counterpart of Gilbert Seldes, who had led me to enjoy Herriman and his Krazy Kat comic strip. (Herriman's device of a background unrolling and shifting while the characters stood still might well be used again in experimental cinema.) Léger was especially addicted to the circus, in France so small and perfect. In contrast, our monumental three-ring shows, so big they frightened me when I was a child, lost much. And those subtle mimes, Grock and the Fratellinis, should never be called clowns, for like Chaplin, they were far beyond being funny.

At the end of the wedding, dozens of white doves were released to fly through the glitter. And the music! It was all an orchestra of glass harmonicas (water glasses), and musical saws. It swelled, somehow more angelic than any choir or chorus of harps, evoking a strange, crystal, gloriously vibrant sound, as a white horse and a dappled gray trotted in to kneel and receive the bride and groom, then gallop away.

My ship had come in, in time for the Cirque d'Hiver. *Monsieur l'Américain est content.* I was sorry that I had told Mina not to meet me at the boat-train. How she would have loved the circus wedding.

The morning after my arrival the photographer Lee Miller appeared. Suddenly there she was, walking just ahead of me down the Boulevard Raspail in a bold, bright aura. In every way Lee seemed bright. Her spirit was bright, her mind, her photographic art, and her shining blond hair. She had the right kind of hair, springy and not wiry, fine but not straight or lifeless. She was the kind of blonde about whom one didn't sing *"pourquoi les femmes blondes . . . ?"* But instead one would hope to sing *"Auprès de ma blonde. . . ."*

I had met Lee briefly the year before with Man Ray, with whom she had, initially, studied photography. Now, as everyone seemed to know,

Lee had left Man, who was half-dead with sorrow and jealousy. Man had gone on a liquid diet, and if he was not drinking Perrier water, then he consumed quantities of orange juice. Though purified, he was unhappy, and it was reported dangerous for anyone to be seen those days with Lee. She was engaged to a rich Egyptian, Eloui Bey, who was out of town. But Man had a revolver and, in default of the Egyptian, was threatening any other rivals who might materialize. Nevertheless, I waved to Lee and caught up with her and made a date for that evening at the Jockey. Sparkling and magnetic, a noted beauty and leading lady in Jean Cocteau's *Blood of a Poet*, she knew her way around all the amusing Paris circles. It promised to be a most pleasant evening if I could charm her. And so it proved. That summer we had many adventures together. Lee introduced me to the salons of what was then *tout Paris,* showed no hesitation when I led her into some of the toughest night dives. "Sweet and Lovely" was the song hit for the season.

That first evening, dancing at the Jockey, she informed me that the extraordinary collection of photographs that the illustrator André Dignemont had been amassing for years might be for sale. We agreed to meet the next day and go to see his collection together.

When Lee and I came into Dignemont's apartment we encountered an uproar that sounded like the Fratellini wedding march gone mad. This rather thrilling but confusing cacophony was directed at us from a pyramid of music boxes piled from floor to ceiling in the middle of the living room, a collection topped by a mechanical nightingale. All of these tinkling machines had been wound and set to go off simultaneously as our host's greeting to his guests. Played singly, we were to discover, each had its distinctive little melody and charm.

His collection of early photographs was equally enchanting and distinctive. They filled shelves of handsome old family albums and overflowed into drawers and cabinets. There were Atgets of course, and Paul Nadars, but also fine work by less well known men, many anonymous masterpieces. And others, some quaint, some naïve, and some humorous. And an extraordinary number of pornographic photographs, chosen with great taste and discrimination. One album I particularly admired; Dignemont told me it had been assembled by the poet Pierre

Louÿs, mostly Italian erotica he had collected on a voyage to Naples. Dignemont had thought perhaps to sell his entire collection, but found he could not bring himself to this rupture. He set aside duplicates, making a rounded collection in itself, and these I bought to serve as background material for the modern photos I planned to present in my gallery. He pressed me also to accept as a gift the Pierre Louÿs album I had admired, and gave me a book, *Trois Filles de Leur Mère,* signed "P. L.," a rare volume of erotica that Dignemont said was written by Pierre Louÿs. Did he know Louÿs personally? I did not think to ask, but he gave that impression. *Trois Filles* was not poetic but was most certainly literate. The author possessed the largest vocabulary of erotic words I had ever encountered, all French, but including various *argots* and incredible improvisations. I was wistfully to recall this variegated vocabulary during my monotonous days of basic training in the U. S. Army, where I encountered all the profusely used and uselessly limited four-lettered Anglo-Saxon expletives. There was some more tinkling of music and drinks of absinthe, and I had to borrow three suitcases to pack my loot back in a taxi to Mina's apartment.

JAMES JOYCE

I often lunched at the Trianon, Joyce's favorite restaurant, because of its authentic regional dishes. Each day the complete menu was devoted to a different province of France. I was occasionally invited to join Joyce at his table for coffee and a half bottle of his invariable wine, *champagne nature.* He once complimented me on "a most beautiful speaking voice." This, from the man with the ear most attuned to the nuances of many tongues and himself possessor of a tenor voice like an Irish angel's, was praise indeed. I have coddled my voice in my chest, reigned in, ever since, only occasionally daring to risk it full range in the open again. Undoubtedly there are other gifts I have allowed to die of the hoarding.

One day he asked me if I would do him a favor when I returned to the States. Would I look up the history of a town named Dublin, U. S. A.? He had been told there was such a one. Was it, by chance on a river? (The Liffey?) With the help of the architect Fritz Kiesler's wife, Steffi, who was a librarian in the inner research sanctums of the New York Public Library, I discovered that there were not just one but three American Dublins. The most amusing anecdote concerned one named for the custom of bundling. In that town at the time of its founding (in fact the purpose of its founding was to provide for legal bundling when that custom began to be outlawed) bundling was called "doubling in." Thus there came about the town of Doubling-in, or Dublin as it came to be called.

I learned from mutual friends, Sylvia Beach corroborating, that far from being grateful Joyce was highly incensed by the information. Not all of the Dublins in America were named in full tribute to Dublin, Ireland! One imposter had doubled in under false colors.

124

When he was told that I was disappointed not to have received some acknowledgment from him for my pains, he is reported to have said, "Levy seems to be an autograph collector, to expect a letter from me."

That first week I stopped in at Jeanne Bucher's gallery to report on Campigli's New York success and thank her for having helped assemble and ship his pictures to me. I always found her back office a center of information, and hoped to discover what painters were in town and where I might reach them. I had tried to telephone Campigli but without success. Jeanne told me he was out of town but was expected back that evening. In fact his phone answered now and, delighted with my news, he wanted me to join them that night for a celebration dinner and dancing. I asked if I could bring Lee along, and we arranged to meet at the Café Flore.

I called Max Ernst, but we decided on my going with him and his wife, Marie-Berthe, to Caresse Crosby's *moulin* in the country that coming Sunday.

Eugène Berman proved still to be in Italy, in Padua, where he had been painting all winter. Jeanne suggested that I visit Jacques Bonjean, Berman's dealer, who might have some of the new canvases. Since it was rumored that Bonjean was going out of business, she urged that I try to see him in all haste. Speaking of going out of business, she was reminded of Pierre Levy whose magazine, *Bifur*, was faltering. He had some manuscripts for sale, among them the original collages for Max Ernst's *Rêve d'une petite jeune fille qui voulut entrer au Carmel.* He had offered it to Jeanne along with *La Femme 100 Têtes (The Woman sans Têtes,* or, *Hundred-Headed Woman).* Perhaps she would buy one and I the other. An appointment was thereupon arranged with Pierre Levy. My first week in Paris was filling rapidly with exciting engagements and opportunities. *Ça c'est Paris,* or so it was that day.

The soirée with Campigli was joyful, and, for me, an adventure. His wife was a good dancer and there was also a friend of theirs, an enormous but beautiful Swedish girl who was as light on her feet and as graceful as occasionally such fat ladies, if they have fine ankles, surpris-

ingly are, and she was as handsome as painters' chosen companions are apt to be. Brought along for me, I supposed. Artists are often good procurers, finding and sharing women, food, wine; and usually they are good company with high standards for all the sensual things of life. I noticed Massimo's face brighten with approval when he met Lee, who was waiting at the Flore, and he commented that although there were now three women to two men it was *"pas de tout de trop,"* not at all too many. I am tempted to list our itinerary of that evening, as it was typical of many such nights on the town in the Paris that all artists and very few tourists then knew. We finished our aperitifs at the Flore, not cocktails, but *Cinzano à l'eau* for all except Lee who ordered, oddly enough, a *menthe verte.* Then we walked to one of those special bistros where, if you were a habitué, you dined as well, if not as ceremoniously, as at the costliest restaurant, but almost literally for a song. I remember one Man Ray first took me to on the Avenue du Maine where an enormous board of diverse cheeses was the specialty. The *proprietaire* was a cheese collector, offered varieties in all stages from ripeness to decay, from every corner of France, served first, like hors d'oeuvres in other restaurants, all you could eat for five francs. This fromage heaven was frequented mostly by carpenters and gravestone sculptors. Two of the earliest participants in the Surrealist experiment, Robert Desnos, the poet, who was an easy subject for Surrealist automatic trances, and André Masson, a painter with a similar automatism, which allowed him to develop free association with a wild and aimless line, often dined there, and Breton too when he came to the Left Bank.

The dancing? No matter how satisfactory any one bistro might prove, one never stopped there. We went from the Jockey (decor by Hilaire) to the Boeuf sur le Toit, decor by Cocteau and others, ending in the early morning hours far up in Montmartre at Zelli's.

Zelli's calls to mind a story of the succubus as told to me by Mina Loy. This phantom of evil was sent by Aleister Crowley, the cult leader whose philosophy involved black magic. It was intended to injure a reluctant lady friend staying in the same hotel. The succubus, misguided, was lost in Mina's chamber, which was next to that of the threatened friend. According to Mina, she contended with it all night, using pray-

126

ers and Christian Science until the poor thing, wilted in defeat, faded away with the dawn. The tale strikes a glimmering echo of some of those chords of Satanism I used to feel vibrate about me mysteriously; sometimes in years gone by with frightening fortissimo, now not even faintly humming.

There was a fascination in that silly lump of self-importance Crowley, who claimed to be Baphomet, the Beast of the Apocalypse, and I remember the half-frightened, half-scornful attention I paid when I first met him in poor, doomed Pascin's studio. Wasn't Crowley rumored, along with Gurdjieff, to have been indirectly involved in some scandal of the deaths of several notables, including Katherine Mansfield? Was it not whispered that a train of disasters and suicides were contingent upon their influence? I myself was made merely ill by my own dissipation one night at Zelli's when the expatriate painter Bob Chanler challenged Crowley to hypnotize him—the winner to pay for drinks and girls on the house. All that night, all the next day, and into the next night the two overage schoolboys sat facing each other across a small marble-topped table in Zelli's bar, staring each other down. Bob McAlmon and I stayed to watch, and to drink, hoping to participate, of course, in the payoff party which never materialized. The contest was called a draw when both fell over flat from champagne.

Very early Sunday morning Max Ernst drove by for me. I was waiting, as arranged, on the corner which joined my street and the boulevard Raspail. Stepping out of his car, my eyes confused a moment by the sun just rising at the street's end, he seemed an *Urgott:* primitive, magnificent, dismounting from some sparkling chariot. Then it was again Max and his muddy old Peugeot. The wind that had blown his white hair (it had always been white, since I'd known him) into an aureole, laid it back flat again.

It is monstrous to confuse men with spirits, but sometimes, sharing this bad habit with poets and mystics, just as I enjoy telling Tarot cards, I am so compelled. With all our jargon of scientific and sociological images, where now are the old women who could say, "I see him with a blue aura about him"? These eccentrics disappeared for a time, and we were the poorer. Perhaps they will return again—a young friend of ours

127

named Blake claims to have aura-full visions. For me some men still seem to offer an archetypal creature in an all but visual aura. Dali, a black panther or, at rare moments, a rat; Tchelitchew and Chick Austin, two elegant and tragic clowns, one faded blue and the other Watteau's "Gilles," chalky white; Arshile Gorky, the Black Monk; Arthur Cravan, a praying mantis. Dali, in his memoirs, speaks of me as a black eagle.

Max, it is well known, thought of himself as a bird. "Loplop, Supérieur des Oiseaux." I saw a creature more Gothic—but feathered, yes.

"Ganz gut," said Max, taking my valise. And "bonjour" chirped Marie-Berthe as she made room for me beside her.

Ernst and his wife and I enjoyed the drive to Caresse Crosby's little *moulin,* a restored mill house, in the Forêt de Ermenonville some eighty kilometers outside of Paris. It promised to be a happy weekend.

The *moulin* was a comfortable compound on the estate of the family of her friend Armand, Comte de la Rochefoucauld. It was lent indefinitely to Caresse in exchange for the remodeling she accomplished on what had been an abandoned ruin. Many years later, in the early seventies, I again encountered Armand and we had a pleasant dinner together with mutual friends, Peter and Ninette Lyon. He and I reminisced about the old mill, while admiring Brigitte Bardot at the next table. Armand had a fascinating wife, young daughters, had retained his easygoing charm and good looks through all the years. Within that month his older brother died, he became le Duc de la Rochefoucauld, and our paths have not crossed again.

I had met Caresse casually in New York. She came with the Kenneth Simpsons to a party we gave one evening in New York but left early to meet her husband, Harry, at the boat—they were sailing for Europe at midnight. The next day we, and all the world, read the pathetic Sunday supplement story of how Harry Crosby had shot himself. Harry and Caresse had made themselves a myth among the expatriates of the twenties—the mystical, inseparable prince and his princess of the Black Sun. In some ways they were figures from a Scott Fitzgerald story: the well-to-do, well-born, and handsome young man and the not so equally well-to-do, but well-born and pretty young woman. They were not rich

enough to be overpowering, but enough so to be spendthrift and generous. Harry was a dancer, not a professional, but he danced his way through life. Caresse claimed to have invented the brassiere and, in a way, begun liberating women, insofar as the brassiere was more liberal than the heavy corsetry which it replaced.

Then Harry was found dead, in bed with a girl in the Hôtel des Artistes on Central Park West. A suicide pact, it was called, and their remains were spread all over the tabloids. I had not seen Caresse since. I remembered her as a heady mixture of champagne bubbles and *poésie*, with a body solid, almost plump.

I turned to Marie-Berthe and told her I had brought my movie camera and hoped to make a short film of her and Max. She cooed like a dove, clapping her hands, "Max!" She begged him to stop. I feared we would be late, and we had been off to such an early start. But Max simply commented that the light was good. We drew up beside the crumbling arched wall of some long-gone factory or priory; perhaps it was older, a Roman aquaduct? Whatever it had been it was now most apt.

Max assumed extraordinarily photogenic aspects the moment the camera was trained on him. He composed himself perfectly in every imaginary frame, and projected an unerring image of a Max Ernst possessed. I have only seen one other individual able to be so galvanized into playing himself, and that was Dali. Dali always created his own self-portrait and could never be directed or interpreted by the cameraman into any direction other than his own. Seemingly unaware of the most candid camera, they both, Ernst and Dali, fell into their pose as instantly as the shutter could snap.

Effortlessly Max acted and I improvised a scenario in accord with the limited possibilities of my camera. Marie-Berthe was less histrionic, but pretty as a pink postcard, the flowery European valentine, with her close curls like a helmet of snails. She posed; stiff, doll-like, appearing and disappearing in ruined archways, on tree trunks, behind a fence post, pursued by Max and by her animated glove and scarf, until she disappeared for the last time and there was only the glove and scarf for Max to capture.

129

This cinema divertimento consumed only about fifty feet of film and no more than fifty minutes of our time. When we later told Caresse about it, she insisted on continuing the play and taking part in it herself. We were scarcely installed in our guestrooms when Caresse was rummaging her closet for a costume, deciding finally on safari boots and white riding pants and insisting she be given an opportunity to fire both barrels of her shotgun. This was all as it should be, of course, in a Surrealist scenario, which now continued in a fugue of complete free-association, each participant contributing his secret whim in defiance of all continuity. The stage was set in the swimming pool which, this early in the spring, was empty of water. Max's scenario began here. He was a hunter stalking an invisible object. He raised a gun to shoot. At the same time Caresse appeared on a balcony overlooking the swimming pool, raising her gun and shooting Max. Ernst was "wounded." The glove and the scarf materialized in a concrete corner near the drain, and the plot, if plot it was, proceeded. Stains of blood appeared to drench a bodiless chemise which floated down from nowhere. Max gently picked it up and, carrying it to the hood of his car, hung it over the radiator cap. (He told me that later, driving back to Paris, the ghost of the chemise flapped wildly in front of the windshield). As more guests arrived they sat at the edge of the pool, watched and tasted champagne.

The ghosts of many self-willed dead were in the Mill Tower. Harry Crosby, René Crevel, Jaques Rigaud, Hart Crane.

For a year or two there had been a cult in Paris in favor of suicide as a Surrealist act. For the politically minded it was anarchy, the final desperate act of freedom: the right to take one's own life. For the Surrealists, it was another experimental entrance into the unknown world of the subconscious and the womb. René Crevel was a Surrealist poet and a victim of this trust in the irrational. Jaques Rigaud was a political writer and an elegant experimentalist with the concept of anarchy. Both had visited the tower at one time or another, and so had Hart Crane, the American poet lost overboard on a voyage back from Cuba, presumably a suicide. And there had been, of course, Harry Crosby himself. During the filming Max had thrown the bloodstained chemise from the top of the tower. A symbolic suicide?

That evening I was given a box of paints and a brush to paint my name among the signatures of more glamorous guests on the wall at the foot of the chestnut stairs. Chatting with Caresse, she surprised me by asking if she could publish my book. "What book?" I wondered. "Why the book you will write, of course," she said. So, I did. And she did. *Surrealism* by Julien Levy—published by the Black Sun Press in 1936.

On Sunday there was a village fair. The Dalis came out for luncheon in the garden. Heaps of lobsters were eaten from the shells with our fingers. With the Dalis was André Breton, the prophet of Surrealism. Breton stepping like a pouter pigeon, speaking to no one, disappeared to fish all afternoon up the millstream in the green woods, camouflaged in his soft green fishing hat and green glasses. There was also the amiable young Armand de la Rochefoucauld, dropping in from the château near-by. Peter and Gretchen Powell arrived with their latest protégé, a baby-faced photographer damp with shyness and fussily mothered by Gretchen. I was urged to interest myself in his unusual photography and we made an appointment to meet the following week in Paris. His name was Henri Cartier-Bresson. The exotic-looking wife of Saint-Exupéry sat nibbling lobster with me. This collection of attractive women and talented men brought to mind, in the luxurious rustic setting of the *moulin,* such a gathering as Marie Antoinette might have assembled at her milkmaid cottage. So, too, the intricate feuding and flirting everywhere sparking up and sputtering out.

These diverse companies were all mobilized into concern, like an intermission audience at curtain call, by the appearance of a gigantic stranger, a blond Apollo, whose boasting voice disrupted everything, even Breton's fishing. "This is Bert Young," proclaimed Caresse. Nobody seemed to know who he was or where he came from, but it was immediately apparent that he belonged to Caresse, that he was prodigiously drunk, and that Caresse belonged to him, was to be drowned in him, infatuated in a most self-destructive way.

"I don't like him." Max conveyed this to me vehemently. "There will be a fight. I am driving Marie-Berthe home." But I stayed. I wanted to see the village fair and would take a late train back to Paris. This

131

fête was set up outside the village in the forest, a short walk from us through the woods.

The great forests surrounding Paris, Fontainebleau, Rambouillet, and Ermenonville, are manicured, like the great lawns of England, by centuries of *dressage*. The resemblance they bear to the American woods is that of the Cirque d'Hiver to Barnum's, a cut gem to a boulder. The enormous trees, their gnarled toes scuffing the black mulch, stood in cathedral rows, and the ground, free of brush, was carpeted with deep moss. A purple sky hung over the treetops, holding in its net luminous pinpricks of stars, lit for this *fête foraine,* this traveling fair, with fireworks and torches. They illuminated the amusement booths and the carousel—its calliope invading a haunt where the ghosts of hunting horns wound in the shadows. The hounds and the deer were banished to a distance from which their eyes glowed red among orange fireflies. There was a moon whose shadow dappled us all like confetti. The villagers wore traditional costume and, as our party watched the scene and them, they gazed right back at us, finding us as picturesque as we saw them. It was all great theater, produced not by a set designer but by the years.

Led by a bellowing Bert, with two of Caresse's giggling serving girls, one under each arm, our band of international revelers invaded the *foire.*

On a night like this, even in the Third Republic, the air was filled with absurd, vestigial feudalism, an *opérette*—fantasy shared and enjoyed. We were cast in the part of blooded blades. The villagers soon joined in our fun and we enthusiastically responded. We carried gold, pounds, and dollars, and in our intoxication we bought a quantity of nonsense.

The moment came when Peter Powell and I hoped to defrock Bert, to puncture his braggadocio, outpoint this swaggering hero, at the shooting gallery. We wanted to call his bluff. At dinner he had told outrageous, incredible stories of his prowess on safari in Africa, in badman feuds in Dakota. We were not to be taken in.

"Have a shot on us," said Peter, who had just won a magnum of champagne. He presented Bert with the bottle and unchained the rifle from its hook. "We've bought a dozen rounds. Forget your elephants and just pop off one little *demi-bouteille* for Caresse." Peter had already

spent twenty bullets at five francs each for his magnum, which could only be won by breaking not the clay pipe, but the thread by which it hung.

Bert sat his girls down on the counter. He casually brought down one pipe. Then a dozen more. He shot between the fingers of the girls, from under their armpits, from between their legs. The proprietor of the booth was in tears. All the champagne was gone when Bert proposed "double or quits." *"Non!"* shrieked the loser in agony. "For love, then," said Bert. And after emptying another *coupe* and kissing Caresse, he borrowed her pocket mirror. With his back turned and sighting from the mirror, he fired over his shoulder. It was another hit.

"He was fabulous," I told Max later when we met again. "Now all his other stories must, I suppose, be believed. Caresse is but *perdue,* quite lost."

Max suggested that the proprietor might have been bribed, the champagne paid up in advance, the strings not shot away but cut. He explored all this hopefully, but without conviction.

None of us was much surprised when Caresse became Mrs. Bert Young.

Dali and Gala returned to Paris the following day, on the train with Consuela de Saint-Exupéry and me. Dali had been rather distant while Max and I had our fun with the little movie we made in Caresse's pool. Now he told me about the *mais mon ami, phénoménale-terrrrifiant"* film he had made for the Comte de Noailles. "With the help of Buñuel," Gala added, trying in vain to be fair. Max Ernst had played a little role. "But he forgets easily where Dali is concerned," said Gala. I wanted to know where and how it might be seen. But it had been forbidden by the police. "Oh, for many reasons." Gala said I might be able to see it sometime clandestinely—she would let me know. *"Un succès de scandale,"* said Dali, happily. *L'Age d'or.*

Consuela later told me that Noailles had been suspended from membership in the Jockey Club because of the film. Diabolically, Dali had asked that a garden party at the Noailles' be photographed and included in the film. A musicale was arranged, a little quartet playing compositions by some of the more fashionable young composers—George Au-

ric, Darius Milhaud—and Paris society had been invited. They were cinematized, applauding politely, in all their summer finery, a pretty little *divertissement* by Poulenc. But when the film was projected they were no longer applauding the quartet. Their lorgnettes and politeness were focused on a brutal scene of erotic violence and ecstasy slyly inserted by Dali in the cutting room. No law for libel existed to meet such effrontery. Taken into context, so to speak. A scandal indeed.

At her invitation I had dinner that evening in Consuela's apartment near the Étoile. *"C'est toujours drôle chez Caresse,"* she said as we reviewed the weekend.

"Drôle," I echoed, but to me it had been a weekend of such concentrated glamour as could only befall a hero-worshiping young American arrived of age in that period between the "Lost Generation" that had begun it all, and the one to follow, for which there would only remain enchanted stories, plus the reckoning: the emptied bottles and the raging hangovers.

Consuela was working on a book. I wanted above all else to meet her star-clad husband. And one noon, during a brief stopover in Paris, Saint-Exupéry asked me to lunch with him. He chose a little café high nearby the Sacre-Coeur, Place du Tertre. Even on land, I told him, he was happier on the highest hill. He had, more clearly than any man I have seen, what Mina Loy calls "aviator's eyes." Mina saw them young in Jarvan, my career-flyer son, when he was an infant.

"Am I afraid of *en bas* (down there)?" wondered Saint-Exupéry that day.

Dealing with A.E.A.

A. Everett Austin, known to us all as Chick Austin, was at the time I opened my gallery in 1931 the director of the Wadsworth Athenaeum. I think of him as I first saw him when I was seventeen, at Harvard. I remember him vividly: all in white, with white spattered on his hair and on his face, with an ambiguous smile, almost melancholy, as he faced his students. This was the origin of my vision of A. Everett Austin as the clown "Gilles," painted by Watteau. He was teaching us how to slake lime for fresco painting, in a freshman class I was taking at Harvard: Professor Arthur Pope's "The Historical Techniques of Painting." As he shoveled the plaster into the water, he was covered with powder and dripping with perspiration. Chick was doing postgraduate work as an assistant to Professor Edward Forbes, and we soon became fast friends. His taste was impeccable, his knowledge impressive, and his personality irrepressible. We stayed close friends until his untimely death in 1956. Then in 1957, with his other friends, I was asked to write a tribute, to be published as a memorial in book form by the Wadsworth Athenaeum. A large portion of the following consists of quotes from that book.

Could we but furnish, in memory of A. E. Austin, the Museum of his Ideal, such a museum would be more than a perfect house for perfect paintings. It would indeed be a realization of Poetry. Not even the Louvre with all the wealth of the Empire, power of the Grand Army, and the unbound ambition of Napoleon, could provide the illuminating touch of poetic insight that Austin projected magnificently, casually, tenderly, tirelessly. A bit in realization, much in suggestion, Austin proved himself a great museum director, fulfilling most abundantly the functions of an inspiring educator, elegant collector, courageous in-

135

novator, energetic catalyst, and innate showman (the distinguished procession not only of exhibitions but of theater, concerts, lectures, and festivals).

To embellish the city, enoble the patron, educate the citizen, encourage the arts, these were a few of the sanguine young dreams we shared at the time I returned from a buying tour in Europe and opened the gallery in New York. Closest to my own concern was the fate of the artist living in our time, for I had been abroad during the years 1927 and 1928, had met Brancusi, Duchamp, and Ernst, had seen the appalling lack of monetary respect paid to their work. Encouragement and enthusiasm from Chick, as a museum director, reinforced my hope that it was possible to jog the museums away from their exclusive preoccupation with art of the past and interest them in what was contemporary. In the first years of my gallery my artists were Berman, Bérard, Calder, Campigli, Cornell, Dali, Ernst, Leonid, Man Ray, Tchelitchew, Tonny. Soon I added Brauner, Chirico, Delvaux, Gabo, Giacometti, Magritte, Matta, Oelze, Tal-Coat, Tanguy. And the Americans Atherton, Blume, Gorky, LeBrun, Quirt, Rattner, Shahn, and Warshaw. (When Pierre Matisse opened his gallery he took over Calder, de Chirico, and later Giacometti, Matta, and Tanguy.) Sooner or later Chick acquired from me works of almost all these artists for the Wadsworth Athenaeum.

I was with Chick in 1931 when he purchased the first modern painting for the museum, Pierre Roy's "Electrification of the Country." We hoped this was a prophetic title, and joked about it without foreseeing that, although there were to be a few power failures, Austin's illumination would become an international glow long before most of his Connecticut countrymen saw the light.

Chick's taste turned instinctively toward Neo-romanticism and Surrealism, in no way surprising considering his princely and poetic leanings. I lent him some drawings and paintings for his first exhibition of the Neo-romantics in 1931. As I have already indicated, that same year I had arranged the group exhibition of Surrealism, and when he saw it Chick asked me to lend it to him first, to give the Athenaeum the prestige of America's first exhibition of the kind. I agreed, considering that

a museum show would carry more weight and give the artists prestige, enhancing the value of the pictures. I brought over the material from Europe, assembled it all, and Chick was able to supplement it. Hartford held the show in the fall of 1931 and I presented Surrealism to New York after the first of the year. We had some lively debates with Alfred Barr about the name, Chick proposing his mischievous Newer Super-Realism, Barr electing Super-Realism, and I held out for Surrealism. The ticklish point was whether one should try to translate the French at all. I thought it a very un-Surrealist thing to do—it was trying to be logical. Super-Realism, like Superman, was a vulgarization, I said. Surrealism was a French word invented by Apollinaire. As an invented word it should exist in its own right. It was, I maintained, untranslatable. Although temporarily Chick and Alfred played around with various translations, the word Surrealism stuck. Usage was to prove in my favor, as Chick noted later, but I remember his irrepressible laugh as he said, "the day will come, Giuliano, when you will find yourself talking again about that 'Little-Old-Newer-Super-Realism.' "

With Chick, business and friendship were outrageously, happily, and rewardingly mixed. It was part of his peculiar genius for putting pleasure into work. And quite contrary to what one might think, this was all in favor of the Athenaeum. Chick and I felt we were associates in two branches of the same business, together advancing the horizons of art. We, in our separate functions, could either be at odds with each other, as was true to some extent with Alfred Barr of the Museum of Modern Art, who seemingly had a suspicion of dealers—or the dealer and museum director could cooperate as Chick and I were able to do over the years.

Alfred did not see this need for cooperation. First of all, he resented a gallery that had more mobility than his museum, that could move faster in making finds and decisions. He complained to me about it. He wanted to give novelty shows, but a gallery like mine took the novelty out of his hands by giving shows before he did. He might have been envious, but not rightfully so, because the gallery is traditionally supposed to be more experimental and temporary, the museum slightly slower, more permanent. In addition to his desire to excel in the field of new discover-

ies, he also placed great importance on his obligation to his trustees' interests in the matter of price, no matter how it affected a dealer like me. For a museum to ask for further reduction beyond the museum discount of 10 percent seemed to me a form of pressure, for the artist and dealer are all too aware that not having museum representation works to the detriment of the artist. The public will wonder about it, and assume that the man is not yet up to standard, or is unimportant. Furthermore, it was made clear to me by implication that it was to the benefit of my artist and my gallery to practically make a present of the picture to the museum, and so enhance the artist's reputation and the value of his other work. No doubt a good case can be made for Alfred's position, and the argument could be indulged in at greather length. Chick, however, didn't try to drive my prices down. When he wanted a picture he knew the right price, about how much he was willing to pay for it, and he didn't haggle, nor did he defer to his trustees. Perhaps this assumption of authority was to be one of the factors that finally cost him his job.

I still feel museum and gallery are two parts of a whole and ought to be mutually helpful. There were times when the museum man found it difficult to raise money for innovative paintings, an established name being the *sine qua non* for trustees who preferred he buy someone known, someone they understood, with their money. To persuade trustees to acquire ultramodern work, a gallery man could do a number of things. He could make the work palatable by constantly exhibiting and writing about it in advance, so that it had a certain recognition when the director presented it to his board. If the gallery was successful and the museum starting out, or struggling to establish a good collection, though short of funds, the gallery owner could persuade his patron-clients to present the work as a gift. Or as a last resort the gallery owner could take considerable cuts in price to help a struggling director with whom he had a give-and-take relationship. In a downward phase of the economic cycle, such as occurred in the thirties when the galleries were depressed because their clients stopped buying, museums and institutions that have a steady income set aside for purchases should in turn judiciously disperse funds in such a way as to enrich their collections at advantageous prices and also to help keep a gallery with integrity afloat.

All this, of course, implies a perfect world, the museum helping the gallery in hard times, the gallery of inestimable help to the museum in good times, so their collections can grow in healthy directions, avoiding academic clichés and power cliques.

In our friendship, for example, I was constantly made aware that Chick's funds for the purchase of modern art were minuscule considering his aims. Naturally, I would cut my prices and persuade my painters to go along with this—so appealing was Chick's fervor, so real were his support and his prestige. I feel sure that with less limited resources the only difference would have been in the ultimate larger size and scope of the Athenaeum collection. His loyalty to his friends and to the museum would have remained just as scrupulously undivided and just as mutually beneficial. He would see no paradox in this. Chick's extraordinary warmth disarmed and encircled his friends, and seduced them into unexpected achievement and cooperation. His conviction was that if the means were harmonious the ends would prove themselves. Most often they did.

In this climate of angelic electricity his first really personal exhibition took shape: "Literature and Poetry in Painting." The concept had style. Russell Hitchcock wrote in his forward, "It is a surprise and even a shock to recognize the parallelism that can be found to exist between a Dali and a Gérôme, or between a Berman and a late Corot." Chick, in this exhibition, was visibly teaching by analogy, by parallel, one is tempted to say by parable. Here was Chick's greatest endowment, his uninhibited exercise of true poetic perception, which he projected magnificently into his job. It was also a revelation of the variety and pace of his taste and, amid disparate objects, his unerring feeling for all that was genuine. William Bouguereau's "Sisters" and Picasso's—that juxtaposition, what a metaphorical coup! I was pleased that Chick asked me to contribute to this significant exhibition. I lent Berman's "Prato della Valle" and "Venice," Dali's "Persistence de la Memoire," Ernst's "Sun on the Desert," "Dancers," and "Butterflies" (subsequently purchased by the museum), and Mina Loy's "Faces."

I have always cherished a wish that the civil face of our towns preserve their character and diversity, each of note for a peculiar and inimi-

table charm, that every Main Street not always resemble every other, and that every museum not be merely a feeble echo of another. Chick's injection of his very special personality into his exhibitions and in his museum collection in general made not only a totally fresh pattern but offers today a program for all small regional museums. Here was that flavor that could compensate for limitations in size and financial endowment; here was the quality that renders quantity unimportant.

Chick's natural expansiveness of taste was curbed and, for a while at least, this served to concentrate his essential finesse. Deciding to specialize rather than attempt to cover too thinly too wide a field, he made a most intense use of his resources by narrowing down to a single period of art. He chose the Baroque. It was both dear to his flamboyant heart and economical, because not fashionable at that moment.

Since his museum provided meager funds for the acquisition of a large modern collection, it made sense to me for Chick to find one theme for a small contemporary and specialized display. The ballet was close to his fancy. Then the miracle happened. The Serge Lifar collection of designs for the ballet came to my attention, and Serge was willing to sell for a nominal price. Among the numerous sketches for costumes, backdrops, and curtains there were some half a dozen important paintings by artists soon to become very well known. I pointed out to Chick, making a prophecy, that the value of these alone would soon soar so high it would justify the entire purchase, a bold guess that very soon proved true. Furthermore here was a collection that could be augmented as new ballets appeared. Lifar had been one of the associates of Diaghilev. One of Diaghilev's great points was that he brought modern artists and musicians into what had been the traditional, academic Russian ballet. From that time on, in the collaboration of stage designer, musician, and choreographer, each had almost equal parts in the public's appreciation. People went to the ballet not just to enjoy the choreography but also hear the new music by Stravinsky and see the new decor by Picasso.

These days Chick was beginning to eat and drink theater, and wander around entranced, humming, "Pigeons on the grass, alas. . . ." And the day came that all his friends remember with unfaded joy, the open-

ing of a new building for the museum, the Avery Memorial. Truly a miraculous event: a shining building, a monumental exhibition, the first extensive retrospective in this country of the work of Picasso, an evening climaxed by the world premiere of Gertrude Stein's and Virgil Thomson's opera, *Four Saints in Three Acts.*

Badly packed, some Picasso terra cottas he imported for the show arrived in shreds. Undaunted, in fact delighted, he crowed, "We've got *pots cassés de Picasso!"* I remember, too, the tiring train ride to Hartford, wondering what to expect, none of us daring to hope too high. The trip was nonetheless animated, for our pullman car and those adjoining were filled with familiar figures from the New York art world, all people we knew, and our friends: the Barrs, the Askews, Allen Porter . . . a gala traveling party. I remember the scene: men changing from traveling clothes to white tie and tails in the lavatory of the Heublein Hotel, and the late Henry Francis Taylor, Austin's sharp-tongued young rival in the museum world, dourly orating in gray flannel underwear on the "unfeasibility of Chick."

Lucius Beebe reported it in the New York *Herald Tribune,* with some mockery that the years have blunted, saying, "bedlam . . . as Messrs. Kirk Ashew and Julien Levy burst into unabashed tears because 'they didn't know anything so beautiful could be done in America' . . . Professor Hitchcock smashed his opera hat and howled for Mr. Thomson . . . tore open his collar and shouted for Mr. Austin." Indeed we were exhilarated. It seemed a public birthday and Austin might well forever ride his star trailing clouds of glory for producing this classic.

Virgil's music was an extraordinary combination of his sophisticated understanding of all the modern theories and intricacies, together with a real or assumed innocence, expressed in such simple musical traditions as that of old-fashioned church hymns as played on a home organ. He also showed a sensitive appreciation of the relation between music and words, subordinating the music to the word. This sensibility and innocent attitude allowed for his perfect interpretation of Gertrude Stein's words in musical form. Reinforcing this resonant, seemingly simple music, were the festive settings, designed by Florine Stettheimer. They

were of cellophane in floating sheets with a dramatic and flamboyant candy box effect. The entire cast was black, extremely talented and dedicated, which made for a freshness and convincing verity that professional white singers might never have attained. The cast seemed intuitively to understand the words and enjoy them, letting the melody pour forth as easily as birds. There were two charming ballets included in the opera, choreographed by a young Englishman, as yet unknown but soon to become famous, Frederick Ashton. He put the blacks into ballet slippers and had them dance on their points, but the music, being rhythmic and simple, encouraged them to use their own sidewalk dance steps. The swinging jazz movement, and their untutored grace combined with the rather elevated sophistication of the *en point* ballet choreography pointed up again that delicious combination of the naïve and the profound in the work.

After the show, a grand celebration was held at the Austins', in Chick and Helen's beautiful Palladian house, designed by Chick. Everyone there was in great elation, and more and more champagne was served. I went up to Virgil to express my enthusiasm and press his hand. Virgil in his meticulous way said, "Oh dear, Julien, didn't you notice that the trumpets came in a beat late at the beginning of the second act?" Not realizing at the moment that this was a form of awkward modesty on Virgil's part, I gave him a small push and said, "Oh Virgil, don't split hairs!" He stumbled off balance and fell backward into a very delicate gold antique bamboo chair which crashed into splinters. Sandy Calder, standing near by, enveloped me in a tight bear hug and asked, "Are you drunk, Julien? I'll put you away in a room upstairs," and lifted me in his arms. I didn't dare struggle, afraid I'd be hugged to death, and I let him tote me upright upstairs. Then, after he'd put me down and disappeared, I came out again to the party. Everyone thought we were having a row. Quite the contrary, we were being overly considerate, each of the other.

Chick and Helen were smothered in congratulations, and the reception was not the last of the celebrations. Weeks afterward friends in Europe were writing to me, reverberating to the news. They had heard to

142

quote one letter: "the balance of power in artistic matters had shifted from Europe to Hartford." This was a measure of Austin's triumph.

Four Saints in Three Acts had such vibrant repercussions after the Hartford opening that an attempt was made to put it on professionally in New York. Joella and I gave a party for the entire cast after the New York opening performance. My father stopped by for a while, not planning to stay long as he knew how overcrowded we were going to be. We had already discussed with him whether we should close off the children's room and hope the boys would sleep or pack them off to friends for the night. He reported that he had heard a young woman, whom he identified as Clare Boothe Brockaw, in the row in front of him at the theater telling a bevy of friends that she understood the Julien Levys were giving a swank reception after the show. She wondered what the address was and suggested they all crash the party in a body, apparently assured that she and her charming group would be welcome although uninvited. My father had leaned over and told her that he knew the address, but impishly gave a fictitious one far out on the upper reaches of the West Side. In spite of this misdirection they turned up later on in the evening.

I must digress to tell of an incident in Paris a year or two before. The sculptor Noguchi had come to me saying that a friend of his, a divorcee named Clare Boothe Brockaw, was eager to visit one of those famous "sights" of Paris, a brothel. She wanted to know if women were admitted. Noguchi told her that he had no knowledge of such places but that he would find out for her, and he came to me to see if I could help him out. I suggested the Sphinx, a place in the artists' neighborhood of Montparnasse. In most of the Paris brothels of the time the girls were usually nude except for long black stockings. At the Sphinx there was a basic costume of a transparent white peplum that could be lowered from one shoulder to expose a breast or hiked up on one hip to expose the private parts. Each girl wore a band around her forehead which was built up into a fantasy headdress expressing a little of the girl's own creativity: flowers, feathers, sequins, or whatever she might invent. The atmosphere was half-nude, very carnival, pretty and amusing. The artists in

143

the neighborhood had developed a habit of coming to the Sphinx at aperitif time in the late afternoon, just for the pleasure of having a glass of wine and chatting in this rather unusual atmosphere. The girls were not at all averse to this, enjoying being treated to a drink by the artists and having a chat before their professional clients came in, usually later in the evening. This became a habitual indoor café for the "in" group. It was nice, and clean, and fun, and the girls were pleasant and pretty, something rather unusual for the everyday, or rather everynight cathouse in Paris.

I said I would take Noguchi and Mrs. Brockaw there myself. Clare had not been there for more than a few minutes when she turned on me in a fury, saying, "How dare you bring us to such a disgusting spectacle? This is in every imaginable way the most complete degradation of womanhood! How can you possibly take part in this and ask me to approve? Good-bye, Mr. Levy!" I was flabbergasted. It was not I who had offered to bring her but she who had asked to be brought.

Remembering this the night of my party for the cast of *Four Saints* when the doorbell rang and she appeared at the door with her retinue, I could not resist saying, clearly and politely, "Why, Clare, do come in. The last time I saw you was in a whorehouse in Paris." She had the grace to blush—and leave.

Later that year, in December, I drove to Hartford with Salvador Dali, who gave a lecture in the Avery auditorium. We brought with us a group of Dali's recent work, which we left in Chick's office as a preview of Dali's coming New York show. From this group Chick purchased for the museum what I consider to be one of the finest in quality, if one of the smallest in size, of any painting Dali ever made, the "Paranoiac-Astral Image." Four years later he was to buy one of the largest and most complex of Dali's paintings, "Apparition of Face and Fruit Dish on a Beach."

Consistently, while Chick was director in Hartford, I lent work for his various shows. As our interests were so much alike, I always had paintings that would fit into his program, and the Athenaeum, through Chick, made many purchases from me, more at the time than the more

144

affluent Museum of Modern Art. In the years following there was a succession of notable exhibitions: Le Nain and la Tour, arranged with Knoedler in 1936; The Painters of Still Life, in 1938, to which I lent Dali's "Accommodations of Desire," Magritte's "Key of Dreams," Tchelitchew's "Apples on a Mantel," and Tal-Coat's "Two Mannequins," as well as two anonymous eighteenth-century paintings; Sculptures by Naum Gabo, a show which I repeated in New York; the unforgettable show Night Scenes to which I lent Berman's "Clair de Lune" and "Still Life with Candle," and Oelze's "Expectations"; later, in 1940, a fine retrospective of Yves Tanguy's work, and finally, in 1943, Men At Arms to which I lent John Atherton's "Egotist" and "Athletes" (which was purchased by the museum).

The calendar, after the opening of the Avery, was crowded with events other than exhibitions for the next few years. There was the famous Paper Ball to which Berman and Tchelitchew contributed decors and costumes, the installation of the Christians Tonny murals, many lectures, concerts, movies, and other activities that made the museum a lively hub of the cultural life of Hartford.

Joella and I were unable to attend the Paper Ball, which Chick gave a couple of years after the opening of the Avery. It was all very regal, very high society, with expensive tickets and an orchestra and dancing on the marble floors of the museum courtyard. The previous week had been devoted to the making of costumes by various artists, each of whom had an entrée at the ball: there was a Tchelitchew entrée, costumes made of cut-up paper, a Berman entrée, more sculpturesque, made of cardboard and molded papier-mâché. Pavlik Tchelitchew's group included his young poet friends, Parker Tyler and Charles Ford; and after all the champagne had been consumed and most of the distinguished guests had gone home, Charlie Ford and Tyler—Pavlik was no longer there—started skinny dipping in the shallow museum pool with a group of the "young fry," mostly Trinity students. In proper Hartford that caused an unfortunate scandal, and Chick came near being fired, although he couldn't be directly blamed. He didn't swim, and had nothing to do with it; he was with other people elsewhere in the museum at the

145

time. However, those involved were his friends, he had invited them, and it was felt that he had allowed "the type of atmosphere" where such a thing could happen.

After that theatricals seemed to run away with Chick a bit.

In his promotion of modern art he became increasingly frustrated by limited funds and the unlimited apathy of the local public. Prospects were not sensibly improving. In spite of his marriage to the daughter of one of the most culturally aware and influential families in Hartford, the Goodwins, his standing with his trustees was dropping lower and lower. This was due in part to the "disgraceful" gossip that seemed to revolve about, or involve, Chick, and also because it was felt he was not a good businessman. It perturbed the trustees that he could fall in love with paintings and spend substantial sums for them, intuitively certain of their worth. And he was always right, the trustees later realized, but too late. The paintings he acquired for them proved to be of great value in a few years—bargains, all. However, at the time, they seemed extravagant, were not Rembrandts or Rubenses, names that could impress the Hartford businessmen who were trustees. His energies were galloping feverishly, but his discretion was wavering, his creative showmanship suffering. Hamlet was more than he could encompass. Exuberant Chick was now occasionally tired and morose. Osram the Magician? One day the Hartford curtain fell and there was no encore for Austin.

He went away. I saw him only on occasion up North, and once in Florida when he invited Iris Barry and me to lecture and show films (she, von Sternberg's *The Blue Angel,* and I, the Dale-Buñuel *Un chien andalou*) at the Ringling Museum in the early days of his directorship there. His assignment—to transform that backwater museum into one of distinction—looked like a Herculean task, and he wasn't happy at it. Somehow I didn't see him as the strong man in his Ringling setting, where he remained until his death, nor as the ringmaster. Harlequin? the Watteau "Gilles," somewhat sad with all his gaiety, wise in his elegant foolishness, clever in his extravagance, generous to the whole world beyond measure.

If one conjures this image of Chick, one thinks also of Pavel Tchelitchew painting a clown, poking the long thin hand that held the brush

146

toward the model, saying, "We all paint him sometimes. Isn't he our symbol today? The most close to an artist, isn't he? Wasn't he yesterday when he had access to kings? Isn't he today when those who concert with his tune are only children perhaps, and all the other artists, and myself?"

The felicitous function of a tuning fork is not only to set the standard to which an entire orchestra may harmonize, but sometimes to set up responsive vibrations in quite disparate elements, standing mute until given the pitch by that unerring arbiter. It is said that even a strong fortress may tumble and fall if the secret sympathy of its keystone be touched to trembling. So one might conceive the reverse, the miracle of the stone touched off to such a shiver as to build of itself an unpremeditated edifice (explosion in reverse). Such a sympathetic builder was Austin who, in his position as director of a museum, set the tone for the inclination of a city, and whose energies and their echoes carried further than was demanded or than might in any way have been expected.

That such a beloved *jongleur* should have played such an inspired role and have been called so soon away. . . .

147

L'AGE D'OR

Between my college forays to the movies with Professor Post and the years of establishing my gallery, my interest in the cinema continued. It had merely been diverted, sidetracked, not abandoned, during this interval. The fascination remained of a dark hall with a little projector spitting onto a screen the images that could dominate a packed, anonymous audience. For one afternoon each week, the gallery was darkened and a small group of people invited to view experimental programs.

I had formed a collection of films reprinted on 16 mm stock, with two purposes in mind: films conceived by such important painters as Duchamp, Leger, or Dali should command much the same value as a canvas from their hand, and if a collector's market could be organized, I thought to persuade other painters to experiment in this medium. I had been making casual films of my own, hoping these would add up to a small library of film portraits. My portraits would not be static; quite the contrary they would be amusingly animated, not to disgrace their title of moving pictures. I planned to construct the action in three movements: the subject engaged in habitual activity, then an abstraction to represent my conception of the character of the subject, finally a drama to be derived from a short scenario written by the subject—his own idea of himself. I had completed only one of these portraits, that of Max Ernst, and partially, those of Brancusi, Leger, Mina Loy, and Campigli, when my money ran short. My eyes were no longer turned toward Hollywood, which already showed signs of unpleasant bloat. As with everything I had tried to accomplish since rejecting my father's business, I no longer looked for large sums to finance my ideas, but I did have need for modest support. Could these homemade samples ever serve as hints? Would they grow, not too big, but enough to earn encouragement? How many people wanted extra-Hollywood films?

My camera led me into some pleasant, startling country. Have you ever seen a forest *built* to man's order? Have you seen the forested park of Chantilly, designed by the architect Le Nôtre, who also designed the Tuileries Gardens of the Louvre? Such is the forest of Ermenonville, near Senlis. And there Caresse Crosby rebuilt her *moulin,* where we completed Max's sequence of my film about the Ernsts. In the garden a horseshoe-shaped refectory table was set, and all about were dogs, lying by the chairs or in the garden, afghans and whippets. As Max prowled the bottom of the empty swimming pool to set his stage, and I raised my tripod, Caresse prepared for us bowls of wild strawberries and champagne.

For her portrait, Mina, claiming bitterly that her true environment should be a dustbin, led me through the byways of the Marché aux Puces, to pose inside, in front of, or on top of, the most disreputable shacks for my camera's eye—shopping on the way, buying old bottles, picture frames, ornaments, even an ancient hurdy-gurdy. "You see your poverty is really luxury?" I pointed out to her, as we finished the day over steamed mussels and a glass of Pernod at the Rendez-vous des Chiffoniers.

In Berlin, when Victor Blum and Maholy-Nagy introduced me to the nudist camp near Wahnsee, there was, across the lake, a National Socialist camp which we visited. I was attracted there to a beautiful blonde. Her body was all sculptured honey, and I wished to photograph her in one of those artful poses that Germans assume when they are nude—leaping through a wheatfield or standing on tiptoes with both arms stretched toward the sun. But Blum hustled me away. "If that poor child is ever suspected of befriending you, a Jew, they'll make her suffer for it if they ever come to power."

Our first program at the gallery began with a montage by Blum, *Sportfilm.* This film achieved the greatest success with our audience, which consisted of as many friends, clients, and figures from the motion picture world as I could summon and squeeze into the gallery. After the sports film I presented Fernand Léger's *Ballet mecanique* and Duchamp's *Anemic Cinema.* These more important films left the audience bewildered and unconvinced. For the second program, therefore, I decided to include a more sensational feature, *Un chien andalou* by Salva-

149

dor Dali and Luis Buñuel. Although quite short, with projection time of under thirty minutes, nevertheless this film marked the greatest single stride I had ever seen accomplished in any one production. It remains exciting today. It acknowledged no precedent, and no imitator has yet caught up with the conceptions so lavishly offered by Dali and Buñuel in this, their first essay.

I believe the showing of this film more than anything else established Dali's reputation in this country. The madness of its apparition was imperious while the method in the madness was irrefutable. Those who came to scoff remained to understand: how the conviction of dream was achieved, not by hanging from the ceiling or barking like a dog, or any such fantastic nonsense which the uncomprehending public thought was Surrealist, but rather by precise attention to accurate, subtle detail. It could all be explained, and I never tired of explaining.

". . . a desk which the newcomer approaches comes onto the screen. On this desk are two books and schoolroom appurtenances. Their position and moral intention are to be determined carefully. . . ."

Precisely so!

". . . and the razor blade passes through the girl's eye, slicing it in two. . . ."

This passage, which invariably impressed the audience (there was an audible gasp at each performance), was intended as a prologue, had no connection with the body of the film. It was *meant* to shock you, shock you into nervous vigilance and a heightened awareness of what followed.

". . . the two people on the balcony appear overcome to the point of tears by the same emotion; their heads move as if listening to phantom music. . . ."

This begins the love scene, but the actors were not told that they should *register* falling in love. Instead they were directed to listen to distant music, now coming nearer and nearer until the eyes almost catch a glimpse of what the ears have foretold. The tenderness of expression resulting from these directions surprised the actors themselves.

". . . as he looks the girl's jumper fades, her breasts appearing through the jumper; thereupon the cyclist's face is seen to take on a look

of terrible, almost mortal anguish . . . the breasts dissolve and slowly the jumper reappears. . . .''

I remind the audience of the commonplace metaphor, ''he seemed to strip her with his eyes.'' And, the simplest having been explained, the serious intention of more difficult images is conceded.

Then a more ambitious production appeared, a full-length film with sound track, by Dali and Buñuel. And our more ambitious organization, the Film Society, undertook to present it in New York.

Reports of this film, *l'Age d'or,* were heard from Paris. It had been attacked, suppressed, Charles de Noailles had weathered much ostracism for financing the production. That summer I had driven with Mina and Lee Miller through miles of dusty suburbs to a little underground hall beyond Vincennes, where they were showing the banned *l'Age d'or.* The surreptitious presentation added excitement to the performance. The hall was packed, and no sooner did the film begin than intramural brawls increased the risk of extramural intervention. Some students cried, *''à bas les Surrealistes,''* and someone answered, *''J'emmerde la Sorbonne!''* Something was thrown, and someone was injured.

I expressed my surprise to Mina. It seemed incredible to me, then, that serious political force should generate from such bodies as the student, the clergy, the aristocracy, or the artist. ''Just as if they were Republicans and Democrats,'' I said, ''or worse.'' It was the first time I had been forcibly brought to realize that the artist, for example, might be considered a moving factor in immediate politics. Later, when the venomous Hitler propaganda drive aimed squarely at the intellectual front, a dignity and respect was granted the artist's position, where before he had been a creature apart, lightly tolerated and, in America, incredibly neglected.

Mina found not only the whole afternoon somewhat overwhelming, but the film too.

''But you must show it in New York,'' Mina said. ''I'm not sure that I like it, but it must be shown.'' And I agreed. There was prospect, however, of difficulties with the censor, and the limited facilities of my gallery would not serve a large audience nor project 36 mm sound film.

In fact the opportunity to import *l'Age d'or* presented itself the fol-

151

lowing year. A group of young men had the ambition to import the idea, already under way in England, of a nonprofit subscription film society, "to combat the low taste-level of the average commercial film, and the restrictions of crude censorship"—in short, to show films either too avant-garde for the public or too censorable. It was also a way of importing European films (at that time, subject to a prohibitively high duty), without paying the tariff. Such an organization could bring over films for a limited, noncommercial showing duty-free by importing them "in bond" and after a showing return them to Europe. Their aims somewhat paralleled my own interests, but I do not think I would have considered their plans had it not been for the writer and journalist Count Raoul de Roussy de Sales. These young men had determination, but little else; neither films, an audience, nor a theater. They did have support from the crusading attorney, Morris Ernst, who was interested in the anticensorship aspect of their program, and there was Raoul, for some reason they had consulted him. I think the original promoter of the group, Critchel Rimington, knew Raoul and brought the matter up in the course of accidental conversation, and Raoul sent him on to me.

Raoul was one of the few men for whom I held a deep affection, and the one best fitted to convince me to undertake an enterprise of this kind. His intelligence was tempered by skepticism and a fastidious heritage which placed him beyond prejudice, in the position of a privileged spectator. By nature and training he was a diplomat, that is, the kind of politican this country has scarcely known since the Civil War. I liked to see him in action. In another age he could have been a powerful Jesuit if not a saint—he was, indeed, descended from the family of Saint François de Sales. In this age he represented for his country the *homme d'esprit,* and might still have had a notable career if he had not been hampered by a serious malady. At moments of great activity he bled internally. Medical science had failed to account for this mysterious hemorrhage, and I always supposed it indicated a spiritual and not organic conflict. Raoul was permitted behind the scenes of those events which were so rapidly changing the stage of culture, and in him the royalist warred with the republican, and the republican with the prelate, the prelate with the intellectual, and Raoul bled. It was during an interval between two hemorrhages that we formed the Film Society.

We were originally eight directors, and conducted our meetings with all the ritual of parliamentary law. Weekly, then almost daily as difficulties accumulated, we met, usually at my house. Joella threw green baize over the dining room round table, and as chairman I held the gavel. The walls of the room were deep red. An elaborate brass chandelier overhung the table, on which were stacks of paper, pencils, a box of cigarettes, and ashtrays at each place. The ceremonial niceties only appeared as so much nonsense when the thread of accomplishment was lost, then broken, in a tangle of discussion, when each man seemed to use his privilege to ask recognition from the chair only to call attention to himself and his persuasive, or rather, I should say, self-persuasive, words. One director, Harry Allan Potomkin, very vehemently urged that we show Communist films, and Communist films only. In this he was seconded by a fellow who had come uninvited to the meeting, who claimed some connection with the importation of Russian films. Later he proved unable to secure a single one for us. One director prepared endless lists of films he personally had enjoyed during the course of his life, on the theory that, being of average intelligence, he was a good guinea pig for an average audience. At moments of most acrid debate, the tallest director, Dwight Macdonald, would stand and clear his throat. He stammered earnestly and cleared his throat often but up to the day he collapsed in frustration and resigned, we never discovered just what he wished to propose. Several available films were considered and rejected, and one unavailable film was unanimously approved.

Meanwhile we had no theater, and no films, but we did have some money and an audience. While the directors argued, Joella and Reine, Raoul's wife, pursued the social efforts of a membership drive, and my secretary at the gallery, Allen Porter, designed and ordered announcements. So, unofficially, this much had been accomplished; in fact the date scheduled for the first performance was almost upon us. Raoul commenced a strenuous course of diplomacy.

"In a miniature way this is only another example of the advantages of dictatorship, *if* you must act, and have not infinite leisure for parliamentary law," said Raoul. "Almost all the members have been enlisted from our personal friends, yours and mine and Joella's and Reine's and Allen's. I feel more responsibility toward them than toward these im-

practical, pigheaded, argumentative directors. We at least have a film in mind that we think is interesting and that we know is available. But I will make one more effort to persuade each director separately that this film is his own bright particular suggestion.''

The film was Georg Pabst's *Opéra de quatr' sous*, and this was the film we finally presented, but not before additional conflict. The little Communist director was not for a minute to be fooled by Raoul's diplomatic tact. He organized an opposing bloc. He mentioned that by corporate law we could not override the director's deadlock without risking criminal procedure. Raoul's face is sardonic at best, and now his eyes gleamed. He delivered an angry review of his activities toward establishing the Film Society, said that he would not think of overriding a vote, but that if an opposition director did not resign, he himself would, and take with him whatever members he originally had enlisted. As Rimington and I joined Raoul, our following embraced almost all the paid membership. The tall director cleared his throat and sourly resigned, so did two others. We replaced them with our own candidates: Iris Barry, who had managed the London Film Society; Louis Simon; and Lincoln Kirstein. But our troubles were not over.

We were officers now of a little schooner and, having calked a leak, and overcome mutiny, were soon to find ourselves scuttled by a Leviathan. I never did quite fathom the nature of the forces frustrating us. Instead of cooperation from the Museum of Modern Art, Lincoln was censured by that institution because of his association with us. Were we rivals then? I had not so imagined. This was only the first of many indications that we were out of our depth. Was navigating in the waters of the film industry dangerous for even so peaceable and small a craft? On we sailed.

I received a three-hundred-word telegram from Sidney Howard. Why didn't he write? Or telephone? And why addressed to me and not to the Film Society?

I AM PRESIDENT OF THE FILM ASSOCIATES . . . SIMILAR PLANS TO YOURS . . . IN FACT DIRECTORS SEEM INTERLOCKING . . . HAVE ARRANGED FOR PERFORMANCES AT NEW SCHOOL . . . SUGGEST MERGING MEMBER-

SHIP, WILL ALLOW YOU PLACE ON OUR BOARD . . . UNDERSTAND YOU
CONTROL DALI FILM WE WOULD LIKE TO PRESENT. . . .

I thought it impossible to comply, as our program was already scheduled and Sidney Howard was planning for a later season. I invited him to join us, but with little expectation that he would, and with even less expectation that two similar organizations could hope to survive. We were to make no profit, either of us, yet here we were in competition. There were neither enough films nor a large enough public for one alone.

If our initial performance succeeded, we thought we could be sure of an established advantage. A brilliant audience filled the large hall, but something was amiss. Joella pressed my hand. Friends were greeting me. The moment came when I concluded a short speech to our supporters, and indicated that the lights should be lowered and the film begin. There was confusion at the back of the hall, and I spoke additional words to fill the interval. The projector exploded. It was repaired. A fuse blew. The hastily repaired projector was inadequate. The image wavered, the film broke three times, and a fuse blew again. Joella could not stay to watch. She was sick in the washroom and went home with Reine de Roussy de Sales. Half the audience had left when we finally overcame the major difficulties and staggered through the program. But of course we never recovered our lost prestige. We completed our promised schedule and then quietly collapsed. I like to remember, however, that we did show our shrunken audience *l'Age d'or*. There was glory and excitement in that, and I daresay the performance will be remembered when others of ours, and of the Film Associates, and of the museum, are forgotten. We were besieged with requests to repeat that program, but we were done in, disbanded, liquidated.

The entire season of 1934–1935 bore an overcast of gloom for me. Almost nobody liked the Giacometti sculptures. Priced at $150 to $250! Nobody bought.

This single paragraph sums up the sensation I had that season, and for many seasons thereafter. I was completely baffled by the lack of re-

155

sponse to the marvelous objects I thought so reasonably priced and so desirable. I can only repeat: nobody bought.

The reverberations from my first Surrealist show having reached Paris, my reputation there, if not my fortune, was made to such an extent that Giacometti wrote to me, without my asking him, offering a show of his early sculpture. He sent over a beautiful collection, some of them very fragile. To my great chagrin, I had to return almost all of them unsold, retaining one for myself.

Each of my artists gave me a gift of one piece after his show, and it was always given with gratitude by the artist. I never had big formal contracts, as later galleries did. Nor did I ever take "rentals," artists who pay a gallery to present them. I dealt in painters I wanted, whom I felt ought to be appreciated, that I wanted to promote in the best way possible. To compensate me somewhat for my rather extensive advertising, for announcements, for shipping expenses, and at times for an elaborate catalogue, I would expect a gift of one work, not necessarily the equivalent in value, but as my compensation, whether or not the art work sold.

For certain of my artists who didn't sell at all, I would hoard what little money I had in order to buy their work and to support them. In time my collection acquired a few bulges. Max Ernsts, because I kept supporting him year after year, although, of necessity, modestly. Berman and Leonid as well. Later Gorky. But, because when I gave a show I received that one single picture for free, I also have a large collection of single pictures from various artists. The Giacometti "On ne joue plus" was just such a one. Giacometti was very pleased that I chose it; in fact, it was one of his favorites, and he said he was glad it was a gift and not a purchase. I sold so little that season that I simply couldn't afford to buy a Giacometti no matter how I yearned for more.

No one ever resented this arrangement except, to my great surprise, Ben Shahn. I gave Shahn a show and the customary gift to the gallery was discussed. But after the show he said, "I don't want to give you a picture, Julien. You didn't sell much." He was a radical and assumed I was rich. "I think the whole setup—I know I agreed to it—that whole setup is exploitation of the artist." I said, "All right, take your picture,

I won't hold you to it." So I have no Shahn, nor were we ever very friendly again.

After the war Giacometti switched to Pierre to show his long, drawn-out figurines. They had a startling success. The piece he'd given me encountered many mysterious misadventures—the "On ne joue plus" (No More Play or Games—or, closer to the croupier's call: No More Bets) was a dramatic flat marble piece that had small sunken shapes and crypts with movable lids and two standing figurines, on the white marble field, like ghosts rising, with one small reptile gliding about. Twice the little figurines were lost when sent out on loan to museum exhibitions. Each time at a Guggenheim museum, first at Peggy's and next at the Solomon Guggenheim Museum on Fifth Avenue. Twice I had to ask Giacometti to replace the figures. In spite of these annoyances, for they surely must have been annoyances to Alberto, he remained courteous and friendly.

And then one day, many years later, decades after the war, I went to greet him at the Café Flore. He suddenly stood up and insulted me. "Do you know that I have never brought myself to tell you this," he said, "but you still owe me for one of my most beautiful pieces." I was shocked.

"What do you mean?" I asked.

"The piece you sold to Patricia Matta which she had cast in bronze."

I started to tell him what happened, and that I had paid him, but he would not listen. "I do not want to speak to you," said he. His face was etched with pain—I believe now that he was already suffering from the cancer that was to destroy him. He would in no way allow me to apologize or explain. I pieced together what must have happened later, when I was alone.

At the time I was being drafted into the Army the most delicate and beautiful piece of Giacometti's in my gallery was a tall plaster figure called "The Invisible Object." It was extremly fragile and had been broken several times in shipping. Each time it had been carefully restored, but I had never dared return this piece to him in Europe. I was always sure I would be able to sell it in the States to save it the harrowing trip, and never had the money to buy it myself. When I was closing the gallery, in wartime, one couldn't ship anything—and I didn't even

157

trust it to a warehouse. I talked of this problem to Matta and his wife, Patricia (who subsequently married Pierre Matisse). They eagerly offered to buy it and I gave it to them in relief, stipulating that if ever they were to cast it in bronze, which was a logical thing to do, it should only be with the express permission of Giacometti and an arrangement for him to share in the proceeds. I then mailed a check to Giacometti on the spot, and forgot all about it, as I went into the Army and the gallery was closed, all records hidden away in storage. Now I wonder, in wartime who could know if he ever received it? And according to him he never had.

My Surrealist group soon became well defined, and well known. The Neo-romantics—Tchelitchew, Berman and his brother Leonid, Bérard and Christians Tonny, never as sensational—did not attain such success. I concentrated on both groups and had frequently to explain that my gallery was not exclusively devoted to Surrealism, although my name, in the popular mind, remained firmly identified with the movement. My interests divided between these possibilities: Surrealism, the literal dream world, and Neo-romanticism, the nostalgic world of fantasy.

Eventually these distinctions were blotted out, after my gallery closed, by the forceful advent of the New York School of Abstract Expressionism, which was the opposite face of all these aspects. It picked up the torch, so to say, from the School of Paris and flung it to the other side of the Atlantic: New York. It swallowed all the after-Picasso aspects of abstraction, Surrealism and Romanticism (which in Picasso's work was represented more or less by eroticism) into one movement.

With growing chauvinism, America rushed to support American art and show new prejudice against all that was European. This included everything after the Post-impressionists, who were already established as classics. I had both European and American artists in my gallery, but except for Dali, there were no sizable sales of my European imports. The American shows sold better.

But somewhere in this account I should mention three American painters in the virtue of whose work I felt the deepest conviction. In spite of my faith and my efforts, none of the three reached the degree of

national and international fame I thought they deserved, unlike almost all my other painters who, with or without my efforts, eventually reached the top. These three were Abe Rattner, Howard Warshaw, and Leon Kelly.

Abe Rattner was discovered in an atelier in Paris on one of the rambles that Pierre Colle and I shared. He produced a flaming, passionate, romantic style of painting with deep colors somewhat akin to Georges Roualt's, a Jewish folklore feeling somewhat more serious and out of Marc Chagall. He came back to America for his first show in my gallery. He would show repeatedly with others, including Edith Halpert's eminent Downtown Gallery. He managed to find a following of patrons and admirers, but still did not have the great recognition rightfully his.

Howard Warshaw, who was the youngest, last-in artist of my gallery, went West to California where he has carved out a considerable reputation and much success for himself. The exhibitions shipped regularly to New York seem not to take flight in the atmosphere of the Eastern establishment, but he is still relatively young, still growing, and my hopes, like his, are high.

As for Leon Kelly, there is no use saying a further word. I have spilled talk and writing on him over a period of many years. Leon Kelly is a very inventive American with a Surrealist angle and a superb technique. As a last attempt to fit him into a niche of respectful attention at least, if not the adoring fame which I thought he deserved, I finally (years after my gallery closed) place him with Alexander Iolas, who was considered by many to have excellent galleries on either side of the Atlantic—but all to no avail. Leon Kelly continues to live like a hermit on a spit of sand in the South Jersey bay area, wallowing in the bitter salt marshes of nonrecognition.

Summer, 1936

Walpurgisnacht Chez Tzara

Defeat and Dream, both had told me secrets. Sailing for Europe this time was like sailing had been year after year, and yet again it was not. I was to become more immersed in the foreign element, displaced or *dépaysé* as the French called it, even contaminated. This was fortunate, in a way. For the Europe of this year and the next were soon to disappear forever. How fortunate, suddenly to become deeply involved with a familiar friend, if later one were to learn you had seen that friend for the last time. I remember my remorse, learning of the death of a college chum, when I realized that my last visit with him had been blurred and degraded by lazy familiarity. I would have welcomed the memory of even a disagreement between us sharp enough to have brought him into focus.

I felt some intimation that Europe was exploding; I thought, well, I will explode with it if it happens. As I saw my family walk down the gangplank I sensed that an irreversible process was begun, that more than an ocean was to divide us. I was as helpless as a patient given anesthetic, watching doctor and nurses receding, and in their place finding fantasies, careless surges of new and obsessive conceits. To stretch back a hand, to exert some effort, would have no effect upon the inevitable events of the next two years, except to agonize the last periods of fading consciousness and touch off painful fireworks of an abortive will.

Raoul and Reine de Roussy de Sales had a cabin and private deck in *première classe,* and I was using it for my own farewells, because it would have worried my father to see my cramped cabin in *troisième* and because Joella wished to see off the de Roussys as well as say good-bye to me. I did not envy the de Roussys their accommodations. I hoped for seclusion, and that I might not be obliged to dress for dinner. I was arro-

160

Julien Levy. Photo by Jonathan Bayer

RUFINO TAMAYU ~PAINTING

PAINTINGS by MINA LOY

ABSTRACT SCULPTURE
BY
ALBERTO
GIACOMETTI

EMILIO · TERRY
ARCHITECTURE

SALVADOR
DALI

DALI

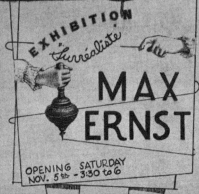

EXHIBITION
Surréaliste
MAX
ERNST

OPENING SATURDAY
NOV. 5th - 3:30 to 6

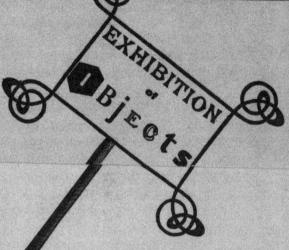

EXHIBITION of Objects

by *JOSEPH CORNELL*
OPENING DECEMBER 6th
JULIEN LEVY GALLERY
FIFTEEN EAST FIFTY-SEVEN

EUGENE BERMAN

EN LEVY
ERY

GIORGIO DE CHIRICO

MASSIMO CAMPIGLI

BY
EUGENE
ATGET

LEVY GALLERY

Tchelitchew

K. To

TONNY *Drawings*

TANGU

ABOVE:
Portrait of Mina Loy (1930) by
George Platt Lynes

LEFT:
Joella Loy by Lee Miller

LEFT:
Mina and Joella Loy, Paris, early twenties

BELOW:
Fabienne Lloyd with her nephew Jerrold Levy

Atget's studio, by Atget

Americana included in the first Surrealist Exhibition in 1931

Photos of Julien Levy (left) and Alfred Barr (right) by Jay Leyda

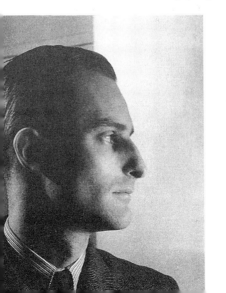
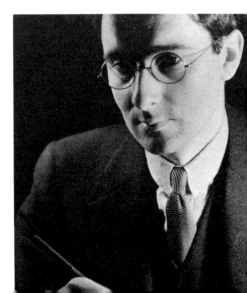

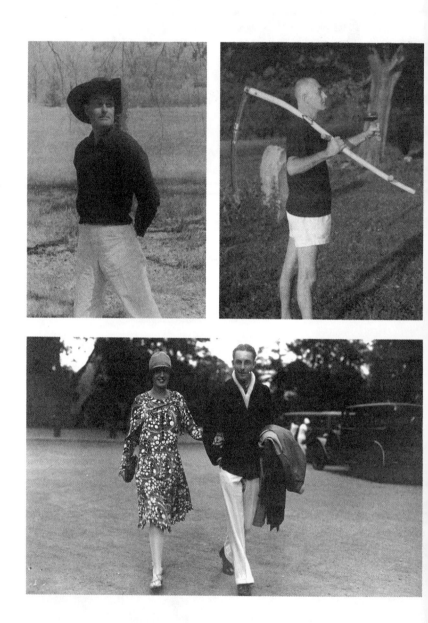

Julien with and without headgear (top), and with Joella

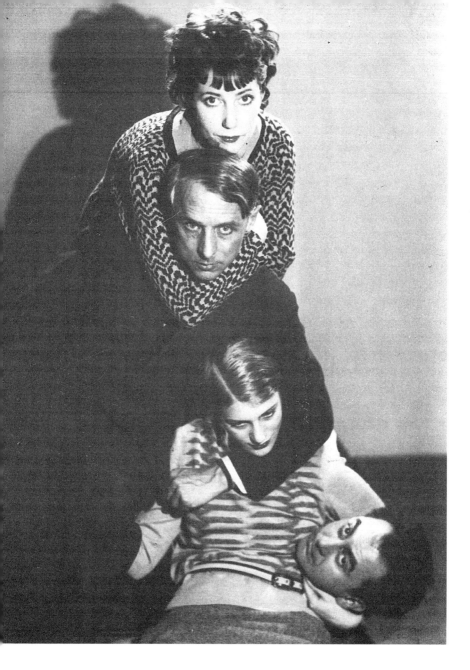

Marie-Berthe Ernst, Max Ernst, Lee Miller, and Man Ray (top to bottom).
Group portrait by Man Ray

Pavel Tchelitchew by Julien Levy

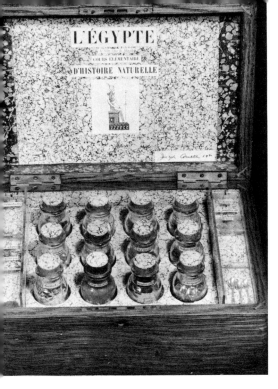

LEFT:
"L'Egypte de Mlle. Cléo de Merode" by Joseph Cornell

BELOW:
The curved walls at the Julien Levy Gallery at 15 East 57th Street

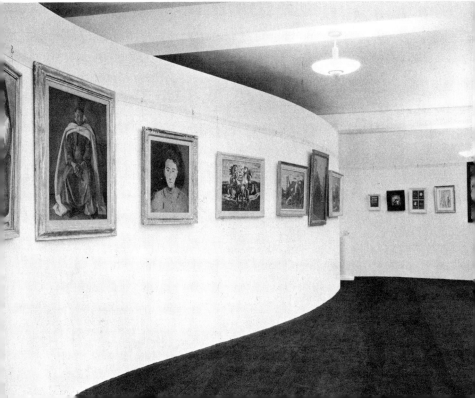

LEFT:
A. E. "Chick" Austin, Jr., director
of the Wadsworth Athenaeum

BELOW:
Four Saints in Three Acts

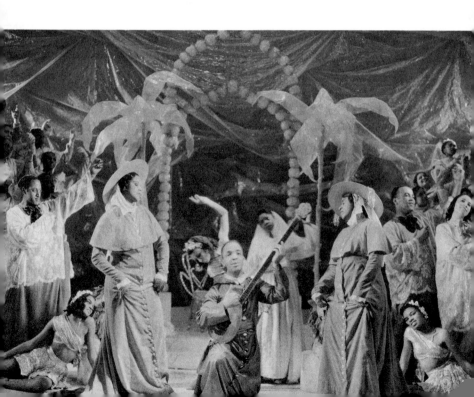

"Color Solid" device, a color chart in three dimensions (left). Massimo Campigli (right).

Russell Hitchcock by James Thrall Soby.

Matta on the site of the "Ready-Made" discovered by him
and Julien Levy; at right: the object itself

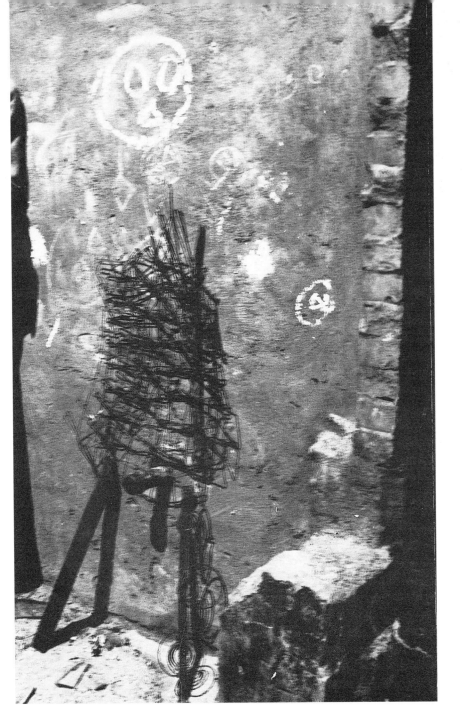

"Arthur, Arthur." Photo by Jonathan Bayer

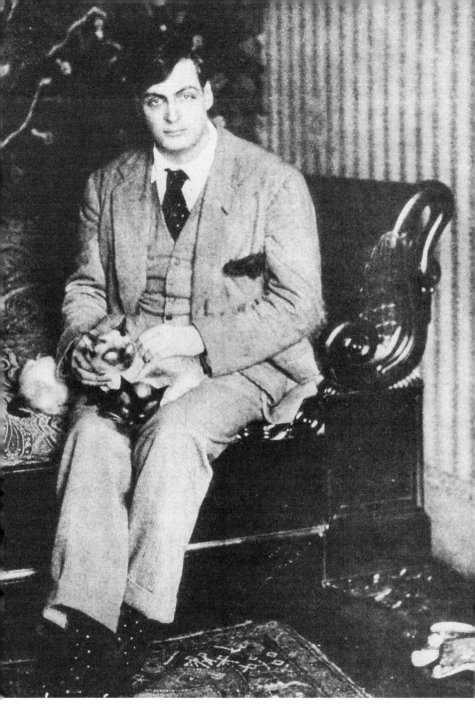

Arthur Cravan

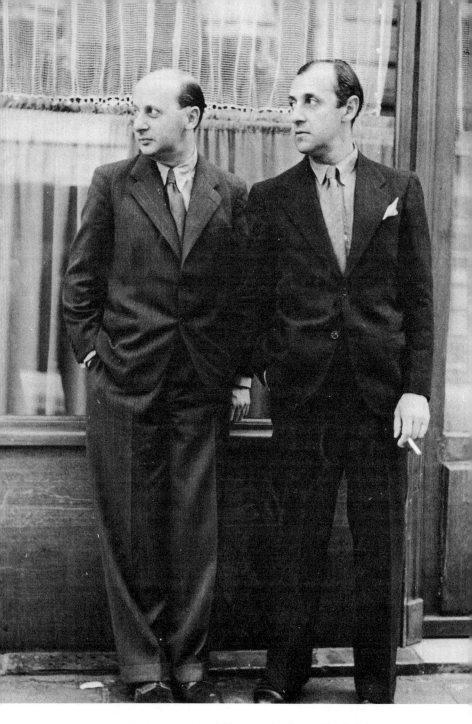

Eugène and Leonid Berman by James Thrall Soby

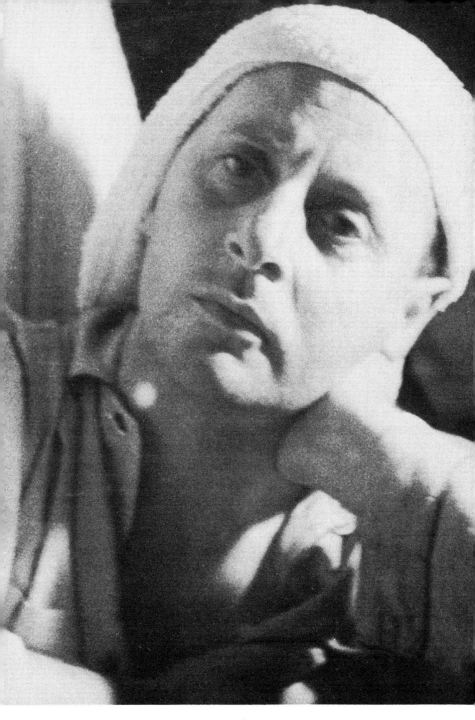

Eugène Berman

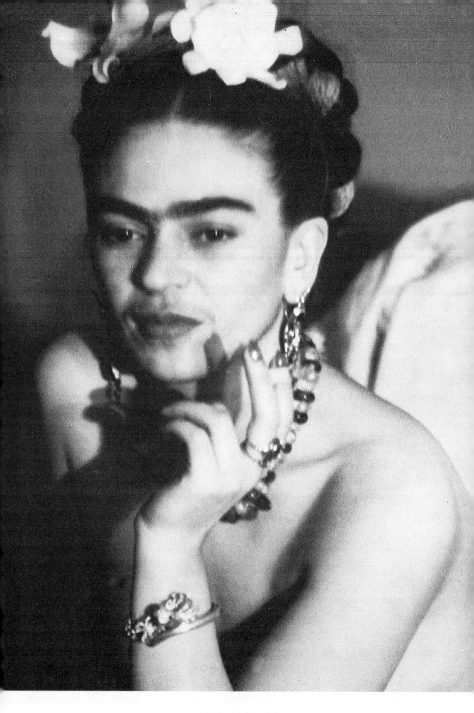

Frida Kahlo Rivera

ABOVE:
Man Ray, 1942

RIGHT:
Carl Van Vechten, photographed
by George Platt Lynes

Leonor Fini in costume

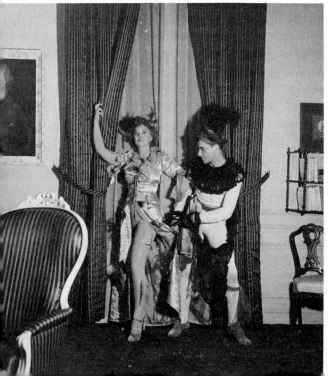

DALI'S DREAM OF VENUS

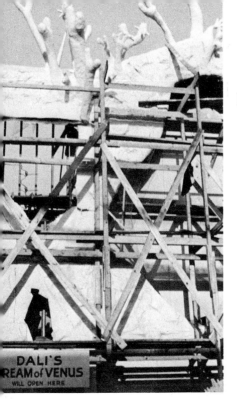

DALI'S
REAM of VENUS
WILL OPEN HERE

ABOVE:
Facade of Dali's pavilion
under construction

RIGHT:
Dali in "Venus" workshop

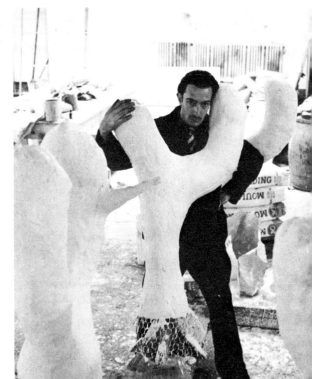

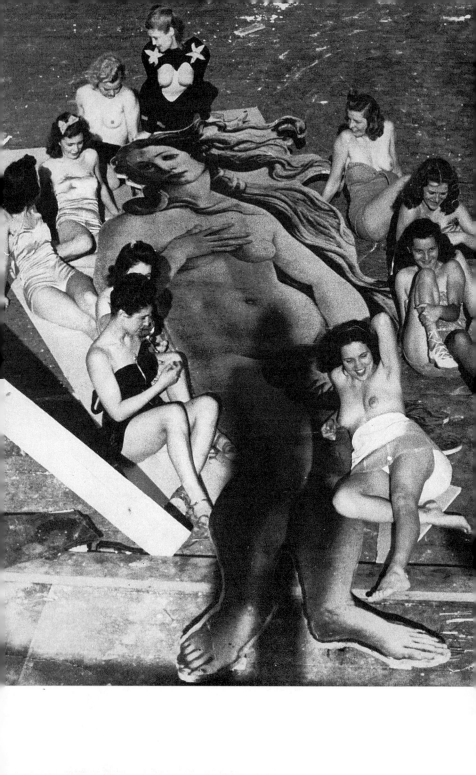

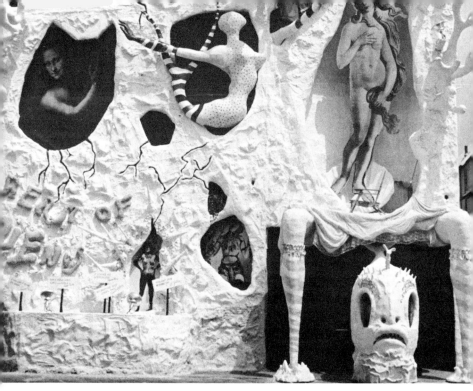

LEFT:
The mermaids resting on the roof with Botticelli's "Venus"

ABOVE:
The completed facade

RIGHT:
Unidentified model, George Platte Lynes, Julien Levy, and Salvador and Gala Dali at the time of the "Dream of Venus"

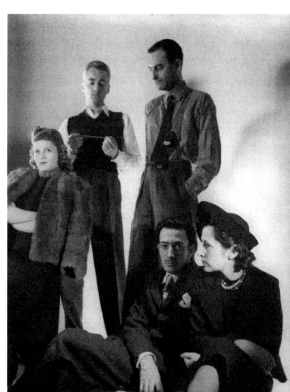

(Left to right:) De Diego, David Hare, Jacqueline and Aube Breton

(Left to right:) André Breton, "An Anxious Friend," and Max Ernst

Ernst and Julien Levy at the summer cottage they shared on Long Island

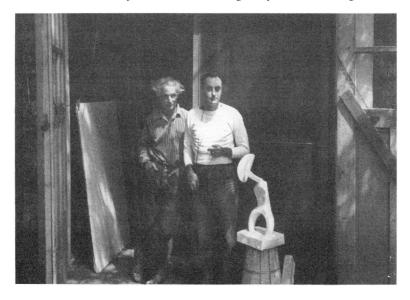

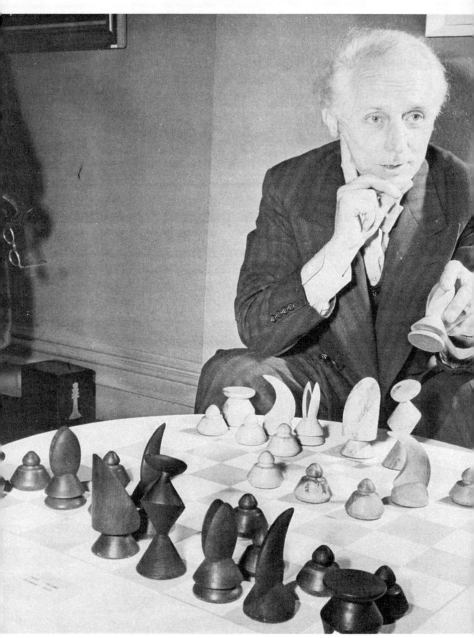

Max Ernst and his chess set

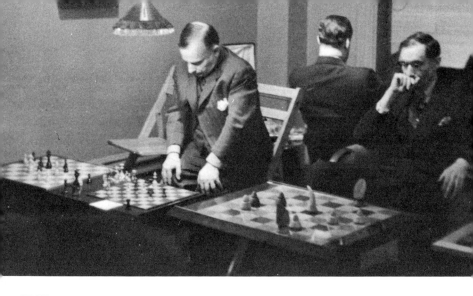

ABOVE:
A blindfold chess match between Grandmaster George Koltanowski (back to camera), Frederick Kiesler (left), and Alfred Barr

BELOW:
Julien Levy and Marcel Duchamp on break during the filming of Hans Richter's *8 x 8*.

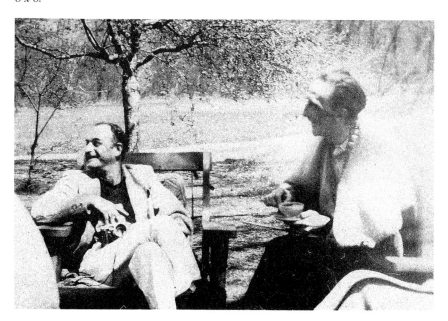

Julien Levy in Hans Richter's *Dreams that Money Can Buy*

An early photo of Yves Tanguy, 1924

Arshile Gorky shortly before his death

gant about what they called my "slumming," too proud to admit the economic necessity which had, at least in part, determined my choice of passage. Étienne Bignou was aboard with his patron, Albert Coomes Barnes. I had seen them earlier on the pier and Bignou asked the number of my cabin. He had seemed shocked. Wouldn't it hurt my prestige with my clients that their art dealer did not travel first class? I smiled grimly. What clients? All that I had were happy accidents.

"You must come upstairs and have all your meals with us," invited Raoul generously.

"Everybody happy?" asked Villard, the purser, as he knocked and then stepped into the cabin to greet Raoul, his distinguished compatriot. He spoke in English because he knew the cabin was occupied by a Frenchman, as he would have asked, *"Tout va bien?"* had the room been filled with Americans.

"That reminds me," I said, turning to Reine, "of a marvelous little Chinese restaurant where we sometimes eat. The headwaiter always asks, *"Anybody* happy?" Reine laughed, Villard looked politely puzzled, Raoul asked Villard to give me a pass to enter first class whenever I wished. I used the pass but once. Why did I not stay in this friendly and upholstered atmosphere? Why did I negate all the connections and advantages that should have kept me safe? I thought, "I must change patterns, find new painters for the gallery—go far afield." But this was an excuse and I knew it. I was really ready to explore.

For some time cabin boys had been parading the corridors with their familiar racket of departure, beating great brass trays to warn visitors off the ship. Now the engines were slowly throbbing. Upstairs in the marbled and carpeted public rooms there was little sensation of sailing, but down in my quarters one could smell the salted paint and wet rubber, and that was as desirable to me as fresh linen and darkness before voyaging into sleep, although there was a subtle difference this time— more like fresh linen combined with disinfectant, darkness with falling, the throb of the engines like the humming in one's ears before going under ether. It would all be for the best, no doubt, and it was too late now to fight back toward shore.

A group of doctors and nurses had cabins near mine. They were on

161

their way to Loyalist Spain. They were all very young, and although they tried hard to remember to be serious about their adventure, you could see they wished to boast. They were gay because they were risking their lives. Now they were singing the "Internationale." The Front Populaire was dominating French politics. Was this revolution I was approaching? Some of my friends among the Surrealists in Paris, conspicuously Louis Aragon, had joined the Communist Party. I myself had studied Marxist tracts. Some painters in America were making "socially conscious" paintings. Allen Porter flippantly called them "socially unconscious" and told the old joke: stopping a demonstrator in front of a striking factory, he admonished him, "It will never get well if you picket!" These unrealities America had democracy, and New York had . . . but New York was not America . . . that was yesterday . . . and the day before. . . .

I wished no lifelines played out as we sailed, tying me to some past anchorage, no attenuated umbilicus. I was to disembarrass myself of the new world and return to the old, and I was granted five days in which to do so. This is not difficult on a ship. You need only sit, and the ship travels for you. The high seas are a strange element, a suspension between the influences of two continents. In measure as you left one influence, it faded, if you permitted it, while the sea winds cleaned cobwebs from your head. In like measure the new became clear. You did not ever speak arrogantly of dollars while traveling in France, and expect to know France. With the purchase of your steamship ticket you bought your sum of francs. On the boat both currencies were in use, but you gradually disposed of your remaining change, down to your nickel and dime, until on the last day of voyage you tipped and talked quite naturally in terms of French money. Once on shore you had also to forget the boat, and I found this required the exact length of time as the voyage. For five nights my bed rolled, for five days my stomach would not take easily to the new food. Friends in Paris asked eagerly for news of friends in New York and I replied with a certain immediacy of recollection. But after five days I was living abroad.

By the second day out, conversation in the *fumoir* concerned politics, of a sort. There was a professor of literature from the Sorbonne, an

aged, highly rouged *chanteuse* from some nightclub in Montmartre, and a tall Australian who professed to be a British Intelligence Officer, but if this were true would he have divulged it? He had a good public school accent. Perhaps he had been in Intelligence. Perhaps he had retired. He had a mad light in his eyes and lent an element of brilliant uncertainty to our gathering.

"Destruction and betrayal!" he would cry. "My friend Colonel Lawrence used to tell me—"

"You mean the Front Populaire?"

"No, that will pass. They are children. They were never allowed to play, and now they have a sport—but they are not clever. It is the ghosts that are about. France has always had ghosts. She is an old country. But the man who will learn to control the ghosts. . . ."

The nurses and doctors at a table across the room broke into the "Internationale," raised their fists in salute toward us. The *chanteuse* waved back. "What beautiful children," she said. "What a potent salute, that with the fists."

"You see? Children, children. . . ."

"If you, madame, and you, gentlemen, will permit me?" said the Australian. "Stalin has concluded, or is concluding, or will conclude, an agreement with Hitler . . . the necessary. . . ."

The French professor was trying to catch my eye. He tapped his head ominously, while the Australian twitched and jerked with an almost epileptic eagerness to explain.

Madame had finished her drink and ordered another, one of the dark-green Pernods, stronger than yellow; a near imitation of absinthe and calculated to give you a sort of slow, frozen lucidity, timeless and inanimate. She asked very distinctly: "Why does not that Hitler drink and eat like a man? Myself, I have no affection for vegetarians. Madame, the concierge of my domicile, was one of these, and it arrived that she left the Church and became Protestant and very pessimistic. Myself, I am Catholic of the best, and very optimistic. And I say a little drinking is not bad for men. The best ideas would flow in profusion, and all the statesmen would know their place without grave effort. With a little abandon it would all be *tellement raisonable.*"

The professor was quivering in his chair and scattering potato chips in excitement. "She is magnificent, that woman, magnificent. A little abandon and we shall have love . . . philologically it is evident . . . orgy and orgasm . . . very good!"

"One must drink, and one must disrobe." Madame pulled her dress down from one shoulder. "Oh, no, do not prevent me! We must *all* disrobe. It is more like war than like love if some abandon themselves and others defend against that abandon. We must take everything off except charity, preserve always some charity." The Australian had taken out a little notebook and was writing down, apparently, the conversation in detail, while I roared with laughter as I considered the spectacle of certain people I knew clothed only in their charity.

So the voyage passed; all our conversations haunted by that cadaverous rogue of an Australian with his infernal notebook and his prophecies that left me feeling that the world of daylight and recognizable men was fast rushing toward sundown, secret occupations, and the dark magics of night.

The boat was delayed. We were told it would not dock until late evening which meant the boat train would arrive in Paris long after midnight, not a comfortable prospect.

"Why don't you and I stay in Le Havre for the night?" It was the Australian. "We'll be in time for a late bit of supper at the Grand Tonneau."

In Le Havre . . . why not? A town through which countless tourists pass and few would think to stay. "Is there a good hotel?" I asked.

"Sure to be," he answered. "See you on the *quai*, my dear fellow, cheerio!"

I did see him on the *quai* for a moment, and then he disappeared. Nor did he reappear the whole time I was in Le Havre, nor ever again, anywhere, for all I know. I cleared my baggage and ordered a taxi to drive me to a central café, where I ordered a drink and asked the waiter if he would watch my bags while I looked for a room nearby. If I did not intend, as the Australian had suggested, to pass my night with a girl, neither did I intend going to the Hôtel de la Gare, or the Grand, or the Ex-

celsior. I was learning my lesson. I would never be a tourist again, I hoped, and it was amazing what a different, intimate face Le Havre put on for me while I was in that mood. I walked for five minutes, chose a little hotel with the most appealing façade and, sure enough, they had a room for me. A lovely room, not too clean, the walls stifled with violent wallpaper flowers.

Remembering the name, I found my way to the restaurant of the Grand Tonneau, and the food was delicious. I ate *escargots* and *bouillabaisse* and *langouste,* as much of everything as I could. During the meal sounds of many mechanical pianos nearby made a network of exciting discord in the room, for as is often the case in France, the best restaurant adjoins the redlight district, sustenance for all the senses in convenient proximity.

Then I visited the streets of the mechanical pianos; the streets of the moon, of the beautiful chickens, of the mystic numbers 11 and 14 and 21. Streets where the dim lights and shadows play a more ominous game than anywhere else in the world, where the thin dogs are more wise and furtive than they should be and all cats are fat and content; where the aches of desire and the courage of consolation play a whispered hide-and-seek; where, nightly, the eternal dance of wish and fulfillment completes its circle most quickly and on the shortest radius. By good fortune the first house I entered, Le Chat Noir, was the best I could have hoped for, and I looked no further. I have been in Le Havre twice since then, and found grander and cleaner establishments, but none as warm and gay, as generous and as grotesque. The "girls" were fairly aged and their shapes not at all neatly matched. Some would say they had been willed to posterity by Toulouse-Lautrec, peacock feathers as a girdle for one, a tiny Spanish comb to embellish the private hair of another, chalk-painted faces with scarlet spots and streaks—female clowns, laughing and crying easily—given to dancing and buffoonery. They could be generous in this house, whether or not you were able to buy drinks around. Who would minimize or excuse Toulouse-Lautrec's life with these ladies? Why, the little man must have felt like the biggest of giants, prolific and content!

With rounds of *vieux marc* for the girls (but why was the *marc* always called *vieux,* and the women always *girls*?) the evening was passed in dancing and song.

<div style="text-align:center">

Et la servante est rousse
Ces jupons se retroussent. . . .

</div>

The door was soon locked against other customers and liquor flowed freely. Madame herself came to my table and described for me the peculiarities of each girl. "That Gabrielle, she is a mad one. I did not have to ask her twice to live with us, not her. She must have a man to love her all the time, and often enough she gives her own *sous,* for love, would you believe it? *Voyons,* Gabrielle! Do your dance." And Gabrielle, giggling vacantly, did her dance. Evidently she was a simple one, but honest. And there was Lili, the prettiest, who would not leave her friends here for better employment anywhere. She mothered all the girls, and had a daughter of her own, somewhere in the country, for whom she was saving money. Several of the girls were knitting or sewing, and Lili was crying quietly about her baby, not professionally but because drinking made her sad.

If this were vice, it was very homely.

When it came to settling the accounts, it was all on the house. Madame said, "But there is nothing to be paid for by you, Monsieur Malraux . . . let us show you something." And she led me to the bedrooms. Under each mattress was a pile of Communist tracts. "My girls distribute these to all promising clients, sailors in particular. You see we are workers, Monsieur Malraux."

Monsieur Malraux? "Allow me to show you this—" And she held out a well-thumbed scrap from the provincial newspaper. A photograph of André Malraux, recently returned to France, looking indeed in this blurred image something like myself.

I tried to track down some paintings by Christian Bérard, known in Paris as Bébé. He was the most elusive of the Neo-romantics and extremely talented. Jim Soby had expressed interest in buying several, and

this wish was a command. Bérard, however, was impossible to find. He was in virtual hiding since he had become addicted to opium through his friendship with Jean Cocteau. The only introduction to Bérard I could uncover would be via Cocteau. And I had yet to meet Cocteau, although I had given an exhibition of his drawings in New York—assembled by George Platt Lynes on one of his visits to Paris. Cocteau was well aware of me, but I also had an introduction from a Harvard acquaintance, Philip Lasell, who was now living in Paris and was also smoking opium heavily.

Cocteau invited me to one of his *levées*. He received me in silk pajamas in his hotel room after his breakfast pipe and before his luncheon pipe—around 11 A.M. We had a pleasant conversation until I began to be dizzy, with my mind slightly disoriented. I had a short waking dream; it seemed of a Chinese setting; and Cocteau interrupted me to say, "Those weren't pagodas. Those were actually Burmese temples."

"How did you know what I was thinking?"

He said, "If you've never smoked before there's enough smoke in this room to give you a slight touch of opium, and any smoker often has a telepathic connection with other smokers. Our minds seem to connect. *I* had this vision of these pavilions while you were having them, but I know they were Burmese."

"How was it," I asked him, "that the opium dream was Oriental?" He explained, "They almost always are, even for a Westerner. It probably isn't an inherent factor of the poppy but some sort of association that we have from childhood that opium smoking is a Chinese vice. Chinese dreams are frequent as the pipes are made in China. So are my pajamas," he said with a smile.

As we talked on, certain disturbances came from the corner of the room. A knocking and clattering, and then from another corner, more knocking and scraping. Cocteau got up and went over to the corner and said, "Quiet! In a little while. . . ."

He rapped on the door of a wardrobe, "Quiet. For a little while longer."

He rapped on a drawer of the large bureau and said, "Quiet for a little while longer."

At that moment the door of the wardrobe at the far side of the room burst open and three young Annamese boys spilled out. They were all very tiny.

"Ah!" said Cocteau, "I'm afraid my secret is discovered. You can come out now," and the other cupboards opened, he slid open bureau drawers, and more little Annamese appeared. "They are all hangovers from my party last night," said Cocteau, "and I hid them away before you came for fear that you might misunderstand."

Before I left he gave me a present of a drawing signed to me: *"À un companion de la table ronde."* And he promised to try and help me to Bérard, but that was never accomplished.

My friendly meeting with Cocteau and exhibition of his work was, of course, anathema to Breton and the Surrealists. Although Breton never gave any precise reason for his stand, I knew he was unalterably against the use of drugs or any form of manipulating the consciousness. The idea of heightened consciousness, he held, should come spontaneously from the release of the subconscious, not from chemicals. Chemicals confuse the issue, whereas the subconscious, curiously enough, clarifies it.

I had been in Paris several day when I met Leonor Fini. I had already heard about her; she was "that Italian woman," or some said "Brazilian"; she was "ageless," or "twenty-two years old," she was "magnificent," she was "impossible." Paul Eluard said, *"Quand c'est Fini, ça commence!"*

At a large reception she had worn a fur coat. Pressed to take it off, for the evening was warm and the gathering indoors, she finally shrugged and threw it aside. Beneath the coat she was nude.

She told me of having invited for tea a man whom she wished to punish. She stuck double-edged razor blades along the bannister. The visitor climbing the stairs did not notice the fine incisions until they bled. By this time he was accepting his tea, and was astonished when La Fini struck. "You pig!" she is supposed to have cried. "You dare to visit me dirty with blood!"

She also told me about a painter who left his canvas in her studio, asking her to study it and suggest what he should work at next. She cut

it into small pieces and mailed it to him with a note, saying: "I am sorry, I could not find a larger envelope."

She was stopped when she tried to visit a museum carrying an umbrella. "They drip all over the museum." "But the sun is shining," she protested, "the umbrella is dry." The attendant insisted that the rule was "no umbrellas." In a rage she was later discovered squatting in the middle of one of the museum galleries. "I just want to show them," she explained, "that it isn't only an umbrella that can wet."

Ho-la, La Fini!

Her paintings were said to be well worth my attention, so I asked for her address and called one afternoon.

She lived in the rue Payenne. No taxi driver was familiar with that street though it was in the heart of Paris. The people who lived there did not take taxis. "Quartier Saint Paul," I explained to the driver. The buildings in that quarter, once of great beauty, are now slums squeezed between a ghetto on one side and marvelous cheap markets on the other. Eugène Berman used to live there too. It was his kind of place. Before the façade of Mlle. Fini's apartment building, which had been a palace, there was a garden. Egyptian and Druidic piles, dismembered arms, and the stone heads of Crusaders, covered with moss, were embedded in the lawn. I am told that this property served as storage for the Musée Carnavalet.

The concierge directed me to the apartment. *"Au fond de la cour, deuxième escalier et troisième étage à droite."* I stood before the door. The corridor was gloomy. I knocked. Within I heard the scurrying of steps and the yowl of some animal. A cat? Doors creaked on their hinges, and silence again, perhaps of preparation? Then the outer latch was lifted, and what seemed to be a supernatural face was before me. Leonor was in the doorway. To illumine her features a torch was held by a black, a black man of wood. A low voice with a moving musical timbre spoke: *"Entrez, Monsieur Salaud,"* which meant, "Come in, Mister Punk." For an instant I was transfixed with surprise, and then I walked into the room as if blinded, making for the nearest chair and determined to show no sign of embarrassment.

"And so you are Levy? I thought you would be an old man."

I dared, for an instant, to eye her fully. Her hair stood about her face like a blue mane; golden hair tinted blue, or was it dark hair dyed blond, then blue? Not a beautiful woman; her parts did not fit well together: head of a lioness, mind of a man, bust of a woman, torso of a child, grace of an angel, and discourse of the devil. While her eyes were her most arresting feature, large and deep black, her allure was an ability to dominate her misfitted parts so that they merged into whatever shape her fantasy wished to present from one moment to the next.

"Si je porte les trous bien?" she demanded.

She was dressed in rags, or rather a gorgeous robe deliberately torn. *"Tout trou* —too true. . . ."* I murmured inanely. The luxurious beggar maiden of King Cophetua, enough to make one's senses reel. Had she practiced before a mirror, I wondered, to be able to discover for you at will a sudden bit of white thigh through the rent skirt, through the artful holes a tip of bosom, or the shadow of an armpit?

She threw her arms high, while bracelets and tattered sleeves cascaded brilliantly from wrist to shoulder.

"Tell me, who is this Sangodin?" (Augustus Saint-Gaudens, director of the Carnegie Institution). "He wants paintings of mine to exhibit in Pissbourgh. Where is Pissbourgh?" She stiffened, seemed as if dead, suffocated. "I think it must be an understudy-city, always hoping the leading-lady-city will die. Sangodin howls outside my door like one of those dogs that try to bring cognac to people lost in the snow." She strides across the room; her eyes blazing: "Shall I beat him? He is not really dangerous, shall I have my *pussycat* scratch him?"

The rich crimson rags which hung about the room concealed a battery of colored lights, as on a miniature stage, and these were operated by imperceptible threads strung through the draperies as if they were cobwebs. The disorder of the room was monumental. Soon after my arrival I noticed that on the floor lay little heaps of excrement. These had been carefully sprayed with perfume, so as to be distasteful only to the eye.

The night of June 24, traditional time of the Witches Sabbath, Leonor invited me to form part of her entrée at a party given by Tristan Tzara. A small, dapper little man wearing a monocle, Tzara had been one of the

originators of Dada, then had been a Surrealist, and seceded from that to become Communist. His wife, a splendid Swedish woman, had bought him a house in Montmartre. She was away, and Tzara planned to celebrate in the proper Dionysian manner on the roof garden of their house.

Shortly after dinner we assembled at Leonor's to devise costumes. Max Ernst was there, and an Italian girl who was a friend of Leonor's. I can't remember the others—about eight in all. Leonor possessed a wardrobe of varied masquerades. The wardrobe was flung open: silks and satins, masks and boots, girdles and stage-jeweled coronets were spilled knee-high about the room. We tried on this and that, criticized or admired each other, until everyone was dressed within the rules which were that we be nude only from chest to thigh. Leonor wore knee-length white leatherette boots and a cape of white feathers. Blue feathers and tinsel dust were sprinkled in the curls of her hair. Max wore a belt of iron spikes, a headdress, and breastplate made from scouring mitts that were squares of shining wire cloth used to clean pots and pans, and sandals with gray wings attached to their heels. I found and wore a bullfighter's bolero and brown hip tights stuffed with false muscles. The Italian girl wore epaulets on which she had sewn streamers of multicolored ribbons, and garters, also with ribbon streamers. The others by this time had locked themselves in the big bathroom, seemed disinclined to rejoin us. We went on to the party without them.

We arrive at Tzara's in expectation of extravagant gaiety. It was near to midnight, at which time a great bonfire was to be built on the apartment roof, a procession was to form, dancing in the dark was to be lit only by the fire's flames. Each of us in turn was to leap over the fire, and that one who leaped highest was to be king or queen of the orgy.

Tzara wasn't there. He had gone to buy red wine. He had been away quite a long time and the twenty-one other guests, one of whom was female, sat cold sober waiting for the party to begin. Max offered to buy cognac, which he relentlessly served to the one girl not of our own band, a pretty model from Montparnasse. There could be no Walpurgisnacht without her, and Max devoted himself to her intoxication. She was then persuaded to take off her clothes and jump over the fire. But she jumped short, and the soles of both her feet were painfully burned.

171

Tzara returned. He was in time to assuage her burns with butter and her spirits with red wine. "Let us be happy," he begged, and several of the twenty grim men who had now had enough of Max's cognac were inspired to make love to the model, who seemed to welcome the attention, forced as she was to remain horizontal because her feet were burned. The scene was not appetizing, nor was it helped by Leonor's horrified whisper: "But everyone knows her! And knows she has a *disease!*" I had seen enough, and lost all the enthusiasm kindled by our fine costumes and excited expectations. But before we could leave, Tzara insisted I must follow him to the basement. He had a painting he wished to sell, which I did not wish to buy, and so the orgy ended in unpleasantness.

Waiting for a taxi to take us home, Leonor stamped her boots on the sidewalk, sat down on the curb and cried. She really was a crazy little darling. I was willing to doubt that every Walpurgisnacht need be as desolate as this one.

Years before, when I was fourteen years old, traveling in Europe with my parents, I had been forbidden more than moderate sips of the wines and alcohols served at every table. Then, one evening in Paris, my father and mother planned to go with friends to the Folies-Bergère, and I was told to stay at home. "Why?" I asked. "Because it isn't good for young boys."

"Why?"

"Because."

Later, my parents having left, I set forth alone. It did not prove difficult to buy standing room to see the Folies, it did not prove exciting either—except the subterfuge to dodge my parents, who were not even looking for me. The game soon wore thin. Walking home, I thought to offset my disappointment by a new exploit: getting drunk. At a café table I ordered a green chartreuse, followed by a cherry brandy. Then, considering that the waiter had eyed me suspiciously, I paid and moved to the next bar, where I drank anisette and cointreau. "I don't feel drunk," I told myself, and resolutely moved on. Thus within a short time, covering about three blocks and six cafés, I consumed twelve

mixed drinks. Then it hit me. How I got home I will never know. I must have told the waiter my address in the split second between being entertained by all of Paris revolving rapidly around, and that next instant when I was cold and *out.* I awoke several times during the night, in my own hotel bedroom, violently sick and nursed by not two, but six images of my mother swinging round the bed. The next day I could swallow no food, but the day after I was well enough to receive my father's reproach. I should have been a thoroughly chastened boy, but when my father concluded by saying, "You see how sick drink makes you, and I trust you have learned a lesson," I wondered exactly what lesson. "Other people drink," I said. "It seems I must just learn *how.*"

I was a brat, quite evidently, but that desperate skepticism I never lost.

It is not unusual to hear people say, "I'll do anything once." But Virgil Thomson agrees with me. One day he remarked, "I'll do anything twice. Once to find out how it is done. The second time to find out what it's like."

When I again saw Dali, in this summer of 1936, he was no longer the half-timid, half-malicious foreigner, but now expensive and elegant and quite formidable. His connection with Pierre Colle was severed. Colle, I was told, had closed his gallery and was off on an escapade in the Midi with the *chanteuse* Damia. Dali had become his own impresario and the darling of that part of the Paris *haut monde* which patronized the arts. He now owned a house in the suburbs out past the Lion de Belfort, which had been remodeled with the help of the gentleman architect whose models I had exhibited two seasons before, Emilio Terry. Coco Chanel and Elsa Schiaparelli competed in the robing of Gala.

I received an elegantly engraved card with Dali's new "crest," the splash of a drop of milk which, stopped in its motion, formed a pearly coronet, an invitation to an exhibition of his recent paintings to be shown at his house for one day only.

The house, in its simplicity, surprised me. I had expected at least some of the Neo-baroque fantasy of Emilio Terry. There was none, nor was there much of Surrealism. The house was white stucco, inside and

173

out, furnished in monastic simplicity with Spanish provincial pieces. He owned a fine collection of modern paintings, discreetly hung. Most notable were a good half dozen fine canvases from the best metaphysical period of de Chirico, almost all dated around 1916–1917. A convex mirror reflected the room in miniature. Dali's own pictures were hung in the large studio which was the entire top floor.

The reception was crowded and eminently chic. There was *"Tout le monde,"* that phrase signaling success and corresponding to our "everybody who is anybody." Dali paid me scant attention. If I were still his American dealer there was no indication, nor was deference being shown. I had no contract, all my previous business having been through Pierre Colle, but I had been presuming on some sort of unspoken agreement since I had been continuously promoting and defending Dali in New York. I had not yet learned that he was scrupulous in regard to agreements, and I was further disheartened when I discovered that none of the pictures were for sale. "They have all been sold already," I was told by Marie-Laure de Noailles. "Not even I have been able to buy one for myself, but then at least he has promised to do my portrait." A pause, then, *"Sales Anglaises,"* she concluded, enigmatically.

Ever more disconsolate, I wandered through the studio. The pictures, I thought, were the most beautiful Dalis I had ever seen. *Tout le monde* was chirping ecstatically, and Dali gave to the chatter of each and every guest his full attention. He often lost himself in enthusiastic, vociferous explanations, sometimes in answer to the most polite and insipid remarks. Gala must always stand nearby ready tactfully to interrupt. She, too, was too intent to say more to me than *"Bonjour Monsieur,"* and *"Bonjour Mademoiselle"* to my companion. I had brought Leonor Fini. I had hoped to shine in her esteem as someone of some importance at this reception. *"Foutons le camp,"* suggested Leonor, "let's take off."

Then, all at once, the volatile Dali took notice of me. He kissed me on both cheeks. *"Ne foutez pas,"* he said. Leonor must have spoken in no mere whisper. "You must meet my dear friend, a good friend for us both, I hope. May I present Monsieur Edward James."

For longer than was polite I was unable to identify whose voice now entered the conversation.

"For quite a time I have held the wildly improbable notion that Julien Levy was a black. You have deceived me." The voice concluded with a sharp, self-conscious giggle. I looked down at least a foot to perceive a pretty and well-proportioned, very miniature young gentleman.

"Edouard, he has acquired the Dali *chef d'oeuvres* of all this year," Dali confided, then moved on, leaving us alone.

"But I promise you, my dear Levy, I assure you I count implicitly on you to show them for me next season in the States. You will, won't you? Dali has assured me. . . ."

"But there would be none for sale?"

"Oh, but there would. First I am to lend them to Lefevre of London. But I have no expectations of great sales in London. I am a prophet, there, you know, in my own country, England. And from those that I do not sell I shall eat a few. You remember, of course, the man with the cream puffs in Robert Louis Stevenson's *Suicide Club*? And those that I do not eat I shall send to you to sell. All honor to me, all profit to Dali and you. Prosit?"

I was never to tire of listening to Edward James. There was, of course, the fact of his indefatigable patronage. But more compelling, he was a poet of sorts, and his precisely clipped, beautifully rounded phrases put one in mind of the speeches of Winston Churchill—one octave higher. And whatever he said never fell short of utter extravagance.

Virtually a present-day adumbration of the mad Ludwig of Bavaria, capaciously rich and richly capricious, he was only a little less than Ludwig in wealth and eccentricity.

In honor of Dali, Edward told me, he had installed red-gold lobsters as mouthpieces on all telephones in his Wimpole Street house. And for his country place in Sussex there was to be a Surrealist garden, in which he had already placed statuary in the form of Lautréamont's "Chance Meeting of an Umbrella and a Sewing Machine on a Dissecting Table."

It would not be long before I heard of more eccentric projects. The story was told of how he conducted his aunt (or great-aunt) on a tour

175

around the world—while merely traveling back and forth between the Hotel Roosevelt and the Commodore. He had promised aunt to take her traveling. His sole problem was a reluctance to leave New York, where he was having the time of his life, engaged in an absorbing affair of the heart. However, old age had rendered his aunt blind, and with this in his favor Edward contrived their travels. He had a machine built that would rock a bed which he had installed in a room at the Commodore together with a wind machine and various other contraptions to simulate a sea voyage. When this was ready he wrapped the aunt in warm travel togs and drove her in a taxi for several city blocks before winding up at the Commodore, where she was helped up a gangplank to her room, and that evening, with the toot of whistles and sound of a foghorn, the bed began to roll. A cast of jobless actors were employed to impersonate purser, steward, and ship's doctor. Fortunately the aunt became quite seasick and there was no need to walk her on deck. Edward had considerable freedom to devote to his New York activities throughout the voyage. Arriving at Le Havre, aunt was again walked down the gangplank, traveling by "boat train" from New York to Mount Vernon and back, and was reinstalled in her suite at the Roosevelt, now provided with a *femme de chambre, garçon, concierge,* and a chauffeur to drive her to French restaurants in the West Forties. And so around the world for several months, or until Edward had worn through his affair of the heart and was ready to take his aunt back to England.

From Charles Henri Ford I learned of a similar charade, a little more cruel, this time perpetrated on poor Pavel Tchelitchew. That delicate and haunted artist was once a guest of Edward on Capri. Edward was determined he should see the Blue Grotto, especially determined as he knew of Pavlik's intense fear of crossing water. But, as with Dali, so with Tchelitchew, Edward was becoming that painter's great good friend and patron, so for Pavel to deny Edward his wish was tantamount to denying his bread and butter. One lovely cloudless day Tchelitchew at last consented to set sail for the hour-long voyage to the grotto on a privately chartered sailboat provided by Edward James. Also provided was a specially rehearsed cast of extras from the local opera.

On the return trip, one of the sailor-actors detected an ominous cloud in the sky. Tchelitchew could see nothing but benign blue, but the captain was consulted and he was fearful, too, from signs his instruments had given him, that they were heading into one of the deadly sudden hurricanes that occasionally devastate that coast almost without warning. A gypsy woman in the galley had the gift of second sight and straightway discovered death by drowning in the palm of Pavel's hand. Overcome with his not unexpected trepidations, Pavel allowed himself to be conducted, for greater safety, below decks, where he was soon joined by the entire cast of emotional sailor-actors and galley cooks moaning and praying in torrential stage Italian that the Holy Virgin might save their souls. This close brush with sudden drowning was one from which Tchelitchew recovered only with difficulty after several days safely in bed in his room.

Such a penchant for elaborate practical jokes, combined with the money to execute them, made of Edward a rather unpredictable friend, and I prepared to be on guard. Meanwhile, my first meeting with him concluded amicably.

After I had more or less arranged matters for Dali's next show, I drew Leonor from the reception. She had become involved in a conversation with Picasso. Dali, already feuding with many other artists, had invited none but this compatriot. Leonor introduced me, and Picasso agreed to leave with us for an aperitif at the café down the boulevard, the nearest one we could find. It was then, at that café, Picasso made an illuminating remark about one of the disconcerting innovations in his recent pictures—the double profile.

"Is this woman with one eye, or three eyes, a development of Cubism?" I asked Picasso.

"Not at all," he answered. "This double profile, as it is called, is only that I keep my eyes always open. Every painter should keep his eyes always open. And how does that arrive at seeing truthfully, one eye or two eyes, you may ask? It is simply the face of my sweetheart, Dora Maar, when I kiss her."

"Look!" Picasso seized a pencil and began drawing on the napkin.

177

When Picasso had concluded his illustration and put the napkin aside, I reached for it. Quickly he snatched it away. Ever since I have wondered why he regarded me with such a degree of suspicion. But Leonor laughed. *"Tu vois comme il retient sa merde même,"* she said with the peculiar whinny which always accompanied her choicest insults.

BERMAN

When Berman obtained his visa and came over to live in America in 1936, he stayed with us until he had time to become acclimatized and find lodging for himself, occupying our guestroom for a few weeks. We had just moved into a new apartment and had rooms to spare. This vast domain was quite near the gallery, an apartment on the corner of 55th Street and Madison Avenue. It had been captured at a price to fit our economy because I read in the papers one day that Polly (*A House Is not a Home*) Adler had been arrested and her call house, this apartment on East 55th Street, had been closed. "Joella," I said, "here's a place that must have more than enough rooms for us." Not only had we been feeling cramped in our current quarters, but Joella was expecting our third child, Jonathan. "That place will be hard to rent now. What do you wager that the landlord will be only too glad to re-lease it for a song?" And I proved right. There remained the expense of redecorating, although I rather liked the gilt flamboyance left behind after the Polly days. Joella found it, however, too gaudy for the children, and I had to admit it might not be altogether appropriate for our business entertaining. Some of my more serious paintings might suffer. Jonathan, my youngest son, was born there, delivered with Christian Science. He would later, with some justification, tell his schoolfriends that *he* had been born in a whorehouse.

With Berman as a houseguest we enlisted his aid in choosing a rather somber color scheme for the foyer, living, and dining rooms. Darkest of all of his ideas was the deep purple dining room, but this might be alleviated, he suggested, by murals that would open up bright vistas on three of the walls. "Agreed!" The scheme was grandiose. We were all very excited. There had been a worry in the back of all our thoughts: on

179

what further monies would Berman exist? The annual sum guaranteed by his contract with my gallery for the sale of his pictures had sufficed for living in Paris, but was rapidly disappearing in New York. I had signed immigration papers for Genia, making myself responsible for him, guaranteeing that he would not become a derelict upon our nation. But neither Joella nor I wished him to become a permanent guest or "Uncle Vanya" in the heart of our household. Painting murals might provide a very good additional source of income for Berman. The three planned for me could serve as samples; and as I really couldn't afford to own them, it was agreed that they would be painted as removable panels so they could be transferred to the gallery for exhibition and eventually resold. They were, several years later, to a Philadelphia collector. The cartoons and sketches, as soon as they were in progress, were shown to Jim Soby, who immediately commissioned Berman to execute a further series of murals in his new house that he and Russell Hitchcock were re-modeling in Farmington, Connecticut. Later Wright Ludington invited Berman to visit him in California and paint murals for his stunning new house in Santa Barbara.

I took Genia on varied excursions around New York. Some of these forays were concerned with finding a studio where he could live and work. Others were just sightseeing tours, but of a special nature. I tried to think of locations for his pictures. Some mornings, early, Genia and I would ride a subway to the docks and warehouses on the lower East River where picturesque fishing boats were anchored in the off season. Perched on a cluster of wharfside piles, he would work with a sketchpad on his knees, using brush and black india ink, effortlessly, rapidly. I would scout up and down the streets for additional points of view. In the early fall season there was no imperative need for me to be at the gallery before noon. Allen Porter would open at the usual ten o'clock and sort out the morning mail, answer the telephone, and attend the very few visitors who might drop in at that early hour. I would come in to relieve him at his noon lunch hour. Joella would sometimes be there in the morning, and was always available in the apartment nearby. We were all equally familiar with the routine and demands of the gallery.

Genia liked good eating and he had been the first to introduce me to

some of the cafés near the markets in Paris. In my turn, I now stopped in at the Washington Market one morning when we were on the West Side and showed Genia how to pick up late breakfast tastes and snacks, wandering from counter to counter accepting samples, a clam here, a fritter there, a generous slice of cheese, combined with anchovies, honey, duck eggs, and a slice of mango. I am not really sure that Genia enjoyed this. He said little and eyed me with a skeptical and tolerant disbelief. I realized that I was trying to show this European such European aspects of my city as I could desperately scrape up. "But he might prefer that someone show him the Statue of Liberty," I thought with exasperation. My aim, setting myself up as an impresario, was to introduce Genia to those elements of our landscape that might lend themselves to his technique: our vistas and courtyards, ruins and constructions, scaffolds and corridors, that expressed our own aspects of nostalgia and romanticism.

One evening as we sat on a penthouse roof I pointed out the splendors of aerial architecture, plateaus of cupolas, balustrades, temples, mosques, and roman citadels that were the unnoticed water tanks and ventilating shafts of a vast plain floating above the clouds. But Genia just turned to me with vaguely disbelieving eyes; he saw only what was missing, not what was there. He longed most definitely for Rome. As the sunset striped our rooftop cityscape he began to conceive of his new pictures not as dark New York phantoms, but as rainbowed, with Baroque egrets. Berman's New World style all at once became a theatrical Old World memory.

At dinner I would say, "Can't you see, Genia, no one has the painting vocabulary you possess to redescribe America through the eyes of a visitor. A series of paintings of New York from your point of view would be a revelation and an education for us—and commercially, a sensation."

"I don't see it so much that way," said Genia.

Then, after supper, we went to one of the Askew soirées and Genia found two of his old friends from Paris, Virgil Thomson and Maurice Grosser. Virgil asked Berman to lunch with him the following day at his studio room in the Hotel Chelsea to meet a couple of American musicians, Aaron Copland and Paul Bowles. There were prospects of some

ballet productions and Berman was interested in designing some stage decor.

Berman went off for awhile with the musical crowd. "Mimi" Pecci-Blunt appeared in New York and gave some elegant private musicales. Genia invited Joella and myself. He now became more our host than our guest. The ballet dancer Alexander Iolas found a studio for him on the top floor of a brownstone where Iolas himself had a little furnished room. Genia moved out of our apartment and started to paint our murals in his new quarters. One day he brought us a little grisaille drawing: "For Julien & Joella." It was a sketch of the largest of the three mural panels. Stretched beneath it, on the floor, was a recumbent Berman. It was signed: "O.K.—K.O.—Genia."

Giorgio de Chirico

The terrible-tempered Dr. Barnes no doubt had much to do with Giorgio de Chirico's first visit to the United States. He probably paid for his passage and certainly intended to play a prominent part in the presentation of de Chirico's work at my gallery. He was called in our little circle terrible-tempered because of an incident recounted by Agnes Rindge, who taught art history at Vassar. One afternoon, provided with the special permission always required long in advance, she had brought a class of students to visit the Barnes Foundation collection in Philadelphia. She guided them to a large Matisse, "The Dance." She told her students there were three versions and, in her opinion, the best was *not* this one, though it was almost as fine. There was a loud alarm. An attendant came in and politely requested Dr. Rindge to remove herself and her class from the museum at once.

"Why, for God's sake, should we do that?" asked Agnes.

The attendant explained that Dr. Barnes thought his pictures were being insulted. He knew this, as the attendant further explained, because the gallery rooms were all wired for sound. When it suited his mood the doctor would push a button in his study and listen to the conversations in any one of his various galleries. He had taken offense at whatever it was Agnes had been telling her students—as a disparaging reference to one of his favorite paintings. Dr. Rindge with her class was, consequently, asked to leave.

I first encountered Dr. Barnes on one of my early trips to Europe. I had cocktails with him in the ship's lounge, together with George Keller, who at that time was working in the gallery of Étienne Bignou. Keller's major responsibility at that moment was to nurse the doctor, to sug-

gest his menu, recommend wines, plan his itinerary, see to his amusements, and, possibly, in fact quite probably, even brush his teeth—such is the prerogative of a very rich and tyrannical old gentleman. Barnes had bought from Bignou many of the most expensive paintings to be found in his collection and consequently was a highly favored client. At the time I remember thinking that if this were the only method of selling pictures I didn't believe myself fit for the task. Now, with de Chirico, I found myself face to face with the issue, and toadying to his wishes for the success of my exhibition. The first command arrived in a letter which said, "I propose to write the preface for your catalogue. It will be eight or ten pages."

I turned to Giorgio helplessly. "I don't budget for that kind of printing job."

De Chirico said, "Please don't worry, I will speak to Dr. Barnes. I feel sure that he will arrange something." Indeed he did. Barnes said without question he would pay for the catalogue.

The catalogue was printed. It was not to my taste. The text was pompous, but I supposed, in my situation, one shouldn't look a gift Barnes in the mouth.

Then one morning I arrived at the gallery at my usual hour of 10 o'clock. Pinned to the door was a note: "8 a.m. We have been here and the gallery is closed.—P.S. 8:30 a.m. We have come again, after some coffee. Still closed. What kind of gallery is this. How do you expect to do business if you are not open when an important client arrives?" It was signed not only by Barnes but also by the three elderly handmaidens who paddled behind him on almost all of his excursions, taking voluminous notes of his conversations—no doubt for a future biography.

Then came the drama of hanging the pictures. Giorgio and I had spent the better part of the previous night hanging the show to our satisfaction. The next morning Dr. Barnes arrived and insisted the whole show be rehung. Arranging an exhibition was one of the few opportunities I had for personal expression. The painter, of course, was the true creator, but my function as exhibitor was to make a presentation that showed each painting to best advantage. The art of gallery installation

was one in which I took great pride, and only with the utmost reluctance did I allow Dr. Barnes to change my careful composition.

Giorgio and I worked and sweated like pigs, taking down the pictures, moving them around, holding them up for the doctor's inspection, down and up again, arranged and rearranged again and, finally, hung. To my intense amusement, they now hung in precisely the same order that Giorgio and I had originally placed them.

Then came the matter of price. The evening before, Giorgio and I had determined on prices which satisfied Giorgio and I also felt to be in a salable range. Dr. Barnes hit the ceiling. "Impossible! Preposterous! Incredible! Why these low, measly prices undercut the value of my whole de Chirico collection. These are very, very valuable pictures. My dear gentlemen, I own many de Chiricos and I value them highly. I insist on raising all these prices tenfold. Ten times as much, ten times!" He took out a pencil and changed every one.

De Chirico took hold of my arm, soothing me and whispering, "We can always change back later when the doctor isn't here, but, of course, you will have to tell your assistant that if the doctor runs in again he must be shown *his* revised prices, and *not* ours."

Sure enough, at the opening Dr. Barnes came again and said, "Before you sell a single picture I want to reserve . . . I want to buy, this one, and this, and this . . . these five. How much are they?"

Very carefully I substituted the prices which Barnes had given us. He threw up his hands and shouted, "Absurd! Far too expensive. I'm taking quite a few, the least you could do is give me a fifty percent discount. I will pay only half that." I quickly agreed to his terms.

We were all well satisfied.

Some time after this I told Giorgio how highly I prized his only published novel, *Hebdomeros*. My sincerity must have been apparent, for he was pleased and became even more docile and friendly. He offered to show me the manuscript of his new book, *Monsieur Dudron,* suggesting that perhaps I might arrange for its publication. A few days later de Chirico handed me the carefully folded manuscript with shaking fingers and indicated that I was the first to read it. I read:

185

MONSIEUR DUDRON

Giorgio de Chirico

"Mysterious Life!" thinks Monsieur Dudron. "Life that begins again
every morning." He gets up, yawns, lights the lamp which is always by
the bed, glances toward the floor near the door to see if anyone has
slipped a letter for him beneath the door, then lights his pipe and contin-
ues to think aloud: "I am returned by tortuous ways not free, alas, of
brambles, stones, and thorns. I am returned to that study of Life which I
had abandoned years ago. I had become interested in sandy shores, those
beaches which give contour to the seas, because I believed their shapes
suggest most numerous, varied and deeply interesting problems. Only,
there it is, *one must consider Life.* So that you are not devoured, or at
least that you are not annoyed, so that your thoughts remain natural, one
should not employ too bright a light. Often the exigencies of Life are in
opposition to those of the sphere in which one wishes to act, work, think,
and create. One must take only a special and precise dose of the sources
from which one derives inspiration. I have known the joy of discovery
and also the bitterness of deceits. And I remember very well that winter's
day, bright and distant; an immense lassitude weighed upon me; the hori-
zon of an inconceivable purity gleamed with the radiance of eternity and
in the harbor the shadows of masts and smokestacks were immeasurably
prolonged upon the quay. Aboard the ship of my thoughts I set sail upon
a chimeric voyage, following an ideal itinerary I had outlined for my-
self." So Monsieur Dudron talks to himself, and meanwhile that fear,
accompanied by a slight feeling of stomach ache which had plagued him
until now, disappears little by little, as a fog brewed in the night is dis-
sipated by the golden warmth of a springtime sun. In place of the fear he
feels rising within him a sense of complete security, the security of the
well-shaved man, well-shod and well-dressed, who taps the buttoned in-
side pocket of his jacket where he feels the thickness of his pocketbook,
well-furnished with bills of large denomination and negotiable cheques,
his identification papers and passport all in order, who added to this,
knows that in other pockets of his suit there is everything that is necessary
for a prudent man of sound body and mind when he is about to leave his
dwelling to adventure in that forest so mysterious and pregnant with sur-
prises that is a big modern city, which is to say: fountain pen, address and

186

note books, penknife, a wooden cylinder containing tincture of iodine, a small roll of sticking plaster, a box of at least six aspirin or pyramidon tablets, watch and compass, tobacco pouch, pipe and matches. . . .

Giorgio de Chirico was of a soft, beautiful ugliness like the violet mole on the face of an Italian fishwife. His deep, purple-ringed eyes certainly had none of the confidence of one who possessed "bills of large denomination and negotiable cheques." You might, however, detect a velvet longing for some sense of complete security, at least the identification papers, all in order, of the "prudent man of sound body and mind." And I am sure his pockets contained double the recommended supplies of pyramidon and iodine. His anxiety to reenter life and fear of confronting reality were both obvious.

I helped him find lodging in New York, and suggested a list of restaurants: Barbetta's, Lindy's, Billy the Oysterman. To all these he preferred the Automat, like every other Italian painter I have known. I have never learned why, for it isn't the machinery that they like. "It has excellent food," they always say.

"Come out with me tonight," I suggested one day, as he was quite evidently disposed to go exploring. Chick Austin was in town and we asked him to join us, for he had been wishing to meet Giorgio. A native, I am fond of visiting New York with foreigners, as if the city were some adored mistress whose points acquired brilliance when noticed and praised by each new admirer.

Dali in particular was always gratifying. He inevitably saw more than one thought there was to be seen. He would flay my city alive, rearrange her limbs, serve her up to me with new sauce and relish, whereas Fernand Léger was the only visitor who ever really disconcerted me, because he liked *everything*. I would point out for Léger the lights of Broadway, "but we won't stop because there is no show that we want to see tonight." "That's Radio City," I would say. "Fifth Avenue." "Central Park." He liked them all along with, I suppose, the Brooklyn Bridge and Grant's Tomb. He was delighted with any skyscraper, or an automobile salesroom with a motor in a glass case, any bathroom display or central heating system, electric, construction, chemistry, or

aviation exhibit, any advertising billboard. I think he believed all the advertisements.

That night with de Chirico, Chick had his car and I wished to drive to a certain spot where there was a curious juxtaposition of electricity and moonlight. The moon was throwing shadows more ambiguous than those poignant and unnatural shadows in Chirico's own canvases, his empty arcades with the haunting shadows which seem to fall toward the light. We drove to the ghetto of New York, under the elevated trestles on Third Avenue near Grand Central Station, past those tiers of composite housing which remind one of excavated levels from past civilizations that, in other countries, are fanned out along the hillsides like cards in a conjuror's hand. In New York, the fan is pressed together into vertical packs of which only the edges show. I wondered aloud with Chick why rich Jews did not move into this quarter, so picturesque and attractive and it could be comfortable if provided with those modern utilities that the Strausses and Warburgs could so well afford. I chanced to notice the sudden, sharp contraction of Giorgio's eyes, and as we went over some rough asphalt, the trembling of his jowls, which were now melancholy and loose. I did not at that time realize how closely our conversation had approached one of what might be called Giorgio's "brushwood piles."

I remember in Kipling's story that all Georgie's dreams began in the same way: "There was the same starting-off-place—a pile of brushwood stacked somewhere near a beach . . . to the right lay the sea, sometimes at full tide, sometimes withdrawn to the very horizon; but he knew it for the same sea. By that road he would travel over a swell of rising ground covered with short, withered grass, into valleys of wonder and unreason." Kipling's Georgie could always find his way back to the lamppost which marked the end of his dream and led him into day. But our Giorgio was never sure of his return; as I was to discover with detailed proof. The sign of the entrance to his special dreams, not just his nightly dreams but that landscape which began with the brushwood pile, had become a symbol to him of terror and remorse. So far he had always come back, but only by accident and after dreams that were of more than usual length. Someday he might not return. The brushwood pile

was a sign of an unpredictable adventure and of such he was wary, if not frightened.

He was clutching Chick's arm, asking him to turn back, for he realized we had inexplicably lost our way. We were now headed uptown while we wished to continue downtown. In the middle of traffic Chick reversed direction to please de Chirico. It seemed to me that the word "Jew" had triggered his brushwood pile. I had a fantasy that Giorgio once wondered if he were a Jew and imagined what *might* his life be like in such circumstances. Thereafter, thinking himself persecuted, he might have protested that he was *not* a Jew and did not deserve persecution. But he would likely have then reproached himself to the effect that it was undignified to deny one's race in adversity and persecution, so bravely *admit* his Judaism and to resolve to suffer if necessary. But secretly he would begin to wish he had *never* been born a Jew. It would be only by the greatest good luck that, one day, he might be reminded that he had *not* been born a Jew, nor had any of his forebears.

The car was stopped by a traffic policeman near Brooklyn Bridge, and Chick was asked to dim his headlights. Chirico begged us to be submissive and polite to "the official." He recalled for us how he had once submitted to an enforced vaccination and how at first he had objected, but later he decided to be discreet, and that the officials then reacted favorably and mitigated their brutality. They allowed him to undergo the operation in a friendly house where he could be sure the instruments were clean and where other friends of his were always nearby, downstairs drinking cocktails. It was possible that the authorities might use a large, old-fashioned, and rusty syringe, and press the needle of it sharply into the corner of his eye. This time, fortunately, they chose a small and gleaming modern needle, asked him only to roll up the sleeve of his left arm and inoculated him. "It was better that way," asserted de Chirico. "It might have been so much worse," he explained, "careless and ruthless!"

Several clouds passed across the moon and the stars reddened for a moment as if the evening were smoldering. We began to feel festive, and when we passed a burlesque theater on the Bowery, we parked and went in. We heard that burlesque might be forbidden soon, and were

189

glad of the opportunity to see one more show. With a burst of music the girls filed onstage in all their brazen diseases, and Chirico, in a flash, disappeared. We waited for him awhile, and watched, then I began to think that I should look for him. I found him outside, and he refused to return inside. We went on toward Sands Street near the Brooklyn Bridge. I hate the Brooklyn Bridge. Like the Statue of Liberty, it has been degraded, lost its dignity, seems like a plastic souvenir. In Sands Street there is a bar, or was a bar, with murals by a primitive Sunday painter of Italianate name and mysterious Chirico technique. We ordered beer and drank it while the belligerent barman told us that if we didn't remove our madman friend (Giorgio) who was staring furiously at the murals, he would have to remove one or the other himself. I wanted to buy those murals, would have bought them, or at least have learned the painter's name had I been sober. He was my candidate for the laurels of Customs Inspector Rousseau. When next I visited Sands Street, the murals were gone, and in their place was a creamed stucco wall pallid as disagreeable cheese. That night I was confused (too much beer) concerning everyone's actions and reactions. What Chirico was really like became clear later at one of the sailor's dance halls where we wound up the evening. The lights were painful, the music was tortured, and the dancers threw themselves about in a kind of agony that was neither pleasurable nor simulated. Giorgio was really frightened. Chick and I were having fun; Chirico, for a moment I understood, really saw *things as they were.* Dali used to say that the only difference between himself and a madman was that he was not mad. Chirico might well say that the only difference between himself and a sane man was that he was not sane.

We brought Chirico back home. I think that is what he always really wanted, someone to bring him home. I doubt that he ever found that someone. After that adventurous evening, we were fond of each other. He was no longer simply a member of my gallery, an artist and sometime antagonist, but a lovable man walking in destruction and tinged with grandeur, commanding at once both sympathy and admiration. We agreed to respect each other in the affectionate equilibrium of a shared experience.

He asked to borrow my copy of *Hebdomeros* overnight, and returned it with a dedication and a drawing on the end paper. I wish I could feel that the drawing matched the quality of the book in my eyes. The Chirico of 1936 was a different man from the author of *Hebdomeros,* and the painter of 1936 also drastically altered from the Chirico who had conceived his earlier work, terminated some time before the writing of his book. My drawing showed four men in classic robes seated on fragments of a column engaged in some discussion. In the background is a Grecian temple, drawn in grayish ink—nothing more.

I dream of countless passages in the book which have remained with me:

> The pure heavens of autumn were being crossed by large white clouds of sculpturesque shape and in the midst of the clouds, in poses of sublime majesty, the apteral spirits were lying; and it was at this moment that the Explorer came out on the balcony of his suburban cottage, leaving his room with its walls covered with furs and photographs representing ships black as ink against the white of the ice-floes, the explorer looked pensively at the great apteral spirits, lying on the clouds; and he thought of unhappy white bears, bewildered, clinging to drifting icebergs and his eyes filled with tears, it reminded him of his travels, camping in the snow, and the slow and painful navigation over the cold seas of the North. "Give to me thy cold seas and I will warm them in mine."

In the skies of my drawing were clouds, but of cotton wool, not sculpturesque. The story of Chirico must always be quite strange, as it must be the story of whatever went on in his interior self. The process of dreaming seems to me to have a great deal to do with Chirico and his imagery. His influence upon younger painters has been frankly admitted by both the Surrealists and the new Romantics. As early as 1914, he had written, "What I hear is worth nothing to me; there is only what my eyes see when they are open and *more often when they are closed.*" But he had been painting his reports of a land of accurate dream since 1911. The dates of his explorations coincide significantly with those of Freud, whose *Interpretation of Dreams* was published in 1913. I like to consider the domain of Dream as a new continent discovered only recently, to

191

which Sigmund Freud and the psychologists conducted their expedition as a well-patterned scientific junket, bringing back to us, as scientists will, those irrefutable, efficiently classified geological and botanical specimens which gave to other scientists the basis for further research. But to us, the public, it gave a very dissected, dictionary impression of what the country really is like. Whereas Chirico, on the expedition uninvited, a stowaway perhaps, was the painter and the reporter, the cameraman who popularized for us some idea, for the first time, of the mystery, the grotesque, astonishing, and enthralling atmosphere of the new continent.

I would like to believe this, but I am forced to remind myself that, unlike the New World of Columbus, this continent of Dream has always been available to mankind. Men and women have always known dreams. So what are we to say of the ancient reports of dreams that do not coincide with our own? True, no critical attention had been directed to dreams until the expedition of Freud, but what is one to think of the reports of the casual traveler who has recorded his memories from time to time in literature, and whose descriptions do not at all match our own dreams? Was he, until 1911, always a colossal liar? The memory for dreams must be carefully cultivated or all details will escape, but that is not enough to explain the extraordinary discrepancy between the accounts of dreams found scattered in our literature, and the dreams we actually enjoy, every one of us, today. I think we are forced to conclude, and even Freud did not consider this enigma, that *the domain of Dream itself changes with time and an interior development which can only hold the most stimulating promise for our future vision.*

Here are three typical dreams, widely separated in time, one from the Bible, one from the nineteenth century, one from the notebooks of Dr. Freud:

> . . . behold a ladder set up on the earth, and the top of it reached to heaven: and behold the angels of God ascending and descending on it. And, behold, the Lord stood above it, and said, I am the Lord God of Abraham thy father. . . .
>
> —JACOB

Bottomless vales and boundless floods, and chasms, and caves, and Titan woods, with forms that no man can discover for the dews that drip all over; mountains toppling evermore into seas without a shore; seas that restlessly aspire, surging, unto skies of fire. . . .

—EDGAR ALLAN POE

A great hall—many guests whom we are receiving—among them Irma, whom I immediately take aside, as though to answer her letter, to reproach her for not yet accepting the "solution." I say to her: "If you still have pains, it is really only your own fault." She answers: "If you only knew what pains I now have in the neck and abdomen; I am drawn together." I am frightened and look at her. She looks pale and bloated; I think that after all I must be overlooking some organic affection. I take her to the window and look into her throat. She shows some resistance to this, like a woman who has a false set of teeth. I think anyway she doesn't need them. The mouth opens then really without difficulty and I find a large white spot to the right, and at another place I see extended grayish-white scabs attached to curious curling formations. . . .

SIGMUND FREUD

To the dream of Freud I would add any passage from de Chirico's *Hebdomeros*. I like to believe both men's minds demonstrate the qualitative difference in Dream over a period of time. I will not attempt to prove the point either with logic or research. By now the reader is surely aware of my abhorrence of the murderously selective scalpel that is logic and my fondness for the qualitative array of potential that is intuition. There is only one correct ugly answer to a sum; there is an infinity of beautiful possible mistakes. And to the dreams of Freud and Chirico, one might also add the visions of Franz Kafka.

From these few examples, I hope it is evident that dream content has gone through an appreciable evolution since the nights of Jacob's dream and that this is not merely a difference of descriptive idioms. If we except the visions of the Apocalypse which are, even today, incredible as dreams, and nearer if not to the realm of revelation, at least to that of sheer invention, then the ancient dreams were conspicuously arid and inhuman. They were astronomical and oracular like the landscape of

193

some lunar volcano peopled by prehistoric creatures. Dreams were wild and savage in the nights of Poe with natives of a different pigmentation than ours, except for wraiths of occasional white maidens who seemed elusive, unconvincing, and completely ephemeral. Today, for the first time the landscape is detailed with vegetation, there are cities and plains and a massive population in close communication with us. Freud, Chirico, and Kafka are teaching us the intrinsic topography of this country, and we had better familiarize ourselves with as many landmarks as possible because soon those travelers may not be the only adventurers of Dream. We may *all* be living there.

The enigma of Dream is intimately related to that of death. The anguish of conflict between life and death, and between activity and contemplation, has only been assuaged in our time by intimations by Freud of the resolution of these antitheses in dream. If I could not see these stirrings of my dreams, I believe I could not see this soul of mine. We live to prepare our own subconscious for better dreams, that we may truly *rest in peace*. We grow by a series of small deaths and little slumbers that we may fully comprehend our integrations, and if a man be violently cut off either in his day or in his slumber I can suppose he will be reborn again until the pattern of his life and death be just. And there is evidence that Chirico was gently slaughtered in a premature sleep.

Voyages into the continent of Dream during a decade, 1910-1920, monopolized more and more of Chirico's time, by day and finally, by night as well. I believe that night made thorough encroachments upon his day, and the reason his shadows fell toward the sun was that the moon began to cast the stronger light. He became quite lost in the land of his explorations, wishing to return to diurnal reality and not infrequently missing his way. And his existence was at last precariously misestablished on an insecure basis of unreality by his first romance in Rome, the first intrusion of those ubiquitous, formidable women. Chirico was then a Greek boy with black hair, a large nose, and smoldering eyes, trying to get on in the Bohemia of prewar Rome, where the Modernists, the Futurists under the banner of F.T. Marinetti, and the academy alike despised him. The woman who was to become his wife was in Rome, too, determined to marry the greatest artist she could find. If

Chirico was not an admired painter or even a respected painter, his virginal eyes were the first to kindle to her wiles. Then, unwilling to confess that she was wife to less than one of the greatest artists of the age, she stubbornly asserted that he was a genius. The irony was that she did not, perhaps, believe it, though in actual fact she was right.

It would seem that no one has ever been so cruelly betrayed into early greatness. In 1914, from fear of war and anxiety to avoid the draft, he hit upon a plan, so I have been told, to establish his madness and so his ineptitude at warfare by painting deliberately irrational canvases, now called his "metaphysical" paintings and considered the best he ever made. They were the paintings which first impressed the Surrealists and left Chirico inextricably involved with the cities and the plains of Dream. When he would return to reality later for short visits, he walked with the faltering step of a hermit who comes to town, innocent and vulnerable, once each year, to purchase some supplies. Reports began to filter in to us of these infrequent reappearances, of the empty and irrelevant self-copies, of the "Greek Seacoasts" and the splendid "Percherons" turned out wholesale, like the notorious Barbizon landscapes of Corot. At first making a sign against the evil eye whenever he passed a Surrealist on the street, there came a time when Chirico decided to re-edit, in a thin and rapid technique, his earlier metaphysical masterpieces.

Then came reports of Chirico canvases painted in the manner of Renoir, luscious women and fleshy fruits. In the *manner* of Renoir? But they were not comparable to Renoir! In a melancholic and unaggressive fashion, Chirico was fond of his new work, and a friend who continued faithfully to call him "Maestro" impressed me deeply by remarking that even the decline of a great man is of greater interest than the mediocre successes of most people. I began to look at the "in the manner of Renoir" canvases by Giorgio with a new eye, and exhibited several. They were then ten years old, and had gained some individuality with age. Hitherto unnoticed qualities acquire significance which observers with an unprejudiced glance are able to discern. They are provocative pictures and do not resemble anything by Renoir. When someone made the expected comment, "Why do you show those pathetic Renoir-

195

Chiricos?'' he simply sounded, to my ears, suddenly and evidently out of touch.

Is it thinkable that there is a decay, a mysterious blight which has affected all our great during the period between two wars? The apparent defeat or the retreat of Stravinsky after the *Sacre du printemps,* or Joyce after *Ulysses,* T. S. Eliot after *The Waste Land,* or, in my opinion, of Picasso after the ''Blue'' and the first Cubist periods—for there are even those blasphemous ones who find in many of the later paintings of Picasso evidence of a progressive deterioration. To call this decadence is to use an epithet thoughtlessly and destructively. What are the real qualities and dangers of decay, when nature gives us such splendid annual pageants of it, with such appealing overtures as autumn foliage? Or, if in the judgment of time we are forced to say these Chirico paintings are dead, then we must add, ''Death has this also; that it openeth the gate to good fame, and extinguisheth envy.''

I am describing here men of greater stature than the people who attempt to proscribe them. If Chirico the painter is indeed dead I am content that his tormented image should haunt me and that endlessly we should visit Sands Street and I should exhibit his paintings. His tragedy is that of a man tormented by something too powerful, for there are stronger things than drink or bankruptcy or disease. There is, for example, excessive dreaming. Not every man can sustain such rapid fire alone. And what have *we* done, these many years, to help him? He is slaughtered in his sleep, the beautiful adolescent!

Dali

Dali was not a charlatan and, contrary to the general opinion, not even the extravagant showman the press called him. His news-catching escapades, at least while I knew him, all grew from his conviction that the least "Dalinian" idea was worthy of realization, and this combined with passion for precision achieves an impressive effect whether calculated or not. The notorious smashing of Bonwit's window is a case in point.

Dali arrived on our shores for the 1936-1937 season more comfortably equipped than previously, accompanied by Edward James who, by this time, had learned that to be in the presence of Dali was a continual adventure. Edward arranged with Prince Obolensky for rooms in the St. Regis, and Dali transferred from the more modest St. Moritz to what was to become a permanent arrangement with Obolensky on all subsequent visits to New York.

Dali had been pleased with the nonsense I had arranged for him with the Hearst papers after his last visit. It was sensational publicity, and Dali was paid for it in the bargain. He now authorized me to arrange some other "manifestation" as he called it. I first approached Saks Fifth Avenue with the project of window dressings by Dali. Saks had made a fine reputation with its novel window displays when it had first moved uptown, but now they were resting on their laurels and were not interested in further extravaganzas. Tom Lee of Bonwits, however, got wind of my scheme and called me. He brought Dali down to the studios where objects, lighting, and mannequins were designed and displays executed. Dali was enchanted by the rich prospect of realizing his inventions in this workshop. He accepted with alacrity, so enthusiastically in fact that he almost forgot to name his price, until Gala and I reminded

him. What a chance to "paint" in three dimensions! The thousand-dollar fee seemed inconsequential by comparison.

Bonwit timed its window display to coincide with the opening of Dali's exhibition at my gallery. That morning early, on my way to work, I decided to detour by one block, from Madison to Fifth, and have a preview of the window. I arrived just two minutes late for the happening. The plate glass lay in shards, a bathtub on the sidewalk, and a small crowd was gathering. The heavy tub, a part of Dali's display, had smashed through the plate glass window, narrowly missing passersby, and a falling piece of broken glass had just missed decapitating Dali as it fell. Dali was already in the hands of two policemen. Tom Lee was pale and shaken. Gala, hysterical, would have scratched him if she had not been torn between her fury and her concern in quieting Dali.

"Get an *avocat,* Julien," Gala cried, "and telephone Edouard." I went on to the gallery and did both, telephoned Edward who gave me the name of his lawyer, Philip Wittenberg, who was to become an ubiquitous figure among us for the next several months.

Dali's show was already hung, except for a few finishing touches which I left to Allen Porter while I went on to the police station. It was imperative somehow to bail Dali out in time for his presence at our vernissage. At the station I sat for a couple of hours with Gala, Tom Lee, Edward, and Wittenberg until the insurance company lawyers agreed to drop criminal charges of willful destruction and came to a settlement of damages with Bonwit Teller.

The story of the fracas made headlines in the evening papers. As Dali conceived it, the central object of interest in his display was the old-fashioned white enamel tub in which was to lie a fully clothed mannequin, wearing one of the dresses Bonwits was promoting. The window had been carefully arranged to Dali's satisfaction the night before, but when he came back the next morning to look at it again, he found the management of Bonwit Teller's had removed the prone mannequin from the tub and stood it to one side, to better display the costume. Seeing this, Dali plunged raging into the store, into the window scene—and somehow, in the melee and confusion, the tub was shoved through the huge plate glass window. Opinion was divided as to whether or not Dali

had planned the entire episode as a publicity stunt. It certainly proved to be a good one, but I do not believe it was calculated—although of course I was not there at the time. I'm sure Dali had too much love for his project, the window display, to destroy it before it ever saw the light. I remember how impassioned he had been the night before when he spoke of it, saying that if a nude mannequin could provoke attention by its lack of clothes, how much more a fully dressed mannequin, *fully dressed in a bathtub,* would call attention to her costume. What an emphasis for their merchandise. "Bonwits will embrace me," Dali had explained, his eyes glowing with pride. It was this very pride and entanglement with his production that had provoked him into the tantrum when his idea was modified, even slightly, by some timidity or indiscretion on the part of Bonwit's managers. "It could only have been convincing if it were precisely as I would wish," said Dali later. Somehow, the tub had crashed through the window.

Wittenberg made it out to be an accident. "The tub had slipped." Gala reminded the court that the falling plate glass had narrowly missed decapitating Dali. "He would not have been interested in his own death," she argued. But Dali admitted to me he had fallen into a rage. "Rage for the absolute," he asserted.

It was, I repeat, part of his passion for precision.

And the opening of Dali's exhibition that afternoon was almost an anticlimax, at least for me. I had seen all the pictures, knew they were good, and felt sure they would sell. With the publicity of the Bonwit window they went like hot cakes.

PART THREE
15 EAST 57TH STREET

In 1937 the gallery moved from its first location at 602 Madison Avenue, between 57th and 58th Street, to larger quarters at 15 East 57th Street. The curved wall in my first gallery had been merely decorative. I now used the idea for the entire gallery, and the floor plan resembled a painter's palette. One could move along a line of paintings, seeing each one individually while the others were around the curve, instead of lined up regimentally along straight walls.

The move was carried out with the help, finally, of a bit of outside financing. I still continued to run a deficit, but now I was in debt to others and this served only to increase my anxiety. However, a 57th Street address was a step up—as was the monthly rent. The improved environment would, I hoped, correspondingly improve my income.

An exhibition of the lucite constructions by Naum Gabo made a handsome display and set off the new curved walls. I was proud to show them in their pristine condition with no paintings as they also were sculptured. The transparency of Gabo's abstract constructions refracted light upon their curves. Gabo had married a beautiful girl I had known slightly in my very young schooldays, Miriam Israels. Miriam and I renewed our old acquaintance, and I found Gabo to be witty and charming with his expressive broken English and abstruse ideas, which were occasionally as inpenetrable as his work was transparent.

In the same year I exhibited Peter Blume's important painting "Eternal City," which had taken him three years of intense work to complete. It was placed near the center of the gallery, surrounded by a galaxy of preparatory sketches, related drawings, and watercolors. Peter Blume was at the time considered an American Surrealist, mainly on the basis of the fantastic effects achieved in his previous painting, "South

of Scranton,'' which had just received a Carnegie award in Pittsburgh. ''Eternal City'' was not particularly Surrealist, but more essentially a political tract directed against Mussolini and the rise of Fascism. Painted in minute and beautifully executed detail, it depicted various scenes of life in a decadent Rome, dominated by a startling head of Mussolini in virulent green. This last, in violent color and gross execution, jumps out, a jack-in-the-box, from the otherwise muted palette and careful painting. I could sympathize with Blume's violent opinions at that time, but I never could bring myself to feel that propaganda took precedence over aesthetic elements in a painting. I wished very much to talk this matter through with Peter, but his stance was of such serene and stubborn determination that I was never able to do so.

Around this time Dali was asked to give a lecture at the Museum of Modern Art. He spoke no English and I was asked to serve as translator. I didn't trust my ability to translate his version of French, buried, as it usually was, under his heavy Catalan accent, so I asked Dali to give me a copy of his opening paragraphs. As I had these notes, I paid very little attention, and launched into translating what I thought was his speech—until, from the tittering and amused expressions of those in the audience who knew French, I realized he wasn't following the script of what he had told me he would say and was, Dali-like, into something infinitely more shocking. Dali looked at me with spiteful glee. Those who understood French, including the indomitable dowager Mrs. Murray Crane, a trustee of the museum, giggled happily when they realized the dilemma, followed by my hasty improvisation meant to clean up his risqué talk. Those who didn't understand French were happily oblivious to the whole episode.

Dream of Venus

In 1938, like a violent little ball of fire rolling through the living room, Salvador Dali again entered my life in New York, and my momentum was multiplied by his relentless energy. An advance letter came from Paris, beginning *"Bonjour, Dali arrive!"* and continued with requests to have ready a life-size taxicab equipped with *inside rain* to be lifted from the street level and placed in the center of my gallery, or a bathtub lined with fur, or a gigantic hardboiled egg, ten feet high and made of real egg.*

The letter read:

> *Tres cher Julien: J'arrive avec tout une nouvelle ideologie philosophique, aussi je'ai fait des decouvertes techniques qui me permeter d'approcher la reve des anciens. Une chosse que je veux construire aussi c'est une chambre inter-uterine, poarrtatif, avec le salive centrale centrale, qui coule sur les murs poileux. Quand il arrive une angoisse quelquonque on monte cette appareile et on entre dedans, comme pourr entrer dans la ventrre de la Mere! C'est tres Hallucinang, —tu verra. Te embrassons. Je suis ici, parceque je viens d'arriver! Soayez terriblement energique, nous allons farre enormement de chosses. . .*

Very dear Julien. I come with an entirely new philosophic ideology, also I have made technical discoveries which permit me to approach the

*This was to be made, the gigantic boiled egg, from the separated whites and yokes of more than a thousand real eggs, poured into aluminum molds for boiling. By an invention of Dali's the mold for the yoke could be collapsed and extracted through a tube in the egg-shaped white section. Standing in the gallery, it was to be tasted by visitors using spoons three feet long, so that they could dig in as far as the yoke and ascertain that the great egg was REAL.

dream of the ancients. One thing I wish to build is an interuterine room, portable, with heated saliva inside flowing down the hairy walls. When one is distressed by anything at all, one mounts this apparatus and enters in, as one would enter into the belly of the Mother! It's very hallucinating—you'll see. We kiss you. I am here, because I have just arrived. Be terribly energetic, we're going to accomplish a great many things. . . .

The Dalinian whirlwind rushed down the gangplank from the boat. "Dali is a hurricane," I wrote in a preface to his catalogue. "With the violence of delirium he blows together and piles into monuments debris too heavy for slighter winds. These natural wonders deserve a National Park." With him always was his wife, Gala, hung with geodesic lines like cobwebs. Her expression flickered from doubt to brilliance like the many-colored sequin jacket she wore. Dali and Gala disregarded every personal interest I might have had, and swept me peremptorily into the vortex of their own ambitions. We lunched at the St. Moritz Hotel, where they then used to stay in New York, and we discussed plans for the season. "What projects have you prepared for me?" Dali asked. This time I had one which he took quite out of my hands, to complete with his own startling maneuvers.

I had been occupied designing a Surrealist pavilion for the New York World's Fair. This had first been suggested by a young architect, Woodner Silverman, who later changed his name to Ian Woodner. He had approached me with the suggestion that I employ him as an architect. He wanted me to arrange a Surrealist exhibition for which he would design the pavilion. He assured me he knew all the ins and outs of how to secure a concession area from the Fair corporation. My plans were based on the conventional funny house: the walk-through exhibit found at many carnivals, furnished with distorting mirrors, dark passages, trapdoors, and tricks and surprises of many kinds. The challenge was to transform these apparati into new, Surrealist novelties derived from universal symbols of the subconscious which, even if mysterious and unusual, would appeal to the common psychological springs of everyone.

In my pavilion I imagined a Dream Corridor, a dark maze in which the public would be subjected to the typical experiences of dream. This would end in an Audible Staircase, a circular flight of steep stairs with

206

microphones hidden in the walls and connected with a loudspeaker in the main hall where the public could hear reproduced the unconscious remarks, heavy breathing, and laughter of those traversing the Dream Corridor and staircase. Rocking floors, pneumatic walls, and various vivid hallucinatory experiences would be provided until the finale would be the Sensation of Falling, quite real, for those climbing the stairs would find themselves catapulted down to the exit.

I envisioned there might be a small art gallery of Surrealist paintings so visitors from distant towns could see these paintings in the original, and there would surely be a waxwork show of Surrealist conceptions executed in three dimensions. I intended to commission the execution of these diverse scenes to each of the important Surrealists so they could share in the creation and the profits of this pavilion. Finally there would be a Grand Hall of Surrealist penny-in-the-slot machines, peep shows of Surrealist films, pinball games, and an apparatus I called a Feelie—two great lips of red velvet, six feet long, in back of which, hidden in the wall, would be a revolving cylinder covered with a heteroclite assortment of objects: sandpaper, hot and cold air vents, silken tassels, sensory rubber landscapes: thrust a hand through the lips and feel!

I had now to set about interesting the Money. I had indifferent success, but the experience was sharp and impressive. It was necessary that I make several visits to the vicinity of the New York Stock Exchange, and I confuse these visits in memory with an excursion to another institution during my college years in the course of my studies in psychology, in the company of a young psychiatric interne. There one saw a number of human unfortunates maintained at the expense of the State. They had been brought from hidden closets or were handed over from the arms of blindly loving, overburdened parents.

In memory, and in my imagination, this asylum is modified, and intermingles with the financial institution. It seems to be perceptibly larger. Nor are the inmates restricted. They are free to come and go as they please. I see also, that there is much money here for my purpose, if I can succeed in speaking a language which will capture attention. My guide at the first institution warned me of a peculiar phenomenon. He told me that although none of these creatures really think as we do in

our meaning of the word, being inarticulate or incoherent, yet they communicate, and possess a sort of sixth sense, a cunning and excellent intuition when certain things are at stake. He told of guiding one visitor to this quiet asylum, whereupon the entire hall fell into turmoil. Not a word had been spoken, but the visitor admitted afterward that he had been thinking with much antagonism and some fear. Like a flash the hostile message of his thoughts spread until the general uproar reached a crescendo considered quite dangerous.

I had been given a letter introducing me to the financier John Loeb. It was written by a boyhood tutor of mine, Allan Kempner, who had married John Loeb's sister Margaret. Allan was intelligent and sympathetic and understood something of Surrealism. He sent me down to Loeb's firm in Wall Street. Here I found breathless haste, noise and confusion, reminding me all too vividly of that other institution, while at the same time I distinguished repeated remarks to the effect that "today is too quiet, too quiet." I heard, also, many self-conscious references (in this year of 1938) to that "madman in the White House." And I seem to remember a man, noticeable because of his enormous head and tiny body, who gave me the impression of being one great hydrocephalic head. He was pulling ribbons of paper from a small machine, now and again clasping his head with his little hands, and bouncing about like an eccentric rubber ball, moaning: "Oi, oi, oi; oi, oi, oi!" Rolling his head about evidently hurt, but he was constantly drawn back to the machine to pull out more ribbon, while others were feverishly occupied, multiplying and dividing numbers and exchanging pieces of paper which represented the fluctuating values of vast enterprises such as factories and railroads. I knew this was our usual system of exchange and finance, but it appeared to me as though all relation between the symbol and the object it represented had been lost, and my guide told me this daily preoccupation had become a systematized delusion, very valid and convincing to the usual innocent spectator because of its vehemence and complexity. I believed that I could have become really friendly with some of these people, although others were, according to *my* intuition, utterly malevolent.

This whole confusion in my memory seemed to me credible until I at-

tempted to separate the elements and began to reflect. In the relation between Surrealism and the practical world there is, for example, a certain antagonism. Between the notion that a lucid intelligence such as Salvador Dali's should be considered insane, and the oppressive feeling that the helpless, fumbling gestures of the financial and political leaders of our realistic society are to be judged competent and trustworthy, there seemed a gap in reasoning. Why, I asked myself, should one be persuaded to abandon individual conviction to such leaders' pilotage?

To realize the building of the pavilion in such detail as I had conceived it, I now saw that I must enter among all these varied people armed with such weapons as they were accustomed to use: pieces of paper. I acquired many letters of introduction, a prospectus, a maquette in three dimensions, and an elaborate budget which added and subtracted in terms of two millions of dollars profit (to be divided between myself with my collaborators and the Money with incumbent bankers and lawyers). This seemed to me unreal and astronomical, but the fact of the matter was that my pavilion, though still only in my imagination, seemed a very real thing, and I wanted to see it built so that it would stand at the Fair, manifest. For my purpose money was only the means. I sincerely expected this money to be returned with interest for all, but it was not a real end in itself for me. For these others, it was so real it existed with autonomous laws of its own. My pavilion, they let me know, was subject to these laws, and of no actuality without them. My pavilion, I must understand, was but a paper model—their money represented the building!

At this point it became apparent that the energy of my imagination might not be equal to the task of *real-izing* the conception. A more violent, bombastic, and experienced imagination such as Dali's might be essential, to condense the immaterial into being.

Dali had come to Paris in 1929, a rather frightened Catalan, because his forceful and disconcerting inventions had made his teachers in the academy angry. He was able to conceive, fix, enforce his obsessive images with a talent that amounted to brilliant technical facility, not only in painting, but in poetry, philosophy, and in mental military tactics. For this reason his disquieted teachers flayed him. He was saved by the

209

Surrealists in Paris who found his expert doodles corresponded with their own experiments—and he saved the Surrealists because he was of a younger generation and had intense drive. They were somewhat discouraged and beginning to despair of conquering the future. It was by reason of Dali, out of Breton, that Surrealism was reproduced. Recently it had been reborn in cinema and in the Hearst newspapers. He could achieve its reappearance at the New York World's Fair. But for the moment I continued my efforts alone.

I was led into a large private room where, not my pavilion or its model, but the on-paper project was earnestly being considered. I was asked to make changes in the budget in order to show greater profit. I multiplied the estimated paid attendance by two, thereby more than doubling the profit, a procedure which left me trembling with astonishment by its very simplicity.

The new budget was accepted after all extra fees I had provided for collaborators were cancelled and the percentage of profit allowed to me decreased. This concluded, there was an excess of hilarity, slapping of backs, and felicitations exchanged, with wishes of best luck to the success of our enterprise. There remained minor items to be discussed. It was suggested that it would be cheaper to erect a prefabricated fun house exactly like those in every carnival, but we would call it Surrealist. On reflection, we were reminded that the name Surrealism might not be familiar to the great majority of our public. It would perhaps be wise to call our project by another name. Someone suggested the name "Laffland." Were we now to finance a Surrealist pavilion which would not be known as a Surrealist pavilion, and would have no Surrealist feature, within or without? Nothing more Surrealist could have been invented by the Surrealists! At this point I gathered up my papers and escaped.

It now seemed to me indispensible to repeat certain ritualistic and imaginary acts which heretofore had always served to help me overcome the anxiety and insecurity occasioned by any such severe frustration. Enclosed in the privacy of my back room, I carefully cleaned a space in the center of the floor and put down on it a small square of asbestos. Then I chose among my books and papers certain items which at the moment were among my most favored possessions: a first edition of

Melville's *Pierre,* two books each by Kierkegaard and Crommelynck, the facsimile of a manuscript by Iamblichus, a pack of early Tarot cards designed by Mantegna, and some twenty pages of my own notes and diary. These I considered (or vividly imagined) burning, a contemplation which enabled me to impress upon myself the relative unimportance of the objects as compared with the inalterable *gestae activa.*

Thus coming to terms with my tendency toward defeated nostalgia, I returned to the attack. I was now sent to visit a little man whom others referred to as Little Napoleon: Billy Rose. I found him to be most voluble, and compared to the limited simplicity of those I had recently interviewed, very helpful and thought-provoking. He advised me generously, and as best I can recall, said:

"I obscured and spoiled my own early career by diminishing for purposes of economy the scope of my original ambition. Whatever money or glory you wish to obtain by your pavilion, it must be thought of by you as the biggest thing at the Fair, or nothing. Something fabulous and colossal, unknown before our time.

"If you succeed you will make the fortune of the Fair. Those, in turn, who are most interested in the financial well-being of the Fair must subsidize you. Otherwise how can you be sure of making money?

"It is surety, not invention, which most infallibly appeals and succeeds. If no reality enters into your perpetual dreams then it is evident that you must think further. Why not bend your energies towards the acquisition of an automobile parking lot? Everyone knows that automobiles will have to park. The Fair must underwrite any expenses towards providing parking facilities. Therefore your portion of ground will be paid for both by the visitors and by the Fair. (That would be a bed of Roses!)

"If you insist on building your pavilion (and I can see you are a sucker) and will be advised by me: the theme for this year will be water, WATER. I don't know why, just a superstition of mine. Anything writ in water will succeed, lagoons, fountains, aquacades, ice coolers, anything you please, but the public is disposed towards water.

"Go to Mr. Whalen (and put a water pistol to his ribs?). If you are bold, you can demand whatever you want.

"But I see you are not bold. Then let me recommend. . . ."

And Napoleon very kindly sent me to a more timid, congenial man whom I shall call Louis Napoleon Morris (William Morris of the William Morris talent agency, the most important man in his field).

I dined with him and wined with him along with various monied men. He was a professional promoter, but it soon became apparent that even more energy and astuteness was needed. After the sensational breaking of Bonwit Teller's window, followed by much national publicity about Dali, Morris confessed to me that a Surrealist pavilion could more easily be financed if Dali's name were featured. At this point the problem if not the solution I had already proposed to myself was affirmed. I must resign myself to handing over to Dali (with all the foundation work I had prepared) whatever autonomy was mine over my own project.

There is a custom of choosing up in America, even among children. When we tossed for baseball sides at school, a bat was thrown in the air. Not the first one to catch it, but the last to get his full fist upon it, was captain.

Dali went directly to the task, as he was well able to do. He outlined several operations. He persuaded his friend and patron, Edward James, to invest enough capital to allow him a reasonable controlling interest, especially if the other investors could be divided. He engaged a lawyer, something I had not thought to do. I have a naïve aversion to employing a bodyguard for an honest mission. Lawyers of the past were dignified professional logicians and advisers; in fact, my family for countless generations had been either lawyers or rabbis. But now, many advocates, like many modern advertising, publicity, and insurance professionals, had begun putting the squeeze on us all for their existence. One must pay protection! You were damned if you did and damned if you didn't. I would consult a priest, minister, or rabbi on questions of theological uncertainty or of spiritual comfort, but I would object, as a well-intentioned man, to paying such a functionary to guarantee my salvation. Dali told me I was an innocent and a romantic. Worst of all, I was a middleman. If he were not so fond of me he would think me perfectly fair game for betrayal. He embroidered on the parasitic function of the typical middleman, such as our Louis Napoleon. "The inventor understands, and the worker, the employee, understands. The promotor, the

middleman, understands nothing but usury. You will see what will happen, Julien. They, and perhaps you too, will fight my conceptions every foot of the way, to dilute them, to compromise, to mediate. *My* problem is how to dominate the situation. And I would rather exploit a lawyer than have a lawyer exploit me.''

Then came the night, some time after I had gone to bed, when Morris telephoned:

"Meet me right away."

"What is it?"

"Never mind."

"But what is it, Morris? You know there have been several false alarms before. I'm in bed. How about tomorrow?"

"All right, Julien. You're asking for it."

He hung up. I immediately knew that I was on my way out. It was recognizable gangster vocabulary. Nevertheless I dressed and hurried to the meeting. Given consideration or not, I wanted to witness everything. It would be profitable to learn what it was they all understood that I didn't. From that point on my role became that of a privileged spectator. The detachment of a tolerated vagrant in a temporal world has a certain dignity.

Cross-legged on his hotel room bed sat a man who, I was told, was a big "rubber man" from Pittsburgh, backed by a syndicate desiring to invest money in the Fair. He had plans for building a large steel and glass aquarium in which mermaids with rubber tails were to swim. "But they advise me," he explained, "this idea is not too hot. It's all wet." (I thought of Billy Rose's "water." Perhaps a combination of this with Dali's crazy ideas might click?)

Before him, on the counterpane, were little rubber objects, samples, he told us, of what his special new process could accomplish. In particular there was a heap of disgusting little rubber peanuts. He was very proud of these. "Look just like peanuts, don't they, until you feel them?"

I remembered what Napoleon-Rose had told me and drew Dali aside. "An underwater show is supposed to have the current magic for this year," I whispered. He answered that he thought it quite probable—a

213

back-to-the-womb symbol. Also he was fascinated by the rubber peanuts. *"Des verritables strructurres mollles!"* Soft construction! If only he were allowed to design their applications! The business was concluded.

"But no mermaid's tails," said Dali. "Explain that to them, Julien."

I told them that Dali insisted he be the sole authority for the execution of his designs. "You understand," I explained, "Dali has suffered in the past from stupid obstacles placed in his way by those who have not trusted. He is very practical. They have always found out too late that he was right and they were wrong. It is a very subtle thing," I continued, "the difference between a general adaptation of Dali's ideas and the proper detailed execution. He depends entirely on minute detail." I addressed myself to Morris. "He knows what he wants. You, with your experience in the theater, must understand the almost imperceptible difference between the timing of a gag correctly or the failure of the same gag."

"Who is this guy?" asked the Rubber Man, and Morris answered that I was Dali's interpreter. I swallowed that humiliation and smiled.

"We don't want any dead weight in our corporation," said the Rubber Man. "I am responsible for my money. What else can he do?"

I suggested that I might do their publicity. But, as I said it, again I realized that this was a further step to oblivion, thus putting me outside responsibility for my own enterprise.

Everyone was really outside, although it was not explicitly so understood then. An old-time carnival promoter later explained to me the classic method of moneymaking in ventures of this sort. The trick was to place oneself in a position which allows you to precipitate the bankruptcy of your enterprise, and then, skipping creditors and original partners, you buy back the enterprise at such low price that, even adding your original investment, the cost is considerably under the value of the enterprise you now wholly own. You borrow and invest, for example, $10,000 of your money, forming a syndicate with an additional $90,000 invested by other shareholders. You build, perhaps, a $110,000 pavilion which cannot pay its full debt and enters bankruptcy. You purchase the other shareholders' interest for, say, $20,000, pay your $10,000

debt, then after adding that original investment of $10,000 you have an $110,000 enterprise for your $30,000 and should be able to make profit. My friend the carnival promoter assured me this method had been routine for him in every Fair in which he had participated, but he was convinced that for once it could not be done. "This Fair is on the level," he assured me. "It is supervised by the City of New York and Mayor La Guardia and I'm going to play my concession straight." I was told that soon after the opening, after unexpected labor difficulties and restrictions placed against him by the Fair Corporation, the Fair Coporation itself purchased and reopened his bankrupt concession. What irony!

I cannot say if the Rubber Man had any such machination in mind. He was not a professional carnival racketeer and was as honest as a businessman can be. The conflict and final disaster was much more complex, much less transparent. The roots lay in a fundamental divergence between the aims of a businessman and of an artist: the one who builds and thinks of a building in terms of paper (and making money), and the other who draws on paper and thinks of the paper in terms of building (and spending money). If neither one defers to the other, an explosion is inevitable. There was an unusual irritant in this instance. It was the role taken by Edward James, who played half artist, half proprietor, and confused the Rubber Man immeasurably in all his safer standards of value. In the beginning, when the legal papers were to be signed to form the Dali World Fair Corporation, Edward had disappeared with his lawyer. On a sudden decision they had taken a plane to San Francisco to inspect the Fair on the West Coast. That would have been sensible had they returned immediately. But once having kidnapped the lawyer, Edward gave free rein to other whims, and the only explanations we received were gay postcards saying, "Chinese are curious," or, from Arizona, "Here's a fine place, full of Indians. Let's build our pavilion here." I knew with this mad beginning that things might end ill.

Edward was fabulously rich, generously constructive, and annoyingly willful. He had deep sympathy for poetry and his discrimination and bounty had often saved artists from disaster. What he lacked in force he made up in nervous energy. Dali often said of him, "Edward is as in-

sanely relentless as myself!'' He was more than a rich patron, because he was a friend, to Dali and to me. If a little mad and maddening, he was certainly not boring or bourgeois. He was what certain great patrons of the past must have been, not an employer, but a fortunate man, gifted with poetic insight. I was always happy to see his miniature figure, with features finely chiseled as an Edwardian doll's, appear in the room squeaking with energy.

The papers were finally signed and, as Dali attempted to dominate a rather hopeless situation, Edward went into action as the Dalinian air arm. Suspecting that the Rubber Man had by no means abandoned his plans for manufacturing rubber fishtails, Edward flew to Pittsburgh and forced his way into the rubber factory to surprise the Rubber Man at his stubborn occupation of doing the very thing Dali had forbidden. Not only were hundreds of fishtails completed, but there were being added numerous little rubber fish, an octopus, and some other quaint whimsies invented by the Rubber Man, all poorly copied from Disney. Caught in *flagrante delicto,* the Rubber Man was furious. Dali planned to leave for Europe as soon as the pavilion was opened, and the Rubber Man had evidently expected that after Dali's departure his own mermaid show could be smuggled in, allowing him to use Dali's name with its publicity value for his own products.

Dali was disappointed. "I had hoped," he said, "that the Rubber Man would prove a competent technician to help me. Instead I find an incompetent obstructionist." The Rubber Man objected to everything he didn't understand, which meant, in fact, almost everything Dali designed. William Morris was miserable and understandably inept, caught as arbitrator between the two formidable antagonists. I was perhaps the only happy one. I was no longer responsible for anything save my publicity work, which was easy enough to do, and which gave me an inside observation post at all times. It was exciting, those days, to be among the workers while the Fair was building, and when the Fair was opened to the public we formed a sort of secret society. Early in the morning before visitors began to arrive, and late at night after the last sightseer had left, the Fair subways were full of the workers, and we soon came to recognize one another—chorus girls, artisans, producers, guides, bark-

216

ers, designers, newspapermen. In the mushroom growth of the Fair we found a comradeship which developed as suddenly as the huge structures.

The girls who were to be featured in our show had been chosen early and rehearsed first in the swimming pool of the Hotel Roosevelt to accustom them to the strenuous underwater work. When their aquarium was at last installed at the Fair, the girls rehearsed there, or more usually lazed about on the roof in the sun, while the repeated crises between Dali and the Rubber Man distracted the attention of their employers. Bea, Dottie, Kelsey, Kay, Toni and the rest, usually allowed to be seminude because our location, the Midway at the Fair, was intended to be sexy, would wave at the passing elevated trains bringing visitors, and shriek endearing obscenities until their manager, Sol Heller (aptly named, these days we were all baking in the bright sun) would climb to the roof and say, "Girls, girls! There's someone from the Vice-Purity Squad coming to inspect the building."

"Who passed this water?" the inspector would ask, dipping his forefinger in the pool and, "We, we," sang Bea, Dottie, Kelsey, Kay, and Toni in chorus.

Half seriously, I suggested that if the Dali pavilion, as originally planned, failed, this whole magnificent atmosphere could be transformed into a cabaret, with some seafood included among the attractions of the aquarium, the Dali decor, and the splendid roof garden and swimming pool. But I often reproached myself with my happy, low-salaried irresponsibility. There were the children, Javan, Jerrold, and Jonathan, to be thought of. If it were only possible to manage a successful and well-paying aquacade for their sakes. . . . I sensed disaster ahead, but what could I do?

Dali's pavilion opened at last, for the press one evening, and the next day for the public. Edward James, to celebrate, invited the cast, now that the job was finished, to a farewell champagne party. Late that evening, after the exhibit was closed to the public, having the keys, Edward and certain of his champagne party came back to swim in the aquarium. This was all the Rubber Man could have wished. He said the next day to Edward, "You will sell out your interest to me. I would not wish to

make public that you held a drunken orgy in the Dali swimming tank. You will sell out, or else. . . ."

So, almost the first day, before Dali's pavilion had really been shown to the public in the form originally intended, it was taken over by the Rubber Man, to be remodeled, diluted, softened, rubberized. It did not succeed at the Fair. There is unfortunately no way of knowing if it might have succeeded had it kept to either my own or Dali's original plan.

The Dali enterprise was called the "Dream of Venus." It was to be a lovely dream, but upside-down, as dreams often are. Venus had been born from the sea. She dreamed of where she had been born, from where Love came. Underwater there was the landscape of her prenatal home. A room underwater, a fire that burned in the hearth underwater. . . .

"Wait a minute," the Rubber Man would say. "A fire can't burn underwater. Never heard of such a thing."

The girls would appear in the room, the sex appeal for which you paid twenty-five cents. They didn't walk, they swam or floated, for the room was submerged. Underwater they played a soft piano, they warmed their hands by the fire. In the distant landscape there was an arcade, even a pool with a fountain—all submerged.

In the next section, which was not under water, Venus is born. She is Love, drowned like a fish out of water, Love observed by a man who is protected by a diving suit and iron diving helmet from breathing the air which has killed Venus.

"This being upside-down is a familiar mechanism of Dream," said Dali. "But I will explain it for the public by two symbols, one inside the pavilion and the other on the façade. There will be a taxicab equipped with *inside rain*. . . ."

"You can't do that," the Rubber Man would interrupt. "We could make a sort of shower arrangement which would spray over the cab and give the illusion that the cab is driving in the rain, but—"

"I said *inside rain*. What interest is there otherwise in a taxicab? Furthermore, by our agreement, I am the designer, not you. If you were doing this you would still have your foolish idea of mermaids with rubber

218

tails, a worn-out notion not even worthy of a penny postcard. Now for the façade I want an enormous Venus, from the famous painting by Botticelli, but with the head of a fish.''

"No, no, no!'' screamed the Rubber Man. "You are really saying this just to annoy me. Who ever heard of a woman with the head of a fish? Absurd, I say, and so would everyone else. Think of it, we have thousands of dollars at stake in this crazy thing. Please tell me you are only joking?'' And when Dali seemed uncompromising, he added, "If our contract doesn't allow me to stop your reckless nonsense, I shall see to it that the Fair Corporation will.'' And the next day two hard-faced men from the Fair Corporation informed Dali he would not be permitted such a display. "No woman with the head of a fish, or else. . . .'' The one was called Mr. Smith, and the other might as well have been named Smith too. They were impassive and immovable, and gave no reason except "Or else. . . .''

So, before leaving for Europe, Dali wrote a little manifesto with all the humor some people think he lacks, in which he parodied our Declaration of the Rights of Man. The woman with the head of a fish was taken symbolically to represent the multiplied difficulties Dali encountered in presenting any idea which contained the slightest grain of poetry. This is the manifesto—of which hundreds of copies were dropped from a plane over New York City:

DECLARATION OF THE INDEPENDENCE OF THE IMAGINATION
AND THE RIGHTS OF MAN TO HIS OWN MADNESS.

When, in the course of human culture it becomes necessary for a people to destroy the intellectual bonds that unite them with the logical systems of the past, in order to create for themselves an original mythology which, corresponding to the very essence and total expression of their biological reality, will be recognized by the choice spirits of other peoples—then the respect that is due public opinion makes it necessary to lay bare the causes that have forced the break with the outworn and conventional formulas of a pragmatic society.

At the beginning of the surrealist revolution, it was declared: "We live in the era of wireless telegraphy; we announce also the era of wireless imagination.'' But it is not wires that confine us now—it is chains of op-

pression that we must break! In confirmation of the above, we announce these truths: that all men are equal in their madness, and that madness (visceral cosmos of the subconscious) constitutes the common base of the human spirit. This oneness of the spirit was proclaimed by Count Lautreámont when he wrote: "Poetry must be made by all not by one." Among the essential rights of man's madness is that which defines the surrealist movement itself, in these words: "Surrealism—pure psychic automatism, by means of which it is proposed to transcribe, either in writing, or in speech, or in any other manner, the true working of thought, dictated by thought without any rational, aesthetic or moral control." (André Breton: First Surrealist Manifesto)

Man is entitled to the enigma and the simulacrums that are founded on these great vital constants: the sexual instinct, the consciousness of death, the physical melancholy caused by "time-space."

The rights of man to his own madness are constantly threatened, and treated in a manner that one may without exaggeration call "provincial" by false "practical-rational" hierarchies. The history of the true creative. artist is filled with the abuses and encroachments by means of which an absolute tyranny is imposed by the industrial mind over the new creative ideas of the poetic mind. Here are a few recent facts drawn from my own experience that I feel it my duty to expose to public opinion.

Probably most of you recall the incident provoked by the heads of a certain New York department store, when they dared alter a number of my concepts without having the consideration to inform me in advance of their decision. At that time I received hundreds of letters from American artists assuring me that in acting as I did, I had helped to defend the independence of their own art. Now an even more astounding battle has taken place. The committee responsible for the Amusement Area of the World's Fair has forbidden me to erect on the exterior of "The Dream of Venus": the image of a woman with the head of a fish. These are their exact words: 'A woman with a tail of a fish is possible; a woman with the head of a fish is impossible.' This decision on the part of the committee seems to me an extremely grave one, deserving all the light possible cast upon it. Because we are concerned here with the negation of a right that is of an order purely poetic and imaginative, attacking no moral or political consideration. I have always believed that the first man who had the idea of terminating a woman's body with the tail of a fish must have been a pretty fair poet; but I am equally certain that the second man who repeat-

ed the idea was nothing but a bureaucrat. In any case, the inventor of the first siren's tail would have had my difficulties with the committee of the Amusement Area. Had there been similar committees in Immortal Greece, fantasy would have been banned and, what is worse, the Greeks would never have created and therefore never would have handed down to us their sensational and truculently surrealist mythology, in which, if it is true that there exists no woman with the head of a fish (as far as I know), there figures indisputably a Minotaur bearing the terribly realistic head of a bull.

Any authentically original idea, presenting itself without "known antecedents," is systematically rejected, toned down, mauled, chewed, re-chewed, spewed forth, destroyed, yes, and even worse—reduced to the most monstrous of mediocrities. The excuse offered is always the vulgarity of the vast majority of the public. I insist that this is absolutely false. The public is infinitely superior to the rubbish that is fed to it daily. The masses have always known where to find true poetry. The misunderstanding has come about entirely through those "middlemen of culture" who, with their lofty airs and superior quackings, come between the creator and the public.

Artists and poets of America! If you wish to recover the sacred source of your own mythology and your own inspiration, the time has come to reunite yourselves within the historic bowels of your Philadelphia, to ring once more the symbolic bell of your imaginative independence, and, holding aloft in one hand Franklin's lightning rod, and in the other Lautréamont's umbrella, to defy the storm of obscurantism that is threatening your country! Loose the blinding lightning of your anger and the avenging thunder of your paranoiac inspiration!

Only the violence and duration of your hardened dream can resist the hideous mechanical civilization that is your enemy, as it is also the enemy of the "pleasure-principle" of all men. It is man's right to love women with the ecstatic heads of fish. It is man's right to decide that lukewarm telephones are disgusting, and to demand telephones that are as cold, green and aphrodisiac as the augur troubled sleep of the cantharides. Telephones as barbarous as bottles will free themselves of the lukewarm ornamentation of Louis XV spoons and will slowly cover with glacial shame the hybrid decors of our suavely degraded decadence.

Man has the right to demand the trappings of a queen for the "objects of his desire"; costumes for his furniture! for his teeth! and even for gar-

221

denias! Hand-embroidered slipcovers will protect the extreme sensibility of "calf's lung railway tracks," colored glass with Persian patterns will be introduced into automobile design to keep out the ugly raw light of diurnal landscapes. The color of old absinthe will dominate the year 1941. Everything will be greenish. "Green I want you green"—green water, green wind, green ermine, green lizards swollen with sleep and gliding along the green skin and the dazzling décolletés of insomnia, green silver plate, green chocolate, green the agonizing electricity that sears the live flesh of civil wars, green the light of my own Gala!

In the nightmare of the American Venus, out of the darkness (bristling with dry umbrellas) the celebrated taxi of Christopher Columbus. Within, Christopher Columbus in person is proudly sitting. He is soaked in a persistent and dripping rain. Three hundred live Burgandy snails crawl up and down his motionless body and in the hollows of his livid face. On the breast of Christopher Columbus one may read this enigmatic sign: "Am I back already?" Why, with his index finger, does he point toward Europe? Why is he accompanied by the invisible ghosts of the Duke and Duchess of Windsor? Why is a somnambulistic Spanish girl attached to the steering-wheel of his deluxe Cadillac with golden chains? Here are still more impenetrable Dalian mysteries, heavy with obscure and far reaching significance. But one thing is certain: A Catalan, Christopher Columbus, discovered America, and another Catalan, Salvador Dali, has just rediscovered Christopher Columbus. New York! You who are like the very stalk of the air, the half-cut flower of heaven! You, mad as the moon, New York! I see you won by the surrealist "Paranoia-Kinesis." You may well be proud. I go and I arrive, I love you with all my heart.

DALI

* * *

This was the year I began the first notes for my Memoir.

Note well your impressions at the age of thirty; it will be of use thirty years later, when your children and your friends' children will be interested in what were their years of earliest formation, and you, with some grace, and a bit of luck, will have reached a moment of maturity. This, if ever, is the time for reminiscence. it is the time of reunions and revivals. To appeal to your children, which means appeal to your posterity, most deeply and with all the genius you possess, process your restate-

ments through the following filters: emotion recollected in tranquillity, the subconscious of emotion and of tranquillity—and here is the beginning of genius—the subconscious of your child, your audience then and now, as best you may perceive. You will uncover a sufficient segment of the spiral of time to ensure your work immediate response and that immortality of magical enchantments the secrets of which only you will know.

For a lazy man I have led the least sedentary life of anyone I know. I had long been either standing or falling down at cocktail parties, dreaming if not lovemaking in bed, or explaining the notions of modern art half dead on my feet toward the end of an upright day in my gallery. Now that I had decided to record, as they unfolded day by day, the memoirs of my gallery, I wondered, how may I find the *Sitzfleisch* that any professional writer before his typewriter (just as any proficient chessplayer facing his adversary) must achieve, how may I now sit down for long hours and with patience and perseverance write a book?

I would hope, in this day of electronics, that a slim, long, magnetized needle might be introduced into the stuff of my brain, there to take a recording that might subsequently be played back, very LP, through some encephalophone. But, born a mite too soon for the age of prerecorded thought, I can at best hope for an electric typewriter, and sit before it watching eagerly to see what its sizzling little keys may choose to spell.

Joseph Cornell

The touching truth, told to me by Mina Loy, was that Joseph's brother was retarded. He had to be tended constantly, and Joseph relieved his mother at this service, sometimes for quite long stretches. The brother was perhaps extremely intelligent, or at least magically perceptive; as such were believed to be by ancient lore. But a spastic, he could neither walk nor talk coherently, nor perform most things with consistency. Early in this brother-sitting Joseph had hit upon a private communication system which combined play with learning. With his scissors and paste pot he illustrated everything, and it soon arrived that it could go on beyond what he had planned to say. As if, since his brother couldn't travel, a photograph of Rome would be shown to convey such a city— but then, combined with other images, it became something much less specific, a place of Joseph's, that tourists could never reach, something somewhere that finally even Joseph had no words to describe. Not "Rome" but "Ro . . . me," a city of his own, imagined, out of his love and devotion to his comprehending and delighted brother.

Another day, a few weeks before his exhibition, Joseph suddenly said, "You once asked me what I really loved. Will you lend me the photograph you have of Cleo de Merode?"

"Of course." I lit a cigarette, very pleased, for she was a favorite of mine too.

Idly picking up a proof of the catalogue cover for his exhibition, I put a match to one corner, watching it brown and curl as the flame spread. "Disturbing, isn't it?"

"Let me hold it," said Joseph, and carefully revolved the paper so that the edges burned almost around, bordering the image. Then he

shook it out. "I wonder how that would photograph?" And we later used that burnt sheet for the jacket of my book *Surrealism*.

"Could I give an exhibition announcement to a girl in my school?"

"Your school! What school?"

"Oh, a school . . . I mean, do you think she would come to the opening?"

Whoever she was, she didn't come to see his show. Joseph had almost forgotten the matter when I asked him what happened about her. "Yes, I waited for her until after school and gave her the invitation, but "I don't know her name . . . she took it . . . but some people will never understand. She seemed frightened and ran away."

There were also the folded announcements he was devising for his second and third exhibitions. Really most ingenious, one of them so complicated that it could fold several times upon itself, always combining new and fitting images.

These ingenuities or ingenuousnesses! I scarcely know which accounts most for the intricacies of Joseph's mind. Sometimes, I must confess, I am not sure that I understand at all the borderlines between the in-genue and the in-genuse, the in-genius.

Nor the Divine Incoherence of the Image.

Consider the Box he made "for" Cleo de Merode. It is an old oak box about 8″ x 10″, containing rows of bottles in compartments as in an apothecary cabinet, or a casket of medicaments. Cornell filled each bottle with small objects, labeled them, and ornamented them with marbleized corks and colorful labels. One can lift them out one by one, hold them to the light, examining their contents, read the labels. Here is an inventory:

225

L'EGYPTE
de Mlle. Cleo de Merode
Cours elementaire
D'HISTOIRE NATURELLE

Préambule. Géologique Pharaonique			Rosée A feuilles de Rose
Temps Fabuleux Fossiles Vegeta aux *Red Window- Birdpeck* (Sphynx)	Météorologique Chutes de Grêles de Cléopatre *Pearls*	Gameh, Kontah Blé *Golden Hay*	Pétrifications Animales Alabatre de Cléopatre *Tusks*
Red Sand	Cléo de Merode Sphynx *Yellow Sand*	Sauterelles *Yellow Sand Green Ball Wall & Desert*	Cléopatride Cadeau d'Emér- audes de Cléo de Merode *Blue Beads* Les Mille et
Nilomètre *Green Water Glass Bulb*	Les Reptiles des îles du Nile *Paper Spirals Green Sand*	Colonnes Tour- noyantes Cleopatra's Needle *Needle & Thread Through Round Block Red*	une Nuits *Gauze & Sequins*

The process of filling out the gaps (to arrive at a *Gestalt*) is a primary requisite of the intelligence cooperating with the imagination. Cornell's filling out of the Egypt Box seems to have been accomplished by this method of free-association, beginning perhaps quite crudely with a pun: Cleo (de Merode) / / Cleo (Patra).

I feel quite certain Cornell had never read Raymond Roussel, an obscure maniac who had been under long treatment with the famous Dr.

226

Janet when he wrote his book *Impressions d'Afrique* and who later described his peculiar method for writing in a book which Marcel Duchamp called to my attention. I wish to offer a brief outline of Roussel's method, because it will suggest but never penetrate the secret of Cornell's method by which consciously or unconsciously he seems to have assembled the Egypt Box.

RAYMOND ROUSSEL
COMMENT J'AI ECRIT CERTAINS DE MES LIVRES

I would choose two words almost alike. (Reminding one of metagrams.) For example, *billard pillard* (billiards, plunderer). Then I would add similar words but taken in two different senses, and thus I would obtain two phrases almost identical.

So far as is concerned *billard* and *pillard* the two impressions of Africa phrases I obtained were these:

1. Letters of white on the bands of the old billiard
2. Letters of white on the bands of the old pilliard

In the first, *letters* were taken in the sense of typographical signs *white* in the sense of a cube of chalk and *bands* in the sense of *borders*.

In the second *letters* were taken in the sense of *missives* white in the sense of *white men*

bands in the sense of *warrior hordes*

The two phrases found, it now was a matter of writing a story beginning with the first and ending with the second.

For it was in the resolution of this problem that I was able to find all my material.

In the light of Roussel's method, which is, after all, just a variant of similar methods hundreds of years old, at least as old as Leonardo's cracks in the wall . . . or as new as Dali's paranoiac-critical activity, or Proust's madeleine or as occult as Zen Buddhism's "controlled accident." Let us examine the series of still photographs which are the random elements around which grew the web of Cornell's spinning of the scenario *Monsieur Phot*.

227

MONSIEUR PHOT
(Flushing, L.I., New York 1933)

Photo 1. Bronze equestrian statue on white marble base surrounded by iron railing in a foreign city. At base foreground nine dark-suited and hatted men (includes one *gendarme* and man bearing laundry basket—or music stand). *"New York City about 1870. A park on a winter afternoon."** In front of a large equestrian statue, the base of which is protected by an iron picket fence stands a row of nine street *"urchins facing the camera."* One holds a basket of clean laundry, another stands beside a harp. The urchins are giving their attention to a photographer and his apparatus *"shown at almost close-up distance on the left edge of the field of vision. His high silk hat is lying by his paraphernalia on the wet cobblestones."*

"Some bickering among the boys causes the photographer to emerge from under his black sheet. . . ."

[And we're off! Cornell's story has started—we have entered the picture, or he has.]

Photo 2. A long hall in an 18th century palace such as Versailles (or the grand salon of a hotel—there is a grand piano—covered)—needlepoint chairs—a row of crystal chandeliers.

"On the left edge of the field of vision, seated in a chair which is half-turned toward the camera, is discovered the sole occupant of the vast hall, the polite photographer . . . suddenly a breeze or strong draught causes the chandeliers to start jangling like Japanese wind bells, filling the hall with very agreeable music etc."

Photo 3. The vitrine of a bric-à-brac shop. . . . A large, sumptuous glass and china establishment seen through plate glass windows. *" (This episode opened with color). . . . Suddenly from somewhere inside, the gorgeous pheasant darts into view. It flies at terrific speed in and out of the chandeliers as if they were branches of his native wood."*

Photo 4. Marble statues and white lamp-posts standing at random in a park, fenced in by a low lattice.

"A street corner at night, at which time it takes on an appearance of a supernatural beauty." Enclosed by a low lattice work fence are *two*

*Italicized text from *Surrealism* by J.L. is the scenario for a film Cornell never realized.

228

lamp-posts placed among life-sized marble statues of women in classic poses. " . . . *snow is falling . . . within this enclosure the urchin with the harp. . . .* "

Photo 5. An old fashioned stage setting seen through a portal. There is an aisle in perspective of pedestals and urns backed by tall trees.

"Lamp-posts.

Seated at each lamp-post is an urchin with a harp."

And the end? There is a shot, darkness and silence.

When the lights of only the lamp-posts go on after some moments there remains nothing to be seen but " . . . *baskets of clean laundry scattered in the aisle and stretching into the distance."*

Cornell's cinematic imagination proved to be an extraordinary exaggeration of the very elements on which motion pictues are mechanically based; the rapid sequence of still images projected at a speed to fuse them by momentum of psychological assumption. Cornell spaced his sequences of stills to an almost unbearable lag, making the utmost demands on one's psyche to furnish continuity of a wild and improvised sort.

To produce such a film as *Monsieur Phot* was beyond Joseph's hopes, without equipment or money. All the same he succeeded in actualizing quite a few short films, beginning with one he called by the unfortunate title of *Goofy Newsreel*. He managed this in a typical Cornell manner, by rummaging in a junk heap. He discovered a warehouse in New Jersey where scraps of old film had been discarded and were being sold, sight unseen, by weight, usually to be salvaged for their content of silver nitrate or whatever other small value they might have as refuse. Joseph bought several tons at a ridiculously low price. After innumerable evenings running these scraps through a viewer, and making his montage with the addition of occasional titles, he had several reels of silent Cornell medleys to show me, and I ran a couple one day at the gallery.

The time finally came when we assembled an audience to see, among other films, two of Joseph's montages. The usual small audience of artists, critics, and select movie enthusiasts were on hand. The Dalis were there. Dali was biting his upper lip as he always did when he was avid. Avid is the apt word, not excited, not exactly eager, but somewhat more

229

explosive. Breton could not have been more just, nor more infuriating, when he described Dali in that venomous anagram—"Avida Dollars." Dali thereafter adopted this proudly—his usual defense and always a successful one.

When Dali is avid something electrifying is happening to him, and something to those nearby too. Dali is generating; you will be shocked.

Dali sat down on a bench toward the rear. If "sat down" would be the expression for someone constantly moving, giving the impression of being up and down, around about, and everywhere at once.

The lights were turned off and film clicked into motion. A preliminary reel, Marcel Duchamp's *Anemic Cinema*, ran its spirals and puns for ten minutes. I don't remember if Marcel was present. It would be unlike him, but I thought I heard continually his dry giggle (he would have been there, of course, to laugh at not being there).

There followed thirty minutes of Man Ray's *L'Etoile de Mer*, cinematizing a poem by Robert Desnos. This whole film matinee was to illustrate the transpositions of word and image—speechless imagery or imaginary speech. So, in the course of the programmed events, there came Joseph Cornell's *Goofy Newsreel*, then *Rose Hobart*. The first, his original venture into montage, easily entertained everyone; the second, an incomplete experiment in a direction new for Joseph, provoked the Dalinian thunder.

On the screen a voiceless heroine mouths silent avowals. Suddenly the sheik enters the tent. The defenseless English girl clutches the bedcovers to her breast as she eyes the intruder with fearful fascination. She draws a deep breath and clasps her hands. The sheik's eyes flash with rapacious anticipation. A ball rolls in slow motion and splashes into a pond. The sheik, the English maiden, the sheik, galloping camels, the ball, the girl again, the splash

Suddenly there was a loud crash. "*Salaud!*" The silence was broken. "Lights!" I called.

"*Calme-toi*," cried Gala as she pushed her way toward Dali.

"*Salaud, et encore salaud*," screamed Dali as he fought his way toward Joseph Cornell.

Dali was in a rage, a state not unusual with him but unusually impres-

sive, somewhat between the firebreathing, lightning-flashing rampage of a demon and the spoiled yielding to frustration that is a temper tantrum. One sensed whirling blades of sharpest steel flashing about him and expected tears of uncontrolled hysteria. One couldn't be exactly frightened, but one couldn't fail to be impressed—except Joseph, who was shocked and confused. He had, apparently, no previous experience of childhood bullies or such full-sized malevolence. And he could not believe he was the one being attacked.

There was little to be said after Gala had calmed Dali and I had comforted Cornell. "It is that my idea for a film is exactly that, and I was going to propose it to someone who would pay to have it made. It isn't that I could say Cornell stole my idea," said Dali, "I never wrote it or told anyone, but it is as *if* he had stolen it."

Cornell protested over and over again, "Why, why—when he is such a great man and I am nobody at all?"

Dali soon forgot this contretemps but Joseph would always remember.

Perspective

" . . . the vulgarity of many a nature spurts up suddenly like dirty
water, when any holy vessel, any jewel from closed shrines, any book
bearing the marks of great destiny, is brought before it; while on the
other hand, there is an involuntary silence, a hesitation of the eye, a ces-
sation of all gestures, by which is indicated that a soul *feels* the nearness
of what is worthiest of respect."

—Nietzsche

In July of 1939 I received a letter from Paris, an occasion for great
relief to me. It was signed "best to you from your Pavlik," Pavlik being
Pavel Tchelitchew.

During the past season, 1937–1938, Tchelitchew had suffered severe
psychological and financial setbacks against which his finely drawn tem-
perament was defenseless, climaxed by an inexcusable dressing-down
from the New York art critics on his most important exhibition to date.
Pavlik had sailed for Europe in a state of discouraged jitters, determined
to repeat his exhibition abroad and invite the punishment of other crit-
ics. His state of mind was precariously balanced, I really feared, be-
tween alternatives of suicide and that chaotic retreat which would cer-
tainly take the form of delusions of grandeur. If his Paris adventure was
not crowned with the laurels of success, then insanity or self-destruction
were possibilities, leaving a charge of helpless worry to his close friends
and to me.

The New York critics had been cruel, with the inhumanity that can
only derive from stubborn incomprehension or from fear. *Art News* so
far forgot the standards of scholarly judgment as to write hysterically:

232

PHENOMENA . . . a work of pamphleteering in full colors . . . is, despite the pretentious array of preparatory sketches and studies exhibited with it, one of the most astounding pieces of slapdash amateur painting ever spread thinly over so large a two-dimensional area. Lacking in every point of professional competence, it displays alone a profundity in its concern with the obscene and the perverse. Those thus captivated, however, ought to be reminded that a great many other pictorial efforts of this nature, for the most part more sincere and unaffected even if far less draftsmanlike, are to be found in profusion on the walls of the public toilets of the city.

The New York *Times* that same week was full of encouraging adjectives for unknown young painters, describing the work of Mr. X as promising, interesting, talented—while the large canvas of Mr. Tchelitchew, an accomplished veteran, was "appropriately vile in color . . . inappropriately delinquent in architecture." I was becoming hysterically bitter, too, in Pavlik's behalf. Perhaps Pavlik's canvas had faults, but it was a matter of attaining a proper perspective. I realized this was often the failing of the New York critics; they did not define their perspective. They were, after all, a hardworking group of men, and honest. It is well known that in the past, in Paris, the critics were sometimes bribed. Over here, in all my experience, never. When Mr. X timidly presented the first picture he dared show, the charitable reaction of the critic of the New York *Times* was to say, "promising"; yet when Mr. Tchelitchew presented his bid to eternal fame, that same critic seemed to me to silently compare it with the work of a Raphael or a Titian, and pronounce it "delinquent in architecture."

Tchelitchew, who had felt a need for contact with public opinion, was thrown completely off balance. He had put up his fists for boxing, and been shot at by cannons. Some sales, or an advance of hundreds of dollars, might have temporarily helped Pavlik's security of mind, but only as a stop-gap, because the psychological wounds were serious. None of us was in a position to contribute much more than our sympathy and our worry. Therefore it can be understood than an exultant letter ending "best to you from your Pavilk" was occasion to celebrate. Let me transcribe in part verbatim:

I had a sensational exhibition of *Phenomena*. Leonor (Fini) had introduced to me two interior decorators who will open their shop for decorative art very soon I suppose. They knew a wonderful place, place Vendome to lent me to show my "phenomenon," just as I wonted it, in a beautiful hotel *particulier abandonne*—because they were rebuilding all the interior rooms and have given me the entree—very beautiful tall room with two white columns and a white stairway going someplace in the dark, etc.—all was litted with candles—masses of them and with candles all around it really looked like a ball at Don Giovanni in Mozart's Opera—the picture was illuminated by two projectors white and day-lighted and was hanging with an enormous bleu velvet draperie in the back of her hanging in the air! It was very lovely—and like in the Don Giovanni—thousands of people came. in—rich, snobs, intellectuals, poor, old, young, etc.—People were often furrius natturally—that I had the nerf of making a fete of sotcha subject—but I was so pleaset and pleaset to see how people were fascinated by *perspective.*

Tchelitchew's large (7′ high by 9′ wide) and crowded mural was the result of more than ten years of research in perspective innovation, more than three years of painting. Christened "Phenomena,"* it represented a superfreak show, a Coney Island macrocosmic. I understand the project was to be a pair of mural panels which, although never so described by Tchelitchew, would constitute a sort of personal and contemporary Heaven and Hell. "Phenomena" was the hellish partner while the heavenly and more delicate project existed at this time only in the form of tentative sketches. I remember Pavlik saying, "Heaven** will be children, children, children, suffer little children. But those freaks! They are many of my best friends, what a Hell! Here is Gertrude Stein and there is Alice Toklas, and Alice Astor because she bought a picture of mine, and Alice DeLamar because she lent me her house to live in, lots of Alices and they are all going to be so *furrius!* The Bearded Lady is

*"Phenomena" is now in Russia, a gift from Tchelitchew to the country of his birth.
**"Heaven" became "Hide-and-Seek," now in the Museum of Modern Art in New York.

Bébé Bérard. He is going to be so *furrius* too. Everyone knows that he is *féerique*, and a great painter and with such a beard that he can't find his brushes when he wants to paint, but in MY Hell, my dear Julien, to find himself in my hell, when he is jealous and hating of me always, he will be so *furrius*.

"All the people in my picture are great, and such genial friends. But they are freaks because growths have grown on them by accident. That is the accident of growing. Bébé grows to have a beard and be a lady, and your Joella grows to have many children and to be heavy with maternity, breasts and breasts and breasts—just a few more babies and she will need breasts along her legs, like five cows! Nobody will understand, but these freaks will be sad and glorious. I paint them always in the most beautiful decayed colors, like pearls and butterflies and oil on water and *les Fleurs du mal*. You will be more frightened when you see my Heaven; the children who are not yet freaks, who have not grown up to have beards and three legs and hunched backs. They are going to be so innocent that they fly without wings, and so pretty that nobody can say, 'Pavlik, how can you be so disgusting and paint such frightening people?' The children are all going to be flower colors, or autumn leaves, or pink and white like candy angels, and fly. Some of them fly down behind the barn, and some of them fly into Mama's and Papa's chamber. You will see!''

What of the perspective? As is often the case when you examine closely the connotations, interpretations, and glossary of any technical trick or artistic mannerism of which the artist seems unduly proud, more than one purpose is served, sometimes without the conscious forethought of the artist. Pavlik's perspective served many ends: physical, psychological, even metaphysical. In the foreground was a boy with a clubfoot, accentuated because that freak was thrust toward you, magnified and exaggerated, the sole of the foot right up into your face and occupying some sixty square inches of the canvas. There in the background, sloping away into distance, was a pinheaded man, the head small, a vanishing object, rapidly departing near the horizon. Physically this had the effect of plunging you, the spectator, into the deep center of the picture itself. You fell in by an irresistible vertigo and you became a

part of Pavlik's painted world. If you did not, if you resisted or were obtuse to the temptations of this vertigo, as were the critics at the time, I felt you possessed very little of the empathetic imagination for which paintings are made, and had best avoid the galleries and museums; stay in your own factual dimension. No need to whistle belligerently in the dark! The dark has its beauty, whistling demands a sort of skill, graveyard ghosts and other spirits cry for understanding and finesse before they may be happily exorcized.

The temptation to enter a perspective is real, at least very real for our generation. Dali calls it the "enigma of space." The enigma resides in this: that space is rigid physically while flexible mentally. Our thoughts seem to travel rapidly in space. The opposite is true, or seems to be true, of Time, where our thoughts have duration, take time, while the physical world in Time seems to be instantaneous. Dali implies that today the new geometry of thought is physics, and if space, as Euclid understood it, was nothing more to the Greeks than a very distant abstraction, inaccessible still to the timid three-dimensional continuum that Descartes was to announce later, in our time space has become, as you know, that terribly material, terribly personal and significant physical thing which weighs us all down like authentic *comédons*. *Comédons*, may I add, *to be defeated by the artist.*

Standing one evening on the cliffs of Étretat on the coast of France, watching the gulls cut tangents through the emptiness which spread below, cliffs which receded beneath one's feet so there was nothing between me and the very far distant and very deep sea, and finding within the imp of the perverse, the desire to sprawl into space like the handsome and hapless and perverse Satan, the falling angel Michael, at that moment was born the discovery that suicide, like a bottomless pit, was endless and immortal; to me *that* was real enough. I *had* leaped, I *had* killed myself, I *did* know every inch of distance between real clifftop and the endless down there. I lived and walked home like any other tourist. But I know I walked a little less with feet of clay and a little more head of clouds. And *that* you can gain from looking at pictures; it is what pictures are for, if you know how to look.

In those days when people came, not only to look at, but often to re-

sent Pavlik's picture, the gallery hummed like a nest of disturbed hornets, and sometimes when the angry drone reached an especially high pitch I would come out of the back office almost thinking that Pavlik's freaks themselves were starting to shriek. Indeed a gallery attendance is not handpicked. There were the very fat and the dramatically thin, the shabby individuals from 14th Street and the lorgnetted from Park Avenue. It entertained me to imagine the feelings of Pavlik's freaks as they stared from their frame. For the freaks in all their ugliness were tinged with a sort of upside-down beauty, which many of the sightseers lacked. One day Pavlik explained to me, "Ugliness can be painted, why not? But everything must belong. It can't be a caricature, fear-distorted, hate-distorted. It must be dignified into a beauty of its own. Great ugliness is dignified, prettiness is not. I know a lady who had the biggest Pompeian nose and she had it operated. Now she has a pretty little turn-up. I can't look at her. When I talk with her I can't look at her face. I see always her face now without a nose, or her nose without a face. I must cover my eyes. It confuses me like some sort of badly pasted *montage*. Picasso's big-nosed women are frightfully ugly, but the big nose is like a *boulevard—impressive!*"

* * *

 . . . a delight in uncertainty and ambiguity, an exulting enjoyment of arbitrary, out-of-the-way narrowness and mystery, of the too-near, of the foreground, of the magnified, the diminished, the misshapen, the beautified.

 —NIETZSCHE

You may think the use of perspective is useful for, and should be restricted to, a more accurate reproduction of nature as the eye sees it. This is not so, not the intention of the artist who uses the mechanics of perspective with relish. Except in unusually pedestrian cases, the purpose of the artist is never to reproduce, but to embellish or interpret nature. This is not a willful assertion in defense of modernisms. Facts very well bear me out. The painter who early exploited the laws of pictorial

perspective, a painstaking and sufficiently scientific man, was Paolo Uccello. It is Paolo Uccello's pictures which present the least illusion of reality, the greatest immediacy of mystery and enigma. I was pleased, when I first opened my gallery and began searching for pictures in the studios and apartments of living painters, often to find a reproduction of some painting by Uccello thumbtacked on the wall in the place of greatest honor, that is, in each painter's workplace. Usually it was a reproduction of a detail from the Urbino fresco, "The Profanation of the Host," which is the background of much Surrealism and almost the closest discoverable source of the strange springs of inspiration which nourished the earlier de Chirico. Less often it was one of the cavalry battle scenes which illustrate an unimportant but interesting tangent in the application of perspective for purposes of pure design.

The first reaction of the painter at the time of Uccello to the possibilities of perspective was not, so far as we are aware, that here were the means to a more accurate representation of anything. Mantegna painted his famous "Pieta," an exaggeration of the familiar, an exuberant foreshortening that equals or surpasses all the distortions with which Tchelitchew so shocked his public. In "Pieta" the figure of Jesus is laid out with the soles of his feet smack against the spectator's nose. But what dignified agony, what a landscape of crucified life was expressed in that representation of Christ horizontal!

The discovery of the vanishing point, eye-level point, and all the optical geometry involved, was nothing other than the discovery of how to use and select *a point of view*. The movie cameraman is still trying to select and elaborate his camera angle. The camera, an instrument for exact reproduction of nature, still tries to avoid direct reproduction in favor of composition and embellishment. Shifts of the camera do not increase verisimilitude, but they do serve, if properly handled, the pictorial effect of a given scene, composing and punctuating it.

The world is full of so many things, and so many ways to consider these things. The biologist with his or her microscope has a profoundly different point of view concerning a mosquito than a pretty girl on the beach. But even the biologist lifts his or her eye from the microscope to dilute his perspective as do most of us. We adjust our discoveries to a

238

mean with other directions, bring our own tributary stream into the general direction of a common river, both for mutual profit and to swell the currents of reality and utility. Each of us has had intense moments, has made specialized discoveries and contributions to our field: as have the lawyer, the farmer, or the mother in theirs, but no one can walk down Main Street daily with eyes focused only on minutiae, or else we all would soon be canceled by some automobile or other accident to our systems. Artists, however, do walk down Main Street looking at things in a singular way, always protected I like to think, by the Gods—for each artist is a seer.

That is why the artist so often is considered absentminded, impractical, queer, or even mad. The artist alone among all the world has the duty to pursue a special point of view to its farthest reach, to exaggerate and embellish just those things which others prudently modify, diminish, or retrace toward the common, less lonely, comprehensible, and useful center. If genius is the artist's infirmity, he is not permitted to disguise his hunched back, calm his stuttering tongue, or veil his eye, and finds it difficult to make himself attractive in the accepted sense. He must pile his hump with garlands; speed his tongue through the circumlocutions and the explosions of poetry, see with his eye things others might not think needful to be seen. He is neither Prometheus to bring fire to men, nor philosopher or scientist to explain the meaning and the properties of fire. It is he who burns, and he must burn, slow or quick, bright or dim, or be more cursed than Esau with no birthright. For you the artist makes a business of seeing.

Knowing that the artist is only universal by luck or by grace, and most often intensely personal, I have always been curious and entertained to discover toward what smells my friends' noses quiver, toward what sights their eyes turn as inevitably as those of a drunkard to the nearest drink. Only the mediocre painter is calculating or purposeful in selection of subject, choice of style. The good artist is more entranced, convulsive, and obsessed. If some can explain or defend a direction, it is with words post facto, often lent to them by critics. Fine work grows from the kernel of a point of view as inevitably and inexplicably as a tree. I used to laugh at Brancusi. He would say, "the one thing I am

proud of is my choice of cheeses.'' His truly fine collection was stored in the cellar, each cheese at its required temperature, to be eaten when ripe, each carefully nurtured as a great wine. He wouldn't talk of his sculpture; Brancusi was proud of his cheese. It was only when I walked with him in the market that I began to see how his play and his work were linked. For there we found cheeses, and sausages too, formed every one with some exotic relation to their taste. They hung in formal ranks, a luxurious jungle of traditional and informative shapes, while Brancusi's studio was filled with their glorified replicas in marble and brass and wood. Brancusi had also, in an evident place of honor in his studio, a piece of old wood which he called his ''crocodile.'' Gray driftwood, it was molded by the elements in conflict with its own material and grain. He found it on a beach. Gray-bleached, weather-beaten wood, the eyes were knotholes and the scales the natural hard grain which had resisted the wash of waves and sand that corroded the softer interstices, leaving hard wood ridges, quite like fish scales. This, an accident of nature, stood equal, and was so respected by Brancusi, to his own marble birds in flight and metal fish. Fundamentally Brancusi worked like a great provincial peasant God, molding *his* cheeses in satisfying shapes, attacking his marble as the elements would, by respecting the intrinsic density of the marble, its resistance and veining, polishing softly and tenderly for months until the shape appeared as the marble shrank imperceptibly away. His chisel never went violently toward a preconceived line. He used to say that if he struck too suddenly and too deep the marble ''would bleed.'' Since knowing Brancusi I have enjoyed more fully the garden markets of the world, bouquets of carrots, piles of cabbages, sacks of dried and uniform beans, rice, coffee, in which I would bathe my hands; the rippled hard sands of beaches at low tide, the smooth waves of windswept dunes or desert reaches, eroded pebbles, crystals, all geometry and inevitable form.

It requires the temperament of a chameleon to transfer from the monumental, druidic universe of Brancusi to the soft anthropomorphism of Dali. Each system has its true form, and each of these vivid personalities can make you forget the one while you are in the magnetic field of

the other. Fortunately or unfortunately, I am a chameleon. I cannot even preserve my own well-schooled French accent. Speaking for a mere half-hour with Paul Éluard, who offered an excellent high French accent, I could roll my r's with the best; but after fifteen minutes with Dali and his Catalan barbarisms no Frenchman can understand me, and must generously conclude that my vivid and abrupt massacre of his language be attributed to the fact that I am a Catalan but recently arrived in France.

When with Dali, I find myself fascinated by everything that is soft. Dali likes cheese too, but not the outer shape with its red, white, gray, or green skin of mold. He loves vivisected cheese, *coulant*, pungent, walking by itself. This is because Dali approves of what he calls the "visceral," the organic and animal. He detests hard forms or primitive rock, prefers the rock's green slime: *algae*, which is the lap of life and of man. He hates modern architecture as "simplicissimus," calls streamlined design the "poverty of reality," abhors machinery (which Léger loved so ardently the engine room of a steamship was his paradise and model for his paintings) as the cannibalistic monster man has invented for his undoing. Dali knows that man's own body is the most phenomenal machine of all, a soft machine. Dali will be happy when men make their implements pliant and mobile as muscles, automobiles become soft and can reproduce among themselves. So, from Dali I learned to enjoy the universe of "soft structures," the beauty of butcher shops, jellyfish, tripe, the morphology of a drop of water, ogee curves, and, long before it became a cult, Art Nouveau.

Tchelitchew was by no means a proud peasant like Brancusi; he was too well bred, almost overbred. His father was a rich landowner in Russia until the revolution, an old patrician who loved the property he would not leave, and at the risk of his life offered to remain in the service of the Bolsheviki. I believe he lived to a great age as chief forester on what were once his own wooded hills and valleys. Pavlik at the time of the revolution was not in Russia, and he never returned. Equipped with the finest of fine gentleman's education, he lived in precarious exile, commuting between the cosmopolitan centers of the West: design-

241

ing for the theater in Berlin, for the ballet with Diaghilev in Monte Carlo, exhibiting his early paintings in Paris, painting a portrait of Edith Sitwell in London, creating "Phenomena" in New York.

This life refined his refinements. He was the opposite of Brancusi, and of Dali too, for Dali is essentially logical even if his logic is perverse, that incredible Surrealist professional, and engineer of soft machines. Though perhaps the most persuasive talker I have ever known, I never once heard Pavlik arrive at a logical conclusion. His paintings are not plastic in the accepted sense, they are really a highly original literature. His portraits are often prophetic. He had and used more intuition than most people dream. I don't know where he found his cornucopia of words and stories. Perhaps it was only that he was Russian. I haven't read the untranslatable Pushkin, but I am inclined to think that Pavlik heard voices. Psychopavlik!

I helped him with research for his freaks and his children, with the aid of medical books and clinical notes from the library of my old friend Dr. Allan Roos, the distinguished psychoanalyst. We found some authentic transcripts of auditory hallucinations, and these broken sentences, repeated by patients who heard voices, I pieced together into a little paragraph for Pavlik.

> We are 729,000 girls. (Who are you?) We want you where we have you. Where can we cut you? We whisper to thee, Our Boy—our little moss, our crime, our splendour, our hyper-hypotenuse. When we whisper we shriek, we cry, we taunt, we telephone, we scream, we crawl in and out and toll and chime and make the bees fly and we will drive you mentally ill. It's an asylum for you, Our Boy. But you have had the magic voices. You know what it is to feel a voice. When they say you are mad you know to answer that it goes in one ear and out the other. You know a word that goes in like a small blue flame and comes out a spurt of red—with sparkling (I once felt these words flowing out my ear like warm blood down the side of my right (left?) cheek burning little lambent flames not hot but blue and disconnected like a plum pudding—little licks). We like to lick too! We are the mistresses of the German Whipping Club. We inhale you! We are moral female anarchists. (Where does the answer go?) If we touch your leg it is bigger than anything. A great

242

leg and a small head and arms and a tiny navel. Sometimes we touch your arm and it is big. Your fingers are branches and you are a small lump at the trunk—a great tree like fingers. Sometimes we touch you, and Oh—Oh, and Ah—Ah! (Do you hear me?)

This piece of clinical data bore considerable resemblance to some of the prose poems which Picasso was then writing:

> give and take twist and kill I cross and light and burn caress and lick and look I ring the bells furiously until they bleed frighten the pigeons and make them fly all around the dovecote until they fall dead tired to the ground I will stop up all the windows and doors with dirt and with hair and I will paint all the birds that sing and cut all the flowers I will cradle the lamb in my arms and give him my breast to be devoured I will wash him with my tears of pleasure and of pain and put him to sleep with the song of my loneliness by SOLEARES and engrave fields of wheat and grain and watch them die lying face up in the sun I will wrap the flowers in newspaper and throw them out the window into the stream which repents with all its sins on its back flowing laughing and happy in spite of all to make its nest in the gutter I will break the music of the wood against the rocks of the waves of the sea and I will bite the cheek of the lion and make the wolf cry of tenderness before a portrait of the water that drops its arm into the bathtub.*

There were new changes unfolding in our concepts of time, space, and consciousness. The artist was aware of this. Dali, Tchelitchew, and Picasso were independent pioneers in a common terrain. When Picasso was young there was a pause. It was a moment for sterilized dissection of the classical geometries, for abstraction, but that was the moment of *reculer pour mieux sauter*, falling back, the better to leap forward.

Of course it was not only painters who were exploring the new prospects of space and time as modified by psychology, or the point of view. Some years ago James Joyce pointed out to me how time was frozen into a kind of stopped-motion heraldic insignia in some of Herman Mel-

Cahiers d'Art, Nos. 7–10, 1935. Translation from *Surrealism* by Julien Levy, 1936. Reprinted, 1969, World Wide and Arno Press.

ville's descriptive passages. His own *Ulysses* offers many examples of slow-motion, simultaneity, and speeded immobilities. Mina Loy, in the book she had been writing for more than fifteen or twenty years, based her entire approach on this sort of temporal disformation. As Mina's book may never be published, I am tempted to quote from it at some length. Alda is her portrait of Joella as a child:

> Of a marble, soft with having grown out of babyhood, her forehead winged with the bluish fragility of temples shading off into the almost invisible implantation of the half-golden, half-curling undulation caressing her face; her forehead—that inverted base—let down the pure shaft of the nose, a pillar in the foreground of an oval. This contour, scarcely interrupted by the almost imperceptible mounts and hollows of underlying muscles, showed, with the pivoting of the head, a suspicion of concavity beneath the lovely height of the cheek; giving her that famished look of beauty ahunger for some unimaginable consecration.
>
> If sight were a sense that took contact with its object, at too close quarters beauty would not disappear. But had I laid my eye on Alda's face, like a man who, fallen flat on his stomach in a landscape, sees nothing but the patch of earth he stares into, I should have seen only the downy slope of a mountain of flesh—a preposterous blow on the retina—dwarfing the world. As a voice becomes sonorous after leaving the lips, beauty is given off by a face—or rather, no beauty appears until brought to that focus where the elements of beauty rush together in combinative grace; beauty being ever a surreality that perturbs our response with the indefinable extravagance of a dream.

Mina is marvelous: "I had laid my eye on Alda's face, like a man who, fallen flat on his stomach in a landscape, sees nothing but the patch of earth he stares into. . . . " That is part of the secret for new visions, a conjure trick! Squint your eyes or stand on your head! Exploit the mote in your eye, astigmatism, myopia, strabismus, nystagmus, presbyopia, or your xanthocyanopsia. It is said that the transcendental elongations of El Greco were the results of his defective vision. There are no limits to the variations of perspective, new ways to see familiar things; sometimes embroidery for the mere fringes of our perception, sometimes opening directions as important as that the seemingly flat

earth can be seen round. Use telescopes and microscopes or Alice's fabulous cake to make your chin meet your feet, or your neck grow long and out through the chimney. Pavlik used a cut gem to view the compositional facets of his "Phenomena," and the rainbow colors in the painting derive from prismatic refraction.

It was during the year of the exhibition of "Phenomena" that Pavlik painted his portrait of Joella. Agnes Rindge now has it, and she was such a friend to us that I could feel the portrait remained in the family and had not been sold downriver.

St. Francis, the ballet for which Pavel designed scenery and costumes, was presented at the Metropolitan Opera House that same year without great success. I consider his sets to have been the first new and extraordinary ballet scenery since Bébé Bérard's *Cotillion*. One scene in particular had three distinct shifts in perspective, dependent on the action of the ballet. The scene itself did not change. It was a backdrop which represented a stone wall. Behind the wall were sky, clouds, foliage. At one point in the action the dancers all leaned toward the audience. The viewer's eyes refocused, and what had been a wall three feet high became a parapet fifty feet deep. The blue sky became the distant sea, the clouds became sea foam and breakers, the foliage far isles and reefs. The third change occurred toward the ballet's end. Lights were dimmed. The sky-seas, the cloud-waves, the tree-lands were barely visible. But in the fading outlines, increasingly clear, appeared the features of some *trompe-l'oeil* deity; Neptune, perhaps, or St. Francis. This without shifting the scene, but by the magic of the designer's illusion.

Pavlik, who had been unable to get tickets for his opening night, stood through the New York premiere of his own ballet. And when the curtain dropped to considerable applause, he was privileged to see Efrem Kurtz brought onstage to take the bows. Kurtz had conducted the orchestra.

All this was why Pavlik had sailed for Europe, discouraged. There he was almost overtaken by World War II, and when he returned to New York it was evident that he felt the end of his world had come. He was a very chastened painter, without the spirit to attack the Customs officers who, as is their custom, had rerolled his canvas, the great "Phenome-

245

na," face in, and cracked off areas of paint. The United States Government will do this, after we have provided for expensive crating, packing, shipping, unpacking. In five minutes at Customs, these precautions can be undone, and we have no practicable redress. This time Pavlik was in no mood to protest. Although he had but a few dollars to his name, he was relieved to be in America. "In Paris even Schiaparelli is closed. There are no lights on the Champs-Élysées. Julien, it's terrible!"

Alice DeLamar invited him to Connecticut. The next time I saw him he was considerably revived, able roundly to berate Alice, who had given him a house on her estate and a cook to look after him. "The house is too small," screamed Pavlik, entirely himself again, "and the cook doesn't know how to cook anything because her ideas are American and she thinks everything should come out of a can. I say to her 'no more cans' and now she is learning to cook divinely. But she still sits in the kitchen when she is alone and plays with a can opener, sadly. And she is black. Her name is Mimi, or Manny, or something, and that black face bores me. In the morning she is black, and in the afternoon, and in the evening. I like a cook that blushes, and gets pale, and sometimes when she is sick she is green—a black cook is MONOTONOUS."

Of himself Pavlik would say: "I am not a white Russian, I am not a red Russian, I am a rainbow Russian."

MATTA

Matta burst on the New York scene as if he considered this country a sort of dark continent, his Africa, where he could trade dubious wares, charm the natives, and entertain scintillating disillusions. He was chock full of premature optimism and impatient disappointment; believing ardently in almost everything and in absolutely nothing, as he believed ardently and painfully in himself, which was the same thing, everything and nothing. For me, he was easily the most fertile and untrustworthy of the younger Surrealists.

A newcomer to Surrealist ranks, he came recommended by André Breton. He was young, he was Chilean, and his name was Roberto Matta Echaurren. He appeared in my gallery confident, exuberant, and mercurial and produced a portfolio of explosive crayon drawings, vowing he would complete enough canvases for an exhibition in the next two months if I were interested. At first glance the drawings were winning, though incomprehensible. Matta seemed to have a powerful obsession with space and could make it vast and inhuman. I was not surprised to learn that he had no apprenticeship in academic drawing or anatomy, but on the other hand was trained as a skillful mechanical draftsman in architecture, in the office of "Miles ven de Rohe," according to him. Translating his perspective into limitless voids past the horizon and beyond the vanishing point, Matta seems to have arrived at his own strange outer world. His epics are sometimes horrible, sometimes coldly glorious, always rent with the passions of physics attempting to become biology. They dealt with magnetic fields where wires and fuselage, molecular crystals and lambent meteors, were half fleshly, where electronic computers became so experienced as to be charged with suffering and cruel hunger, cosmic consciousness and short circuits.

247

Matta looked like rather a pudgy little Rimbaud, assuming that Rimbaud was as his photos seem, rather beautiful and perversely angelic. And he often acted out what one might imagine to be the everyday behavior of Rimbaud. His giggle was rather a malicious version of Peter Pan's crow. Come to think of it, I've known several artists who giggled. Tanguy, who made a strangled noise something like ''tchk-tchk tk,'' a chortle of pleasure. Duchamp's was rare, surprising but elegant; Matta's more like vocal backslapping, including you in a friendly punctuation. He was an *enfant perpétuel*, always in a tantrum or a triumph of self-admiration. I never saw him in the depression that should have balanced such hyperactivity, but I never saw him at peace either.

His heritage was from the laboratories of Tanguy and Duchamp, but without their humanity. Once Duchamp suggested a book for him to read, the *Ego and Its Own* by Max Stirner. This rather thin distillation of complete nihilism from Nietzsche became Matta's unprofitable Bible.

He and his wife, Anne, soon found a small cold-water room in picturesque Patchin Place in the Village. I had recently moved to the Village, to Grove Street, so we were neighbors and began to see each other frequently outside of working hours. E.E. Cummings, the poet and occasional painter, also lived in Patchin Place, and I brought the Mattas to call. I rarely saw Cummings and his beautiful girl, Marion Morehouse, because Cummings resented the slight to his paintings implied when I had held an experimental exhibition of tentative and rather naïve first paintings by a talented close friend of his, Charles Morgan, and failed to extend to Cumming's work the same honor. The fact was that his paintings were neither tentative nor experimental, and I liked his poetry better. But like Brancusi with his cheeses, Cummings was more touchy about his extracurricular paintings than he was about his curriculum poems.

Matta and I explored the village for cheap but good eating, looking for the New York equivalent to the bistros of Paris, and in those days we were often successful. Our search for a version of the Paris café, on the other hand, was frustrating. There was always the sidewalk café at the

Brevoort, and the stylish indoor bar at the Hotel Lafayette with card and chess players busy day and night at the marble-topped tables; but these were specialty spots and too expensive for us.

Down an accidental street, and there are many such in the Village, I came one night into another territory and found a dimly lit "restaurant" with swinging bar doors, plus a set of bolted iron doors, now open, an inside bar, now closed, and a large dance hall with garden furniture crowded into one corner where drinks were being served. There sat three men wearing hats and playing cards. Two girls in frilly, incongruous organdy party dresses were drinking vermouth and idly watching the game. In the wall above was half of a stained glass window illuminated from behind by an electric bulb. One pane was missing, and I could see a brick wall a few inches behind the window. It all seemed like a stage set, between productions, as indeed it may have been. I sat at a small table and ordered a glass of vermouth for myself, and asked for soda with ice. I began to recapture the feeling of deliberate "Kafka" that Leonor Fini had shared with me in an empty railroad restaurant in a slum *quartier* we found, where we ordered genuine absinthe and surveyed the unconvincing reality. "*Jouer la comédie*," she called this, and it was a part of her way of life. This odd place in the Village, was not an outdoor café, but its strange dislocated atmosphere offered a similar illusion. Were the patrons prostitutes and gangsters? An Italian family complete with incidential relatives at a loss how to conduct this awkward new business? I intended to bring Matta here and suggest to him that we make it our special rendezvous; a pineal gland or upper thalamus for the nerve center of artistic activity that Matta continually sought. However, I never found it again. Like a stage set it seemed to have folded up and vanished out of the real world that very night.

Evenings I participated in Matta's preparation for his show, as his neighbor, rather than his dealer. He showed me his sketches and canvases as they progressed. He was an inventive talker, and I decided to draw up his footnotes as appendages to his paintings. Condensed from his habitual verbal flights, his rationalizations, "These will be *pseudo-*explanations of what I mean," he said. They would, I reasoned, help

publicize his ideas and create handles for those art lovers (unfortunately a majority of the public) who prefer the adornment of explanation to the naked image.

Matta was fascinated by intellectualizations, preferably irrational, usually perverse. He enjoyed Karl Marx chiefly because Marx "turned Hegel upside down." If Hegel had turned Marx upside down he would have preferred Hegel. He avidly picked up scraps of neo-scientific novelties and used them for personal science-fiction explorations of his own.

He found a shop that sold fluorescent mineral paints, bought a special lamp that burned with "black light" that activated the colors of the minerals, and excitedly began a series of paintings using a palette of these fluorescent colors. Some he could obtain commercially (they were manufactured for novelty advertising displays). Others, he gave me to understand, he ground and mixed himself. He meant to include in his coming exhibition a series of these "black light" pictures. His problem, as he outlined it, was to devise multiple compositions that would look one way in ordinary daylight and another under the "black" fluorescent light, and still maintain a pictorial relation between the two. We built a peepshow box in which to view these pictures, a series of six, with a toggle switch on the front panel to change the lights, and a viewing aperture. This made drama and news at his exhibition. Unfortunately the life of the lamp was short and its price quite dear ($15) so the apparatus was more often burned out than functioning.

Even without the black light, Matta's show was colorful, meteoric, and mystifying. Our panels of typewritten aesthetic explanations clarified little to visitors unwilling to believe such science-fiction explosions were more than an insulting joke. Matta pinned all his hope on that potential patron of Modernism, James Johnson Sweeney. According to Matta, Sweeney was a connoisseur who not only would immediately recognize Matta's unique message and buy, but would also influence the New York art world in his behalf, bringing him professional distinction and financial success.

Instead of a catalogue for the Matta show I published a leaflet in the form of a pseudo-newspaper (precursor of Dali's *Dali Mail*) with the

250

collaboration of two of the more interesting young poet-critics, Nicolas Calas and Parker Tyler. Known as the *Twenty-one Star Final*, the "weather report" in a box over the masthead read as follows:

> Sun spots partly modified,
> little change today or tomorrow,
> unconnected with surrealist
> exhibition

I invited Sweeney to a preview. He was polite and noncommittal. So noncommitted he did not buy then, or for some time to come. The exhibition was a resonant flop. It was to be another year before Jim Soby developed a persuasive enthusiasm and bought several paintings. Matta's work later began to sell to other collectors, but by that time dealing with Matta was out of my hands.

There was a rumor Matta had a rich family in Chile, but Matta, like his prototype Rimbaud, resented any family dependence or interference. His wife, whom we called Paquarito (Matta's affectionate name for her which meant "little bird") was gentle, shy, and unobtrusive. She expressed a muted hope that she might have a child and that the Chilean family would "help take care of everything." Matta, however, was violently opposed to any form of responsibility outside of that which he pledged to art. Much as he resented family dependency, he resented parental duties more.

He found a temporary expedient for his living with a small collection of modern paintings entrusted to him by an English friend and patron, a mysterious young painter, aesthetician, and adventurer named Gordon Onslow Ford. Matta had authority to sell some of these pictures for Gordon's account and take a commission from the proceeds. Perhaps some even belonged to Matta. Whatever the case, Matta produced these canvases and sold a few. I helped him with certain of these sales and so did Pierre Matisse. I was soon to lose touch with Matta's affairs when I entered the Army.

Several summers later, when I saw Matta again, it was the year he had his "eye put out of joint." He had been commissioned to paint a mural in a bar-restaurant in Southampton, a venture in which Caresse

251

Crosby was interested, one of her "Let's-get-together-and-everyone-make-a-combination-chic-party-and-business-venture-in-honor-of-the-arts," what Chick Austin would have called "friends and enemies." Caresse came to me and asked if I would lend pictures for an exhibition in the foyer of this venture, fishing or sea pictures of decent quality, of course, and I promised to lend a couple of Leonid's and a couple of Theodore Lux's series of "Sidewheelers." (Theodore Lux's real name was Lux Feininger, he was the son of the famous painter, Lyonel Feininger, and introduced to me by Lincoln Kirstein.) I gave Lux two exhibitions. He was a charming and sensitive young painter. I went out to Southampton for the inauguration of Caresse's venture, and found Matta there as a sort of artist in residence. He had a black patch over one eye; the other eye was inflamed, too, and seemed infected. He was very excited about the hidden obscenity he was incorporating in his mural. He showed me a few sketches; I never saw the finished work. He was separating from Paquarito because she was subjecting him to the indignity of becoming a father. "I take it as a form of half castration," he said. "I consider fatherhood an indignity to my testicles, and that is why I am losing one of my eyes, because I have displaced from the lower balls to the eyeballs."

"Why is your second eye also infected?" I asked.

"Sympathetic," he answered.

It soon turned out that Parquarito gave birth to twins—two unidentical boys!

OUT of THiS CENTURY

By the end of the 1930s the Museum of Modern Art, both in prestige and size, had grown to awesome proportions. The talents of Alfred Barr were being smothered by the accumulation of administrative detail. A new man was brought in to share the burden, a surprisingly tall, charming Austrian aristocrat and scholar, René d'Harnoncourt. My old friend Frederick Kiesler wished to get us together. "It should be mutually beneficial," he said, as he wanted me to get to know d'Harnoncourt more intimately and hoped I might recommend his new work and sculpture for exhibition in the expanded Modern Museum. Up to that time he had been known mainly as an architect. He invited both of us down to his studio to show us his new sculpture, an enormous wooden abstract construction stored in pieces in the back room of his apartment. We sat around assembling his unique edifice. It was necessary for him, at one point, to have help carrying in an extremely long and heavy carved wooden plank which was the spine upon which his whole construction depended. D'Harnoncourt offered to help. May I say that Fritzy Kiesler was an extraordinarily small man; stocky, charming, and witty, and decidedly insignificant in stature. D'Harnoncourt was, on the other hand, more than tall. He was gigantic. The two returned, each carrying his end of the long beam. First came d'Harnoncourt, standing upright, one hand swinging at his side, the other negligently holding one end of the beam. After d'Harnoncourt and the beam filed into the room and past me, Fritzy appeared through the door, holding his end triumphantly in upraised fists. Between d'Harnoncourt's lowered and Fritzy's upright grasps, the beam moved absolutely level and parallel to the floor.

During this period, the years of 1939 to 1941, the turmoil in Europe, matched by upheavals in my private life (and lack of funds), made it im-

253

possible for me to make my usual European buying trips. However, more and more of the European painters were coming to our shores as refugees.

Wolfgang Paalen passed through New York on his way to Mexico and exhibited with me. I also showed several Americans new to my gallery, the Magic Realist painter Walter Murch; and John Atherton, a top commerical artist who suddenly was converted to serious Surrealist painting. I presented the sculptor Theodor Roszac and the exciting first sculptures of David Hare, the young Surrealist—brilliant, taciturn, and full of promise.

My interests branched into the popular arts and led me to show the sketches for Milt Caniff's cartoon strip *Terry and the Pirates*; the Walt Disney Studio watercolors for *Snow White* (I tried and failed to get those for the classic *Fantasia*), and just for fun, the paintings of the surprising comedienne Gracie Allen, wife and partner of George Burns.

I continually saw Max Ernst in Paris and exhibited his work until the outbreak of war in Europe. One day in 1941 Peggy Guggenheim came into my gallery and asked innumerable questions, expressing the lively, youthful curiosity she still has today. She invited me to go with her to visit Max on Ellis Island, where he had been detained on his arrival from Europe. Peggy had escaped the World War II invasion of France and sailed home in the company of Max, several other artists, and the collection of paintings she owned, many snapped up at ridiculous prices during the last panicky period before the Germans arrived.

Peggy hired a little launch and we chugged out to the island. I was not permitted to leave the boat, but Peggy spent an hour with the despondent Max, who was held in quarantine by immigration red tape. Rocking in the boat, I waited for her, and on the return voyage she informed me that she and Max were to be married. She also told me she planned to open her own gallery-museum in New York and, since Max was to be her husband, his pictures would naturally be exhibited and sold in the future in her gallery and not in mine. From hearing this, and the turbulent boat ride, I began to feel a little sick.

When Max was again a free man and on American soil, I intended to talk the business over with him. If not his honor, then at least my repu-

tation was in the balance. Much later, he and Peggy granted me two canvases for exhibition on the West Coast when I was to set out on a new adventure there in 1941.

In 1941 business was not only terrible, it was nonexistent. Trying to stave off disaster, I became absorbed in another hopeful pioneer project: a traveling gallery, a caravan of modern art. Preceded by a boxcar holding the materials for a movable show—drapes, lights, and paintings—I drove out to California, hoping to make some of the sales that were eluding my New York efforts. I rented temporary space, first in San Francisco and then in Hollywood. In each city I gave successive shows: first my entire gallery of Surrealists, then the Neo-romantics, and an exhibit of the paintings of Tamara de Lempicka.

An incident in San Francisco was typical of my success there. An obviously wealthy woman asked the price of a canvas. It seemed to her expensive. She asked the price of a drawing. Then, regretfully showing me a diamond-studded wristwatch, she said, "Oh, my dear, if I had not just bought this I might have considered it." I showed her a fifteen-dollar etching. She volunteered that her husband was not really "strong for art," and added, "but where did you get those glass thumbtacks, so unobtrusive and attractive?" I told her where to buy them, gave her one, and ungallantly hoped she would take it home and sit on it.

Hollywood was more agreeable. And a lot more amusing. I met the celebrities and was introduced to the wonderful Arensbergs and shown their collection of Duchamps. He lent Marcel's "Bride" (which I had once happily owned for several years) to my exhibition. I went about often with Man Ray.

When I first knew Man Ray he had been happy enough to be known and celebrated as one of the world's great photographers. (Though he never ceased his activities in painting and sculpture, that work was rarely shown at this time.) He had discovered a secret that many photographers have since discovered: that the camera's eye focused on a beautiful woman can act as the most insidious and seductive caress. Almost all the beauties of the world will fall under the spell of even the ugliest photographer if he stimulates her self-love by the astute use of the lens. But now in Hollywood I was to hear the beginning of what was to be a

255

constant and rather just complaint of Man's: that people did not appreciate him for his real art, that is, his drawings, paintings, and sculpture. He was forced, he said, to refuse to take portraits, refuse to do photographs, in order to establish that he was an artist. Man would say, "I tell you again and again, I am not a photographer, I am a *faute*grapher. I take a *faute*graph, a false line. My true line is the pencil and the brush." It was difficult to play along completely with his desire for total admiration of his painted work; the road was paved with secret mines. Saying one admired his paintings implied a derogatory attitude toward his photographs, which might aggravate him just as spoken admiration of his photographs would sometimes annoy him. At other times one felt forced to ignore his marvelous photographs in order to show one's genuine sympathy for his painting stance. Be that as it may, we came to a compromise, because without any reservations I loved and admired what he called "the objects of my affections." After the war when he came to New York on his way to Paris he helped me assemble an exhibition of these objects. My catalogue had the curious cover I've already described, "The Kiss," designed by our friend Marcel Duchamp. In later years Man turned out editions of these objects in reproduction, the most curious being a metronome with a photographed eye affixed to the waving wand of the time keeper. This metronome with the moving eye cut-out from a photo of Lee Miller tick-tocked, tick-tocked when wound and was called "Indestructible Object." Many decades later it was to be transformed into *frozen* time, the opposite of Dali's melting time, when Man's metronome was inexplicably immobilized—cast in bronze.

Now, on my trip West, I found Man Ray in Hollywood sporting a marvelous new blue Graham Page, a supercharged auto which he drove like a maniac through the streets of Los Angeles. He said that at first he had walked interminable miles and enjoyed having whole boulevards to himself. Los Angeles was stretched out so far few walked. It was a relief, he said, after his years of walking in Paris and being jostled by Parisians. Suddenly, one afternoon during one of his walks, he saw this startling blue car and bought it, love at first sight.

"How can you, a refugee from war-torn France, afford living out

256

here and sporting such a luxurious car," I asked, "when after all, you say you turn down offers to do photography or portraits?"

"Well," said Man, "during my years in Paris I never knew what to do with American commissions from my magazine work for *Vogue* and *Harper's* and others. They paid in dollars and rather well. I said, 'stick 'em in a savings account, stick 'em in a savings account,' and forgot all about it. After years, when I arrived in New York and looked up my account, I found quite a surprising nest egg there."

He was living with the vivacious and beautiful Julie Browner. (They later were married in a gala double ceremony with Max Ernst and Dorothea Tanning in 1946, following Ernst's divorce from Peggy Guggenheim.) He met Julie, he told me, on his third day in Hollywood. A New Yorker, she was a dancer, had studied with the Martha Graham group, and been Bill de Kooning's girl for a while. She came out to Hollywood to visit a friend, simply for a vacation, and the day they met she was to return to New York. Man Ray said, "Why? You just stay right here with me!" It was a happy combination—to last throughout a lifetime, as did the marriage of Max and Dorothea. All of Man's old and new friends loved Julie, her gaiety, her sympathy, and the little comic dances she would improvise at parties. Man, who was always dour, was less so with the devoted Julie around.

Chick Austin appeared briefly in Hollywood, so did Edward James. Genia Berman had installed himself more or less permanently in a duplex studio in an annex of the Garden of Allah Hotel. They, together with Man, Walter Arensberg, whom I found immediately agreeable, and the right honorable, right lovable Wright Ludington, were for me an oasis of warmth in what otherwise would have been rather a desert.

For the opening of my caravan gallery, the Baron Kufner had provided elegant catering—buffet and bar—in the neighboring parking lot, inside a large circus tent. We stood together, myself and my friends, all of us thoroughly familiar with the pictures I was exhibiting, and watched the Hollywood stars, with whom I was less familiar. While the guests seemed to enjoy to the full all benefits of buffet and bar, I was curious to see if any of them would eventually have the good manners to go into

the gallery and look at the pictures. Finally, John Barrymore, as usual outrageously drunk, did go in. Perhaps thinking it was a men's room, he did me the honor of urinating against the lower lefthand corner of a Max Ernst painting. I admired the respect he had for the signature, which was on the lower right hand. Never understimate the power of a signature, I thought. For some folk, therein lies the true value of a painting.

I sold but one, to Wright Ludington, the great Dali painting "Accommodations of Desire." He had driven up from Santa Barbara. Frank Perls, who had an established gallery next door to my rented space, was helpful and charming. (It was he who brought the distinguished John Barrymore to see a Surrealist vernissage.)

I returned in haste to New York, Lotte, my secretary, following more slowly in a car. I arrived in Penn Station to hear the news of Pearl Harbor blaring from loudspeakers.

Lotte, who is apt to embroider, told quite a tale of that trip. According to her, she was stopped by a sheriff in one of the more rural towns of Georgia. (What was she doing that far south?) She had a German accent and it was wartime. She also had my 16 mm print of *Un chien andalou.* The sheriff had it projected and decided that, if not subversive, it was at least in code, so he clamped her in jail and sent for the FBI. Lotte reported that this showing was also Surrealist, for it was projected backward. She was terrified. Amazingly, when the FBI agent arrived from Washington and saw it, he, surprisingly knowledgeable, pronounced the film to be the work of Buñuel and Dali, quite harmless, and ordered her released from jail.

I was soon in the Army, my gallery closed. Between closing my gallery and entering the Army in 1942, I was at Durlacher's, where my friend Kirk Askew allowed me to give my own shows (alternating with his) to artists I had already promised exhibitions for the 1941–1942 season. Much of my service in the Army was spent in hospitals with a mysterious malady—of the thyroid glands, as I was to discover just in time to save my own life.

Entering the Army, and my prolonged illness, interrupted my participation in the events of the New York art world for a period which was to prove of much significance for subsequent decades. The struggle was

acute between the influx of European influences brought over by the exiles, notably the Surrealists from Paris, and the rising tide of independence asserted by the artists who were to become the New York School. Both tendencies were fostered by the money and energy of Peggy Guggenheim, who arrived on the scene and rapidly took over, adopting for her counsel on one hand her husband, Max Ernst, and on the other a new critic who had appeared on the horizon, Clement Greenberg. The latter supported the efforts of Jackson Pollock and soon was allied closely with those who were to become the Abstract Expressionists.

Aside from Greenberg, Jackson Pollock had a special influence on Peggy, as he became her intimate friend, and she saved him several times from drunkenness and suicidal depressions—or shall we say simply from suicide—she was not the one to deprive anyone of alcohol.

The following events took place: the mingling of the exiles from Paris with the New York artists; the installation by André Breton with the advice and collaboration of Marcel Duchamp of a large Surrealist show in New York; the debut of the magazine *VVV*, edited by Breton and David Hare; and, most important of all, I feel, there began the extensive dialogue between Arshile Gorky and André Masson in Roxbury, Connecticut, and later of Gorky with Matta. Another event was the opening of Peggy's gallery, Art of This Century, which rocked New York with the violent drip paintings of Pollock. Much of this took place while I was fighting my own unheroic battles in and out of Army hospitals.

Not long after my Army Corps basic training in Florida, I was assigned to a school for mechanics in Manhattan, of all lucky places. Before I could enjoy many free hours, however, I found myself dropping out of ranks mornings at roll call and subsequently being summoned to the medic's office. There seemed to be something drastically wrong with me. I could no longer keep up in the parade. I was rapidly gaining weight. My features were so swollen my eyes were all but closed, and my face considerably coarsened. After a series of cursory examinations I was marched off one night and conducted by subway, in the company of a medical officer, to an Army hospital. Arriving after lights out, I unpacked my duffel in the dark and sank onto the cot assigned to me in a row of twenty, most of them occupied. I tried to sleep, for I was ex-

259

hausted. Almost immediately a strange series of convulsive sounds filled the room. There would be a chorus of grunts from the other GIs on their cots. Then a concerted laugh, followed by a roar of laughter. Long silences. Suddenly one heard a series of whistles—all in concert, and without apparent reason. It kept me awake for an hour. At last, from sheer fatigue and puzzlement, I fell asleep. Not until morning did I find an answer. The mysterious concert was, if not Surrealist, at least a sort of "Massimo." Each of the hospital cots had a headphone attached, tuned to a common radio program. All the occupants of the cots were laughing, grunting, sighing, gasping, whistling, and laughing again at the same radio offering—a comedy hour.

That was but the first of several after-lights-out experiences. I was often transferred quite mysteriously from one hospital to another, with no explanation of the nature of my illness. After one long train ride, with drawn blinds, for we were never allowed to know our destination in the Army at any time, I arrived—again late at night—and was assigned to a darkened hospital barracks. The room seemed to hold a curious group of cases. These men were done up in plaster casts interlaced with blue and pink rubber tubing. When I asked my neighbor on the next bed what maladies they suffered, I was told that this was a ward for skin transplants. Obviously I was to be there but temporarily, until other quarters could be found for me. I began to drift off to sleep, watching patterns made by shafts of moonlight slanting across floating notes of dust in the air, and was awakened by an audible stir in one corner of the barracks. I heard some murmuring and some gurgling, and within minutes a grotesque dance began. These sculptured figures in white, writhing and misshapen, were stamping and waltzing, humming and weaving in and out of the moonlight, their red and blue tubes swaying like ropes or maypole ribbons, their flesh showing through the casts—they were like mad sculptures coming to life, becoming finally flesh and blood. And, as in a Gothic nightmare, there was blood, a sizable puddle of real blood in which the whole crazy troupe had begun to slip and fall. Someone called for the doctors. Someone else put on the lights. The ward was a shambles.

What had happened? Again I had to wait for morning to find out.

260

Then I was told. The previous day three of the patients had been released, and went on furlough into town. They had promised the pals still confined to the ward they would slip them a few bottles of booze through the windows. And so they had. These poor men, deprived of alcohol and exercise for months, were completely and soddenly drunk within minutes after sharing the bottles. So they danced their drunken dance and stumbled and fell in their blind orgy without care for the damage that they would do to their careful packaging or themselves.

Aside from these experiences the days were quite tedious, and eventually terminated by my medical discharge in time for Thanksgiving at home in 1942. It seems that what I had was a tumor of the thyroid which had interfered severely with my metabolism. This could only be treated, for some obscure military reason, by civilian doctors. So I was soon honorably discharged to civilian life. My doctor in New York straightened me out and I returned to normal. The cure consisted of carefully exact small doses of thyroid extract, to be taken the rest of my life.

PART FOUR
42 EAST 57TH STREET

I reopened my own gallery in 1943 in smaller quarters at 42 East 57th Street. As might be expected, most of my regular artists were now with other dealers, but I was soon to find replacements, newcomers of equal fascination, and so I resumed my exhibitions. Pavel Tchelitchew a rd Peter Blume had transferred to the gallery of my friend Kirk Askew who, while I was in the Army, had decided to present modern art. His specialty up to then had been seventeenth-century Italian.

Eugène Berman came back to me with a new and rather florid style he developed living in Hollywood. Marcel Duchamp secured my first Victor Brauner show. He had been in touch with Brauner and discovered the poor man's financial problems and his tribulations in a concentration camp in France. He also learned that a great many early Brauner pictures were in the possession of a friend of his in Mexico. With Brauner's permission, he had the Mexican pictures shipped to my gallery and concluded a contract for me for next year's work, assuming, optimistically, that Brauner by that time would be released and free to work, which turned out to be the case.

My father, since my return from the Army, offered to help. I relaxed my pride a bit and he relaxed his purse strings to match. He now gave up all hope of my abandoning the gallery and the world of art. He had always hoped financial need would convince me to join him and my brother in the family real estate business, but I never would admit defeat. So now he lent me, quite freely, and without strings, a modest sum, but enough to give contracts to several outstanding artists. In this way I obtained not only the Brauner pictures but also the work of Max Ernst from 1942 to 1948. After he left Peggy Guggenheim, Max was soon back with my gallery, to stay until I closed in 1948.

At this time, too, my Paul Delvaux exhibition was arranged through the efforts of a friend of Delvaux, a brother of the Belgian Prime Minister Paul Henri Spaak, who was in turn able to diplomatically facilitate shipping of the paintings to the States when times were difficult for commercial shipping.

I had discovered the work of a beautiful girl, Dorothea Tanning, who was creating a whole world from her subconscious, precisely painted, authentic as Dali must have wished when he asked for a camera to take colored photographs of the interior of his mind. The interior of Dorothea's mind was of a very different sort, and erotic in another way, than Dali's. Her paintings were utterly fascinating. I gave a party for her after her vernissage in the gallery and introduced her to Max Ernst. Almost immediately they were off together and Max had broken with Peggy. Peggy suspected, even insisted I had done it on purpose, out of spite, or as some sort of revenge. None of this, of course, was true. I had simply felt sure that Max, always helpful and generous to other painters, could be most helpful to her work. Indeed, with hindsight one can see theirs was an authentic and inevitable match. As the world well knows by now, of all girls Max knew or married, Dorothea was the one to last.

One of the first artists to take refuge in the United States from the European war had been Yves Tanguy. He came over the same year as Matta Echaurren; I believe it was 1938, much earlier than the other Europeans because his entry was facilitated by marriage to a wealthy American painter, Kay Sage, and also because his living was guaranteed by a contract with Pierre Matisse. With some embarrassment, and a great deal of affectionate gratitude, for we were good friends, he explained this to me, apologizing for not continuing with me. He appreciated the fact that I had given him his first show in the States some years before, in 1936. Yves and Kay lived first in Greenwich Village, and the following year were to discover that marvelous section of Connecticut countryside around Roxbury, Bridgewater, Sherman, Waterbury, and Washington, which Yves, with roaring good humor, always called Washington *d'ici*. I suppose they found the neighborhood through David Hare, who was a Sage and Kay's cousin, already living in Roxbury. This

countryside was to become a center for free-lance painters and writers, and later a haven for many of the artist-refugees from Europe. Earliest arrivals had been the returned expatriate writers of the twenties, Malcolm Cowley and his Muriel, and Matthew Josephson and Hannah, joined in Sherman by the painter Peter Blume and his wife, Ebie. Sandy Calder and Louisa moved up to Roxbury. Yves and Kay bought an elegant colonial mansion which they rehabilitated, in the grand style, preserving the façade as it should be preserved but opening up the interior to avoid a colonial effect. They developed their own combination of the modern, the old, and the chic, set in tones of cool white and grays. A stone terrace at the back gave a splendid view over meadows where a pond was dug, shaped after a design by Yves from one of his paintings. A year or so later they went so far as to persuade a distant farmer who owned land bordering theirs at the end of their view to permit them to bulldoze their horizon line, again to match an Yves Tanguy drawing. Sitting on their terrace at twilight, having a before-dinner cocktail, one felt immersed in an Yves Tanguy landscape, otherworldly and at peace.

The first year in Connecticut Kay set out to camouflage Yves as a Connecticut country gentleman. Escorting him through Abercrombie and Fitch, she bought him a corduroy hunting cap, a jacket with leather shoulders, leather arm pads and other piping and patches—in short, an elaborately tailored shooting jacket. For Christmas he received a double-barrel shotgun and rifle. Yves was desperately unhappy over all this. A proud and sturdy Breton, he had no picture of himself as a country gentleman. As their evenings of isolation in the country wore on and his inclination to drink crept up on him, his nostalgic drunken stories would more and more turn back to his vagabond days as an artist, or he'd recall earlier days as a sailor in the merchant marine. None of these things, he vowed, ever involved double-barreled shotguns. In fact, he hated the idea of hunting or shooting in any form. If he got slightly drunker than this, he would go even further back and start all over again to fight with much passion that tragic French trauma, the Dreyfus case, which he took very much to heart as a boy in France. He would look for somebody who could argue the opposing, anti-Dreyfus side so that he could relive the epic debate and fight with them. His method of fighting was to

267

suddenly grab the ears of an opponent, or a friend, or any man handy and bash his head against theirs. "Banging heads" he called it, simply. He claimed that his head was harder than anyone's. As hard as an ivory ball, he'd insist. A solution to this ominous game, or quandary, of Yves' drinking followed by obsessive skull-cracking was arrived at one day by Kay. Yves agreed to install a huge and beautiful—the finest— billiard table they could find, in their vast and immaculate drawing room. Yves was immensely cheered. The shotguns were put away out of sight, the drinking tempered to improve his game, and the billiard balls were happily banged against each other, morning, afternoon, and night, to Yves' great satisfaction, and the relief of his friends, who found visits with him safer and more peaceful when Dreyfus was forgotten and the painful head-banging ceased.

Kay Sage soon became a proficient and rather dramatic Surrealist painter with a style and statement of her own. Kay and Yves had separate studios in the barn at one side of the house. Each studio was immaculate with the precision and neatness they both cherished, although Pierre Matisse, visiting one weekend, was exasperated to find, he was to claim, cobwebs on Tanguy's neat brushes.

Many years later, after I closed my gallery and retired to my own Connecticut farmhouse, came death, sudden and tragic, overtaking Yves in his sleep. Apparently it was a stroke. Kay courageously tried, but never quite became reconciled to her loneliness. She painted, wrote an enchanting book of short poems, entertained friends. Then came the threatened loss of her eyesight. Some years after the death of Yves, in the early sixties, she shot herself in the heart, leaving a statement, it was said, that her mind was too good to be blown to pieces but that her heart was sick.

Kay had written a beautiful and complete autobiography, parts of which she showed to me. It was the story of a weird and unhappy child who chose to wander about the spas and capitals of Europe with a beautiful and neurotic mother who was quite dependent upon her. Kay only occasionally could visit her staid, rich American father and sisters. Then came her early first marriage to a handsome, titled Italian, Prince

San Faustino, which turned out unhappily. Happily enough for her, in later years, after her divorce, she was to meet Yves in Paris.

Kay's family approached me with the intention of publishing a rather censored version of this autobiography, together with my criticism of her paintings, perhaps even a complete catalogue raisonné of her work. I considered one of her most important paintings to be one showing the bare back of a woman, as she sat quietly facing out over a desolate Surrealist landscape. I wanted to call the book *The Princess Who Turned Her Back,* as Kay had been a girl who had turned her back on a proper Connecticut family life and fortune, on a proper Italian title, on anything or anyone who bored her, and, finally, on herself, by suicide. However, when the family understood my intention, that the book would really be centered around, or culminate in, the motif of her suicide, which they had hoped to underplay if not entirely overlook, the whole project, or at least my version, was dropped.

In 1942 Joella and I were divorced. And in 1944 I married a young painter, Muriel Streeter.

A Summer with M. E., 1944

Max and Dorothea had found an old rambling house far out on Long Island we might all share over the summer. The rent was reasonable, for it was on the cove of Great River, not on but opposite the smart and expensive shores of the Hamptons, but it had swimming and was near the house of David Hare and Jacqueline Breton. These past weeks in New York had been days of crowds, of murk, and rain, and like sun breaking dimly through a fog, Max's enthusiasm showed through his usual ironic reserve. I accepted the house, sight unseen.

It was not possible to close my gallery before the middle of May. Max and Dorothea went on ahead to take possession of our vacation place. He sent me a postcard: "No chess set available at the village store."

We drove out to Great River, a drive of about two and one half hours. Max had become completely diverted from painting. He was making a chess set and a large sculpture he called "The King Playing With the Queen." Dorothea was painting in a corner of their upstairs bedroom. Max had taken over the garage as a studio and there he poured his plaster of Paris into ingenious molds. His molds were of the most startling simplicity and originality—shapes found among old tools in the garage plus utensils from the kitchen.

I must note something I felt about Max's eyes. Clear gray-blue, they did not really refuse to meet one's own, but seemed at times to be looking directly beyond at something else. And his spark of ferocious glee. Was it that which, at times, made him seem so cool, even forbidding? Then again, his gaze could be suddenly warm, almost always humor-

ous. One evening he picked up a spoon from the table, sat looking at it with that abstracted, distant sharpness one finds in the eyes of poets, artists, and aviators. He carefully carried it to his garage. It would be the mold for the mouth of his sculpture, "An Anxious Friend."

Our dogs became acquainted. They were both Tibetan oddities. Mine was a finely bred Shih Tzu that Maude Morgan brought back from India, "Belinda." Max's was one of the brood Peggy Guggenheim was always raising, and was named "Katchina." Playing together, they made a droll montage of hair. Dorothea intended to paint their portraits, but delayed "because both ends look so alike it is hard to know where to begin."

My son Jonathan came to visit me for a week or so. He was an engaging eight years old. I loved him dearly (though it should not be said, for in Surrealist terms sentimentality falls between the poetic and the cruel). He silently brooded all one day over the canary singing in its cage, and finally when nobody was looking he opened the cage door. When Max came in from the garage he was horrified by the empty cage, deeply disturbed about the missing canary.

Max found a small ladder and frantically climbed tree after tree all along the alley lane behind the lawn. He was whistling, cajoling, calling for the golden bird that fluttered frightened, farther and farther away.

Jonathan was crushed, in tears. "I only wanted him free," Jonathan wailed. "Freedom is not in question," answered the angry Max.

We left the cage door open, day and night, out-of-doors, by the window, surrounded by enticing food, suet, seeds. The canary would never return. Max thoughtfully explained to Jonathan that freedom is a splendid idea, but a domesticated canary would not know how to use it. He will simply die, a panic-stricken novice in the wild jungle of life-on-his-own.

Then I saw Max Ernst in his deepest Janus-dialectic. One moment, up in the trees, lofty, imperious, he was a Loplop—King of the Birds. Next moment, with Jonathan, he was the gentlest realist.

271

"I feel joy, calm and ferocious," he could say. There was no in-between.

The field of hayweed and shrub behind our hybrid house became a sculpture garden. On improvised pedestals Max mounted his finished plasters, including the latest, "Moon Mad," which we placed at night by the light of what was not (some fault of the moon) the proper illumination. The white plasters created a deteriorated impression of the Luxembourg Gardens, several centuries after memory. I was fearfully impressed, confided to Dorothea that Max had become the greatest sculptor in the modern world, forgetting that he always was, for these were not his first. (He had made a series of ultraoriginal sculptures in the early thirties.)

"Of course," said Dorothea, who knew Max Ernst was the most marvelous man in the world.

These statues, because they have two opposite faces, would seem to contradict the conventional concept that three-dimensional sculpture, unlike paintings (or bas-relief) should be walked around, properly viewed from every side. The contradiction in this case is only superficial. These statues of Max Ernst's bear their third-dimension inside— the relation between the two fronts takes place in-between. Ernst's visual perception is not from flat to round, but from fact to dream.

By a magic ingenuity the ingredients of these statues, like intricate puzzles, form each its own opposite.

The water of Great River was quite brackish, so we often took the rowboat out down the bay where we had discovered a good bathing beach. I made a chess set, so did Max. My Humpty-Dumpty chess set was for playing on the beach, with round bottoms that could be pushed into sand. We drew the chessboard with our fingers. After breakfast each morning, while Max was making his big plaster sculptures, I poured plaster into empty eggshells. With our newfound enthusiasm for chess, I conceived the idea of staging a chess exhibition in my gallery the following season.

* * *

We also occasionally rowed across the bay for dinner at a pleasant seafood restaurant where the speciality was called Chicken of the Sea. This is a fish none of us had tasted before. It was caught locally. The meat of the tail was white, sweet, and delicious. The rest of the body was quite horrid. In fact it was also known as a blowfish because when attacked it swallows water or air and swells to large proportions, to frighten the enemy, and becomes a round fish-balloon covered with prickly spines. The restaurant had lampshades made of these dried and spiky globes.

André Breton came to visit. He admired Max's sculpture and I could see that Max was pleased, that he gave great weight to Breton's opinion. I photographed Breton and Ernst in the field with Ernst's sculpture, "An Anxious Friend."

Later in the afternoon Breton wished to go fishing. As he never removed his green jacket and vest, he looked more important than any sportsman and, of course, the first fish he hooked was a blowfish. Dangling from the line at arm's length, eyes bulging at the astonished Breton, the fish blew itself up, swelling larger and larger. Red-faced, Breton began to puff up too. This fish, it would seem, was an affront to his dignity. The meeting of two rather unusual authorities.

Max and I read the headlines together when the mushroom cloud formed over Alamogordo. The power of the atom had been released. I was immediately beyond myself with jubilation, not thinking of this as a deadly weapon. "Max," I said, "here is our plenty, the one-hour workweek for all, the forty-two extra hours for art and anarchy." I thumped his back while he scowled. "Desolation. . . ." he predicted. But he said it with some indication of inventive glee. He seemed to see deserts sprouting with his own "lunar asparagus," craters peopled with his flocks of birdmen and plumaged women, and all the other apparitions of his *Götterdämmerung* liberated in the devastation.

Yet his actions were never destructive. Forever making things flourish, he was not happy when idle. It was Max who turned his hand regularly to cultivating our little truck garden, providing fresh greens all

273

summer long for our meals. And he ceaselessly turned every odd object into a new idea for his opportunistic painting and sculpture. The more ironic his fist the greener his thumb.

Max found a carpenter in the village who agreed to block out in mahogany rough copies of his chess set and two or three of the large sculptures. Later Max would carve the final details, smooth and finish them. They were to be included in his exhibition in my gallery next season.

I was pleased with my own chess set too, kept in the original white plaster. I wrote to various artists associated with my gallery, suggesting a group project—"Designs for Chess"—and invited contributions from Breton, Cage, Calder, Cornell, Duchamp, Matta, Tanguy, Tanning, and others. The waves of Ernst's energies were spreading in expanding circles.

> This summer is past!
> A dimension removed from the distant thunder of war.
> A dimension illumined by the lightning of Max Ernst.

I proceeded with my summer plan and scheduled the Chess Show. In addition to the painters and sculptors who contributed paintings, chessmen, and boards, two musicians offered to contribute: the manuscript of a chess sonata by Vittorio Rieti, and a beautiful paper chessboard by John Cage on which he had, in his beautiful script, set down a score for "Chess Music." I can't perform the music, but visually the Cage chessboard offers an intriguing optical illusion. The bars and notes are drawn in sequences of alternating dark gray and white ink. The background is a solid medium gray, but the variations of the script give the optical illusion of the alternating dark and light squares of the conventional chessboard.

When the time came for the opening of the show, "The Imagery of Chess," we gave a special evening performance, organized by Marcel Duchamp, who persuaded the grand master George Koltanowski to play blindfolded a number of simultaneous games against a group of amateurs, including me. Playable chess sets were contributed by Calder,

Duchamp, Ernst, Filipowski, Heythum, Noguchi, Man Ray, Tanguy, and the psychoanalyst Gregory Zilboorg. Probably the most important set was the one by Max Ernst. The audience and players had a marvelous time, and in some ways Marcel and I later thought of this as a "pre-happening" happening.

I was also tremendously pleased to find so many new chess sets, designed without radical departure from the traditional, yet more harmonious and more agreeable to touch and to see and far more adequate to the role the figure has to play in the struggle. Thus, at any moment of the drama a set's optical aspect could represent, by the shape of the actors, a clear and incisive image of the game's inner conflicts. In our complicated modern games the figures should inspire the player instead of confusing him. They should whisper to him at the right moment, "Move now to QB4. . . . Break through the center. . . . Pin the Knight. . . . Let me win a piece. . . . We can exchange Queens, the Pawn will be metamorphosed into a new Queen . . . to mate the King," and they should never make mistakes.

After the war I found my life in the gallery less preoccupying than it had been in the early days. Having been disappointed in previous hopes of sales, I even began to discourage young artists coming by the gallery and tried to avoid looking at new work. I no longer had confidence I could be of much help and resorted to the critical evasion Edith Halpert told me was invented by her majordomo. Whenever he took over the gallery as "watchman" when Edith went out, he would undertake to remark on pictures shown him by artists: "*My,* this is a painting!" Or, "My, *this* is a painting!" Or, "My, this *is* a painting!" Or, "My, this is a *painting!*" Any combination of these seemed to satisfy the artist, so eager was he to hear a positive comment.

I asked Marcel to coach me with the chess games I was playing by post. Duchamp became increasingly interested in my postal chess moves. Finally, he would take home my move of the day and return the next morning with a long diagramatic analysis of all the possibilities that could result from the several moves. I wondered if this was quite fair play, but Marcel laughed at my scruples, "Don't you think your opponent is having as much consultation as possible, too?" Finally, with

275

Marcel's help, I won one game so brilliantly that I received an irate card from my opponent asking, "What kind of devils do you have working for you in that confounded gallery?"

I went around more often with the music crowd, saw a great deal of Paul Bowles and his wife, Jane, and met in their home the songwriter John Latouche. I loved listening to him tell the story of the jungle of modern art in which the wild duck calls "Braque, Braque, Braque," the parrot says "Picasso, Picasso," the snake hisses "Matissssse, Matisssse," the lion roars "Rrrrrouault, Rrrrrrouault," the coyote barks "Arp, Arp, Arp," and so on. Finally the train of civilization enters the jungle huffing "Tcheli-tchew, cheff, cheff, Tcheli-tchew, cheff, cheff."

Max Ernst used to say there could be no Surrealist music. He never explained why he felt this way. It is true one seldom, if ever, dreams of music. Perhaps he considered romantic music too vaguely emotional and classical music too consciously reasoned. Occasionally, at a party, if there was a piano, Max would call for a couple of oranges and with one in each fist would pound them and roll them about on the keys, until they were mere handfuls of sticky pulp, which brought the set to an end. These improvisations had some rough resemblance to Henry Cowell's tone clusters but, more satire than serious, they contributed little more than rhythmic noise to an unrestrained party.

At this time I came to know John Cage and his fixed and silent sound at the home of Jean and Schuyler Watts. Cage, his wife Xenia, and the dancer Merce Cunningham, were an inseparable triangle at that one moment, at the next Xenia and John were separated. Xenia went to a psychiatrist to help her adjust to inevitable divorce, and during this period made rather delicate mobiles, different from Calder's in that they were lighter, feminine, and made not of metal, but of wood strips with insets of paper, somewhat resembling kites. They were in fact a combination of Oriental expression inspired, no doubt, by John's investigation of Japanese and Balinese music and what she called her "White Eskimo" background, her parents having been Alaskan and her childhood spent in that far region. Abstractions of the marriage of a kite and a canoe, many of her pieces had great charm. I decided to give her a show and devised do-it-yourself invitations for her exhibition of mobiles. They

were paper shapes to be cut out, threaded, and hung. Schuyler Watts arranged some very mysterious aqueous lighting effects for the show which I scrapped the night before the opening, sad to say, in a fit of egotistical petulance combined with an oncoming attack of the grippe. When I think of it now, his lighting was probably as effective as any, although so muted as to make the objects almost invisible. But, as has happened once or twice before, I felt that my own showmanship was being invaded. Lighting or no lighting, nothing sold. Poor Xenia's rather dire financial straits were to be alleviated by Marcel, who stepped in and gave her a job assembling an edition of his "Valise" from materials he brought from France, a project financed, I believe, by Patricia Matta.

That winter was rich with musical experiences in the Village with the Cages. Once at the home of Joe Campbell, who was working on his editing and commentaries of the Oriental reports of Heinrich Zimmer, Xenia executed a piece composed by Joe to be played on flowerpots, and Merce improvised a dance in which he seemed rather like a lost Afghan puppy pretending to be a faun. The Stravinskys came to town and were flatteringly curious about everything I had in the gallery. Igor overwhelmed me with an effusion of courtliness and courtesy that would have seemed overdone but for its evident sincerity and warmth. Vera Stravinsky was considering opening a gallery in Hollywood, and Berman was anxious for me to cooperate with her, but after my caravan trip I was not persuaded the time was opportune. With Berman and the Stravinskys I was invited to some of the grander concerts of chamber music in private homes. These were mostly supported at the time by expatriate Europeans. Lighter, wittier evenings at the apartment of John Latouche were filled with musical and literary improvisations. But in general this was my winter of discontent.

I had begun to realize that credits of discovery and early recognitions that were mine were being brazenly claimed elsewhere. Such unpleasant instances appeared to be multiplying; instances when I felt I offered my aesthetic ideas and treasures only to see them immediately preempted by others. It became increasingly difficult for me to take these quite normal slights with humility. I began to feel undernourished, bored, tired of giving and not receiving. Then Muriel left me temporarily. We

had lived together for years, but only just been married. Depressed, I was drinking heavily. Hans Richter appeared on the scene, like a life-saver, with a diversion. It was his project to make a movie called *Dreams That Money Can Buy.*

For my film paramour a pretty girl was found. Her name was Io. My activity in *Dreams* consisted mostly of whispering and panting, in a phone booth, leaning over Io's bedside, dying in the basement. . . . It occurred to me that a sound accompaniment of rhythmic sibilants would be novel and fitting. I first thought of John Cage, but then decided in favor of Paul Bowles and suggested that he compose this. He accepted enthusiastically. I had thought to make an instrument of the human whisper, now that sound reproduction could amplify the sound of even a whisper into a roar. For shipwreck scenes, the whisper would turn into rhythmic waves. For the love scenes, the tender murmured obscenities tuned down to an almost inaudible obbligato. But to my disappointment Paul rejected my suggestions and elaborated the theme into a music of his own that departed almost entirely from my idea, which I had hoped to hear actualized. To add injury to insult I was cut out of several appearances, cut to fit his score instead of the music composed to fit the action.

With the best of intentions on both our parts, my relations with André Breton always seemed to prove abrasive. One day after the war he said to me, "Julien, you can never be a true Surrealist."

"*Pourquoi pas,* Papa?" I asked, "why not?"

"There, you see," he said, "you are too *humoristique.*"

He had very generously written a preface for my first Gorky show. For a long time afterward he manifested evident coolness, which I could not understand. Finally Marcel explained, "You know Breton is hurt you never paid him for his preface to your catalogue. Don't worry. I'll undertake to explain to him that this is not an American custom. No doubt, you, for your part, could persuade Gorky to give him a present of one of his drawings. That I think is not unusual in America and would please Breton enormously."

Then came the day when Breton asked me to lend him all the copies I had of his books. An English edition of some of his essays was being

published, and Brentano's had arranged for the window in their Fifth Avenue shop to be devoted to a display of Breton's work. Breton, of course, had nothing of his own to show as he had left France as a refugee with the smallest amount of baggage possible. I was justly proud of my lovely collection of first editions of his work on special paper, many bought directly from Breton in Paris in past years and many warmly inscribed to me from him. After the Brentano exhibition I waited for the books to be returned. Nothing happened. Finally I asked Breton about it. "I am keeping them," said he.

"You are what?"

"Yes, I am keeping them. They are, after all, mine; I am the author." What could I say? He kept them. My Breton library remains sketchy. At first I decided, recovering from the shock, that this was a new Surrealist attitude toward ownership. Then I slowly came to realize that, after all, the man, through no fault of his own, was entirely bereft of any example of his own work, and though he could have put the matter more tactfully, it was more important for him to have his books than for me to keep them in my library.

André organized a café meeting place for artists, trying to reproduce his Paris routine, to duplicate in New York the little table where he presided over the Surrealists at his favorite Paris café. He took over a back room in a bar near 8th Street. All the Surrealist exiles, and a few other painters including Léger and Chagall, crowded into the room for the first reunion. We were all enjoying ourselves, alive with great expectations and a feeling of enormous camaraderie, when Breton raised his fist and pounded on the table. "This will be a serious meeting," he said. "We will conduct it in perfect parliamentary fashion. When you wish to speak you will raise your hand and I will acknowledge your signal with the words *La parole est à tel-et-tel, la parole est à vous!*"

Leonara Carrington burst into laughter which she tried in vain to smother. Breton rapped sternly again for order, so Marcel and I hooted. This *lèse majesté* was, I suppose, unforgivable. I was also under a cloud with Breton because of my close friendship with David Hare, the cause of André's divorce from Jacqueline Lamba. David and Jacqueline eventually married, and had a son, Merlin. David was a young and talented

279

sculptor I had met through Chick Austin. When I first knew him he was married to Suzie, daughter of Mrs. Frances Perkins, Secretary of Labor in Roosevelt's cabinet. A visit to their house in Roxbury was my first introduction to that part of Connecticut where I now make my home. David and Suzie had lent me their house one summer, and another summer they lent it to Arshile Gorky. When they sold it they bought another in Hampton Bays, Long Island, and when I went to visit, I found Suzie gone and Jacqueline Breton installed. I was most enthusiastic about David's new sculpture and the following winter gave him an exhibition.

Vivid in my memory of the Jacqueline and David menage were the adventures of a kinkajou they kept as a pet, an eccentric animal David somehow smuggled out of South America and was trying to housebreak, with small success. Once a very fastidious Hindu diplomat came to visit, arriving in a chauffeur-driven limousine. He was dressed in an immaculate white suit. The kinkajou gave a squeal of delight, leaped onto his shoulder, hugged him tightly, whispered into his ear, and soiled the whole front of the white suit.

The kinkajou was like that. His only calm moments were when he discovered their old Victrola. He was fascinated, spent hours watching the phonograph record going around and around, and he would press his nose as tightly as he could down on the spinning grooves and listen intently for the possible sound of—interior music?

Leonid

The season 1946–1947 saw the arrival of one of the last of the last wave of refugees from Paris: Leonid, the younger brother of Eugène Berman. I had already given Leonid several shows. He was, like his brother and Tchelitchew, a Neo-romantic painter. Leonid's work, more calm and lyric than his brother's, was equally nostalgic. He painted seascapes: beachscapes of the Normandy coast, of oyster beds, of the back shores and bays around Venice, and in America he painted beaches wherever they could be found.

He made his permanent residence New York and became a U.S. citizen, marrying Sylvia Marlowe, a harpsichordist. I met him at the boat. We taxied to an address in the Upper East Side where he was to stay with Leon Kochnitzki, a music critic. We started across town. Passing Tenth Avenue, Leonid asked, "Where are we?" I said, "This is Tenth Avenue," and he said, "Yes!" At the next block I told him, "This is Ninth Avenue." He said, "Oh, *yes!*" Next block I said, "This is Eighth Avenue," and he said, "I know, the next is Seventh." "Perhaps," I said. "We cross Broadway first." "Oh, I know about Broadway. And the *next* is Seventh?" And I said, "Yes." "The next is Sixth?" "Yes," I said. "And this is Fifth?" "Yes—and this is Madison." "Oh?" "And this is Lexington." And he said, "Oh, dear, *Lexington*. I'm lost."

At some moment during these postwar years Dorothy Miller stopped me in the Museum of Modern Art and reproached me. She said that except for the showing of Arshile Gorky I had really made no new presentations. I reminded her that in the years 1944–1947 I had shown for the first time in New York:

Victor Brauner
Paul Delvaux
Dorothea Tanning
Rico LeBrun
Howard Warshaw
Jeanne Reynal
Kay Sage
Leon Kelly

and given repeated showings of some of the greatest work ever done by Max Ernst.

During those same years I showed the later work of the last of my Surrealist discoveries, Arshile Gorky, the painter now generally conceded to be the "eye-spring" of Abstract Expressionism. André Breton was the first to write of the quality of Gorky in a preface to my first exhibition of this extraordinary painter in 1945, "The Eye-Spring."

A New Wave was surging in modern art, one that dealers, embassies, and banks were to ride successfully for twenty years. The School of Paris had married with the New York School, and the International School was their prodigious child.

Arshile Gorky

Arshile Gorky did not come to my gallery directly to show me his own work. In the winter of 1932 he came urging me to look at the work of a friend of his named John Graham, and it was Graham who generously suggested that I also look at a portfolio of Gorky's own drawings. "My portfolio is already in your back office," Gorky reluctantly confessed, and my secretary told me that "that man is always leaving his portfolio in the back office. He comes back days later and pretends he has forgotten it."

"Yes," said Gorky shamelessly, "and I always expect you will have opened it and discovered masterpieces. . . ." So I sorted through them, and I answered Gorky gently. If I did not find masterpieces, I nevertheless thought I detected future greatness. I went down to Union Square with Gorky and looked at everything in his studio. I listened to his passionate discourses concerning the faded illustrations tacked on his walls, monochrome reproductions of Mantegna and Piero della Francesca and photographs of Ingres drawings. I listened to the woes of his financial disorder, and I lent him $500. Later, when he couldn't repay, I bought some of his drawings. But I could not promise him an exhibition.

"Your work is so very much like Picasso's," I told him. "Not imitating," I said, "but all the same too Picassoid."

"I was *with* Cézanne for a long time," said Gorky, "and now naturally I am *with* Picasso."

"Someday, when you are *with* Gorky," I promised.

I had never before met a painter with the empathy to enter so completely into the style of another. I thought of the translations Charles Scott-Moncrieff had made from the French of Proust. It was said that he

memorized a dozen pages of Proust at a time, and then having completely absorbed the text, he translated with no further reference to the original. I also remembered a concert given by Harold Samuels playing the clavichord works of Bach shortly before a nervous breakdown which led to insanity and death. Samuels interrupted the performance of one variation. "I had not intended to write it that way," he said to the audience, and proceeded then to play the fugue quite differently. He thought he was Bach.

"I hope Gorky will think he is Gorky," I murmured to myself, "before it is too late."

There was a long period after my first meeting with Gorky during which I saw little of him and nothing of his work, although he religiously visited all of my shows. His economic difficulties had been ameliorated by the WPA for which he was doing projects in much the same manner as his earlier work.

What change of climate so suddenly provoked the rapid flowering of Gorky's genius, so long in germination? What conflicts of ideas, of cultures, of techniques had first to be resolved, and what finally deepened, released, and affirmed his freedom after so protracted a period of absorbing, invisible growth?

When my book *Surrealism* was published in 1936, he straightaway read it in the back room of my gallery and soon borrowed it to take home. I later found he had paraphrased several paragraphs of what was already a paraphrase by Paul Éluard, "Simulations," translated in my book by Samuel Beckett, for use in love letters.

Perhaps he had listened while I told how Éluard confided to me one of his "systems" to stimulate the birth of a Surrealist poem. "I hum a melody," said Éluard, "some popular song, the most ordinary. Sometimes I sing quite loudly. But I echo very softly in my interior, filling the melody with my own errant words." I can imagine Gorky telling himself one of his strange stories, reminiscing from his childhood, "how my mother's embroidered apron unfolds in my life," and skillfully casting his linear nets to trap his images.

Then there was the year he had married. With his new wife, Agnes Magruder, called by his private name of affection, "Mogouch," he

spent some time in the country and began to paint from nature outside of his studio. Perhaps this was not the first time he had painted from nature. There had been the period when he studied Cézanne, but he had not really let the sunlight burn into his shoulders and the rain wet his palette. He had also been married before, but without the same passionate and jealous love he discovered with Mogouch.

He gave much thought to the problem of camouflage for a class he organized as a contribution to the war effort. The unconscious is, so to speak, the domain of camouflaged objects, and Gorky was to discover that if the realistic object can be camouflaged, so can the unreal, or "surreal" object be decoded and decamouflaged. He began, by some such liberating accident, to regard painting as a deliberate confusion rather than an analytic dissection. There was an emotional orgy in this liberation. For Gorky, automatism was a redemption, and it was also this new visceral freedom which brought him close to the Surrealists now in America—Ernst, Tanguy, Masson, and in particular Matta and André Breton. To understand Surrealism is to understand that an indispensable part of Gorky found meaning with the Surrealists who helped both to bring himself to the surface and dig himself deep in his work. They made Gorky realize that his most secret doodling could be very central. He found his fantasy legitimized, discovered that his hidden emotional confusions were not only not shameful but were the mainsprings for his personal statement, and that what he had thought had been his work had been just practice, and what had been his play was closer to his art.

I was in the Army when Gorky thus became Gorky—and received the André Breton accolade. When I came out of the service Gorky soon visited me. He hoped that I would be reopening my gallery.

With high expectations I arranged successive exhibitions of Gorky's new work and was his dealer during those last years, 1945 to 1948. The promise I had suspected in his early experiments seemed fulfilled. The arduous disciplines of tradition were exploding into the new, and the problem of the figurative versus the nonfigurative was in the process of solution. Here were the "hybrids" which André Breton described as "the resultants provoked in an observer contemplating a natural specta-

cle with extreme concentration, the resultants being a combination of the spectacle and a flux of childhood *and other memories*. . . .'' And appearing again, ''You and the splendid blindman who shadowed you/ The figurative and the nonfigurative. . . .'' in Breton's moving poem ''Farewell to Arshile Gorky.''

For Gorky was to die of many discouragements.

Goodbye My Loveds

Mogouch closed the book from which she had been reading aloud. Gorky had fallen asleep.

"What, you are still here?" said Mogouch, as if just noticing me, although I had been standing in the doorway listening to her reading. Had she possibly forgotten that she must drive me home? My broken collarbone was taped and my smashed car was in the shop. It was Mogouch, in fact, who had brought me to visit Gorky that afternoon. I had passed the time walking around the hospital and talking to one of the interns, to allow Mogouch a private hour with her husband.

"Every day he says to make way for crowds who will come to visit him. 'Make way for the throngs,' he says; his very words. And he says he is a famous genius." The intern tapped his head and looked at me with a question. "Is he?"

"Possibly," I said. "Quite possibly a genius," I quickly added. "But not many people know it . . . really still his own secret."

"Throngs will come, he says, when they learn we keep him here, detain him on a rack of torture."

The heat was even squeezing little beads of perspiration from the white enamel of the hospital walls. "Poor Gorky, I hope he does have plenty of visitors." In traction as he was, these hot days and nights, stretched out on the hospital bed with a leather chinstrap tied to a winch to immobilize his head and keep his broken neck stretched, it did indeed seem a torture. And he had only submitted to it almost by force.

"Get me to New York," Gorky had begged, sitting in my house that day after the accident. Kay and Yves Tanguy were there, trying to make him sit still. Kay and Yves had driven over from Woodbury to offer comfort. My broken collarbone had me housebound, and my new boxer

puppy gave evidence of injury. He seemed in pain and was limping. Kay offered to drive me with him to a vet. There had been no indication that Gorky had suffered even a bruise in our accident until an hour previously when he telephoned, saying he had a terrible headache and was feeling lonely and depressed. We had gone to a vet, who bandaged the puppy for a torn ligament, and picked up Gorky on the way back to my house for lunch. He was quiet during the meal, then put through a call to Virginia, trying without success to reach his wife. He wanted Mogouch back.

Then came a telephone message from the hospital. The X rays had been reexamined. Gorky had a broken neck.

At the end of my visit, while Mogouch was preparing to leave the hospital room, Gorky had a chance to say to me secretly, "No word, Julien, please, about her diary. I think we will try to forget that."

He was referring to confidences he had made to me about his finding and reading her diary the morning just prior to our accident. A warm June light was washing the big gray barns on the pasture hill behind my house. The house was now my home, but I thought of the barns as Gorky's. He had been house-hunting with me, a few months ago in deepest snow, when I had bought the property. He had thumped the sturdy cellar beams, declared it a "good, strong house." Looking through the barns and smelling their composted animal warmth, Gorky had taken a deep breath and said, "This is something you must always have nearby to smell, if you live in the country, this and a fireplace."

Another day we were sniffing the beery odor of the fermenting silage, a cow with her calf was turning heavily in her stall, and in the loft above, the dry hay still carried vestiges of the scent of an earlier autumn. We looked over the green New England pasture punctuated with meager stones and dark little hemlocks. Gorky said, "I hope you are happy Julien. I am not. Mogouch is leaving me."

"Mogouch? Oh, no!" I cried in protest more than in disbelief.

"I read from her diary last night. What can I do?" groaned Gorky.

And I had no answer.

"Let's face reality," I said with banal inadequacy. "You are just beginning your own greatness. Nothing should diminish that. Let's go and drink to that. Let's go," I repeated, "or we'll be late for lunch."

We were invited to lunch with the Allan Rooses in Ridgefield. I expected Muriel, who had been away overnight on one of her frequent visits to New York, to meet us there. And Allan had promised to give me a boxer puppy that was now just old enough to be separated from his mother. I had been divorced, reluctantly, from a boxer when I was divorced from Joella. His name had been Khufu, and I had already named this new puppy in my mind. It was to be Cheops, a variant name for the same Egyptian Pharaoh who had built the Great Pyramid, *Vale,* Khufu; *Ave,* Cheops.

"Would you like I should also get a dog for a friend?" said Gorky, looking at me dubiously. He retired into sadness. He remained melancholy throughout one of the epicurean banquets the Rooses always provided. Mostly the guests were Allan's colleagues, also psychoanalysts, and their wives. I found myself in an illuminating discussion with Dr. Sandor Ferenci about his views of the role of the unconscious in artistic creation and I urged him to talk with Gorky, whose work he did not know. At one point in the afternoon Allan drew me to one side and expressed some concern.

"Your companion is depressed."

"He has reason to be," I answered, "real reasons, not imaginary."

"Perhaps he should have help."

"It's been offered," I said, remembering that Mogouch had told me she and Jeanne Reynal had both urged him to try a Jungian analysis. That must have been after his cancer operation, to help him adjust. "Don't dare mention analysis to him," Mogouch had warned. "The very idea throws him into a rage."

"The very idea throws him into a rage," I repeated to Allan. "I think his wife has been seeing someone."

"Jungian or Freudian?"

"Jungian," I said.

"Quite right for him to rage, in that case," the Freudian Allan pronounced.

Soon after this brief conversation we left the party, packed the puppy into the car, and were on our way back to Bridgewater. I persuaded Gorky to stay for supper in spite of his considerable reluctance. He said he should go home as he hoped for a call from Mogouch, wherever she

might be. A look from me, however, left him abashed, and I started to prepare our dinner, a nice thick steak. The steak was no sooner on the broiler than one of those sudden summer storms came down from the Berkshires. The electricity went off, and we soon found that the telephone lines were also down. Gorky became frantic. We decided to pack the partly cooked food in a picnic basket and drive to his house in Sherman where, Gorky said, even if the electricity and telephone were off there too, he had grills and pots to cook over a fire in his enormous fireplace.

We started through the driving rain. Night had fallen early, punctuated with lightning and wild thunder. I was hungry and thought with warm anticipation of Gorky's cheerful hearth, until I happened to glance sideways at Gorky. I met his eyes and felt suddenly pervaded by a sense of more than ordinary gloom, of uncanny desolation. Who was this other black presence who seemed to be exuding darkness over all of us like a tangible substance? Yet this was just a trick of the night silhouetted against lightning.

We were starting down Chicken Hill when the skid began, slowly and relentlessly. I had time to remember that Chicken Hill had its name from the past, when carriages skidding out of control had played havoc with the farmers' chickens.

The few seconds were so slow, vivid, and out of time that one could relive the past, visualize the flock of fool chickens, half hopping, half flying clumsily across the road to get to the other side, gasping, beaks open, squawking as the carriage slashed a trail of slaughter through their witless ranks. But this would have been in daytime; chickens were not abroad in the night. It was nightfall now at the top of Chicken Hill, and only the rain was hopping and flying sightlessly across the road. I myself was not driving as fast as the rain. I slowly, gently, and with great caution pressed the brakes. But it was too late. Everything for hours past seemed to have been too late. Especially the answers to Gorky's question, which repeated itself again and again in his eyes. "What shall I do?" I felt again the sad fatality, that shape of blackness, presaged, and as the road sharply turned, that darkness left the car, struck inaudibly against the clay bank, and the pine trees and, passing through them, vanished like smoke.

I almost pulled the car out of its skid, but not in time. The front wheels narrowly missed a roadside post, the back wheels sideslipped, perhaps only three or four inches, enough to hang up the hub for a moment. The car jolted, then as it stopped it turned slowly over on its left side. Gorky fell heavily against me and I felt a cracking pain in my shoulder. The puppy started an endless frightened yelping from somewhere in the back seat, from which Muriel scrambled, unharmed.

People were already out of houses by the roadside and lifting us through the uppermost door. No one seemed hurt, no cuts or bruises, and even the puppy had ceased his cries. Someone, all the same, drove us to the hospital where I was interviewed by a state trooper and a doctor insisted on taking X rays. Then it was found that my collarbone was broken. While my shoulder and arm were being strapped, Gorky impatiently arranged for someone to drive him home. "If Mogouch phones, tell her you need her," I said. "Call me in the morning."

> "Tanya!"
> He cried to Tanya, cried to the great garden with the miraculous flowers, cried to the park, to the pines with their shaggy roots, to the rye-field, cried to his marvellous science, to his youth, his daring, his joy, cried to the life which had been so beautiful. He saw on the floor, before him a great pool of blood, and from weakness could not utter a single word. But an inexpressible, infinite joy filled his whole being. Beneath the balcony the serenade was being played, and the Black Monk whispered to him that he was a genius, and he died only because his feeble, mortal body had lost its balance, and could no longer serve as the covering of genius.*

I often wonder why I thought of that black presence that night. It was more the image of a Rasputin that had entered my mind, not the figure from a Checkhov story I had never read. It was only on leaving the hospital room that Mogouch told me that over and over again Gorky demanded that this story be read aloud to him, only then that the events of that dark night came back in sharp detail, so that again I could feel the torment and despair.

For longer than Gorky's stay in the hospital, my arm was disabled

*From *The Black Monk* by Anton Chekhov.

and I was deprived of a car. I was dependent on Mogouch or Kay Tanguy to take me to visit him. And I saw him only once after his release from the hospital. In his home, the Hebbeln House in Sherman, he seemed happy, surrounded by his children, cared for by his wife, and preparing canvases to paint again. He looked like some barbaric warrior in the strange armor of his leather and steel neck brace, and he showed me a model of an arbalest he was carving. I was to be greatly astonished to later learn that Mogouch left him again, taking the children with her.

Gorky was in the hospital for about ten days, then it was another two weeks or so until the end. This period was somewhat lightened by our chance encounter with the divorced wife of an old college friend of mine. We discovered that we were not too distant neighbors, and quite often when Muriel would leave me alone, she was kind enough to drive by for me and bring me to her home for the day, feeding me luncheon and dinner together with her two children. My old friend, her ex-husband, was a highly respected psychoanalyst, she herself had been in analysis during the progress of her divorce. Our conversations often turned to the viability of the "analytic way," and in a veiled manner I was able to discuss the problems of Gorky or, in general, the artist and his special vulnerabilities. I began to think of making an effort to dissuade Mogouch from reliance on a Jungian adviser. It would seem, whoever he might be, however well-meaning, that her present course might be tangling rather than unraveling the problems of the Gorkys' life. Perhaps Dr. Roos could suggest a good Freudian who would respect the artist's mysteries and prove congenial and helpful to her. Now their economy would be helped by the considerable sum of money Gorky had been assured he could collect from my accident insurance policy, by way of settlement against future claims for damage and complications traceable to the accident. Gorky's injuries, interior and physical, and my own semi-immobility depressed me, and I found alleviation in these hopeful thoughts and projects.

Late in the evening of July 20, 1948, Gorky telephoned. "Can you get me a woman?" he abruptly asked. If I had not somehow sensed the matter to be serious I would have joked with him over this subcollegiate cliché. But he explained that what he was searching for was occasional

292

companionship, female; occasional cooking, female; occasional sympathy, female.

The glass house was too desolate, alone. This I could well understand. I thought of our divorcée friend. Might she not, perhaps, invite him to her house for lunch, tomorrow? But now it was almost midnight, too late to make arrangements. I must wait for morning. Always too late. I suggested he try to sleep, and in the morning we would think of something, someone.

He had only just hung up when Kay Tanguy phoned. "Have you heard from Gorky?" I told Kay of our conversation. His calls were the first news either of us had that Mogouch was away. "He sounded drunk or crazy to me," sniffed Kay. I told her he sounded to me perfectly understandable, given the circumstances. But he had told her, Kay continued, that he was calling all of his friends. "What is worse, he is apparently asking them for help, asking each something different." I remember thinking that Gorky rarely asked favors of the friends to whom he so generously gave his warmth and sympathy.

"Someone should go to him," we said together. I still couldn't drive, so Kay decided: "I'll try to reach Peter Blume or Malcolm Cowley; they live nearby."

Kay phoned me again a little later. "Peter will look in on Gorky," she said, "if not tonight, tomorrow. In the morning."

It is morning. Whose voice is telling me that Gorky is dead? Has hanged himself! I cannot recognize the voice, it is so horrified, eviscerated by the happening. Or am I? It is I who cannot take it in.

There remained the funeral to attend. It had been difficult, but finally a cemetery plot had been found, and a clergyman, intelligent and compassionate enough to bury a suicide. It was Father Day, the somewhat rascally rector from Roxbury, who gave his consent.

Mogouch and I found ourselves together for a moment in the studio before going to the cemetery.

"I want to give you back some of Gorky's paintings," I said.

"Would that be one of yours, your contract pictures?" Mogouch pointed to a cavernous black canvas on the easel. "Because that one is unfinished. He wouldn't have thought an unfinished painting would be

293

ready for a dealer. Anyhow, Jeanne Reynal has asked me if I wouldn't give it to her.''

"For Jeanne, certainly," I answered. I felt strongly that Jeanne, for her unswerving support of Gorky, had a claim to that and more. Hard pressed as I was for funds, except for her special pleading I might not have renewed his contract—I had advanced the year's money on it—a contract of infinite hope, now never to be fulfilled. I looked again at what was to be known as "The Last Picture." A macabre souvenir, I thought, the Black Monk again.

I turned and made my way to one of the cars waiting to take us to the graveyard.

The skies darkened and it started to rain, first a drizzle but soon a chilling downpour. We stood huddled on a hillock somewhat removed from the grave, the Blumes and Saul Schary and I. Yves and Kay had not come. "I don't take much stock in funerals," said Kay. The Admiral, Mogouch's father, stood joking and sharing a nip of whiskey from a flask with the minister, Father Day, who, when the gathering of mourners was complete, moved down hill, staggering slightly, to read the brief service. It was audible only to the little knot of close family, Gorky's sisters and their husbands. Mogouch was conspicuous in her black widow's weeds, pale and potent as in some Gothic romance. The rain increased.

Suddenly the scene became macabre. Mogouch, dripping wet, hovering over the grave, insisted that it be filled with earth to the last shovelful. The gravediggers grumbled, the mourners drifted uncomfortably away and then moved nervously to the shelter of the cars. The few who remained fixed by her widow's commanding stare waited for the last spadeful to fall and the last sod to be placed. The grave was then stamped down by Mogouch, the perfunctory service compensated by this protracted ritual of death.

On the drive home Jeanne Reynal pieced together for me the details of Gorky's last night. He had phoned many friends, on one pretext or another, perhaps to hear their voices for the last time. He was drinking, progressively became more intoxicated, but must have decided to die long before beginning to drink. More than one noose was prepared,

hanging from different branches and rafters, each ready in some favorite spot so that at the last Gorky could make his choice. He had chosen the rope tied about a beam in a shed where he often went to read or dream alone in bad weather. Across the rafter in chalk he had written "Good-bye, my 'loveds.' "

These words joined together in my mind with other sadnesses. My growing distaste for the work that I had for so long pursued against all odds, but until now with far more pleasure than pain, now filled me with revulsion.

I decided to close my gallery; to live simply in the country; to write, perhaps; to pursue other interests; to finish these memoirs.

I kept the gallery open for one more season, to arrange for a retrospective show of Gorky's work and to place my various artists in other galleries to their best possible advantage. I echoed Arshile Gorky's last words. "Good-bye my 'loveds.' "

Julien Levy Gallery

602 Madison Avenue

1931 / 1932

Retrospective of American Photography: Strand, Sheeler, Stiechen, White, Brigman, Käsebier, Stieglitz	November 2–November 20, 1931
Massimo Campigli, Paintings	November 21–December 11, 1931
Photographs by Nadar and Atget	December 12–January 9, 1932
Surrealism Paintings, Drawings & Photographs: Picasso, Pierre Roy, Max Ernst, Salvador Dali, Marcel Duchamp, Man Ray, Cocteau, Joseph Cornell et al	January 29, 1932
Modern Photographs by	February 1–February 19, 1932

Walker Evans and George
Platt Lynes

Modern European Photogra- February 20–March 11, 1932
phy: twenty photographers,
including Man Ray, Walter
Hege, Helmar Lerski, Peter
Hans, Lee Miller, Maurice
Tabard, Roger Parry,
Umbo, Maholy-Nagy . . .

Drawings, Paintings by March 12–April 8, 1932
Eugène Berman

Photographs by Man Ray April 9–April 30, 1932

Photographs of New York May 2—June 2, 1932
by New York Photographers

Alexander Calder, May 12–June 11, 1932
Sculpture: Mobiles

Modern Photography Summer 1932

1932 / 1933

Berenice Abbott, September 26–October 15, 1932
Photographs

Retrospective Show of Por- October 15–November 5, 1932
trait Photography: Old and
New: including David Oc-
tavius Hill, Alfred Stieglitz,
Lynes, Pirie MacDonald,
Berenice Abbott, Man Ray,

Ralph Steiner, Arnold
Genthe, Adam Salomon,
Brady, Käsebier, Clarence
White . . .

"Surréaliste" Exhibition by November 5–December 3, 1932
Max Ernst

Picasso, Etchings November 26–December 30, 1932
Joseph Cornell, Objects

Charles Howard, Paintings December 30–January 25, 1933
and Drawings
Lee Miller, Photographs

Carnival of Venice: Max January 26, 1933
Ewing, Photographs

Mina Loy, Paintings January 28–February 18, 1933
Luke Swank, Photographs
of the American Scene

Pavel Tchelitchew, February 24–March 25, 1933
Drawings
Kurt Baasch, Photographs

Eugène Berman March 25–April 22, 1933

Georges Rouault, Etchings April 26–May 20, 1933

1933/1934

Henry Cartier-Bresson, November 15–October 16, 1933
Photographs
"Antigraphic" Photography

Gjuro Stojana, Sculpture, Drawings, Paintings	October 14–October 30, 1933
"25 Years of Russian Ballet" from Serge Lifar Collection, including Leon Bakst, André Benois, Bauchant, Bérard, Korovin, Steletzky, Survage, Gris, Matisse, Derain, Picasso, Rouault, Laurencin, Miró, de Chirico, Braque, Cocteau, Ernst, Gontcharova, Larionow, Leger, Mallo, Pruna, Rose, Schvervashidze, Sert, Tchelitchew . . .	November 2–November 18, 1933
Salvador Dali	November 21–December 8, 1933
Toulouse-Lautrec, Posters Joseph Cornell, Objects Perkins Harnley, Watercolors Harry Brown, Montages	December 8–January 3, 1934 —December 31, 1933
Emilio Terry, Architecture	January 9–January 31, 1934
Helene Sardeau, Sculpture	February 6–March 3, 1934
Remie Lohse, "Candid Camera"	February 13–March 3, 1934
Marc Perper, Paintings	March 6–March 24, 1934
Salvador Dali, Drawings and Etchings	April 3–April 28, 1934

299

Wynn Richards, April 21–April 28, 1934
Photographs

1934/1935

George Platt Lynes, 50 October 1–October 15, 1934
Photographs

Eight Modes of Painting. October 22–November 2, 1934
An exhibition under the
Auspices of the C.A.A.
(Prepared by Agnes Rindge;
Survey of twentieth-century
art movements: Monet, Re-
noir, Matisse, Rousseau,
Braque, Picasso, Léger,
Otto Dix, Kandinsky,
Nolde, Hiler, Sheeler, Dali,
Ernst, Klee, Miró, Eil-
shemius, Lurcat, Ber-
man . . .)

Corinna de Berri, Paintings November 3–November 19, 1934

Dali November 21–December 10, 1934

Alberto Giacometti, December 1–January 1, 1935
Sculpture

Pavel Tchelitchew December 12–December 31, 1934

Emilio Amero, January 5–January 31, 1935
Photographs

Massimo Campigli February 8–February 25, 1935

Leonid, Paintings February 26–March 18, 1935

Keith Martin and Charles Rain	March 19–April 1, 1935
Eugène Berman	April 2–April 22, 1935
Henri Cartier-Bresson, Walker Evans, Alvarez Bravo, Photographs	April 23–May 7, 1935
Jean Cocteau, Drawings Bernard Sanders, Etchings and Drawings	Through May, 1935

1935 / 1936

Brett Weston, Photographs	—October 14, 1935
Marcel Vertes, Watercolors, Drawings, Prints	October 15–November 5, 1935
Juan Gris, Paintings & drawings	—October 31, 1935
Abraham Rattner, Paintings	November 1–November 19, 1935
Leonid	November 19–December 17, 1935
René Magritte, Paintings	January 3– January 20, 1936
Massimo Campigli	January 28–February 17, 1936
Walter Quirt, Paintings	February 18–March 9, 1936

301

Yves Tanguy and Howard Rothschild	March 10–March 30, 1936
Early American Folk Art (Isabel Carleton Wilde Collection)	March 31–April 21, 1936
Berman, Paintings & Drawings	April 21–May 11, 1936
Atget, Photographs	May 11–May 29, 1936

1936 / 1937

Jacques Bonjean Collection of Paintings (Bérard, Tchelitchew, Berman, Leonid . . .)	September 18–October 27, 1936
De Chirico, Paintings and Gouaches	October 28–November 17, 1936
Max Ernst and Leonor Fini, Paintings	November 18–December 8, 1936
Dali	December 10–January 9, 1937
Tamayo, Paintings	January 12–January 30, 1937
Ferdinand Springer, Paintings and Drawings Leonid	February 1–February 20, 1937
Kristian Tonny, Drawings and Prints	February 23–March 15, 1937
Eugène Berman	March 16–April 10, 1937

Paul Strecker, Paintings, Drawings	April 13–May 15, 1937

1937 / 1938

Dali, Ernst, Berman, Tchelitchew, Leonid	October 6–November 1, 1937
Tchelitchew, Portraits	November 2–November 22, 1937
Peter Blume, Paintings, Drawings	November 24–December 14, 1937
de Chirico	December 15–December 31, 1937
Bernard Sanders René Magritte, Drawings	January 3–January 18, 1938
Robert Francis, Paintings	January 11–January 25, 1938
Tal-Coat, Paintings	January 18–February 1, 1938
Leonid Alice Halicka, Assemblage	February 1–February 19, 1938
Florence Cane, Paintings	February 9–February 27, 1938
Leonid	extended to March 7, 1938
"Trompe L'Oeil" Old and New: including Willen Claez Heda, Pierre Roy, Berman, Magritte, Battista Bettera, Tchelitchew et al.	March 8–April 3, 1938

303

| Marc Perper | March 15–April 5, 1938 |
| Naum Gabo, Constructions in Space, Sculpture | April 5–May 1, 1938 |

1938 / 1939

Walt Disney Studio Gouaches for *Snow White*	September 15–October 10, 1938
Gracie Allen, Paintings	September 26–October 4, 1938
Honore Palmer, Jr., Paintings	October 11–October 24, 1938
Tchelitchew "Phenomena," Paintings, Drawings	October 25–November 1, 1938
Frida Kahlo-Rivera, Paintings	November 1–November 15, 1938
Maud Morgan, Paintings	November 15–November 29, 1938
Maryla Lednicka, Sculpture	November 29–December 13, 1938
Ione Robinson, Drawings: benefit of Rehabilitation Fund of the Abraham Lincoln Brigade	December 8–December 23, 1938
Documents of Cubism: Picasso, Braque, Gris, Léger, Gleizes, Severini, Metzinger, Marcoussis et al . . .	December 13–January 3, 1939

Costume, Advertising Illustrations, Interior Designs and Paintings (New York School of Fine and Applied Art: Parsons)	December 29–January 9, 1939
Abraham Rattner	January 4–January 17, 1939
Campigli	January 17–February 7, 1939
Jared French, Paintings	January 24–February 7, 1939
Eugène Berman	February 7–February 27, 1939
I. Rice Pereira, Compositions	February 20–March 6, 1939
Leonor Fini	February 28–March 14, 1939
Frede Vidar, Paintings	March 7–March 21, 1939
Dali	March 21–April 17, 1939
John Atherton, Paintings	April 18–May 9, 1939
Remo Farrugio, Paintings (Federal Art Project)	April 18–May 9, 1939

1939 / 1940

Color Photograms by Nicholas Haz	October 17–October 30, 1939
Walter Quirt, Colored Drawings	October 24–November 6, 1939
Bertram Goodman, Paintings	November 1–November 11, 1939

305

Gabor Peterdi, Paintings	November 7–November 18, 1939
Souchon, Paintings	November 14–December 4, 1939
Leonid	November 21–January 9, 1940
Cornell, Surrealist Objects	December 6–January 9, 1940
Charles Norman and Marshall Glasier, Paintings	January 9–January 22, 1940
Gallery Group: Decade of Painting: Twenty-four painters including Berman, Leonid, Bérard, Dali, Richard Oelze . . .	January 23–February 25, 1940
Joseph Pollet, Paintings	February 26–March 17, 1940
Maurice Grosser, Paintings	March 5–March 19, 1940
Milena (cousin of King Alexander of Yugoslavia), Paintings	March 19–April 16, 1940
Robert Francis, Drawings	April 6–April 15, 1940
Wolfgang Paalen, Paintings	April 9–April 22, 1940
Tchelitchew and Matta	April 23–May 7, 1940
Theodore Lux and Ben Shahn	May 7–May 29, 1940

1940/1941

Maurice Grosser	October 17–November 9, 1940

Group Show, Abstract paintings, Sculpture, Photographs: Theodore Roszak, Clarence Laughlin, Max Ernst, Prampolini et al	November 12–December 7, 1940
Ludwig Bemelmans, Drawings Milton Caniff, Drawings	December 10–December 26, 1940
David Hare, Colored Photographs	December 10–December 26, 1940
Joseph Cornell, Objects	December 10–December 26, 1940
Old American Theatrical Posters	December 31–January 20, 1941
S. C. De Regil, Paintings	January 21–February 10, 1941
Bernard Sanders, Drawings	January 21–February 15, 1941
Eugène Berman	February 18–March 24, 1941
John Enos, Paintings	March 4–March 24, 1941
Abraham Rattner	arch 24–April 6, 1941
Tamara de Lempicka, Paintings	April 7–April 19, 1941
Dali	April 22–May 19, 1941

OpENEd 1942 AT 11 EAST 57TH STREET (DurLAcHER BROS.)

1942

Eugène Berman	—February 28, 1942

John Atherton	March 3–March 30, 1942
Leon Kelly, Drawings Dorothea Tanning, Paintings	April 1–April 16, 1942
Tchelitchew	April 21–May 18, 1942

1942 / 1943

Maud Morgan	October 13–November 7, 1942
Grosser	December 7–January 2, 1943
Leonid	January 12–February 13, 1943

April 1943 Opened at 42 East 57th Street

Matta, Drawings	April 5, 1943
Jesus Guerrero Galvan, Paintings	April 6–May 4, 1943
Max Ernst, Drawings	May 5–May 25, 1943
Catherine Yarrow, Ceramics	May 22, 1943

1943 / 1944

American Nineteenth Century Painting: "The Picturesque" Tradition: Tomkins H. Matteson, Jerome Thompson, William Brad-	–October 30, 1943

308

ford, Thomas Chambers, et
al

Eugène Berman	November 4–November 30, 1943
"Through the Big End of the Opera Glass" (Marcel Duchamp, Yves Tanguy, Joseph Cornell)	December 7–December 28, 1943
Xenia Cage, Mobiles (lit by Schuyler Watts)	—January 8, 1944
Rico Lebrun, Paintings, Drawings	January 11–February 5, 1944
Leon Kelly	February 8–March 4, 1944
Atherton, Paintings & Drawings	March 7–March 31, 1944
Tanning	—April 30, 1944
Ernst	—May 8, 1944
Peter Miller, Paintings	May 10–May 31, 1944

1944 / 1945

Kay Sage, Paintings	October 3–October 30, 1944
Harold Sterner, Gouaches	October 31–November 21, 1944
Morris Hirshfield, Paintings	November 21–December 7, 1944

Imagery of Chess	—January 31, 1945
Group Show (Chirico, Tchelitchew, Bérard, Berman, Lebrun, Tanguy, Atherton, Grosser)	—February 15, 1945
Fabrizio Clerici, Drawings G. Viviani, Etchings	—February 28, 1945
Arshile Gorky, Paintings	March 6–March 31, 1945
Man Ray, Objects	April 10–April 30, 1945
Max Ernst	May 1–May 31, 1945

1945 / 1946

Peter Miller	—October 31, 1945
René Portocarrero, Paintings	—November 30, 1945
Leon Kelly, Drawings	December 4–December 28, 1945
Group Show (Berman, Atherton et al)	January 8–January 28, 1946
Grosser	January 29–February 16, 1946
Howard Warshaw, Paintings, Drawings	February 19–March 9, 1946
Berman	March 19–April 6, 1946
Arshile Gorky	April 9–May 4, 1946

310

Gar Sparks, Paintings	May 6–June 8, 1946

1946 / 1947

John Atherton	October 8–November 9, 1946
Leonid	November 9–December 7, 1946
Paul Delvaux, Paintings	December 10–January 11, 1947
Theodore Lux Feininger, Paintings	January 15–February 5, 1947
Carl Hall, Paintings	February 16–March 1, 1947
Gorky, Drawings	March 1–March 8, 1947
Max Ernst	March 18–April 5, 1947
Victor Brauner, Paintings	April 15–May 1, 1947

1947 / 1948

Kay Sage	October 14–November 4, 1947
Carl Hall	November 4–November 22, 1947
Maria, Sculpture	November 22–January 3, 1948
Dorothea Tanning	January 5–January 31, 1948
Leonid	February 1–February 28, 1948
Gorky	February 29–March 20, 1948

Gianfilippo Usellini, Paintings	March 23–April 10, 1948
Howard Warshaw and Guy Sparks	April 10–May 28, 1948

1948 / 1949

Group Show	October 15–October 31, 1948
Jeanne Reynal, Mosaics	October 26–November 20, 1948
Gorky	November 16–December 4, 1948
Herman Rosse, Paintings	December 6–January 8, 1949
Continental American Group Show	January 8–February 14, 1949
Paul Delvaux	February 15–March 15, 1949
David Hare, Sculpture	March 15–April 12, 1949

INdEX

Dale, Maude, 85, 95, 100
Dali, Gala, 73–74, 131, 173–74, 197–98, 206, 229–31
Dali, Salvador, 15–16, 70–75, 80, 82, 85, 96, 98, 108, 118, 128, 129, 133–34, 136, 139, 144–46, 148–50, 158, 173–77, 190, 197–99, 204–6, 209–22, 227, 229–31, 236, 240–43, 250, 258, 267
Damia, 74, 173
Davies, Marion, 96
Debussy, Claude, 96
Degas, Edgar, 92
Delacroix, Eugène, 94
DeLamar, Alice, 234, 246
Deluaux, Paul, 118, 136, 282
Derain, André, 70, 118
Descartes, René, 107, 108
Desnos, Robert, 126, 230
Diaghilev, Serge, 15, 140, 242
Dignemont, Andre, 122–23
Disney, Walt, 254
Doolittle, Eric, 32
Doolittle, Hilda, 33
Draper, Muriel, 106
Draper, Paul, 106
Drew-Bear, Bob, 87
Drew-Bear, Lotte Barrit, 87
Dubuffet, Jean, 29
Duchamp, Marcel, 12, 17–30, 31–34, 39, 46, 47, 53, 81, 83, 96, 106, 115, 118, 136, 148, 149, 230, 248, 255, 256, 259, 265, 274–78
Duchamp, Teeny, 22
Duchamp-Villon, Raymond, 19
Dumas *père et fils*, 94
Duncan, Isadora, 34
Dunham, Maggie, 87

Eddy, Mary Baker, 78
Eliot, T. S., 32, 97, 196
Elisofon, Eliot, 98
Elliman, William, 33
Éluard, Gala. *See* Dali, Gala

Éluard, Paul, 72, 73, 81, 168, 241, 284
Ernst, Marie-Berthe, 125, 128, 129, 131
Ernst, Max, 15, 64, 77–79, 81, 82, 108, 125, 127–30, 133, 136, 148, 171–72, 254–55, 265, 266, 270–77, 282, 284
Ernst, Morris, 152
Erwin, Hobe, 56
Evans, Walker, 69
Ewing, Max, 101, 106

Fantl, Ernestine, 104
Feigen, Richard, 87
Feininger, Lyonel, 252
Filipowski, 275
Fini, Leonor, 168–72, 174, 177–78, 234, 249
Flanner, Janet, 34
Forbes, Edward Waldo, 10, 135
Force, Juliana, 99
Ford, Charles Henry, 145, 176
Ford, Ford Madox, 31, 32
Ford, Gordon Onslow, 251
Fosburgh, James, 17
Fosburgh, Minnie Cushing, 17
Foujita, 92
Francken, Ruth, 87
Frankau, Edla, 116
Fratellini family, 120–21
Freud, Sigmund, 81, 191–94

Gabo, Naum, 136, 145, 203
Gallatin, Al, 51
Genaues, Emily, 99
Giacometti, Alberto, 117, 136, 155–58
Gide, André, 34
Gilson, Étienne, 105
Goethe, Johann Wolfgang von, 98
Goodwin, Phillip, 71
Goodyear, A. Conger, 82
Gorky, Agnes Magruder, 284, 287–94

315

317

319